D0363237

Gender and Art

ART AND ITS HISTORIES

Gender and Art

EDITED BY GILL PERRY

JUBILEE CAMPUS LRC

Yale University Press, New Haven & London
in association with The Open University

Copyright © 1999 The Open University

First published 1999 by Yale University Press in association with The Open University

10 9 8 7 6 5 4 3

All rights reserved. Except for the quotation of short passages for the purpose of criticism and review, no part of this publication may be reproduced, stored in a retrieval system, or transmitted, in any form or by any means, electronic, mechanical, photocopying, recording or otherwise, without either the prior written permission of the publisher or a licence permitting restricted copying issued by the Copyright Licensing Agency Limited. Details of such licences (for reprographic reproduction) may be obtained from the Copyright Licensing Agency Ltd, 90 Tottenham Court Road, London W1P OLP.

Library of Congress Cataloging-in-Publication Data
 Gender and Art / edited by Gill Perry
 p. cm. -- (Art and its histories : 3)
 Includes bibliographical references and index.
 ISBN 0-300-07759-9 (cloth). -- ISBN 978-0-300-07760-5 (paper)
 1. Masculinity in art. 2. Femininity in art. 3. Gender identity in art. 4.
 Artists--Psychology. I. Perry, Gillian. II. Series.
N8222.M38G46 1999
 704′.04--dc21 98-34691

Edited, designed and typeset by The Open University.

Printed in Italy

a216b3i1.1

1.1

1006694012

Contents

PART 4 GENDER, MODERNISM AND PSYCHOANALYSIS

Preface

This is the third of six books in the series *Art and its Histories*, which form the main texts of an Open University second-level course of the same name. The course has been designed both for students who are new to the discipline of art history and for those who have already undertaken some study in this area. Each book engages with a theme of interest to current art-historical study, and is self-sufficient and accessible to the general reader. This third book is designed to introduce readers to the role and importance of gender in the study of art and art history. As part of the course *Art and its Histories*, it (along with the rest of the series) also includes important teaching elements. Thus the general reader will find that the text includes discursive sections written to encourage reflective discussion and argument, and to contribute to the on-going critical debates which surround the issues of gender and sexual difference. As this is a field of study which has employed and developed some complex theoretical models, certain concepts have been explored and revisited at several points within the book. This process of repetition and on-going review is a central part of the teaching strategy.

The six books in the series are:

Academies, Museums and Canons of Art, edited by Gill Perry and Colin Cunningham

The Changing Status of the Artist, edited by Emma Barker, Nick Webb and Kim Woods

Gender and Art, edited by Gill Perry

The Challenge of the Avant-Garde, edited by Paul Wood

Views of Difference: Different Views of Art, edited by Catherine King

Contemporary Cultures of Display, edited by Emma Barker

Open University courses undergo many stages of drafting and review and the book editor would like to thank the contributing authors for patiently reworking their material in response to criticism. Special thanks must also go to all those who commented on the drafts, including the A216 course team, Nicola Durbridge, Open University tutor assessors Peter Jordan, Anne Gaskell, and Sue Vost. The authors are especially indebted to Professor Will Vaughan who provided detailed and constructive criticisms of an early draft of this book, and whose ideas and comments influenced the subsequent development of the text. The course editors were Gill Marshall and Nancy Marten. Picture research was carried out by Magnus John and Tony Coulson and the text was keyed in by Janet Fennell. Debbie Crouch was the graphic designer and Gary Elliott was the Course Manager.

Introduction: gender and art history

GILL PERRY

In this book we are concerned with some of the ways in which art history has increasingly become engaged with issues of gender. As we shall see in the case studies which follow, gender issues can affect the conception, production and interpretation of art works. Many, though not all, of those art historians who have shown interest in such concerns have been feminists. The label 'feminist' is being used here to describe someone (either female or male) who studies, exposes and challenges women's cultural, political and social positions and disadvantages. Thus a belief in 'feminism' involves a philosophical mode of enquiry which is the subject of ongoing debate. The term 'feminism' includes a wide range of positions and interests, many of which have shifted and evolved during the second half of the twentieth century. Art history is only one of many academic disciplines which have been affected by a growth in feminist ideas and debates. But before we look more closely at the different ways in which issues of gender can inform our study of visual imagery, we need to clarify exactly what we mean by the word 'gender'.

What do we understand by the concept of 'gender'?

'Gender' is defined here as the cultural construction of femininity and masculinity, as opposed to the biological sex (male or female) which we are born with. Although feminist theory in its various forms does not offer us any single explanation of the differences between men and women, most feminists would reject the idea that male and female characteristics can be found exclusively in any fixed biological attributes. Although some feminists are more concerned than others with tracing masculine and feminine characteristics to their essential biological roots (and are sometimes referred to as 'essentialists'), most feminists from a wide range of positions have contributed to arguments about the relative importance of social, cultural and psychic forces in the construction of identity as either feminine or masculine. (Please note that I am using the terms 'male' and 'female' here to describe characteristics which are most closely associated with biological or physical natures, while the terms 'masculine' and 'feminine' are being used to describe broader cultural associations which may include biological attributes.) These kinds of debates have informed (to a greater or lesser degree) the case studies which follow in this book. For example, in Part 1 'Made in her image: women, portraiture and gender in the sixteenth and seventeenth centuries', by Catherine King, and Part 2 'Gender, genres and academic art in the eighteenth century', by myself and Emma Barker, the authors are concerned with notions of artistic creativity as a predominantly 'masculine' characteristic. We show how the activities of women artists in sixteenth- and seventeenth-century Italy and Northern Europe, and in eighteenth-century Britain and France, may cause us to reject such gendered assumptions and easy generalizations. The authors also seek to explain and understand

something of the cultural and political environments in which these preconceptions were widely accepted. Our interest in the gendering of art and culture is not confined to the study of painting and what we might call 'gallery art'. In Part 3, 'Gender, class and power in British art, architecture and design', Christy Anderson explores the ways in which architectural practice was gendered in seventeenth-century Britain, while Colin Cunningham shows how gender issues played an important part in Victorian perceptions of applied design and the 'decorative arts'.

In recent years there has been a marked growth of interest in the study of sexuality as an important aspect of gender studies. The concept of 'sexuality' has increasingly been separated from that of 'sex'. While the latter is generally used to describe the biological status (of female or male) at birth, 'sexuality' is more often used to represent forms of sexual desire or behaviour, whether towards the opposite or the same sex. Within western patriarchal societies[1] the most culturally desirable sexuality has generally been seen as heterosexual. The ways in which codes of sexual behaviour have been cultivated, exercised and policed have interested many cultural theorists and feminist scholars, for whom sexuality can be seen as an important indicator of the gender relations within a particular class, ethnic group or culture.[2] Some art historians, for example, are interested in the ways in which female and male sexuality is represented in visual imagery, and what this can tell us about perceptions of sexual difference within the cultural and artistic context in which the work was produced. Thus in Part 3 of this book, Lynda Nead's 'Class and sexuality in Victorian art' looks at the complex relationship between class, morality and sexuality which is suggested by the imagery of some Victorian paintings of women.

Within art history, some theorists concerned with representations of sexuality have argued for a more flexible approach to the concept of gender.[3] They have suggested that our tendency to define sexual difference largely in terms of binary opposites between male and female within a predominantly heterosexual framework can erase the sexual ambiguities which some images may evoke or reveal if interpreted in a less orthodox way. An approach has emerged which allows for the possibility that the artist may, on occasion, have intended to represent a more ambiguous sexuality, or that we may look at or read an image differently according to our sexual inclination. (I will return to the important issue of how we look at images later in this introduction.) This approach has informed both art practice and art-historical methods. For example, some contemporary gay and lesbian artists actually include overt references to their homosexuality in their works, as in the work of the American photographer Robert Mapplethorpe or the American artists Nicole Eisenman and Catherine Opie (Plates 1 and 2). And some recent

[1] I am using the term 'patriarchal societies' to describe those societes in which the organization of culture (i.e. political, legal, educational, religious, etc.) is dominated and controlled largely by men.

[2] See, for example, the work of the French cultural theorist Michel Foucault, in particular *The History of Sexuality*.

[3] Such issues have been addressed in the work of, for example, Whitney Davis. See his essay 'Gender' in Nelson and Shiff, *Critical Terms for Art History*. See also his essay in Edwards, *Art and its Histories*.

writing on the American pop artist Andy Warhol has suggested that, as his work became canonized as one of the most important examples of American Pop Art (Plates 3 and 4), the homosexual contexts and references of some of his works have been played down or expunged from art history.[4] This form of writing seeks to reposition Warhol's art in relation to the homosexual identities and politics which (it is argued) may help to give it meaning. This form of gender studies, now labelled 'queer theory', allows for the interpretation of images or texts in terms less clearly divided between conventional heterosexual categories.

An interest in gender, then, need not necessarily be the exclusive domain of those concerned with the representation and history of women. It also gives us a framework to explore a wide range of issues, including the ways in which ideas of femininity *and* masculinity are constructed in our culture, which will often involve study of how different sexualities are defined. Such an interest can, of course, also be applied to the study of race and ethnicity. This might involve, for example, an exploration of the work of women artists of colour working within western or non-western contexts, or a study of representations of gender and identity (both feminine and masculine) in visual imagery from non-western cultures. Although some of these issues are addressed in later case studies, we are primarily concerned in this book to introduce the reader to the ways in which gender has informed the study and development of western art history.[5]

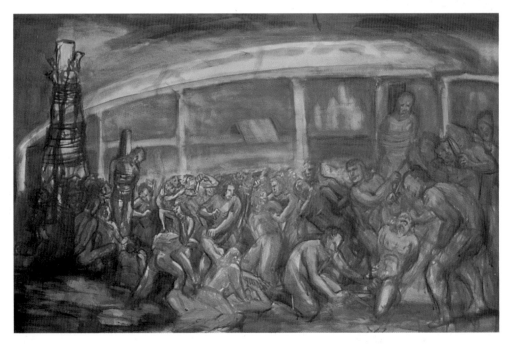

Plate 1 Nicole Eisenman, *Amazon Composition*, 1992, ink on paper, 60 x 90 cm, Jack Tilton Gallery, New York.

[4] For a discussion of this debate on Warhol see Butt, 'Avant-Garde and Swish'.

[5] The role of race and ethnicity in the construction of identity is addressed in the fifth book in this series, King, *Views of Difference*.

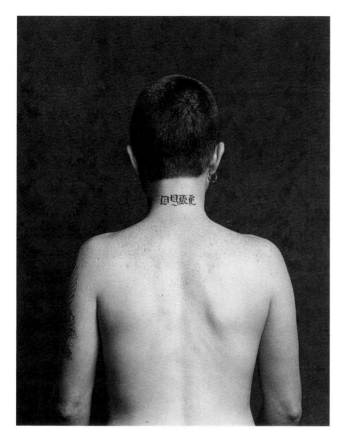

Plate 2 Catherine Opie, *Dyke*, 1993, chromogenic print, 100 x 75 cm. Photo: Courtesy of Regen Projects, Los Angeles.

Plate 3(a) Andy Warhol, *Torso*, 1977, silkscreen ink on synthetic polymer paint on canvas, 127 x 107 cm, private collection. Reproduced by courtesy of Gian Enzo Sperone, © ARS, New York and DACS, London, 1999.

Plate 3(b) Andy Warhol, *Torso*, 1977, silkscreen ink on synthetic polymer paint on canvas, 127 x 96.5 cm. © The Andy Warhol Foundation for the Visual Arts / ARS, New York and DACS, London, 1999.

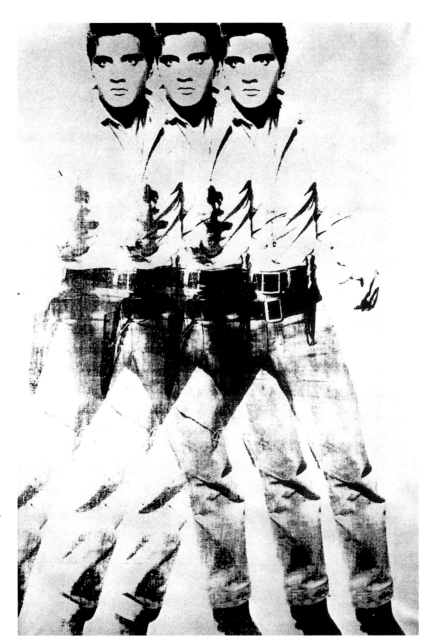

Plate 4 Andy Warhol, *Triple Elvis*, 1963, acrylic on canvas, 208 x 153.4 cm, private collection © The Andy Warhol Foundation for the Visual Arts / ARS, New York, DACS, London, 1999.

How can issues of gender be useful for the study of visual imagery?

As this book is largely concerned with the role of gender in the production and interpretation of art, the history and status of women artists will inevitably form one important aspect of study. But, as I have suggested, a concern with gender can engage our interest on many levels which will involve both questions of authorship and questions of representation. I want now to consider in detail what these different levels might be, with close reference to a painting by the nineteenth-century French artist, Édouard Manet (1832–83), *The Balcony* (Plate 5).

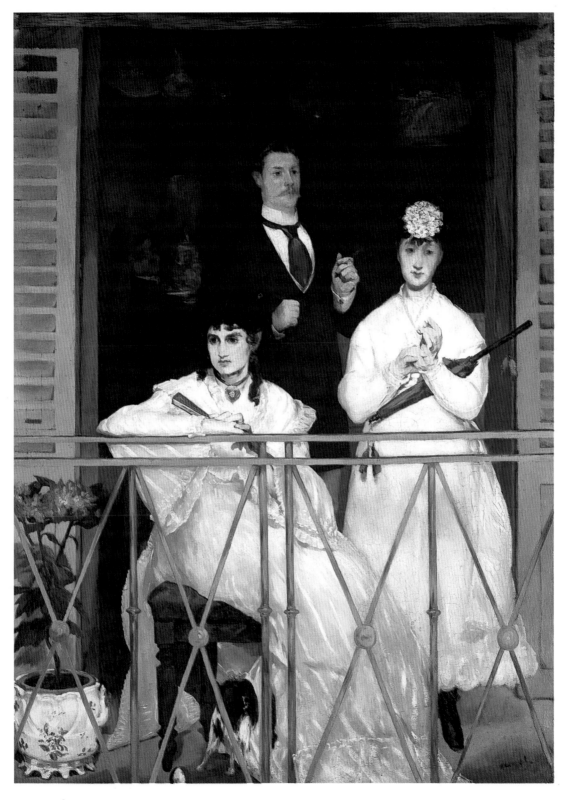

Plate 5 Édouard Manet, *The Balcony*, 1868–9, oil on canvas, 170 x 129.5 cm, Musée d'Orsay, Paris. Photo: Réunion de Musées Nationaux, Paris.

I have made the following checklist of questions which would be of interest to anyone primarily concerned with issues of gender difference in this work.

1 Questions of authorship: was the work painted by a man or a woman, and can our knowledge of the artist's gender inform our understanding of the work in any way?

2 Questions of representation: how is gender difference represented in the image; if the image includes figures, how are men and women represented? Do any aspects of these figures and the ways in which they are painted suggest specifically feminine or masculine characteristics?

3 What is the role of gender in the physical or social environment represented: are these figures depicted as inhabiting a specific social/domestic/private/public space which could be related to their gender?

4 Can the actual processes of representation be seen as gendered: can we talk about the techniques of painting as being either masculine or feminine?

5 How does our gender affect the way in which we look at a painting: does a male viewer see an image of a woman (or man) differently from a female?

Although the various contributors to this book adopt differing emphases and interests, they are all concerned with some or all of these sorts of questions. With these points in mind, I have deliberately chosen to look at *The Balcony*, a nineteenth-century French painting in which naturalistic conventions are used. In other words, figures are clearly depicted in this work, which allows us to address questions 2 and 3 above. Questions 2 and 5 would not apply if we were looking at a landscape, and questions 2, 3 and 5 would be redundant if we were looking at a later abstract or 'non-figurative' work in which there are no identifiable references to the visible world. We could argue, then, that some gender issues are more easily identified and discussed in works which contain figurative references. This raises some difficult issues for the discussion of modern and contemporary art which we will address later in this book.

Manet's *The Balcony* depicts a group of his friends, the artists Berthe Morisot (1841–95) (seated in the foreground) and Antoine Guillemet, and the violinist Fanny Claus (standing on the right). Although Manet declined to participate in the first exhibition of Impressionist painters in 1874, aspects of his work have been seen to anticipate that of younger Impressionists such as Monet and Pissarro, particularly in the freedom of the brushwork and the informality of some of his subjects, which contrasted with the more polished finish and more formal historical or literary subjects favoured by some contemporary academic painters (Plate 6).

Questions of authorship may raise issues about contemporary historical and cultural context. Manet's profession was dominated by men in the late nineteenth century, and much has now been written about the limited educational opportunities available to aspiring women artists, and the social and cultural disadvantages which they encountered.[6] In Parts 1 and 2 of this book the authors address issues of the limited professional and academic

6 See, for example, Garb, *Sisters of the Brush*.

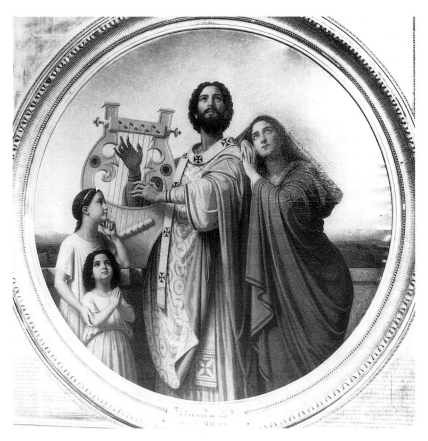

Plate 6 Pierre-Eugéne-Jules Maison, *L'Hymne du Soir*, 1864, oil on canvas, 189 cm in height, Musée de Troyes. Photo: Jean-Marie Protte.

status available to women artists within post-Renaissance western culture, and in Part 4, Case Study 8, I discuss the situation in late nineteenth-century France when women were not admitted to the state-run École des Beaux Arts until 1897. So if this painting had been produced by a woman, it might cause us to consider what specific circumstances had enabled her to produce the work given the particular constraints which women were working under. Interestingly, Manet has included a woman artist, Berthe Morisot, within the portrait group, although there are no clues provided to tell us that she holds the professional status of artist. The other female figure in the portrait, the violinist Fanny Claus, is also represented without reference to her professional skills. Broadly speaking, conventions were well established for the representation of male artists or writers revealing or acting out their professional skills (Plates 7 and 8). But before we argue that this work reveals the absence of such conventions for women, it is worth noting that the male artist present, Guillemet, is also shown without reference to his professional career. In other words this portrait seems to represent a social activity rather than a professional gathering. In order to construct an argument about gendered perceptions of women we would need to see the painting in relation to other portraits of male and female artists which reveal different conventions for the depiction of men and women. In fact Manet painted many portraits of Morisot (Plate 9), all of which are without references to her professional status.[7] So the ways in which gender relations can be seen to inform visual imagery are complex, and we should be wary of oversimplifying the relationship between cause and effect.

[7] See Garb, *Modernity and Modernism*, p.246.

Plate 7 Édouard Manet, *Emile Zola*, 1868, oil on canvas , 190 x 110 cm, Musée d'Orsay, Paris. Photo: Réunion des Musées Nationaux, Paris.

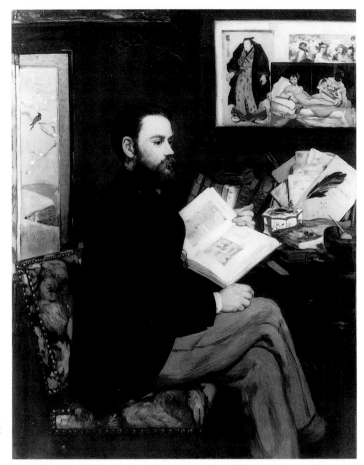

Plate 8 Henri Fantin Latour, *L'Atelier des Batignolles*, 1870, oil on canvas, 173 x 208 cm, Musée d'Orsay, Paris. Photo: Réunion des Musées Nationaux, Paris.

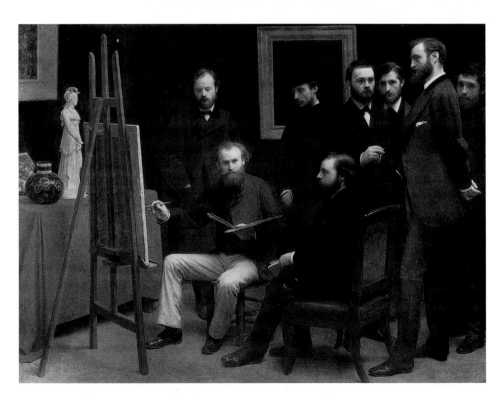

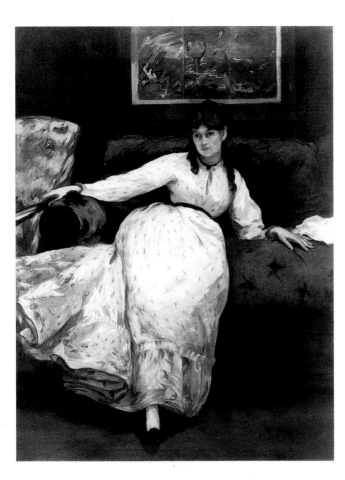

Plate 9 Édouard Manet, *Le Repos* (*Rest*, portrait of Berthe Morisot), 1870, oil on canvas, 145.5 x 122 cm, Museum of Art, Rhode Island School of Design, Providence. Bequest of the Estate of Mrs Edith Stuyvesant Vanderbilt Gerry.

Manet's painting seems to have been intended, then, as a representation of an informal domestic scene. As such it can perhaps tell us something of the class of the subjects represented, and (I would suggest) the way in which issues of class may intersect with those of gender. These are issues which relate to points 2 and 3 in my list above. The femininity of both women is emphasized in the depiction of their flowing summer dresses, their feminine accessories (the fan and the parasol) and their wistful or pensive expressions. In this respect they seem to contrast with the seemingly more alert, dark suited figure of Guillemet behind them. Other portraits of Morisot by Manet (Plate 9) show her in similarly rich feminine dress, itself a signifier of her upper-middle-class status. As the daughter of a wealthy civil servant, Morisot belonged to the French *haute-bourgeoisie*. Feminist historians and art historians have produced a wealth of material to show how contemporary ideals of bourgeois femininity, as revealed in various forms of written and visual culture, often revolved around models of domesticity, passivity and prettified images of decorative women. Of course, these were not the only representations of women available in the visual arts, but their prevalence has led such images to be referred to as 'normative' constructions of femininity. Thus portraits of women were widely expected to represent their decorative qualities, their beauty and fashionable or elegant dress and by implication the status and wealth of their husband or family. It is this process of representation of women, which reduces them to the level of an object to be looked at, which is often described as the 'objectification' of women. And this objectification raises the important issue of what happens when men – or male artists – look at and represent women. Does the process of looking itself involve relations of power

which we can see exercised in other aspects of culture? This is one of the issues in my question 5 above which will be considered in more detail in the final section of this introduction.

There's another related aspect of this work which could, I think, be embraced under questions 2 and 3 above. The organization of Manet's composition with the two women in the foreground on the balcony providing the main source of visual interest, with the male figure in the background, could be seen to reinforce the argument that women were often objectified in visual representations as a decorative or beautiful spectacle. Moreover, this organization echoes a popular contemporary convention for representing the (bourgeois) audience at the opera, in which etiquette determined that women sit in the front of the box or balcony, providing a highly visible and elegant image, with male figures seated behind. The feminist art historian Tamar Garb has suggested that this convention could be seen to be appropriated in paintings from the same period such as Auguste Renoir's *La Loge*, in which the beautiful woman functions as a spectacle to be looked at while the male figure behind her actively looks (at other women?) (Plate 10). Garb goes on to argue that looking is central to psychoanalytic accounts of how identity is constructed, because 'in psychoanalytic theory, it is through sight that a recognition of sexual difference first occurs in the infant boy or girl' (*Modernity*, p.221). As we shall see in Part 4 in particular, psychoanalytic theory has had an important influence on recent feminist art history. It has also had a more general influence on debates about gender, and the vocabulary employed by a wide range of feminists. Many of the terms now used to describe processes of looking, such as the idea of a male (or female) 'gaze', have their roots in psychoanalytic theory.

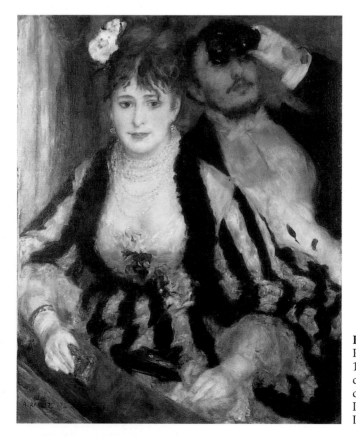

Plate 10 Auguste Renoir, *La Loge*, 1874, oil on canvas, 80 x 63.5 cm, Courtauld Institute of Art, London.

My final topic in this discussion of *The Balcony* relates to question 4 above. Much critical writing from the nineteenth and twentieth centuries about the techniques of painting suggests that the actual processes of painting could be overtly or covertly gendered. For example, within nineteenth-century academic theory drawing was often perceived as a more intellectual, masculine practice, while an interest in colour and surface texture was seen as predominantly 'feminine'.[8] Such associations were reworked around the end of the nineteenth century, when an increasing taste for both 'modern' subjects from contemporary urban life and innovative techniques was accompanied by shifts and tensions in critical writings. The emergence of what we now call the Impressionist movement provoked an impassioned and often gendered debate about the handling of the *surface* of paintings. In academic terms, Manet's loose handling of paint and lack of polished finish were seen as quite unorthodox. For some, his fluid use of paint seemed quite inappropriate to the elegant feminine subjects of, for example, *The Balcony* or *Le Repos*. The loose finish and lack of subtle chiaroscuro in his work were seen to be more suitable to coarser 'masculine' (and lower class) subjects, such as *The Old Musician* (Plate 11). But critical positions soon evolved which could re-evaluate these techniques, claiming them for a modern and predominantly masculine creativity. Thus the more freely painted works of the Impressionists and later Post-Impressionists (such as Van Gogh, Gauguin and Cézanne) were increasingly associated with a bold and essentially masculine notion of innovative creativity. This gendering of artistic practice, of the actual processes of painting, is one of the themes of Case Study 8. As we shall see, within western art of the last two centuries such gendered associations have been characterized by tensions and contradictions.

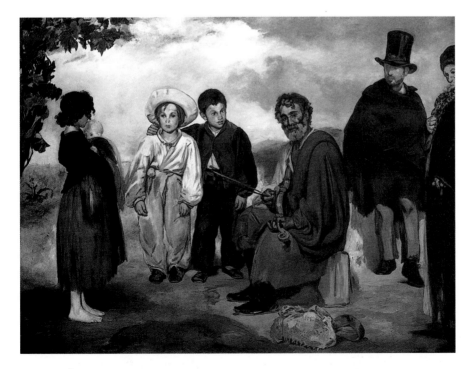

Plate 11 Édouard Manet, *The Old Musician*, 1862, oil on canvas, 230.5 x 289.6 cm, National Gallery of Art, Washington, DC, Chester Dale Collection.

8 See Callen, 'Coloured views', pp.23–30.

In my attempt to open up these issues I have used an analysis of painting. But as we shall see in the different case studies included within this book, questions of gender can be applied equally usefully to the forms and cultural contexts of other visual arts, including architecture, sculpture and applied design.

What is feminist art history?

So far we have been looking at issues of interest to feminist art history. I want now to try and map out some developments in feminist art history itself, by exploring the responses to a feminist work of art from the 1970s. In 1979 the American artist Judy Chicago first exhibited her large installation, *The Dinner Party* (Plates 12, 13 and 14), at the San Francisco Museum of Art. This is a collaborative multi-media work consisting of an open triangular table covered with embroidered cloths and set with 39 place settings, thirteen on each side. Each place setting commemorates an ancient goddess or important woman from western history, and includes needlework designs and ceramics decorated with images which suggest female genitalia (Plates 13 and 14). The triangular banqueting table is placed on what Chicago called the 'Heritage Floor', a polished porcelain surface on which are inscribed the names of 999 women.

Plate 12 Judy Chicago, *The Dinner Party*, 1979, mixed media, 1440 x 1290 x 90 cm. Photo: Donald Woodman, courtesy of *Through the Flower*, Belen.

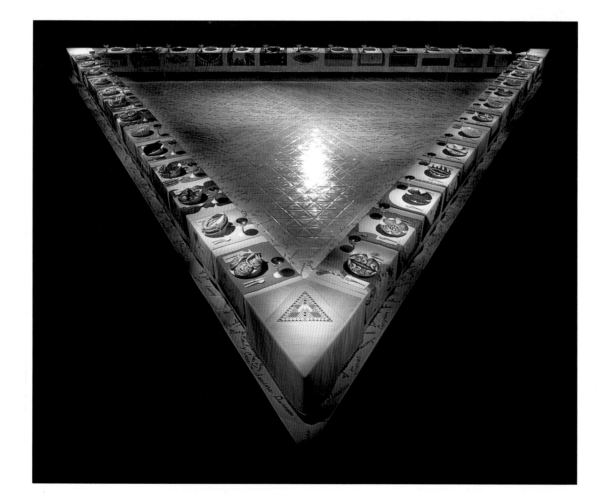

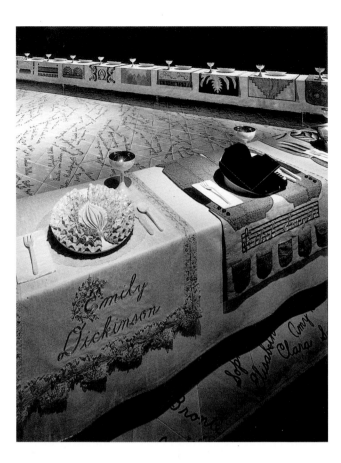

Plate 13 Judy Chicago, detail of *The Dinner Party* showing place setting for Emily Dickinson. Photo: Donald Woodman, courtesy of *Through the Flower*, Belen.

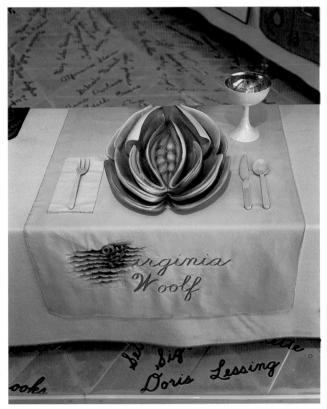

Plate 14 Judy Chicago, detail of *The Dinner Party* showing place setting for Virginia Woolf. Photo: Donald Woodman, courtesy of *Through the Flower*, Belen.

When the exhibit opened in the 1970s it provoked a storm of controversy. Within the art world and the feminist movement views were divided as to its aesthetic, art-historical and sociological importance. Many members of the art establishment shunned the work, suspicious of its exclusive celebration of women and uncomfortable with the sexual imagery. *The Dinner Party* was subsequently shown in Houston, Boston, Brooklyn, Cleveland and Chicago, followed by well-attended showings in five other countries, including Britain and Australia. It was placed in storage in 1988, but in 1990, following a suggestion that it be found a permanent home in the University of the District of Columbia in Washington, another storm raged. As the university's funding was overseen by the American Congress, several politicians blocked the vote to house *The Dinner Party*, attacking it as pornography. Partly in response to this, the directors and curators of the Armand Hammer Museum of Art and Cultural Center at the University of California, Los Angeles decided to hold a show in 1996 which would place the work in the context of other examples of past and contemporary feminist practice, and situating it within the development of feminist theory. The show was called 'Sexual Politics: Judy Chicago's *Dinner Party* in Feminist Art History'.

Whatever views we may have on the meanings or value of *The Dinner Party*, there is no denying that it has become a cultural icon, guaranteed to generate controversy, which has informed the development of feminist theory in America and Europe. The different interpretations which it has helped to provoke provide a framework for our discussion of some different and evolving concerns within feminist art history.

Amelia Jones, the feminist art historian invited to contribute as guest curator to the 1996 exhibition, has emphasized the role of *The Dinner Party* as a catalyst for feminist debate. She argues in the catalogue that despite this function,

> it has not been incorporated in any satisfactory way into the histories and theories of feminist and contemporary art: it seems that the very contentiousness of the piece has precluded the thoughtful examination of its effects. Whether adored or abhorred, the piece has tended to be viewed in a vacuum, isolated from its rich historical, artistic and theoretical contexts.
>
> (Jones, *Sexual Politics*, p.24)

The 1996 exhibition sought not to celebrate and elevate Chicago's work, but rather to apply a critical and historical framework to our understanding of it.

Chicago's idea for *The Dinner Party* grew out of her research into women's history begun in the late 1960s. She records that she undertook the study in a bid to discover

> whether women before me had faced and recorded their efforts to surmount obstacles similar to those I was encountering as a woman artist. When I started my investigation, there were no women's studies courses.
>
> (Chicago, *The Dinner Party*, p.3)

Chicago's project then belongs within what is sometimes seen as the first wave of feminist art history in the 1970s, itself a response to the growing political activism of the Women's Movement in America and Europe in the

1960s and 1970s. A major concern for this first generation of feminist artists and art historians was the 'reclaiming' of the work of women which had been marginalized or hidden within conventional histories of, and courses on, art. Several monographs and surveys appeared in the 1970s which documented the work and achievements of women artists. While a documentation of, and interest in, the work of women artists has continued (broadly speaking) to form an important aspect of feminist art history up to the present day, the methodologies and critical approaches adopted have changed and evolved. Thus many of the first wave of feminist surveys were subsequently seen to reveal uncritical approaches to conventional notions of 'greatness'. In 1987 an important article, 'The feminist critique of art history', written by the American art historians Thalia Gouma-Petersen and Patricia Mathews argued that many of these books shared the (usually unspoken) objective to:

> prove that women have been as accomplished, even if not as 'great' as men, and to try to place women artists within the traditional historical framework … we believe such an approach is ultimately self-defeating for it fixes women within pre-existing structures without questioning the validity of those structures.
>
> (p.327)

The authors go on to argue that this tradition has come close to creating its own alternative canon of white female artists, which is almost as exclusive as the male canon which its seeks to undermine.

In seeking to question 'pre-existing structures' many feminist art historians working in the early 1980s sought to unpick existing and patriarchal definitions of 'greatness'. In the process they examined the existing criteria upon which works of art are judged to be 'good' or 'bad', arguing that such criteria are based on patriarchal values. An enormously influential book from this period, *Old Mistresses: Women, Art and Ideology,* was published by two British feminists, Rozsika Parker and Griselda Pollock, in 1981. In the preface to their book they explain that they are not just presenting more information about women artists, but are concerned rather to 'explore women's place in the history of art' (p.xvii). Noting that 'it is only in the twentieth century that women have been systematically effaced from the history of art', they set out their project as one which seeks to know how and why

> women's art has been represented and what this treatment of women in art reveals about the ideological basis of the writing and teaching of art history … Our book is not therefore a history of women artists, but an analysis of the relations between women, art and ideology.
>
> (Parker and Pollock, *Old Mistresses,* pp.xvii, xix)

Parker and Pollock's book has come to be seen as something of a landmark in the evolution of feminist art history. Informed by post-structuralist techniques of analysis and models from psychoanalysis, their work is widely seen to have shifted the terms of the debate.[9]

[9] For a more detailed discussion of the role of this and other approaches within feminist art history in the 1980s, see Gouma-Petersen and Mathews, 'The feminist critique of art history'.

We've seen that Parker and Pollock were especially concerned with the ways in which the art history of the twentieth century has systematically effaced or excluded women. Along with some other feminists writing in the 1980s, they argued that such exclusions are sustained by particular ideological assumptions about women's relation to art. Art history has been infused with a 'feminine stereotype' which has tended to see the 'masculine' as the main force of cultural creativity, rendering the idea of the woman artist as something of a contradiction in terms. These ideas have been developed and reshaped in much of the feminist art history of the late 1980s and the 1990s. You will find that many of the contributors to this book build on and rework these ideas to suggest that notions of femininity and masculinity are complex and shifting categories which are constructed through cultural discourse (whether visual or written).

In examining the various ideas and assumptions which have helped to create feminine – or masculine – stereotypes, feminist art history has often drawn attention to the separation within patriarchal culture of a predominantly masculine sphere of 'high art' from a more feminine sphere of applied or decorative art, of embroidery and 'craft'. This separation, with its roots in European academic theory, has helped to devalue the 'feminine' pursuits of the decorative arts in relation to a supposedly more 'masculine' and more intellectual notion of high art.[10] Judy Chicago had addressed this separation in *The Dinner Party* when she included ceramic painting and 'decorative' embroidery designs as a central part of the work (Plates 13 and 14). But there has been disagreement on how embroidery, or decorative design generally, should be reconceptualized within feminist theory. While some art historians have tried to reclaim the decorative arts as producing important objects of aesthetic value worthy of a place in mainstream art history, others have argued that we should not accept the separation (encouraged by mainstream art history) of art and craft, which implies a mindless and inferior role for the latter. In other words, we should question the whole value system which underpins most conventional art histories. Such issues are raised in *Old Mistresses* and explored in detail in Parker's book *The Subversive Stitch*, published in 1984. By studying the relationship between the history of embroidery and changing notions of femininity from the Middle Ages to the twentieth century, Parker shows how perceptions of the roles of art and embroidery across classes were related to contemporary ideals of feminine behaviour. She writes 'to know the history of embroidery is to know the history of women'.[11]

The reception of Chicago's *Dinner Party* focused on another contentious issue for feminist art history. During the 1980s, many feminists identified the use of vaginal or vulval forms, some of them raised, on the commemorative plates (Plate 13) as essentialist. The work was accused of celebrating a female identity in biological terms, rather than situating that identity in a more social and political framework. In this context, *The Dinner Party* was also accused of monumentalizing one aspect of female experience which, in its guest list of

[10] The ways in which this separation was established through the development of European academic theory was discussed in Book 1 of this series, Perry and Cunningham, *Academies, Museums and Canons of Art*.

[11] In a review of Parker's book, Tamar Garb identifies *The Dinner Party* as a self-defeating work which seeks to exalt women's 'decorative' arts such as embroidery on the same terms as modernism without challenging the terms of modernism ('Engaging embroidery', p.132).

'great' female names, was seen to be implicitly white, heterosexual and middle or upper middle class. In defence of Chicago's position it has been argued that she belonged to a group of feminists for whom the main objective was a unified coalition to fight women's oppression, and for whom race was then a separate issue. And it is important to note that by the 1980s, when many of the debates around Chicago's work were raging, the changed political circumstances in both Britain and America had shifted the agenda for many feminist artists and art historians. While it is sometimes suggested that *The Dinner Party* was produced during an era (the 1970s) of relatively progressive cultural politics, the election of Margaret Thatcher as Britain's prime minister in 1979, and Ronald Reagan as President of the United States in 1980, marked significant political shifts to the right which threatened both socialist and feminist ideals alike. Given these shifting contexts, it has been argued that it was the optimistic activities of the Women's Movement during the 1970s which made Chicago's *Dinner Party* possible.[12]

Apart from accusations of pornography from many members of the political establishment and the art world, the vaginal imagery of *The Dinner Party* also generated a heated debate within feminist ranks about the ease with which these images might be appropriated for male pleasure. Several of Chicago's works from the 1970s also explore female sexual identity. Works such as *Female Rejection Drawing* of 1974 (Plate 15) were produced as attempts to resist the objectification of women by developing geometric and flower-like forms which evoke female genitalia. Chicago argues that such forms are used metaphorically to symbolize both strength and vulnerability. The representation of female sexuality has been an important focus for feminist artists and art historians since the 1960s, and the reclaiming of women's sexual pleasure was an important theme of work from the 1970s. But during the 1980s some feminist criticism became more concerned with analysing and critiquing *male* pleasure. Thus in *Old Mistresses* Parker and Pollock take a different view of Chicago's imagery from the 1970s. Although *The Dinner Party* does not feature in their discussion, *Female Rejection Drawing* is the focus of a lengthy analysis of these issues which argues for a rejection of such images. They argue that although women may feel affirmed by such attempts to validate female experience, representing hitherto repressed or censored aspects of their lives, they are images which only really have a limited effect. The authors juxtapose an image from *Penthouse* next to *Female Rejection Drawing*, arguing:

> They are easily retrieved and co-opted by a male culture because they do not rupture radically meanings and connotations of women in art as body, as sexual, as nature, as object for male possession.
>
> (Parker and Pollock, *Old Mistresses*, p.130)

Whether or not you agree with Parker and Pollock's conclusions (written in 1981), it is important to acknowledge that these are issues which have informed feminist art history for several decades. During the 1980s such issues were increasingly tied up with the question of looking. In other words the questions 'how do men and women look at each other, and what sexual, cultural and power relations might be involved?' have become central to much feminist art history of the late twentieth century.

12 For a discussion of these issues see Malvern, 'Virtuous and vulgar feminisms', pp.483–9.

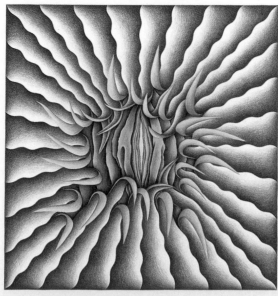

Plate 15 Judy Chicago, *Rejection Quintet: Female Rejection Drawing*, 1974, 75 x 60 cm, San Francisco Museum of Modern Art, Gift of Tracy O'Kates.

Why is gender important in our understanding of the processes of looking?

Art history is concerned with the visual arts, a term normally used to include art, architecture, sculpture, the decorative or applied arts, popular prints, photography and film. While this may seem like stating the obvious, the label *visual* arts tells us that these art forms all communicate primarily through the visual sense (although it could be argued that sculpture, for example, can also communicate through the tactile and film through the aural senses). Our understanding of these art objects depends largely on looking. You will probably have noticed that within art history several terms are regularly used to describe the person or persons who look at works of art, including 'viewer', 'spectator', 'audience' or 'beholder'. I have already cited the term 'gaze' as one which is now widely used, particularly within gender studies, to describe the processes of looking involved. Margaret Olin has summarized some of the wider connotations of this term:

> 'Gaze' is a rather literary term for what could also be called 'looking' or 'watching'. Its connotation of a long, ardent look may bring to mind the intensity in which knowledge and pleasure mingle when I behold a work of art. While most discourse about the gaze concerns pleasure and knowledge, however, it generally places both of these in the service of issues of power, manipulation, and desire. There is usually something negative about the gaze as used in art theory. It is rather like the word 'stare' in everyday usage.

After all, parents instruct their children to stop staring, but not to stop gazing. A typical strategy of art theory is to unmask gazing as something like staring, the publicly sanctioned actions of a peeping Tom.

(Olin, 'Gaze', p.209)

When Olin describes the usually 'negative' implications of the term, she is referring to critical theories of the gaze, mostly originating in feminist and psychoanalytic studies, which are concerned with the social and psychic processes involved when men and women look at each other. Perhaps the most seminal essay on this theme originated in film theory: Laura Mulvey's 'Visual pleasure and narrative cinema' of 1975. Mulvey argued that 'the place of the look' was central to cinematic viewing. Drawing on psychoanalytic theory, she identified the viewing of films as involving an erotic voyeurism taking place on several levels. These levels involve the artist who produces the image, the male spectator who views it and the figure/s who look at each other within the cinematic narrative. She developed a theory of the gaze in which 'the determining male gaze projects its fantasy onto the female figure which is styled accordingly'. The 'male gaze' is thus seen as the structuring principle for the representation of women. Since the late 1970s, the theory has been widely applied to the historical conventions for the painting and reception of images of women. Such conventions have been developed mostly by male artists, and (broadly speaking) have been identified as constructing images of women's bodies to satisfy male pleasure. As the female nude is one of the most important themes in the art history of the last two centuries, it is argued that in painted representations women's bodies have often been objectified through male desires and fantasies.

Modern theories of the gaze, then, have helped to give an important critical edge to our concept of looking, encouraging us to see the social and gender relations involved. Part 2 of this book looks at some eighteenth-century ideas on the viewing of art, and the related notion of the ideal male 'contemplative' viewer of paintings of the female nude. Now I want to think about how we might apply a theory of the gaze to another image from late nineteenth-century French art.

Please look at Paul-Joseph Jamin, *Brenn and his Share of the Plunder*, 1893 (Plate 16). (Note: this work belongs to a traditional school of French nineteenth-century painting which favoured anecdotal realism.)

How do you think a theory of the gaze might be applied in an analysis of this painting?

Discussion

The theme of this nineteenth-century work lends itself almost too easily to Mulvey's model. A conquering Gaul warrior stands victorious at the entrance to a besieged palace in which he surveys his 'plunder' or booty in the form of five naked captured women, victims of war and, by implication, of the rape which will probably ensue.

We could argue that a 'male gaze' is crudely represented as taking place within the actual narrative of the image. The strong, victorious and upright figure of Brenn gazes at the relatively passive figures of the women, the focus of his lascivious desires. Apart from this obvious 'gaze' of the figure depicted within

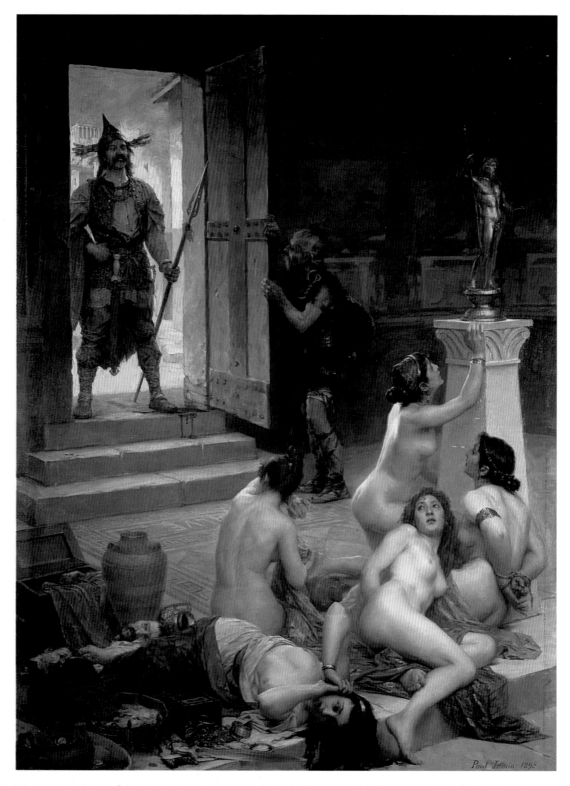

Plate 16 Paul-Joseph Jamin, *Le Brenin et sa part de butin* (*Brenn and his Share of the Plunder*), 1893, oil on canvas, 162 x 118 cm, Musée des Beaux Arts de La Rochelle, France. Photo: © J+M, La Rochelle, France.

the painting, we could see the artist as producing an image which, although it claims historical authority, invites an erotic voyeurism on the part of the male spectator. The captured women are deliberately shown naked and/or tied up, with the bodies shown from different angles, thus encouraging (possibly violent) male sexual fantasies. The female figures could be seen to have been 'styled' according to male fantasy. The male spectator of the work is thus invited to project his own sexual fantasy on to the image, to see – and to control – these women's bodies as objects of desire.

◆◆◆

In Part 4 of this book Claire Pajaczkowska will consider in more detail the theoretical aspects of this model, and the role which psychoanalytic theory can play in our understanding of the unconscious desires at play in the process of the 'gaze'. The exercise above also raises difficult questions about the possibilities for a 'female' or feminist gaze. Can a female – or even a male – artist escape the constraints of a patriarchal culture and produce different sorts of images of women's bodies? The issue of how women artists approach the representation of female sexuality and desire, and the problems this poses for a theory of the gaze is also addressed in Part 4 of this book.

We've seen that looking is central to psychoanalytic models because it's through sight that we form our earliest recognition of sexual difference. Theories of the gaze have drawn much from the psychoanalytic models of Sigmund Freud (1856–1939) and the French psychoanalyst Jacques Lacan (1901–86), who were both concerned with the privileged status of the *phallus* (the symbolic signifier of the penis) in the development of the human psyche (mind). Lacan developed Freud's ideas on the unconscious to assert that it is structured like a language. As a language it is constantly in flux, and like language (or words) it cannot have any fixed relationship to reality (objects or ideas). The writings of both, particularly Lacan, are notoriously opaque and difficult, and in Part 4 of this book Claire Pajaczkowska, Briony Fer and I will be looking in detail at some of the ways in which their psychoanalytic models on the role of the unconscious mind can be of value to those interested in gender studies. But it's important to note here that through their interest in the dominant role of the phallus in the formation of sexual identity, both Freud and Lacan reinforced the perception of gender as socially constructed rather than biologically determined.

There are many evolving strands in feminist art history, and theories of the gaze helped to inform a tendency in the 1980s to look critically at male pleasure, and at how images of women might be constructed as objects for that pleasure. Although it's dangerous to generalize about developments in feminist thinking, the late 1980s and 1990s have witnessed further shifts and changing emphases. Some artists and theorists have returned to earlier preoccupations with women's sexuality, challenging some conventional notions of female eroticism and desire. Hence the growth of lesbian and gay art which I mentioned earlier.

This later period has also been marked by a critical approach which emphasizes the fluidity and instability of gender relations, and which sees femininity, masculinity and sexuality as constantly being redefined. This approach could be seen to be informed by some of the psychoanalytic models

which I refer to above, particularly the idea that unconscious ideas are (like language) constantly in flux. Given this instability, our identities as masculine and feminine are formed within a network of shifting associations and connections. In a catalogue article of 1985 for an exhibition of the work of feminist artists including Mary Kelly and Yve Lomax, the British art historian Lisa Tickner describes the emergence of this changing approach in feminist theory:

> The result was a shift in emphasis from equal rights struggles in the sexual division of labour and a cultural feminism founded on the re-evaluation of existing femininity to a recognition of the processes of sexual *differentiation,* the instability of gender positions, and the hopelessness of excavating a free or original femininity beneath the layers of patriarchal oppression.
>
> (Tickner, *Difference*, p.23)

You will find that several contributors to this book (myself included) have been informed by this model of the instability of gender positions. As a result some of the case studies which follow will reveal shifting constructions of femininity and masculinity as represented within the different examples of art, architecture and design which we study. And we are well aware that many of the ideas and theories which have underpinned feminist and gender studies are difficult and sometimes confusing. Using the reception of Chicago's *Dinner Party* as a focus, I have tried to map out only a few of them. When you have finished the book it might be useful to re-read this introduction, and see how some of the issues and positions which I have described weave in and out of studies by different authors. We've seen that *The Dinner Party* belongs to the first wave of feminist interests which Tickner describes above, but an early response to the work, although framed in the concerns of late 1970s and early 1980s, still holds a certain resonance:

> *The Dinner Party* is both clumsy and pathbreaking ... *The Dinner Party* is right on time. It comes in the wake of modernism, in loud colours and emotional, high-pitched tone; it rides on the wave of feminist study and insight; it takes seriously both the truths and excesses of female consciousness; it fills a large room; it engaged some 400 workers in something bigger than anyone; it cannot be ignored and it should not go away.
>
> (Goodman, *'The Dinner Party'*, pp.22–3)

References

Butt, G. (1997) 'Avant-Garde and Swish', *Art History*, vol.20, no.1, pp.164–8.

Callen, Anthea (1993) 'Coloured views: gender and morality in Degas' bathers pastels' in Andrew Benjamin (ed.), *The Body*, London, Academy Editions, pp.23–30.

Chicago, Judy (1996) *The Dinner Party*, Harmondsworth, Penguin.

Davis, Whitney (1996) 'Gender' in R. Nelson and R. Shiff (eds) *Critical Terms for Art History*, University of Chicago Press.

Edwards, S. (ed.) (1999) *Art and its Histories: A Reader*, New Haven and London, Yale University Press.

Foucault, Michel (1976) *The History of Sexuality*, Harmondsworth, Penguin.

Garb, Tamar (1986) 'Engaging embroidery', *Art History*, vol.9, no.1.

Garb, T. (1993) *Modernity and Modernism: French Painting in the Nineteenth Century*, New Haven and London, Yale University Press.

Garb, T. (1994) *Sisters of the Brush*, New Haven and London, Yale University Press.

Goodman, Elizabeth (1981) *'The Dinner Party*: a matter of taste', *Women Artists News*, February/March.

Gouma-Petersen, Thalia and Mathews, Patricia (1987) 'The feminist critique of art history', *Art Bulletin*, September.

Jones, Amelia (1996) *Sexual Politics: Judy Chicago's* Dinner Party *in Feminist Art History*, Berkeley, University of California Press.

King, Catherine (ed.) (1999) *Views of Difference: Different Views of Art*, New Haven and London, Yale University Press.

Malvern, Sue (1997) 'Virtuous and vulgar feminisms', *Art History*, vol.20, no.3, September, pp.483–9.

Mulvey, Laura (1989) 'Visual pleasure and narrative cinema' in L. Mulvey, *Visual and Other Pleasures*, London, Macmillan (first published in 1975 in *Screen*).

Olin, Margaret (1996) 'Gaze' in R. Nelson and R. Shiff (eds) *Critical Terms for Art History*, University of Chicago Press.

Parker, Rozsika (1984) *The Subversive Stitch: Embroidery and the Making of the Feminine*, London, The Women's Press.

Parker, Rozsika and Pollock, Griselda (1981) *Old Mistresses: Women, Art and Ideology*, London, Routledge.

Perry, Gill and Cunningham, Colin (eds) (1999) *Academies, Museums and Canons of Art*, New Haven and London, Yale University Press.

Tickner, Lisa (1985) *Difference: On Representation and Sexuality*, New York, New Museum of Contemporary Art.

PART 1
MADE IN HER IMAGE: WOMEN, PORTRAITURE AND GENDER IN THE SIXTEENTH AND SEVENTEENTH CENTURIES

Introduction

CATHERINE KING

In studying women artists working in Western Europe during the sixteenth and seventeenth centuries, feminist historians like Ann Sutherland Harris, Linda Nochlin and Germaine Greer began by analysing what was known about the biographies of women artists and the social, educational, and legal barriers preventing them from becoming Great Masters in the early modern period. Women artists were, it became clear, usually either trained as part of household workshops of artists by their fathers, and belonged to the skilled craft worker class, or they might be noblewomen, whose fathers paid for them to be tutored by professional artists. A female of the skilled artisan class might go on to marry another artist and paint as wife or widow, or she could obtain a court post working for a sovereign. A noblewoman who had trained as an artist might also seek a position as lady-in-waiting, making portraits of her employers, and teaching their children artistic accomplishments. In addition, women might also make art in the shelter of a convent.

The two case studies which follow present research which rests on the insights obtained from the biographical approaches, but considers the work of women artists from somewhat different angles. In the first case study I survey the evidence provided by portraits of women artists and their self-portraits. Since neither men nor women left extensive verbal texts explaining their views of women artists, this visual evidence of the way women artists represented themselves and were represented by men seems important in considering the psycho-social positioning of women artists. In the second case study I turn to look at the kinds of art, in terms of media, forms, and subjects, which women artists felt able to explore, in order to consider how women artists were located in the complex and shifting patterns of values assigned to different sorts of art practice. In other words, these two case studies look at how women artists were represented, and what they represented, to see how they were positioned in society and the ways in which they were able to re-position themselves.

Plate 17 (Facing page) Clara Peters, detail of *Flowers with Ceramic Dish, Money, Drinking Goblets* (Plate 55).

Two major shifts were taking place in art and religious culture in Western Europe during the sixteenth and seventeenth centuries. First, I note a shift in attitudes towards art practice. During this period concepts of an elevated 'high art' executed by gifted and learned artists were being established. These ideas were promoted by theoretical and historical texts produced by artists themselves such as *Lives of the Artists* by Giorgio Vasari in Florence (1568) and Carel van Mander's *Lives of the Painters* in Amsterdam (1604).[1] The idea of a gifted and learned artist was embodied in the figure of Leonardo da Vinci (1452–1519) in the way he combined practice as a painter, sculptor and architect with the writing of a theoretical treatise on art. This treatise stressed the importance of theorizing about perspective, light and anatomy to render his imaginative concepts in paint, bronze, or stone. Other artists like Marten van Heemskerck of Haarlem (1498–1574) expressed their theories about this new intellectual art in visual images rather than verbal texts, and many artists – including Marten – placed great emphasis on knowledge of the art and culture of Greek and Roman antiquity in order to recreate the greatness of ancient civilization (Plate 18). Although some areas, like the Netherlands and England, carried on producing work solely within the guild system of regulation and education, other areas, such as France and Italy, instituted academies of art alongside the guild workshops with their assistants and apprentices. These academies were founded to represent the new concept of an imaginative and scholarly artist whose education could no longer be entrusted solely to one workshop master, but required some group instruction by a variety of experts, and a grounding in theory through attending lectures. Whether or not artists lived in an area with an academy, from 1563 onwards (when the first academy was founded in Florence) they were working in the knowledge that alternative ideals of artistic production were available. Many artists travelled to Rome, whose academy was founded in 1592, visiting the academies of Bologna (1582) and Perugia (1573) on the way or (later on) they had contact with the academy in France (1648).

In Europe during the sixteenth century women were less well educated relative to men, so the academies' emphasis on scholarly attributes made it more difficult for them to aspire to the highest standards in art, whether as knowledgeable patrons or as well-informed artists. Women had always been second-class citizens in terms of guild membership. They were able to belong as an apprentice to their father, or as a wife or widow of a guildsman, or they could practice in a family workshop with their brother, but they could not take office. Women artists' rights to belong to the guilds were just as restricted in the new institutions. Although Artemisia Gentileschi (*c.*1597–1651/3) was able to belong to the Florentine Academy, she was the first woman artist to do so and, later, Giovanna Garzoni (1600–70) was allowed only to be a member of the religious association attached to the Academy at Rome – the Confraternity of Saint Luke – and could not benefit from academic instruction. The Roman Academy in 1607 laid down that women members could not attend lectures.

[1] See Barker *et al., The Changing Status of the Artist* (Book 2 in this series), historical introduction.

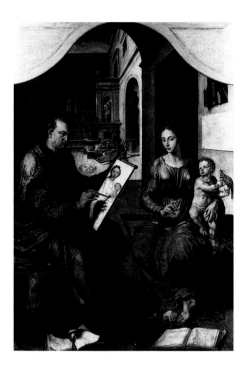

Plate 18 Marten van Heemskerck, *Saint Luke painting Mary and her Child*, 1550, oil on panel, 203 x 145 cm, Musée des Beaux Arts, Rennes, originally for the Guild of Saint Luke, Delft. Photo: courtesy of the museum.

Another important cultural shift during the period of Catholic Reformation was in religion. In areas where the Catholic Church retained power throughout the period, as in Italy, or intermittently, as in the Netherlands, women in religious orders were able to train and support women artists. In these areas there were convent communities alongside the institution of the family providing some opportunity for women to purchase and make art. Where Protestant views held sway, convents were demolished. From the late sixteenth century onwards those remaining were subjected to rigorous enclosure. Nuns who hitherto had some degree of contact with their families and friends outside the walls were now more locked away from ordinary life.

How did women who were artists in the sixteenth and seventeenth centuries fare in this environment? In all spheres – legal, political, social, educational and economic – the status of women was relatively lower, weaker, and more restricted than that of men. This meant that their rights to travel or to walk about a city alone, looking at buildings and studying ancient art *in situ*, was severely restricted. Only in the spiritual right to reach heaven did women have equality with men – and even here women's virtue was regarded as different to that of men. Womanly goodness consisted of modest behaviour and chastity or virginity. Male goodness could comprise these sorts of traits too (in a monastic life, for example) but men also could honourably do good in an active political, martial, or civic career and their honour was not contingent upon their chastity.

The lower status of women was related to the notion of women's dependence on men and their supposed need to be cared for in the private sphere of the family and household, and may be understood in terms commonly employed by anthropologists to interpret how gendered behaviour is displayed in a diversity of societies. In introducing an anthology of articles on the way gender differences were culturally represented, Sherry Ortner and Harriet

Whitehead (*Sexual Meanings*) suggested that in all societies the 'masculine' is seen as capable of governing society because men can belong to any sphere – whether public or private. Ortner and Whitehead argued that men are regarded as social chameleons, who have the right to speak for all in their public capacity. Since men are represented as able to take any position they can claim objectivity and universality. In contrast the 'feminine' is shown as corralled into a smaller area of activity, tied to the interests of her children, husband and herself, and is represented as having partial or sectional views and knowledge. The 'masculine' stands for the unlimited and omniscient while the 'feminine' is represented as limited in vision and knowledge.

If we look at the portrayal of both male and female artists in the sixteenth century, we find that there were many more ways of representing men as artists than women. Men could be represented in portraits destined for a public audience, but they also participated in portraiture of a more intimate and familial sort. An analogous situation can be found when considering the *kinds* of art made by women and men. Where men could practise in any media, form and on any scale with all kinds of subject-matter, women artists inhabited a more restricted field.

Beliefs about the relative value of women in society were institutionalized in European systems of government which disallowed women election to public office or electoral powers, except within a convent community. In legal terms daughters were almost invariably under the control of their fathers. With some exceptions – such as the English and Netherlandish tradeswomen who were treated as independent from their husbands in their business capacity – the possessions and earnings of wives were administered by their husbands. Only as widows might women control their finances, and have the autonomy to buy, sell and litigate. In some areas, as in Italy, women were further restrained by being subject to their fathers until his death or until he decided to emancipate her. In some places (as in Florence) no woman, even the emancipated widow, was able to act in legal terms without a male guardian called a *mundualdus*. In the Netherlands women were emancipated automatically when they were 25 but still needed a *mundualdus* for legal transactions. A woman who was an artist therefore might well not control her earnings. Where women were legal witnesses, the weight of a woman's testimony was often not given the same value as that of a man, and two or more women would be required to testify where the word of one man would have been accepted. Such legal rules embodied wider beliefs about women's inferior capacities in acting, knowing, learning and speaking which must frame our understanding of what it took and what it meant for a woman to become an artist.

References

Barker, Emma, Webb, Nick and Woods, Kim (eds) (1999) *The Changing Status of the Artist*, New Haven and London, Yale University Press.

Greer, Germaine (1979) *The Obstacle Race*, London, Secker and Warburg.

Ortner, Sherry B. and Whitehead, Harriet (1981) *Sexual Meanings: The Cultural Construction of Gender and Sexuality*, Cambridge University Press, pp.1–33.

Sutherland Harris, Ann and Nochlin, Linda (1976) *Women Artists 1550–1950*, exhibition catalogue, Los Angeles County Museum of Art.

Portrait of the artist as a woman

CATHERINE KING

In this case study I am concerned with two questions: how did women artists represent themselves in the Western European tradition, and how were they represented by contemporary male artists?

Portrait-signatures

The earliest known self-portraits by women are those which represent them as makers of a painting or a piece of needlework with an inscription on the work itself to identify them. Such portraits were quite common during the medieval period. In such portrait-signatures they often represented themselves in kneeling poses, in contemporary dress and in a modestly marginal position. Such portraits had a religious role – in asking the prayers of the spectator for the soul of the artist. The figure of the nun Guda on the book of sermons that she painted and wrote in about 1150 shows this type of 'portrait-signature' (Plate 19). She holds the letter which she has illuminated and on which she has inscribed the statement, 'Guda a sinner wrote and painted this book', while she raises her right hand as if in a gesture of greeting.

Plate 19 Guda, *Self-Portrait, c.*1150, *Homelies*, Stadt- und Universitätsbibliothek, Frankfurt am Main, MS Barth 42, fol.110 recto.

During the sixteenth century, women began to portray themselves in other ways and men began to portray women as artists too. I begin by considering the kinds of models available for portraying the woman as artist and the conventions for portraying women in other spheres. During the fifteenth century family portraits tended to show nubile daughters and good wives and mothers, portrayed at the behest of fathers or husbands. These women appeared dependent in status and attractive to the male gaze. Attached to this group were portraits of widows, sometimes commissioned by themselves, and often emphasizing signs of ageing, perhaps to indicate that the woman was not ready to remarry and would remain independent. However, these conventions of portaiture were not easily adopted by women artists because they were created by men particularly for women of high social class – a class to which only some women artists belonged.

At the same time there was a developing tradition of representing male artists, but examples of these were of somewhat limited use to women artists in a society in which the feminine was regarded as very different to the masculine. First, there was the representation of the activity of 'men making art', which dates from the thirteenth century onwards. More usefully for women, however, from the early sixteenth century, painting and sculpture were often personified as women holding their tools (brushes or chisels) as attributes. Second, there were representations of artists as saints, though these were all male. Third, there were representations of artists as the Children of Mercury – because they were considered to be under the astrological influence of the planet – made from the fourteenth century onwards, but never including women. Fourth, also from the fourteenth century onwards, there was the rather more useful category of representations of ancient Greek and Roman artists, which included the images of female artists described by Pliny the Elder: Thamar, Cyrene, and Iaia (sometimes called Marcia). Marcia, in particular, was a good role model since Pliny the Elder had reported that she was famous for her self-portraits (Plate 20).

Plate 20 *Marcia Working in her Studio, c.*1470, MS on vellum, miniature, Boccaccio, *Des Cleres et Nobles Femmes*, Paris. New York Public Library, Astor, Leno and Tilden Foundations, Spencer Collection, MSS 33, fol 37 recto.

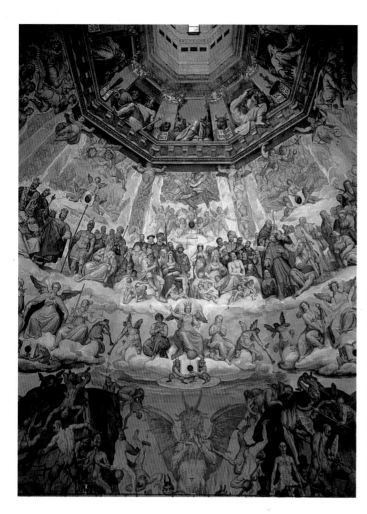

Plate 21 Federico Zuccaro, *Sophonisba Anguissola and colleagues at the Last Judgement,* *c.*1600, fresco, cathedral interior, Florence. Photo: Index/ Arch. Fot. Soprintendenza B.A.A., Florence.

The portrait-signature was still in use – but only by men at this period. Only one woman – Sophonisba Anguissola (*c.*1535–1625) – may have appeared as a 'bystander portrait' in which male artists showed themselves or their friends in painted and sculpted crowd scenes (Plate 21).

From the fifteenth century onwards artists began to make independent portraits as funerary monuments or to commemorate an important event in their lives. No woman artist was honoured with a funerary portrait, but women were accorded bronze commemorative medals and a few painted, engraved and drawn portraits were made by and of women artists. Some types of independent portrait were adaptable for women, such as the small portraits made by artists to introduce themselves to a powerful client or the portrait of a woman artist for her family to keep as a memento in the privacy of the household. In other cases the new categories of independent artists' portraits were less easily taken over. For instance, portraits honoured male artists as teachers or as fathers, but no portraits commemorate women as artistic tutors or the teaching mother. Nor were women artists portrayed to mark the attainment of high office at court or honours given them by rulers, like some male artists.

It was in the sixteenth and seventeenth centuries in Italy and the Netherlands that women artists were portrayed in new ways, including portraits on medals, in miniatures, large paintings, drawings and engravings. In establishing new ways of portraying women artists, painters could look to a number of developing traditions. What they produced tended to be some sort of compromise or cross-fertilization between the iconography of the good wife or daughter and the iconography of the male artist.

During the sixteenth century artists were establishing the writing of the history of art, to celebrate the artists of the past and to memorialize the lives of modern artists. Such writings were sometimes accompanied by images commemorating artists as heroes. It is of interest that some women artists too were represented as heroines of modern art history in this way.

'Good daughters'

The earliest known independent self-portrait of a woman in Western Europe was made by Catarina van Hemessen (*c.*1528–87) in 1548 (Plate 22). Catarina represented herself in plain clothing and with a solemn expression – perhaps to refuse resemblance to portraits of the young woman seeking a husband. As in some portraits of young male artists, the image included an inscription in Latin: 'I Catharina de Hemessen painted myself aged twenty years.' However, it was unlike any previous male self-portrait in that it showed her actually at her easel in the act of painting herself. This means that this is the earliest self-portrait at the easel either by a man or a woman.

What do you think were the reasons for her representing herself in this way?

Discussion

This unprecedented choice suggests to me the extreme measures needed to be taken to insist that Catarina really had painted herself. It is possible that she drew here on the illustration of the ancient painter Marcia known in manuscripts of Boccaccio's *Des Cleres et Nobles Femmes* (see Plate 20). Such a precedent would have been socially safe because Pliny the Elder had described Marcia as remaining a virgin throughout her career. In an age when male artists wanted to emphasize the rational and imaginative element in art rather than the practical – with its craft associations – a woman artist might have different priorities and wish to prove she could handle paint.

◆◆

Given the presence of the inscription it seems unlikely that this self-portrait was made for her family, but rather perhaps as a gift to impress a potential patron. She did in fact achieve a court post in 1556 from the Hapsburg ruler of the Netherlands, Mary of Hungary. Such a court post was an important way for a woman to succeed. Catarina had been trained by her father in Antwerp within the guild system, but by taking a court post she could work without being controlled by the guild.

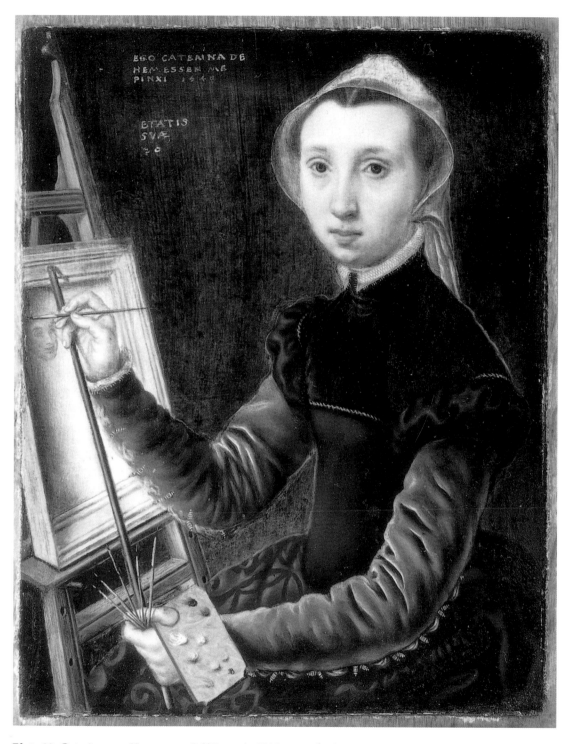

Plate 22 Catarina van Hemessen, *Self-Portrait*, 1548, varnished tempera on oak wood panel, 31x 25 cm, Offentliche Kunstsammlung Kunstmuseum, Basel, Martin Bühler.

The most substantial group of self-portraits made to advertise youthful talent by a woman was made by the Cremonese painter Sophonisba Anguissola in the 1550s and 1560s (Plate 23) Her father Amilcare, an impoverished nobleman, seems to have been her business manager, sending her self-portraits to influential men in hope of preferment. Perhaps he had in mind the posts already obtained by Catarina van Hemessen at the court of Spain, and by Levina Teerlinc of Bruges in 1545 at the court of England. He achieved his object in 1559 when she was appointed tutor in painting to the king's daughter at the Spanish court – a post for which he, as father of an unmarried daughter, received the pension. Gifts of her self-portraits were made to Pope Julius III and sent to the courts at Ferrara and Mantua as well as to the Roman critic and scholar Annibale Caro. Caro was delighted by her self-portrait:

> because at the same time one is able to find two marvels together: the one being of the work and the other of the mistress.
> (Quoted in King, 'Looking a sight', p.387)

Since men had been making such self-portraits for over a century by this time, it seems unlikely that a male artist's self-portrait would have been regarded as a 'marvel'. Sophonisba was only the second woman we know of who had made a portrait of herself. Such an oddity needed to represent herself as sufficiently feminine and ladylike to convince her prospective employer that he could safely leave his wife and children with her. In fact the self-portrait shows her with the neat hair, high lace collar, and lack of jewellery of a well brought-up noblewoman. In seeking out safe ways of advertising her professional skills and at the same time her gentle birth and virginal decorum, the female artist had to invent outside the mainstream iconography of the male artist and at a tangent to the iconography of the family woman. In this portrait Sophonisba holds a small book inscribed in Latin, 'Sophonisba Anguissola virgin made this herself 1554'. No male artists showed themselves with books, although portraits of gentlewomen might include a small devotional book of this sort. In other portraits she showed herself playing the clavichord – and on one occasion with a maidservant (Plate 24). Again no male artists used these attributes in self-portraits, and this suggests that they too were seen as special signs of femininity. Perhaps the idea that music was an accepted ladylike accomplishment introduced the idea that painting too could be a gentlewomanly art, while the presence of a female companion could suggest decorous social behaviour.

Any portrait of a woman artist might be read in a way which subordinated an appreciation of her artistic talents to praise of her feminine beauty. This tendency is, for example, evident in Vasari's description of the portrait commemorating Irene di Spilimbergo (1540–59) (Plate 25). Irene was celebrated for her promise as an artist, musician and poet after her early death in 1559 by a valedictory anthology of poetry and also by a portrait painted by Giovanni Paolo Pace. Both the book and the portrait were commissioned by her maternal grandfather, who had brought her up, the latter being intended as a family portrait. She carries a wreath of myrtle sacred to Venus, which suggests the marital love she forewent, and she is accompanied by a landscape with a unicorn to denote her maidenhood. (According to the medieval bestiary a unicorn could only be caught by a virgin.) The inscription in Latin on the column beside her reads: 'If the Fates

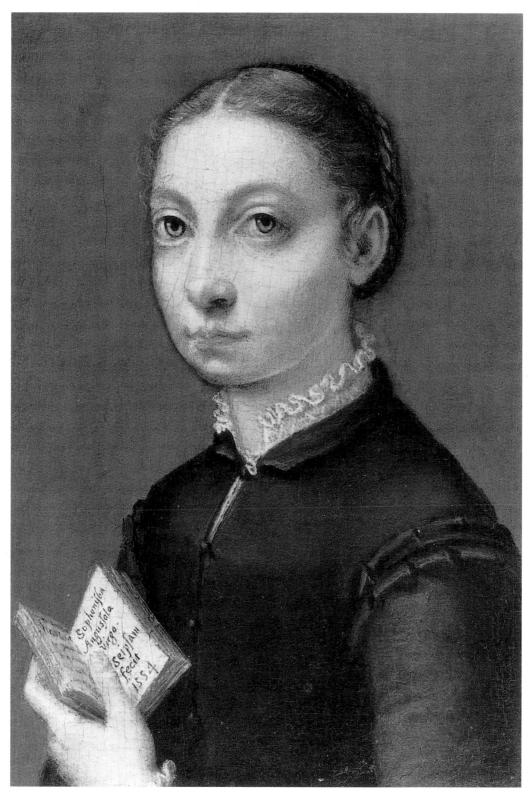

Plate 23 Sophonisba Anguissola, *Portrait of the Artist with a Book,* 1554, oil on panel, 19.5 x 12.5 cm, Kunsthistorisches Museum, Vienna.

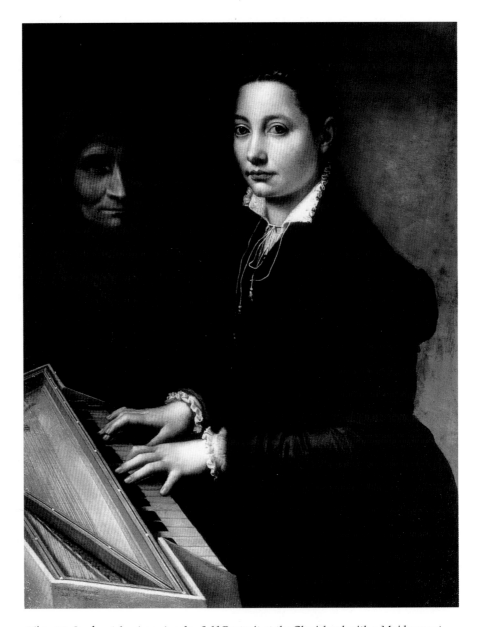

Plate 24 Sophonisba Anguissola, *Self-Portrait at the Clavichord with a Maidservant*, 1563, oil on canvas, 88.9 x 81.3 cm, Althorp, Northampton, collection of Earl Spencer.

had carried her forwards.' Behind her are two palms – possibly signifying her victory over death. Vasari described this in 1568 as showing 'the lady Irene, a most beautiful virgin, lettered, a musician, and one talented in design' (quoted in King, 'Looking a sight', p.391). So Vasari spoke first of her rank, then of her beauty and unmarried status, and finally of her intellectual and imaginative attainment. By comparison, in describing male artists in the introductions to his biographies, he gave details of the man's father, teacher and geographical origins, and then moved to his artistic skills. He did not comment on how good looking they were.

How does this portrait (Plate 25) differ from Plates 22 and 23, and why ?

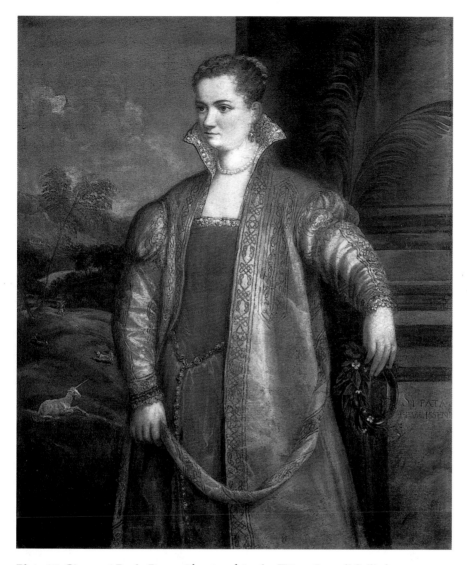

Plate 25 Giovanni Paolo Pace with retouching by Titian, *Irene di Spilimbergo*, *c*.1560, oil on canvas, 122 x 106 cm, National Gallery of Art, Washington, DC. Widener Collection, © 1998 Board of Trustees, National Gallery of Art.

Discussion

The size of the portrait and the three-quarters view denotes Irene's noble birth. Clearly her painterly talents were an accomplishment, not skills to be hawked about the courts of Europe. Also she is not shown as looking at the viewer and she is wearing a low-neck dress and jewellery. Could these differences relate to the fact that this is not a self-portrait and also to its function as a valedictory portrait for family eyes only, which was intended not to introduce her to an unknown client but rather to commemorate her as a beautiful and marriageable young woman?

The portrait remained in the possession of the Spilimbergo family for four centuries.

Wives and widows

So far I have considered the iconography of the maiden artist who practised her skill in the private sphere of her parents' house, or sent representations outside the family circle which had to assure the viewer – who associated the public sphere with the masculine – of her feminine propriety and modesty at the same time as advertising her talents as an artist. But what of the iconography of the artist who was a wife or widow?

The earliest known portrait of the wife-artist may be the double portrait of the artist Pieter Coecke van Aelst with his second wife Mayken Verhulst (recorded as an artist in 1567), who had been married in 1540 (Plate 26).[1] The small panel has been over-cleaned, removing the inscription which was painted on the sheet of paper or *cartellino* represented as if pinned above their heads. It could have been painted by Pieter before his death in 1550 or by Mayken Verhulst before her death in 1600. The fact that he has his hand on a skull might support the idea that Mayken shows herself here as widow, and indeed her clothing would suggest this. Mayken was the grandmother of Pieter Bruegel the Younger and, according to Carel van Mander, she taught her grandson to paint. The appearance of Pieter Coecke can be verified from an engraving published in 1572 after his death. This double portrait takes the form used previously by some male artists in the Netherlands and is a smaller version of the marriage portraits made for wealthier clients. The depiction of the woman in widow's weeds was not unprecedented either. Since widows often received income from their husband's estate as long as they did not remarry, they had an interest in making portraits to keep in their house showing their intention to remain faithful to their dead spouse.

In about 1561 the Roman manuscript illuminator Giulio Clovio wrote to the Netherlandish miniaturist of the court of the Queen of England, Levina Teerlinc (*c*.1510/20–76), thanking her for the gift of her self-portrait. From this we can see that being married did not necessarily prevent a woman artist from having her image read as the object of amorous regard. Her portrait (which has not so far been identified) was still in Giulio's possession in 1578 at his death. Levina, daughter of the Bruges illuminator Simon Bening and married to George Teerlinc, seems to have intended her gift to imitate the masculine custom of exchanging examples of one's skill with eminent practitioners in distant areas, such as are recorded to have taken place between Dürer and Raphael. Giulio's letter referred to this kind of exchange:

> As indeed artists are accustomed to enjoy seeing diverse styles of those who work in their field, I judged that it would not displease you to be able to consider the style of those of us working in Italy.

But he then went on to comment on her beauty and exceptionality:

> for you are a lady, such that being not only so beautiful and so youthful, are also so excellent in an art which is very rare amongst men, let alone, amongst ladies. Love and wonderment combine to have me keep your portrait beside me and I enjoy it at all hours.
>
> (Quoted in King, 'Looking a sight', pp.395–6)

[1] Mayken was married in 1540. We do not know her birthdate. Guicciardini recorded that she was a painter in 1567 though none of her works are certainly known. Later van Mander recorded that she taught her grandson to paint. She is recorded as dying in 1600.

Plate 26 Pieter Coecke van Aelst or Mayken Verhulst, Pieter Coecke and Mayken Verhulst, c.1550, 50.5 x 59 cm, Kunsthaus, Zurich. © 1997 by Kunsthaus Zurich. All rights reserved.

However, if we look at a pair of equal-sized medals celebrating the skill of Diana Scultori, the engraver of the Ghisi family from Mantua (*c.*1530–88), and her architect husband Francesco da Volterra (doc. 1565–88), it can be seen that images of the matron-artist could successfully rebuff the 'beautiful freak' reading (Plates 27 and 28). These images assume equality between husband and wife, with Diana's artistic skill being presented in the same matter-of-fact way as is Francesco's. Diana's medal has a reverse showing her hand with the burin engraving an image of the Virgin and Child and the inscription in Latin: 'We engrave the metal'. In the inscription on the obverse, which shows her with a matronly veil, she is styled simply 'Diana of Mantua' without giving her father's or her husband's name as was usual for a woman. Francesco's medal has a reverse showing his architect's compasses and the motto: 'If we are worthy'. The inscription also reads simply, 'Francesco of Volterra.' These bronze medals are signed by the unidentified medallist T.R. and were probably made about 1570 to celebrate their marriage.

Plate 27 T.R., Diana Scultori, bronze medal, obverse and reverse, *c*.1570, 4 cm diameter, © British Museum, London, no. 628 G III I.U.P. c4056.R.4a.

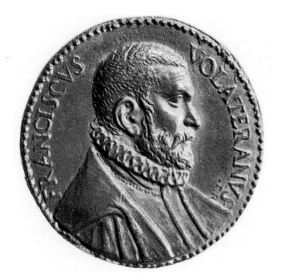

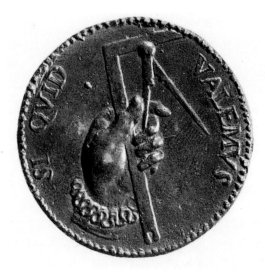

Plate 28 T.R., Francesco da Volterra, bronze medal, obverse and reverse, *c*.1570, 4 cm diameter, © British Museum, London, no. 627, 1908.2-4-7.

Even when a woman died at a great age, after an immensely successful and remunerative career (Plate 29), she might still be signalled for her looks first and her skill second. Sophonisba Anguissola's husband had the following inscription put on her gravestone:

> Horatio Lomellini dedicated this last rite of commemoration in 1632 to his wife Sophonisba, a woman of *noble parentage*, originating from the long line of the Counts of Anguissola. She was numbered amongst the illustrious women of the world, because she was endowed with extraordinary gifts of nature in terms of *beauty*. In *representing the images of men* she was so outstanding that none was estimated during her lifetime as her equal. Affected by vast grief, Horatio Lomellini dedicated this worthy commemoration which, while too small for so great a woman, is truly all that any mortal can have.'

(Quoted in King, 'Looking a sight', p.399; emphasis added)

Plate 29 Anthony van Dyck, *Portrait of Sophonisba Anguissola*, 1624, ink on paper, Italian Sketchbook, © British Museum, London, 1957-12-14-207(110).

Although the woman artist was a professional trained viewer and maker of representations who could claim to present new things to be seen, she still tended to be seen in portraits as an object of the male gaze rather than as one who claimed full ownership of the gaze herself. She was likely to be portrayed as dependent in status, as the daughter or the wife of a man, with her appearance and physicality being all-important, rather than as a fully autonomous individual whose physical appearance could denote experience of life and a strong character and personality. Women artists were often regarded as exceptional beings whose very existence, let alone their talented works, was to be marvelled at.

The famous 'woman artist'

Some portraits of women artists do, however, credit the woman's artistic creativity and skill rather than draw attention to her appearance. A few of these portraits were intended to reach a wide public by printing them in large numbers. Commemorative medals could also be cast in quite large editions.

From the late fifteenth century onwards male artists were being celebrated as heroes of modern art in portraits for tombs, printed books and engravings. In addition to this cult of biography, certain artists were picked out as standing for whole epochs or schools of painting. Thus, in 1549, the Guild of Saint Luke in Antwerp had been presented with a drinking cup on which were portrayed busts of Raphael, van Eyck, Dürer, Zeuxis and Apelles. These stood for Italian, Netherlandish, German and ancient Greek painting. This category of portraiture was problematic for a woman to enter because of its very public

connotations. Nor was it likely that a woman could stand for all that was excellent in the art of some nation. It seems, however, that a woman could signify the rare skill of women in art. It is perhaps in these terms that Vasari provided the woodcut of the Bolognese sculptor Properzia de' Rossi (c.1490–1530) in his *Lives* in 1568, which he entitled ' Madonna Properzia de' Rossi scultrice bolognese' (Plate 30). The portrait heads a chapter in which Vasari gathered together all the women artists that he knew of. Properzia was the only one who was dead, so that her portrayal at the head of the chapter (it needed a portrait to match his other chapters) protected the other women from publicity. It shows her veiled as a married woman and wearing a high-necked dress.

An engraved portrait of Diana Scultori was also made – attributed to Cherubino Alberti. This engraving is printed on a separate sheet which is inscribed in the same style used by Diana herself: 'Diana the Mantuan – citizen of Volterra' (Plate 31). Alberti worked in Rome between 1560 and 1615, and most of his engravings date from between 1560 and 1580. Diana, who also worked in Rome, seems to be attired in the same way as on her medal, though she appears somewhat older. Such free-standing engravings had celebrated a few artists like Dürer and Michelangelo, but the engraving for Diana seems to be the first to circulate the fame of a woman artist abroad on an engraved sheet of paper in this way. The elaborate sculpted surround with its swags of fruit and flowers suggests that this could have been a funerary commemoration in print.

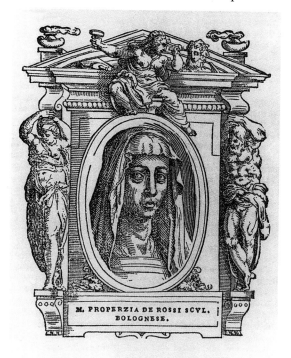

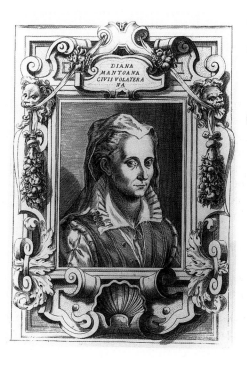

Plate 30 *Properzia de' Rossi*, woodcut from Giorgio Vasari, *Le Vite de'più eccellenti pittori*, 1568, Firenze, Appresso i Giunti. British Library 137d.14-16, reproduced by permission of the British Library Board.

Plate 31 Attributed to Cherubino Alberti, *Portrait of Diana Scultori*, engraving, 24.3 x 16.8 cm, Graphische Sammlung Albertina, Vienna.

There was some interest in publishing the portraits of famous women artists, as we know from the correspondence of Alonso Chacon and Lavinia Fontana (1552–1614). Chacon was a Spanish Dominican living in Rome, who planned to publish an engraved gallery of 500 portraits of illustrious people which he called a 'museo' in book form. (The book was never published, despite support from Archduke Ferdinand of Austria.) He was in touch with Lavinia Fontana in Bologna because he had commissioned her to make portraits of distinguished scholars and clerics in her home city and send them to him as the originals for the engraver to copy. Lavinia Fontana had been trained by her painter father in Bologna and was married to another painter, Giovanni Paolo Zappi. In his correspondence Alonso begged for a portrait of her too to go in his museum, promising her:

> this great glory, that granted you already have sufficient is still not known by all, as I plan to celebrate and propagate it through the centuries for a kind of eternity.
>
> (Quoted in King, 'Looking a sight', p.402)

She replied in May 1579 when she sent her self-portrait to him. When he had first written to her, she explained that she was dubious about placing herself in such illustrious company along with Signora Sophonisba. But eventually she changed her mind when she realized that:

> just as good musicians sometimes place dissonant notes to form consonants the more sweet, and just as a cloud makes the ornaments of the heavens show themselves off the more splendidly, so, you My Lord, had decided with the imperfections of my portrait, to highlight so much the more prominently the nobility of your museum.
>
> (Quoted in King, 'Looking a sight', p.402)

This letter shows the tension for the woman artist between ideals of feminine modesty and the artist's need for fame. By taking a self-deprecating identity as a discord or a cloud or an imperfection, Lavinia can apologize herself into being able to accept Alonso's offer. In the verbal picture she paints of the museum, Lavinia suggests that she will take a background role while others are highlighted and appear splendid and perfect. In contemporary handbooks of conduct women were warned not to push themselves forward, but always to behave and clothe themselves in ways which never attracted attention or invited comment.

Look at the self-portrait which Lavinia sent to Alonso and the engraving made much later which will help you discern all the detail (Plates 32 and 33). What sort of image of a woman artist is represented in this self-portrait?

Discussion

I think this is a clever image which presents Lavinia as in calm possession of feminine beauty, confident of her attractiveness and status as a married woman (a fact she announced with her ringed left hand and the inscription on her table) and at the same time showing her scholarly knowledge of the art of antiquity. In a world in which (masculine) brains were not supposed to go with (feminine) beauty, Lavinia was welding very powerful qualities together. The artist is in the foreground and the highlight strikes her temple.

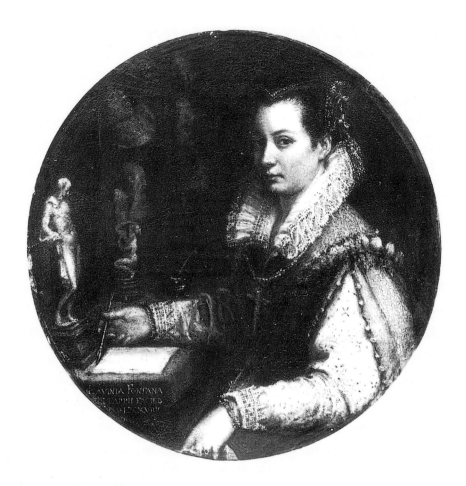

Plate 32
Lavinia Fontana,
Self-Portrait, 1579,
oil on copper, 15
cm diameter,
Uffizi Gallery,
Florence. Photo:
Alinari.

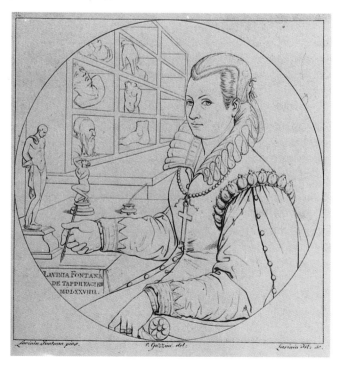

Plate 33
Engraving of
Lavinia Fontana's
portrait, Castello
Sforzesca,
Raccolta
Bertarelli, Milan.

The composition is harmonious, with her figure to the right balanced by the interesting detailing of her studio equipment to the left. In the subliminal structure of the painting she is associated with the circular form of the framing in the circles of her ruff and epaulette, her rings and necklace, her waist and head, and the ornamental roundel of the chair arm. These are powerful references because the circle was regarded as the most perfect geometric figure in contemporary scientific and philosophical thought, as it described the path of the planets and the structure of the cosmos. This is the sole female self-portrait made in the sixteenth century to demonstrate the academic skills of studying the nude and drawing after the antique. On the table are antique statuettes of a man and a woman. On the shelves behind are casts of parts of the body. Since her father had been made an academician, Lavinia could claim knowledge of the best artistic education from him. The statuette of the naked man has been placed in the foreground. Since the statuette's glance is downwards, there is no risk of the viewer imagining the naked man looking at the woman while she is looking at us. It is, rather, she who is in charge of the gaze.

◆◆

She also wanted to assert her interest in representing the female nude but she placed the statuette of the kneeling woman in the background, and she blocked any dangerous slide from the male viewer's consumption of this sight across to mentally undressing the artist herself by portraying a cupboard filling the background in which she has arranged plaster casts of parts of male bodies. In the row closest to the viewer she keeps three male heads. In the next row are a hand, a foot and a male torso. The use of the miniature nudes and the objectification of the male body through fragmentation represents the latest teaching aids being used by male artists, and at the same time counters the misinterpretation of the female self-portrait as lovely lady by stating that she is in control of representation. The way the orthogonals of her table and cupboard converge to frame her face recall the perspectival diagrams in treatises on art of this period, which used similar diagrammatic effects to demonstrate the optical theory of how rays of light are reflected from objects and converge to enter the eye (Plate 34). Such diagrams related to explanations of linear perspective, which was a key technique of Renaissance pictorial realism. Such a reference would lay further claim to a knowledgeable viewpoint. But could Lavinia really claim an acumen equivalent to that of a young man?

To help answer the question I suggest that you look at the engraving made by Cornelis Cort and designed by Jan van der Straet to illustrate the programme of study at the Roman Academy in 1578 (Plate 35). What sort of activities are represented as being appropriate for male artists to undertake?

Discussion

In Cort's ideal academy there are no women artists. Young men draw statuettes, and learn anatomy by studying a flayed body and a skeleton. A mature man paints a fresco of a battle scene. Sculptors carve free-standing statues. The engraving points up the way subjects of high standing like battle

pictures were masculine in association. It seems interesting that Lavinia had not felt able to show herself studying anatomy from a cadaver. It appears to me that Lavinia could only claim a feminine version of academic knowledge. As well as being limited in her range of knowledge and what can enter her studio space, she is alone, not part of a group.

◆◆

The bronze medal made of Lavinia Fontana three years before her death and dated 1611 celebrated a woman who had been able to move from Bologna to Rome and had found favour there with key patrons. Instead of being confined to the relatively lowly genre of portraiture, Lavinia was employed to make large religious scenes for altarpieces. Felice Antonio Casoni portrayed her with a hint of a double chin, aged 59 years, with beautifully plaited hair, veiled as a matron, in profile with the inscription: 'Lavinia Fontana wife of the Zappi family, paintress 1611' (Plate 36). On the reverse most significantly he showed a personification of Painting seated at her easel painting vigorously. This representation follows the description of Painting made by Cesare Ripa in his iconographical handbook – the *Iconologia* – printed in Padua in 1611. Ripa's text emphasized the cerebral imaginative powers of Painting through attributes to which Casoni too gave prominence. For example,

Plate 34 Carlo da Urbino, Diagram showing proportional adjustments for drawing the human figure needed for different viewing points, *c.*1560–80, *Codex Huygens*, folio 101 recto. Pierpont Morgan Library, New York, MA 1139.

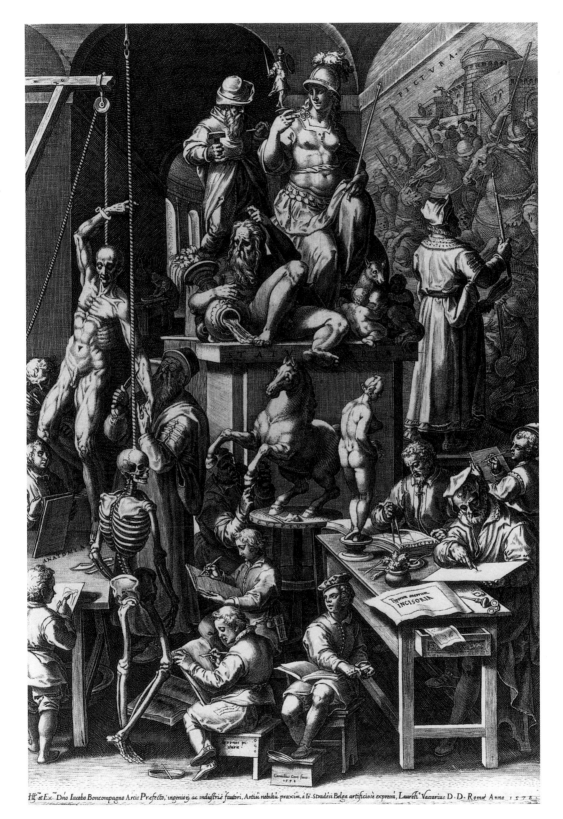

Plate 35 Cornelis Cort after Jan van der Straet, *An Ideal Roman Academy*, 1578, engraving,
© British Museum, London.

her hair is luxuriant, spread out above her head and ringletted in various parts, which seems the product of negligence, to signify that just as her hair is born on the exterior of her head, so inside are born the thoughts and fantasms that are the means both to speculation and also to creating material works.

(King, 'Looking a sight', p.404)

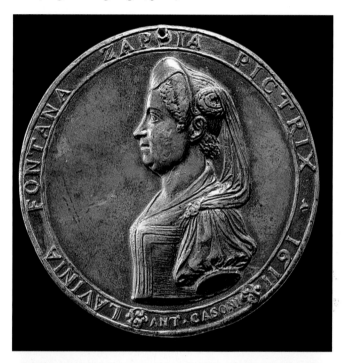

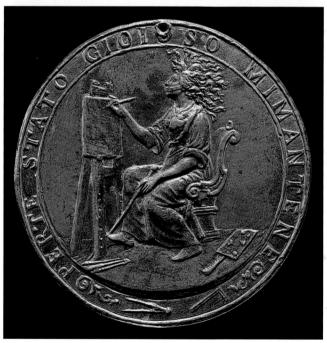

Plate 36 Felice Antonio Casoni, Lavinia Fontana, bronze medal, obverse and reverse, 1611, 6.7 cm diameter, © British Museum, London.

Ripa also described Painting as gagged because, following the dictum of Horace in the *Art of Poetry*, Painting is mute poetry creating elevated images of great events in legend and history through visual representation rather than words. Round her neck is a chain from which hangs a mask to signify, as Ripa explained, the power of painting to imitate and make convincing fictions.

The words on the reverse are 'O through you, a joyful state sustains me.' It seems likely that the statement should be read as being spoken by Lavinia herself to Painting. Such a statement alluded to the theme of the prizes of art[2] in which the rewards of money and worldly fame were relinquished in favour of the loftiest purpose – that of painting for sheer love of your art. And according to this theme working for love of art brought its own reward of joyfulness. This idea was embraced by male artists from the early fifteenth century onwards.

The same idea may be behind the self-portrait of Judith Leyster of Haarlem (1609–60), painted about 1630. Judith turns to the viewer conversationally as if about to speak, with a happy expression in her eyes, and is busy working on a painting of a smiling musician (Plate 37). This is a *tour de force* in terms of handling paint – in the suggestion of transparent starched muslin and point lace framing her face and cuffing her wrists. Judith could be developing the theme seen previously in the medal of Lavinia Fontana by deciding to show her joyfulness directly in her expression, while the smiling musician could be there to underscore the point.

Although Lavinia's hair in the medal is so very neat, it is intriguing to notice that Painting is negligent about her appearance because she is giving birth to imaginative works of art. Casoni had shown Lavinia's joyful relationship with Painting, but the Roman painter Artemisia Gentileschi (1593–1652), who was trained by her father, took one step further twenty years later and represented herself in the guise of Painting with uncombed hair concentrating on her work (Plate 38). She has also portrayed herself with the mask hanging on a necklace to denote another attribute of Painting. On the evidence of her letters, the portrait seems to have been made to send to a patron. The fact that Artemisia has chosen to disguise herself as Painting and is turning away from the viewer makes it difficult to regard her as merely seeking admiration for her beauty, though the view of the woman artist as a beautiful body was still very much current, as we saw in the epitaph of Sophonisba Anguissola.

Of the portraits that you have seen so far, which do you think contest these dominant readings that put the physical appearance and the social and marital status of the artist before her skill?

[2] The theme of the prizes of art had been explored by male artists from the fifteenth century onwards in Italy and the Netherlands. It was originally associated with the career choices of statesmen, soldiers and scholars, and had a venerable genealogy in the texts of ancient Greece and Rome. According to this tradition, love of one's profession entailed hard work but would be rewarded by joy. Young men were advised not to take the easier paths to success, which had as their inferior goals love of money or worldly fame, rather than love of art itself. See King, 'Late sixteenth-century careers' advice', pp.77–96, 193–8 and Barker *et al.*, *The Changing Status of the Artist* (Book 2 in this series), Case Study 2.

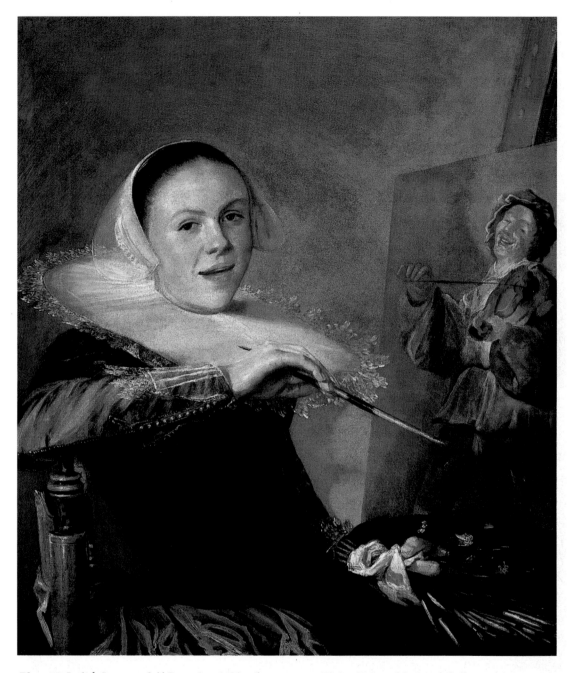

Plate 37 Judith Leyster, *Self-Portrait*, *c.*1630, oil on canvas, 74.6 x 65.1cm, National Gallery of Art, Washington DC. Gift of Mr and Mrs Robert Woods Bliss, © 1998 Board of Trustees, National Gallery of Art.

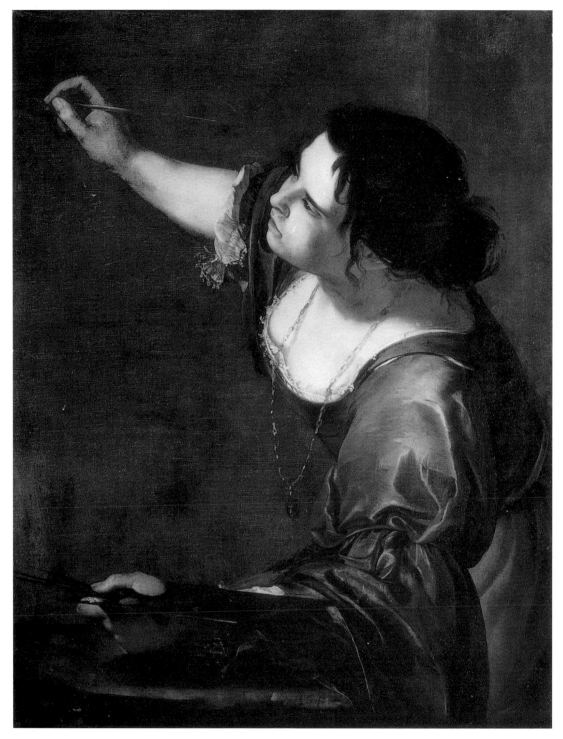

Plate 38 Artemisia Gentileschi, *Self-Portrait as La Pittura*, 1630, oil on canvas, 96 x 76 cm, Kensington Palace, London. The Royal Collection © Her Majesty the Queen.

Discussion

I think that the portraits that give prominence to the artist's professional tools and show the painter at work are signals of refusal to conform (Plates 22, 32, 37 and 38). Other signs could be covering hair tightly or wearing no jewellery (Plates 22, 36 and 37). A trangressive effect could also be obtained by insisting that loveliness and skill *could* go together, as in Lavinia Fontana's portrait (Plate 32), or when Judith Leyster forces spectators to marvel at the virtuoso paint work as they admire the exquisiteness of her lace (Plate 37). The medal of Diana Scultori at least countered the interpretation of a woman artist as a marvel by the way it balanced that of her architect husband (Plates 27 and 28). Arguably *any* portrait made for public consumption could contest the notion that women should be confined to the household (Plates 27, 30, 31 and 32).

◆◆◆

Conclusion

Relatively speaking, a tiny number of portraits of female artists were made during the sixteenth and early seventeenth centuries. However, just as with their male counterparts, the study of these images shows how the iconography of the woman as artist developed considerably from the earlier medieval concentration on the portrayal of artists on their art work as their 'portrait-signature'. The range of portrayals available to male artists was much more extensive than that open to women artists because men were expected to hold high office, have elaborate tombs with their effigies, and act in the public sphere. Nevertheless, some women did use portraiture to associate themselves with the new definitions of artistry which men were claiming, as in the scholarly and scientific allusions present in the portrait of Lavinia Fontana (Plate 32). Further, there was no neat coincidence between transgressive self-portraits by women and conformist portraits of the woman as artist by men. The self-portraits of Sophonisba Anguissola, for example, had good reason to display the docile feminine, while the medal of Lavinia Fontana by Antonio Casoni associated her with qualities of imagination and intellect through his portayals of her with the personification of Painting. In the next case study I turn to look at the equally subtle ways in which women artists contested and obeyed stereotypical expectations in the kinds of art works they produced and subject-matter they represented.

References

Barker, Emma, Webb, Nick and Woods, Kim (eds) (1999) *The Changing Status of the Artist*, New Haven and London, Yale University Press.

King, Catherine (1995) 'Looking a sight: sixteenth-century portraits of women artists', *Zeitschrift für Kunstgeschichte*, 58, pp.381–406.

King, Catherine (1988) 'Late sixteenth-century careers' advice: a new allegory of artists' training – Albertina, Inv. no. 2763', *Wiener Jahrbuch für Kunstgeschichte*, XLI.

CASE STUDY 2

What women can make

CATHERINE KING

Were women artists pushed towards making certain kinds of art by their being barred from learning certain skills, by the education allowed them, or by the dominant notions of what was correct behaviour for a respectable woman? How did women artists negotiate such expectations and restrictions? How did they design 'against the grain', stating their own different viewpoints in what they made? These are some of the questions I will address in this case study.

The gendering of the genres

My phrase 'the gendering of the genres' alludes to the idea that within the range of subjects, forms and media regarded as the field of art at any time, the female artist will be expected to practice in areas which symbolize in some way her relative weakness, her dependence, her decorum as daughter, wife or mother, and her supposed intellectual incapacity. Male artists can be found specializing in all genres – flower paintings, landscapes, portraits, narrative paintings illustrating scenes from ordinary life to point a moral, scenes from religious or secular history, and allegories or mythologies. They designed a wide variety of buildings and sculptures too. In contrast, women were more likely to paint than to sculpt or to build and, within painting, were encouraged to confine themselves to representations of still life or portraiture or whatever were thought of as easier and smaller fields. If they ventured into narrative painting they were more likely to remain in the religious sphere or represent scenes of modern life than to broach allegory, myth or ancient history.

Although the 'hierarchy of the genres' was explicitly formulated in the seventeenth century in Western European art, the notion of some kinds of images and skills being more taxing and superior was put forward much earlier. In his treatise – *Della pittura* – Leon Battista Alberti argued in the 1430s that the making of history painting was the highest activity for image makers. Alberti outlined a regime of education in anatomy, in the forms and content of ancient Roman and Greek art, and in perspectival theory, which was eventually provided by the academies – but only for male artists, equipping them to invent such compositions. Women artists could get access to this education by the side door only – through hiring their own nude models and being taught by their fathers, brothers and husbands.

Alberti's Florentine followers reiterated the belief that imaginative inventiveness and idealization were of particular value within art whilst imitative realism was seen to have a lower status. In this system, portraiture, still life or landscape (in merely reflecting the visual world as it is) was lower in worth than history paintings. In Northern Europe, on the other hand, a higher value seems to have been placed on accurate representation, as it was

associated with intellectual veracity because of the scientific worth of clear and careful observation. Nevertheless, here too narrative paintings of scenes from modern life which taught a moral lesson, as well as scenes from religious and secular history, were likely to be regarded as most worthy. North and south of the Alps, images requiring numerous human figures were thought to entail the supposedly more difficult tasks of suggesting feeling and thought. In the Netherlands women artists were more likely to feel comfortable painting inanimate things or portraits rather than attempting 'higher' genres. Both in Italy and elsewhere women artists were, in addition, less likely to be thought able to produce narrative or allegorical works because such representations were regarded as carrying important religious and ethical ideas: they were the artistic equivalent of the sermons and political speeches which required a masculine authority and objectivity to utter.

The gendering of representational skills: brush, chisel or needle

The academies demoted all artistic skills except painting, sculpture and architecture. In contrast, the guilds included painters, carvers, builders and many other associated skills. For example, the guild of Haarlem, which Judith Leyster belonged to, comprised goldsmiths, painters, engravers, glass-painters, illuminators, sculptors, embroiderers, casters, clock-makers, book-binders, printers and makers of organs. Such admixture meant that women – all widows – in the Guild of Saint Luke in Antwerp in 1586 comprised 8 per cent of the members, while in the Guild of Saint Luke at Bruges they fluctuated between 12 and 25 per cent between 1454 and 1480. In England, however, painting and embroidery, although still regarded as crafts, were not in the same guilds.

The association of needlework with painting in the world of the guild may have made it easier to accept women as painters, and conversely may have meant that the status of needlework remained quite high. Indeed tapestry could entail designing in relief like sculpture as well as in the flat like painting, and was created on a large scale as mural decoration to be displayed in public state rooms in a house or as an altar frontal for a large congregation. It often communicated themes from the prestigious fields of mythology or secular and religious history, and it could represent grand allegories. For instance, the tapestries designed and created by Mary Queen of Scots and Bess of Hardwick, between 1568 when Mary arrived in England and about 1574, represented legendary and historical women and personifications of different virtues (Plate 39). They were hung in the drawing room and best bedroom at Hardwick Hall in 1590 – the house which Bess had built. Since Mary was recorded as 'delighting in devising' she may have been responsible for the design, but this was a collaborative effort since Bess employed four professional male embroiderers and enlisted the help of ladies in waiting, grooms, maids and boys of the household.

The first series was of five hangings praising the virtues of Queen Zenobia, Queen Artemisia, Queen Cleopatra, Lucretia, and Penelope, each associated with different virtues. The list was derived from Boccaccio's account of famous

Plate 39 Bess of Hardwick and Mary Queen of Scots, *Penelope with Perseverance and Patience,* 1568–*c.* 1574, wall hanging, Hardwick Hall, Derbyshire. Photo: National Trust Photographic Library / John Bethell.

women in history. These virtues are framed by classical architecture suggesting triumphal arches and the classical order is that of the Ionic – believed appropriate for celebrating matrons rather than maidens. The second series was of three hangings and showed Faith, Hope and Charity treading down their contraries in the form of Mohamet as a representative of Unbelief, Judas as figure of Despair, and Sardanapolis as the luxurious man who spent all on his own ease (Plate 40). The idea of representing heroines and the female virtues opposing men represented as vices was conventional, though the way in which Mary and Bess rendered the concepts entailed drawing from a wide variety of contemporary printed books. In addition, the scheme seems to have been partly designed to affirm Mary's loyalty to her cousin in showing Elizabeth I as Faith combating the infidel.

The pioneer writers of European art history, following Vasari, gave priority to three arts (painting, sculpture and architecture) in their accounts – all of them supposedly practised by professionals. But arguably, as their heirs, we may decide to revive broader definitions of art, which can include those representational skills practised by women, whether (rarely) as professionals or (more often) in their homes.

Plate 40 Mary Queen of Scots and Elizabeth Hardwick, *Faith and Mohamet*, *c*.1590, wall hanging, Hardwick Hall, Derbyshire. Photo: National Trust Photographic Library.

Portraits

Portraiture of individuals seems to have been an acceptable field for women artists to work in, and this was usually the task of women appointed to princely courts. Catarina van Hemessen was perhaps grooming herself for her court post in producing portraits of herself and others, including what may be a portrait of her father (Plate 41). Sophonisba Anguissola was kept busy at the Spanish court making portraits of her patron Philip II, his relations (like his sister Joanna) and Isabella his wife, as well as teaching Isabella to paint (Plate 42). Since such patrons were considered worthy of full length life-size portraits, the resulting images could make a splendid effect. Moreover such artists had the important task of creating the political imagery of sovereigns. Indeed Roy Strong has emphasized that as well as making numerous miniature portraits of Tudor monarchs from 1546 onwards, Levina Teerlinc was probably also responsible for designing the new seal for Elizabeth I. In addition, he argued that she created the conventions for portraying the Queen as Defender of the Faith (Plates 43 and 44). Practising the imitative art of portraiture could therefore give artists important state roles (Strong, *The English Renaissance Miniature*, pp.54–64).

Plate 41 Catarina van Hemessen, *Portrait of a Man*, 36 x 29 cm, 1552, National Gallery, London. Reproduced by permission of the Trustees of the National Gallery.

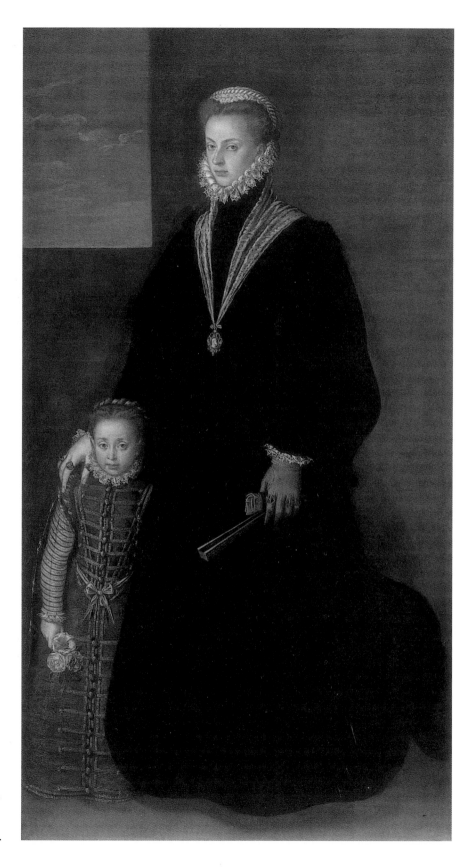

Plate 42
Attributed to
Sophonisba
Anguissola,
*Joanna of Austria
with her Child*,
1561–2, oil on
canvas, 194 x 108
cm, Isabella
Stewart Gardner
Museum, Boston.

Plate 43 Attributed to Levina Teerlinc, *Queen Elizabeth distributing Maundy Money, c.*1565, oil on vellum, miniature, Madresfield Court. Photograph: Victoria and Albert Museum Picture Library.

Plate 44 Levina Teerlinc, *Initial of Elizabeth I*, woodcut from J. Fox, *Acts and Monuments ... Book of Martyrs*, 1563, Bodleian Library, Oxford. Douce F. Subt.2 fol Bi recto.

History painting

Although narrative or historical painting was regarded as especially difficult, as privileged in communicating important social and religious ideals, as needing imaginativeness and creativity and, thus, as a man's work, some women did produce such compositions. For example, Diana Scultori, who was trained by her father alongside her brothers in the busy engraving workshop of the Ghisi family in Mantua, continued to engrave narratives in Rome after her marriage. Such engravings were often copies after designs by others, such as the engraving of the woman being pardoned by Christ for her adultery, which had been designed by Giulio Romano (Plate 45). In other engravings Diana took the prestigious role of making copies of famous ancient Greek sculptures in Rome, such as the recently excavated group then in the Farnese collection (Plate 46). Although she worked on a relatively small scale in a relatively cheap medium, the circulation of her images publicized her skills.

Other women created religious narratives for large altarpieces, which would have been seen by the public in church and were charged with the solemn role of providing moral and spiritual guidance. It appears that a nun trained as an artist and working with the help and protection of her convent could possess the social licence to produce such images. Thus Sister Plautilla Nelli

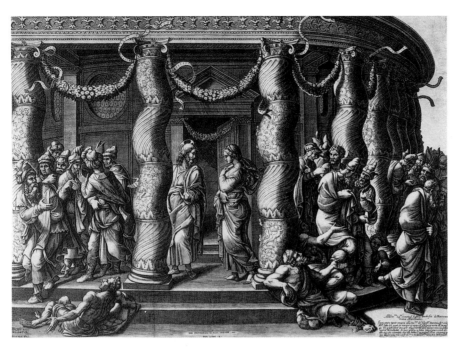

Plate 45 Diana Scultori after Giulio Romano, *The Woman Forgiven for her Adultery*, 1575, engraving, 42 x 57.2 cm, dedicated to Duchess Eleanora of Mantua, Rome, © British Museum, London, V, 8–8.

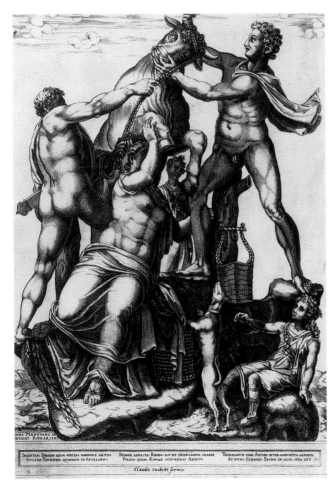

Plate 46 Diana Scultori, *Amphion and Zetus Punish Dirce for Harming their Mother by Tying her to a Raging Bull*, 1581, engraving, 36.6 x 26.8 cm, Rome, © British Museum, London, 1863 7.25.1754.

(1523–88) worked from her base in the convent of Santa Catarina da Siena in Florence and produced large altarpieces during the 1550s and 1560s. Plautilla was from a wealthy family and was with her sister Costanza, who entered the convent at the same time, joint heir to her family property. As well as having a wealthy upbringing, she had entered a convent that had been charged by the theologian Savonarola to work at the arts and writing to communicate religious ideas and earn money. The nuns were consequently taught to paint by friars from their brother convent San Marco, which had a respected tradition of artistic expertise in the work of Fra Angelico, Fra Paolino and Fra Bartolomeo. Plautilla may have been taught by Fra Paolino. He and Fra Bartolomeo are known to have studied using plaster casts of the human body and drawings after the antique, methods which would have been considered appropriate to a nun. Consequently Plautilla was able to work outside the guild system, with payment being made for her work to her community. And, while it is customary to single out Plautilla Nelli as a lone woman artist, her near contemporary Serafino Razzi, writing in 1590, listed her many pupils as still working together in her convent. It seems that only in the convent setting could women artists work together as a group.

Plautilla made altarpieces and illuminations for her own convent as well as painting for outside clients. For example, Padre Serafini Siepi records a *Pentecost* commissioned in 1554 by Guglielmo Pontano, Professor of Law, as his funerary altarpiece, which is in its original location in the left transept beneath the organ at San Domenico, Perugia. The patron's memorial is over the door to the left of the altar. This splendid altarpiece shows two Dominican nuns in the background to the holy event directly behind the Virgin Mary. Plautilla further feminized the Pentecost by the unusual inclusion of Mary Magdalen and another woman on either side of the Virgin. Although the foundation of the ministry of the church was often shown as an all male event, Plautilla put five women centre stage and grouped the apostles six each side (Plate 47). Following the policy of complete enclosure[1] in the 1570s, such nun artists could no longer be trained by external experts.

During the sixteenth century one secular woman artist – Lavinia Fontana of Bologna – managed to paint equally large-scale religious compositions. She was a highly sought after portrait painter in her home city, but graduated also to producing altarpieces in and around Bologna and then in Rome. Whilst she bore her husband, Giovanni Zappi, eleven children, the fact that he was content to manage her career rather than pursue his own enabled her to work towards acclaim. She was entrusted with huge and elaborate portraits such as the family portrait of the Gozzadini, painted in 1584, with its life-size figures (Plate 48). This was commissioned by the woman on the right, Laudomia, soon after her sister Ginevra, to the left, died. Since both Ginevra and her father Ulisse in the centre were dead, portraiture in this case could hardly be

[1] 'Enclosure' derives from the Latin phrase *in clausura* meaning that both nuns of the second order (like Benedictines) and sisters of the third order (like Franciscans) were bound by ecclesiastical law to remain enclosed from the outside world. Before the 1570s some communities were strictly enclosed, while others were able to receive visitors or go out occasionally. After the 1570s absolute isolation was enforced.

Plate 47 Plautilla Nelli, *Pentecost*, 1554, oil on canvas, life-size figures, San Domenico, Perugia. Photo: Index, Florence.

said to entail mere imitation. Lavinia was asked to create a composition to represent the relationships of trust between the sisters (both here in their wedding dresses), their father and their husbands, in order to symbolize the financial obligations entailed by the commissioner's father's will – which had left his fortune jointly to his two daughters and their heirs.

In the same year she also undertook a prestigious public commission for the altarpiece of the chapel of the centre of civic government in Imola – the Palazzo Communale. The commission was given by a unanimous vote of the city fathers, including her father-in-law, and showed the city of Imola beneath the crowned Virgin surrounded by musician angels (Plate 49). Following their instructions this vision is painted as if it were seen by Saint Cassianus and Saint Peter Chrysologus – the former being the founder of Christianity in Imola and the latter a defender of the belief in the immaculacy or special sinlessness of the Virgin Mary. The panel embodied the hopes of the city for the protection of the Virgin, relating to recent miracles associated with an image of the Virgin of the Assumption at a wayside altar on the Ponte Rotto.

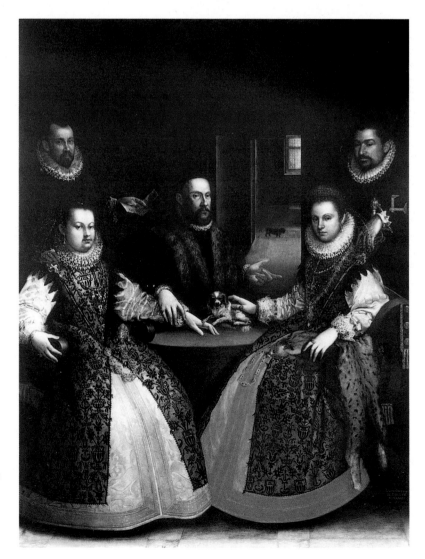

Plate 48 Lavinia Fontana, *Ginevra Gozzadini and her husband Annibale, Laudomia Gozzadini and her husband Camillo, and the father of the women Ulisse Gozzadini*, 1584, oil on canvas, 253 x 191 cm, Pinacoteca Nazionale, Bologna. Photo: Mario Berardi.

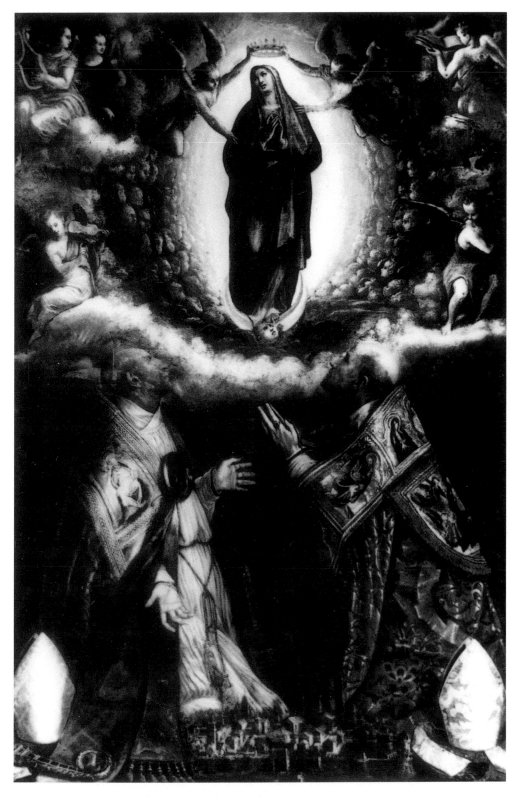

Plate 49 Lavinia Fontana, *The Vision of the Virgin adored by Saints Cassianus and Peter Chrysologus*, 1584, oil on canvas, 252 x 164 cm, Pinacoteca Civica, Imola.

Greek and Roman myth

From portraiture and religious narrative to classical myth – one of the most highly regarded types of subject-matter – was still something of a leap for a woman artist. However, the fact that a few of Lavinia Fontana's paintings do take mythological themes is a further reason for seeing her career and her scope of expertise as a challenge to stereotypes of the feminine. Amongst her works are two images of Venus, whilst her final known painting – made in Rome – showed Minerva, life-size, in the act of dressing herself (Plate 50). Minerva was the goddess of war and of wisdom and presided over excellence in arts and crafts – especially weaving. The owl and the laurel are her attributes (Plate 51). This is another large painting, and seems to have been a commission of Cardinal Scipione Borghese.

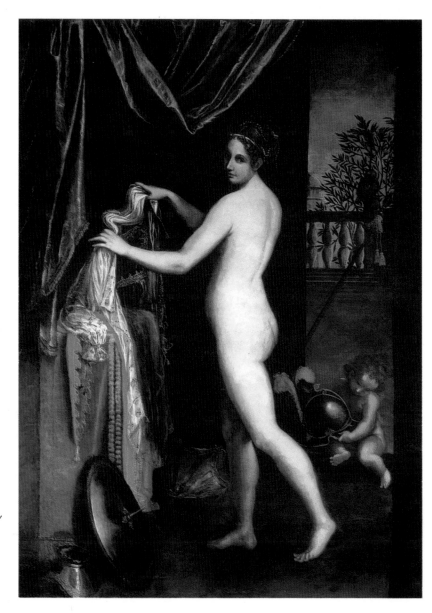

Plate 50 Lavinia Fontana, *Minerva Dressing and Arming Herself*, 1613, 260 x 190 cm, oil on canvas, Galleria Borghese, Rome. Photo: Jandi Sapi Editori, Archivi Arte Antica, Milan.

Plate 51 The owl (detail of Plate 50). Photo: Jandi Sapi Editori, Archivi Arte Antica, Milan.

Do you think the painting of Minerva represents conventional concepts of femininity? See Plate 51 for the owl background right.

Discussion

I think there are conventionally submissive and domestic elements in the way Minerva is shown inside her palace, her gentle glance, the way she modestly turns her back to us, and the presence of a child. However, the painter is showing off virtuoso skill to suggest different kinds of light – in the moonlit scene beyond Minerva's candlelit bedroom and in the armour with its complex reflections. I also think that the top-right view of the outside might suggest the powerful and active characteristics of Minerva beyond the confines of the household. The lance of the goddess is propped on the balcony to point out the laurel tree of Minerva. The owl with its luminescent eyes might propose another kind of look for women than the soft gaze of Minerva in the foreground. These are eyes which not only see in the dark, but are associated with wisdom, intelligence and skill.

◆◆◆

Allegory

The subject-matter of allegory was regarded as the loftiest mode of representation at this period, for it suggested that the creator was capable of fully abstract thought. Artists at this period were attempting to assert that painting and sculpture were liberal arts, and the distinctive characteristic of a liberal art – like geometry, arithmetic or logic – was that it was a theoretical

not a manual skill.[2] Artists argued that, just like liberal artists who used pens to write down their ideas, they merely used brushes and chisels to demonstrate their concepts. An allegory used personifications of qualities placed together to express ideas. You may recall that the Roman painter Artemisia Gentileschi had actually made an allegorical self-portrait of herself in about 1630 where she showed herself as the personification of Painting (Plate 38). Earlier, in 1617, with the encouragement of the great nephew of Michelangelo, she was able to paint a contribution to an allegorical scheme to decorate Michelangelo's house in Florence (Plate 52). The allegory demonstrated the elements which had gone to create the success of Michelangelo, and she was given the task of personifying *Inclination* – the supposedly innate tendency to artistic inventiveness (Plate 53). Artemisia showed *Inclination* holding a mariner's compass in her right hand, being guided by a star over her head. However, this was only part of a scheme, as was her level of participation in the allegory created by her father Orazio Gentileschi of *Peace and the Arts under the English Crown* for the Queen's House, Greenwich, in 1638 (Plate 54). Artemisia had been trained by her father, and she arrived in England in 1638 in time to assist him and her brother before her father's death in 1639. It seems that a woman could not be given responsibility for the whole of a large-scale allegorical programme.

Plate 52
Room showing
Michelangelo's career,
Casa Buonarroti,
Florence. Photo:
Index/Perugi.

[1] See the historical introduction to Barker *et al.*, *The Changing Status of the Artist* (Book 2 in this series).

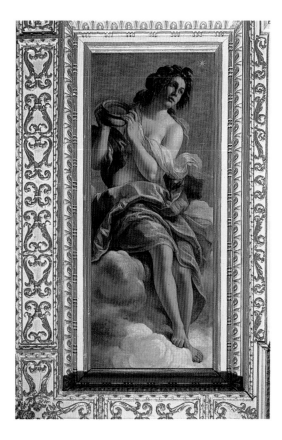

Plate 53 Artemisia Gentileschi, *Inclination*, 1617, oil on canvas, 152 x 61 cm, Casa Buonarroti, Florence. Photo: Index, Perugi.

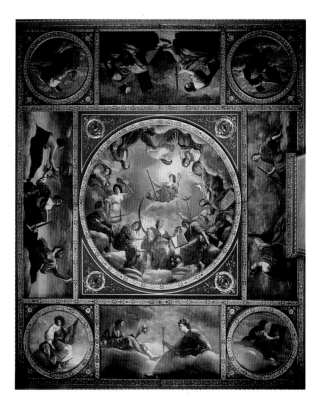

Plate 54 Orazio Gentileschi and his family, *Peace and the Arts under the English Crown* for the Queen's House, Greenwich, 1638, oil on canvas, now in Marlborough House, London. Photo: Royal Commission on the Historical Monuments of England. Crown copyright.

Still life

The first dated still lives – as independent canvases or panels devoted to the representation of flowers, food, and utensils – were produced from the very end of the sixteenth century. Amongst the earliest examples are still lives by the artist of Antwerp, Clara Peeters (b. *c.*1594) (Plates 55 and 56). It is understandable that a woman artist should have been one of the pioneers in a genre which represented things in a domestic setting for placing in an interior. In this case the image is one of luxury – making reference to the ceremonial silver-gilt drinking cups which confraternities, guilds, and political

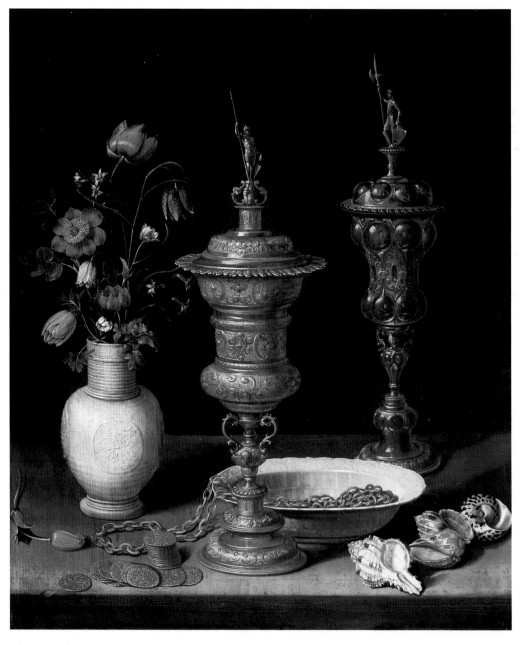

Plate 55 Clara Peeters, *Flowers with Ceramic Dish, Money, Drinking Goblets*, 1612, 59.5 x 49 cm, Staatliche Kunsthalle, Karlsruhe.

Plate 56 Clara Peeters, detail of goblet (Plate 55).

groupings used at banquets. Both the goblets have lids topped with statues of a soldier with helm and lance. The vase represents spring and summer flowers which were expensive imports to Antwerp, such as the tulips from the Middle East and anemones from the Mediterranean, as well as flowers of careful cultivation and breeding in Northern Europe like the Gallica rose. The shells are trophies of far distant shores, coming with the ships which brought goods to Antwerp. To make absolutely clear that this is a picture of money and power, a gold chain trails out of a porcelain dish and there are piles of coinage beside it. The kind of patrons who ordered images like this were members of guilds of merchants and artists, or religious confraternities who shared in regular devotions dedicated to a particular saint or element in church belief. Such guilds and confraternities held regular banquets in their society's assembly rooms when they used expensive goblets of the sort depicted by Clara Peeters. It seems possible that the society in this case was dedicated to a soldier saint, such as Saint George. A member of the society could have commissioned the painting for his house (possibly to commemorate being elected as an officer of the guild or society) or the guild could have ordered the painting to adorn its banqueting room. The artist showed herself reflected on the shining bosses of the goblet to the right (Plate 56). Others, like Parmigianino, had represented themselves reflected in convex surfaces.[3] None had recorded reflections in twelve such surfaces – each set at a different angle to the viewer. A young woman when she painted this, was Clara Peeters proving both that she had painted this *tour de force* and that 'mere imitation' was not quite so easy after all?

[3] See Plate 43 in Barker *et al., The Changing Status of the Artist* (Book 2 in this series).

Moralizing from scenes of modern life

From the sixteenth century onwards, Protestant dislike of religious imagery in churches meant that artists working in areas ruled by Protestant governments no longer needed to create large narrative works with religious subjects, and an entire tradition of narrative art was lost. This change signalled some shifts in the scheme of values given to different genres. Women artists had to find their place in this new order. In the Netherlands in the areas where altarpieces were no longer required, narrative paintings were still being made but for rather different locations: they had an important moral role in the home to promulgate good behaviour. For this market paintings were created on a small scale which showed incidents as if from ordinary contemporary life. They were regarded as a modest variety of history painting. One woman artist working in the Netherlands during the early seventeenth century achieved acclaim for her production of landscapes (a genre not then associated with the feminine as it was considered too 'outward bound'), portraits, still lives, and these small-scale narrative images. Judith Leyster was accepted by the Guild of Saint Luke at Haarlem in 1633 as having the right to sell on the open market from her studio, in the picture lotteries and at fairs. She had her own studio and apprentices and eventually married a painter – Jan Molenaar – in 1635. It is not known who taught her – she was not from an artistic family and her father was a brewer. In her discussion of Leyster's paintings, Frima Fox Hofrichter has analysed the way in which Judith was able to create modern moral paintings which sometimes offer readings of male behaviour from the viewpoint of her gender ('Judith Leyster's *Proposition*'). The idea that women lead men on and then say no, or that no might mean yes, was, as Fox Hofrichter shows, a common subject for male artists who admonished women to behave clearly and honestly.

What do you think *The Proposition* (Plates 57 and 58) suggests – and what sort of audience does she play to?

Discussion

The man seems quite a lot older than the woman, and he seems to have come in from outdoors while she is indoors with a little brazier at her feet. She is dressed plainly in a plain interior. He leans over her offering her money with his right hand and nudging her shoulder with his left. She has nothing in her hands but a seam she is sewing on white cloth and she bends over her work with eyes downcast. He seems to be cajoling her to look at him. Femininity, youth and lowly class are represented in a highly affirmative manner. The woman is placed in the centre of the picture field. She is shown as being still and poised, and her form is rendered in bright tone. As a figure she is associated with the warmth of the fire at her feet. It seems to me that this is a painting which appeals to female viewers in the sense that it shows a man, who is pestering a poor seamstress, in a bad light. Judith Leyster's painting reinforces concepts of gender differences (in contrasting active, insistent man with passive, introverted woman), but it does show the female as resistant and not as compliant in insisting on her virtue. This might have appealed to women viewers, whereas somewhat similar images by male artists had represented women as waiting to be persuaded and holding out for gain, in a way that Fox Hofrichter argues would have pandered to masculine viewers.

◆◆◆

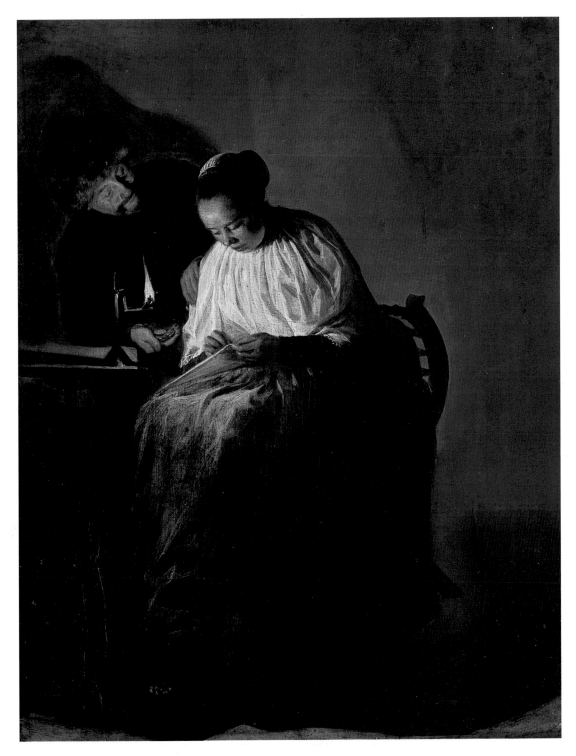

Plate 57 Judith Leyster, *The Proposition*, 1631, 30.9 x 24. 2 cm, oil on panel, Mauritshuis, The Hague.
Photo: © Mauritshuis, The Hague. Inventory 564.

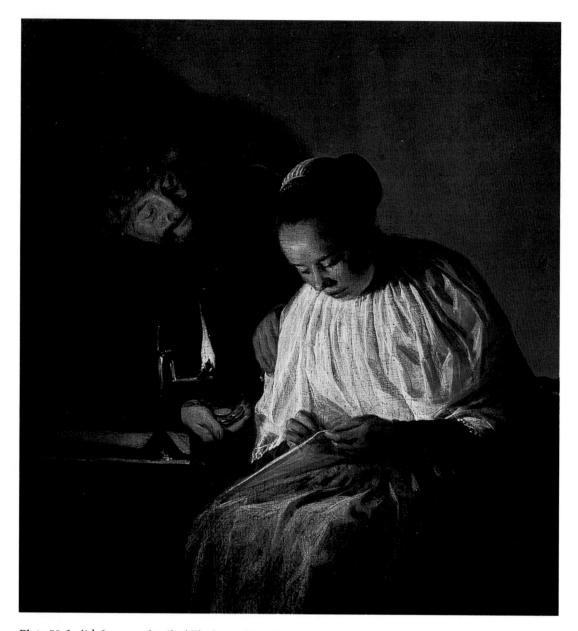

Plate 58 Judith Leyster, detail of *The Proposition* (Plate 57).

Women artists needed to conform to expectations of femininity to some extent in order to be able to practise at all in a man's world. But however conventional they were asked to be by social custom, they seem to have had a spring of creative ideas about the status they deserved and their right to representation. An example of this combination of the conformist and nonconformist may be found in the person of Giovanna Garzoni (1600–70). Giovanna was a conventional woman artist in terms of her subjects and her media. She was from a family of artists on her mother's side in Ascoli Piceno and was also taught by Giacomo Rogni in Venice. She travelled often with her brother and worked for princes of state and church in Italy and France. She produced

exquisite calligraphy, and also painted miniature portraits and still lives (Plate 59). However, Giovanna was the first woman artist to have a tomb with her portrait – 250 years after funerary portraits began to be made for male artists (Plate 60). She achieved this by means which no male artist had had to employ: she left her estate to the Accademia di San Luca (to whose religious confraternity she was allowed to belong) on condition that she was entombed in the Academy church in Rome. Although she did not specify a portrait, a fellow painter from her home town, Giuseppe Ghezzi, and the architect Mattia de' Rossi eventually marked her sepulchre in 1698, thirty years after her death, with an oval painted portrait which was the traditional form for a male artist's portrait, although they had portraits in marble or bronze.

Conclusion

During the sixteenth and seventeenth centuries, women who were artists were few and tended to work in a more restricted area of subjects and media than their brothers and fathers. Most have been marginalized or even written out of art history. If their works were ambitious they were later attributed to their male relations or teachers or, if signed, were subsequently spoken of as exceptional. If they seemed poor in terms of skill, women's works were not

Plate 59 Giovanna Garzoni, *Figs, a Goldfinch with a Chinese Porcelain Dish*, tempera on parchment, *c.*1660, 26 x 38 cm, for Stanza dell'Aurora, Medici Villa Poggio Imperiale, now Galleria Pitti, Florence, inv no 1890– 4750. Photo: Index/Orsi Battaglini.

regarded as belonging to the dominant narrative of stylistic change and artistic progress. Nevertheless we have seen that many individual men helped women artists by commissioning their works, teaching them and encouraging them. Equally some women artists themselves can be seen as having been resiliently inventive in negotiating the terms in which the 'feminine' and the 'masculine' could be represented. In analysing the images they made, we can gauge something of the pliability of the systems of visual conventions within which they worked.

Plate 60 Mattia de' Rossi and Giuseppe Ghezzi, tomb of Giovanna Garzoni, 1698, marble, paint and wood, San Luca e Martina, Rome, portrait now stolen. Photo: Jandi Sapi Editori, Archivi Arte Antica, Milan.

References

Barker, Emma, Webb, Nick and Woods, Kim (eds) (1999) *The Changing Status of the Artist*, New Haven and London, Yale University Press.

Fox Hofrichter, Frima (1982) 'Judith Leyster's *Proposition*: between virtue and vice' in N. Broude and Mary D. Garrard (eds) *Feminism and Art History: Questioning the Litany*, New York, Harper and Row.

Strong, Roy (1983) *The English Renaissance Miniature*, London, Thames and Hudson.

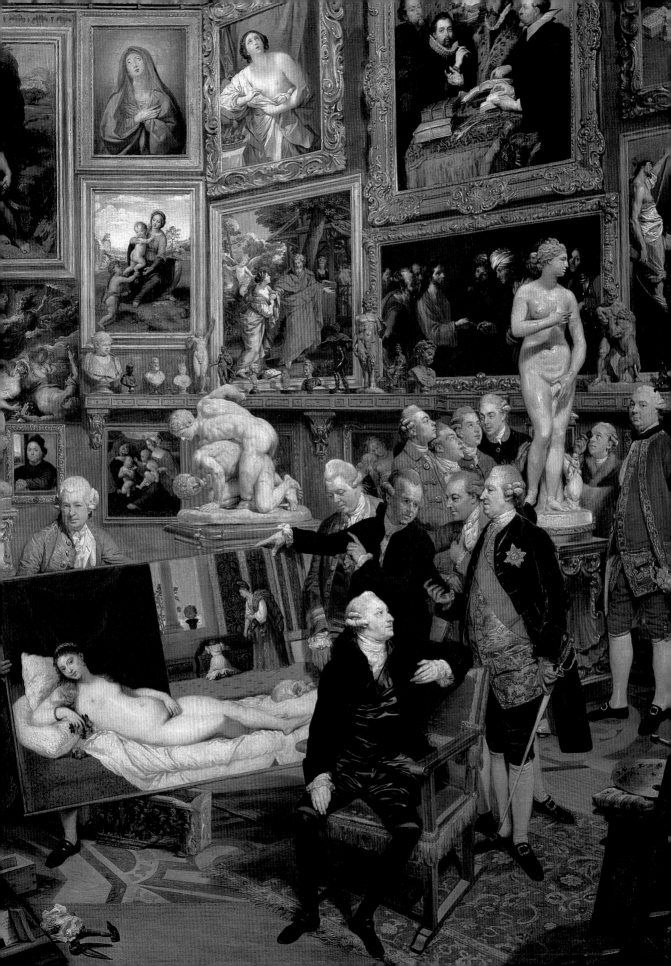

PART 2
GENDER, GENRES AND ACADEMIC ART IN THE EIGHTEENTH CENTURY

Introduction

GILL PERRY

In 1764 a letter from a young British artist working in Paris appeared in *The Morning Chronicle*. He describes a visit made the previous evening to the life class at the Academy of the Louvre

> where there were at least 200 students in a large hall ... all copying from a living man, who was placed naked in a reclining posture. The room is illuminated above the object by a very large lamp, with a dozen or twenty different flames. There are two rows of benches around the room; the highest for the statuaries, the other for the painters; every one has his own light placed at his right hand, with a screen between it and the object ... there are students here from all parts of the world ...
>
> (Quoted in Bignamini and Postle, *The Artist's Model*, p.16)

During the mid-eighteenth century many British artists (with sufficient means) studied at public academies in Paris and Rome, where drawing from antique casts and the living model were central aspects of an artist's training. From the Renaissance onwards the culture of the life class had become part of a common European language of art education. The establishment in 1768 of the Royal Academy of Art, the first state-sponsored British academy, was partly an attempt to institutionalize an artistic training which centred around the life class, thus following the model of French and Italian teaching systems.[1]

It is significant that the quotation above makes no reference to the use of *female* models. Study from the female nude did not become part of general academic practice in European academies until the nineteenth century. During the seventeenth and eighteenth centuries the use of female models was forbidden in the French Royal Academy in Paris and the French Academy in Rome. Most students (who could afford to do so) would study from the female model in the privacy of their private studios. However, a distinctive feature of the newly-formed British Royal Academy was the use of both male *and* female models in the life class. Not surprisingly perhaps, this relatively radical development set into sharp focus some of the gendered assumptions which had originally excluded studies of the female model from most academic curricular. Martin Postle has written:

Plate 61 (Facing page) Johann Zoffany, detail of *The Tribuna of the Uffizi* (Plate 64).

[1] The formation of, and the 'academic' codes associated with, these French and British institutions are discussed in Perry and Cunningham, *Academies, Museums and Canons of Art* (Book 1 in this series).

> As there was no established precedent for the use of the female model in European academies, there was no theoretical basis for instruction … the low social status of female models was gravely at odds with the aura which surrounded their mythological counterparts. Male models, chosen principally for their musculature and physique, were often pugilists or soldiers. As such they were respected as individuals whose athletic appearance echoed the classical heroes with whom they were compared. Female models, by way of contrast, were regarded with curiosity and suspicion, especially as many were also prostitutes.
>
> (Bignamini and Postle, *The Artist's Model*, p.19)

In the study which follows on women artists and the British Royal Academy we will consider some of the gender issues which are raised by such aesthetic and moral differentiations between the study of male and female nudes.

Some other gendered aspects of this educational culture are partly hidden in the quotation from *The Morning Chronicle*. The writer only uses the male possessive pronoun (*his* own light) to describe the artist's equipment, thus revealing that there were only male students studying from a male model. Throughout Europe, women were excluded from the life class in those academies which were based on Renaissance tradition. Moreover this exclusion from the pedagogical core of such institutions helped to marginalize women artists at both educational and professional levels. As we shall see in our two case studies taken from Britain and France in the eighteenth centuries, this exclusion was usually justified on the grounds of propriety and female modesty, and helped to bolster arguments in favour of the limited – or reluctant – admittance of women to the official (i.e. patronized or sponsored by the state) academies of art.

A training in life-drawing was essential for the production of the most respected genres of art, in particular, history painting, which often required detailed observations of figure groups in epic, historical or mythological contexts. The French Royal Academy of Painting and Sculpture (founded in 1648) trained artists to reinforce the dominance of this genre, and provided a model upon which the British Royal Academy was partly based (Plate 62). As we shall see in the case studies that follow, both institutions restricted – or even barred – female membership.

Some of the most important and influential work done in feminist art history of the 1970s and 1980s has addressed the ideological implications of these historical exclusions and restrictions. For example, in 1981 Rozsika Parker and Griselda Pollock argued that the effects of these restrictions went beyond reduced access to exhibitions and professional opportunities.

> It signified their exclusion from power to participate in and determine differently the production of languages of art, the meanings, ideologies and views of the world and social relations of the dominant culture.
>
> (Parker and Pollock, *Old Mistresses*, p.xvii).

The historical conditions of women within (and outside) officially sanctioned institutions, then, will affect the way in which they are able to paint, think and relate to their contemporaries. Allowed limited access to many of the practices which were seen as central to the production of the most respected genres, women were more likely (as we saw in the preceding section) to be portraitists or still-life painters, or to work on the 'lesser' or applied arts such

Plate 62 British School, *The Antique Room of the Royal Academy at New Somerset House,* *c.*1780–83, oil on canvas, 103 x 161.75 cm. © Royal Academy of Arts, London/Private Collection.

as miniature painting and embroidery. As will be argued in the discussions which follow on the British and French academies in the eighteenth century, the effects of these institutional structures go beyond the nature of women's practice; they inform a complex culture of art which involves the language of theory and criticism and social relations, and which helps to inform contemporary ideas of femininity and masculinity.

Recent feminist art history has tended to emphasize the complexity of such ideas as they shift and evolve in response to cultural and political forces. Thus in the case studies which follow we will be looking not simply at attitudes to women artists within what might loosely be called the 'social relations of the dominant culture', but we will also be considering some of the differing ways in which women negotiated that culture. The simplified picture of eighteenth-century women artists as largely passive victims or participants in an oppressive patriarchal culture is increasingly subject to scrutiny. As we shall see, women responded to cultural and institutional restrictions in varied and sometimes imaginative ways.

References

Bignamini, I. and Postle, M. (1991) *The Artist's Model,* Iveagh Bequest, Kenwood.

Parker, Rozsika and Pollock, Griselda (1981) *Old Mistresses: Women, Art and Ideology,* London, Routledge.

Perry, G. and Cunningham, C. (eds) (1999) *Academies, Museums and Canons of Art,* New Haven and London, Yale University Press.

Women artists, 'masculine' art and the Royal Academy of Art

GILL PERRY

In the 1770s the artist and Royal Academician Johann Zoffany (*c*.1733–1810) produced two ambitious paintings which are now often cited and celebrated as images of English late eighteenth-century taste and academic values: *The Academicians of the Royal Academy*, 1772, and *The Tribuna of the Uffizi*, 1772–7 (Plates 63 and 64). The former shows the first Academicians assembled in the life class where they are surrounded by plaster casts after antique sculptures and two male models. Founded under royal charter with Sir Joshua Reynolds as its first president, the Royal Academy sought (in theory at least) to establish the practice and teaching of art as a professional activity subject to academic rules and hierarchies.[1] Zoffany's image, then, reinforces the importance of the life class at the centre of this 'academic' discipline. The Academician in charge poses the male model, while Reynolds stands in the centre looking on with his colleagues in rapt admiration. Zoffany's painting, then, represents an exclusively male activity with the nude male body as its focal point.

Plate 63 Johann Zoffany, *The Academicians of the Royal Academy*, 1771–2, oil on canvas, 100.7 x 147.3 cm, The Royal Collection © Her Majesty The Queen.

[1] These issues are explored in '"Mere face painters"? Hogarth, Reynolds and ideas of academic art in eighteenth-century Britain' in Perry and Cunningham, *Academies, Museums and Canons of Art* (Book 1 in this series).

Following our earlier discussion, it is significant that the nude female model, although used in the Academy's life class, is absent from this image. Within such 'masculine' spaces, women are depicted as the objects – rather than the producers – of representation. As they were prohibited from the life class, the only two women among the thirty-six founder members, Angelica Kauffman (1741–1807) and Mary Moser (1744–1819), are shown as portraits on the wall to the right of the assembled group. Moreover, the only other female form to be shown as part of this academic activity is an inanimate object – a headless and legless plaster cast consigned to the side of a bench. The sexual rather than aesthetic implications of this damaged female torso are suggested by the pose of the artist who appears to press his stick dismissively into its stomach. The artist is Richard Cosway, elected as a Royal Academician in 1771, who was renowned for both his neo-classical interests and his promiscuous attitudes. Zoffany's choice of mannered pose in his depiction of Cosway suggests a sexual arrogance which does not seem out of place within this gendered space.

The association made here between the appreciation of classical objects and an exclusively male gathering is also a theme of Zoffany's *The Tribuna of the Uffizi*. Much like *The Academicians*, this work is made up of a series of portraits of well-known figures from British artistic and political circles, including connoisseurs and members of the aristocracy gathered in the main room of the Uffizi Gallery in Florence. This famous room is shown crowded with sources deemed central to contemporary eighteenth-century ideals of artistic taste.

Please look carefully at the reproduction of this work and the key provided (Plates 64 and 65). What kind of image of eighteenth-century taste do you think Zoffany was seeking to convey? Does the painting raise any gender issues similar to those which we have been considering in Part 1?

Discussion

From the information provided in Zoffany's image you might presume that in the eighteenth century a notion of 'taste' was largely an issue for middle- and upper-class English men who were hanging around the Uffizi with time to spare. This would be a fair assumption, for contemporary ideas of what constituted good 'taste' in the visual arts were dominated by a reverence for classical and Renaissance sources, which were most directly accessible to those (mostly male) wealthy travellers and connoisseurs who took the Grand Tour through Europe and Italy.[2] In fact the twenty-two portrait studies have all been identified as members of the British aristocracy or well-known art lovers, and include a portrait of the artist himself (see Plate 65).

The concept of 'taste' which this painting could be seen to celebrate is, then, partly dependent on a masculine culture of travel; the Uffizi seems to have been colonized by British dignitaries and art lovers who are claiming a whole range of non-British art – largely antique and Renaissance – as signifying

[2] Several notable women did, however, do the 'Grand Tour' and record their impressions, including the writer Anna Jameson.

aesthetic value. You may have noticed that the revered works which surround them include antique Greek and Roman sculptures (Plate 66), High Renaissance paintings including many Raphaels and Titian's famous *Venus of Urbino* (Plate 67), and two Rubens.

You probably also noticed that while the group of spectators is male, many of the art objects which they admire represent female themes, whether in the form of Madonnas, Venuses or Bacchantes. Moreover, Titian's *Venus of Urbino* dominates the foreground where it is being venerated by a group including Sir Horace Mann, who was then 'Envoy Extraordinary' at the Court of the Grand Duke of Tuscany. The Duke had recently decreed that the painting had been copied too much and should not be taken down for this purpose. In Zoffany's painting, however, the *Venus of Urbino* is represented as if removed for copying, itself an indication of the special privilege and status accorded to Zoffany, who produced his work under royal patronage. He had been commissioned to paint the portrait while in Florence by Queen Charlotte, wife of George III, herself an active patron of the visual arts.

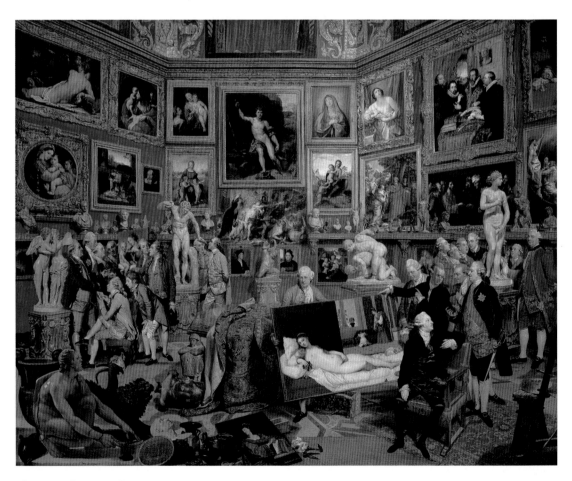

Plate 64 Johann Zoffany, *The Tribuna of the Uffizi*, 1772–7, oil on canvas, 154.9 x 123.5 cm, The Royal Collection © Her Majesty The Queen.

35 Holbein. *Sir Richard Southwell.*
36 Lorenzo di Credi. *Portrait of Verrocchio;* now described as a portrait of Perugino by Raphael.
37 Now attributed to Niccolò Soggi. *Holy Family.*
38 Guido Reni. *Cleopatra.*
39 Rubens. *The Painter with Lipsius and his pupils.*
40 Raphael. *Leo X with Cardinals de' Medici and de' Rossi.*
41 Pietro da Cortona. *Abraham and Hagar.* Now in the Kunsthistorisches Museum, Vienna.
42 School of Caravaggio. *The Tribute Money.*
43 Cristofano Allori. *The Miracle of Saint Julian.*
44 Unidentified. *Roman Charity.*
45 Raphael, 'Niccolini-Cowper' *Madonna*, formerly at Panshanger and now in Washington.
46 Guercino. *The Samian Sibyl.*
47 Titian. *The Venus of Urbino.*
Of these Nos. 24, 25, 27, 29, 33, 38, 39, 42, 43 and 46 are now in the Palazzo Pitti, Florence.

Statues
48 The *Arrotino* or *Scita Scorticatore.*
49 *Cupid and Psyche.*
50 *The Satyr with the Cymbals.*
51 *Hercules strangling the Serpent.*
52 *The Wrestlers.*
53 *The Venus de' Medici.*

Objects on the Floor
54 South Italian or Apulian *cratere*, 4th century B.C.
55 Etruscan helmet.
56 The Etruscan Chimera.
57, 58, 59 Roman *lucernae.*
60 Egyptian Ptahmose, XVIIIth dynasty.
61 Greek bronze torso.
62 Bust of Julius Caesar.
63 Silver shield of the Consul Flavius Ardaburius Aspar.
64 Bronze head of Antinous.
65 South Italian *cratere.*
66 Etruscan jug.
67 South Italian *situla.*
Nos. 54, 55, 56, 60, 61, 63, 64, 65, 66, 67 are in the Museo Archeologico, Florence; No. 57, is in the Bargello, Florence; and No. 62 in the Uffizi, Florence.

Objects on the Shelves
(Many remain unidentified)
68 Bust of 'Plautilla'.
69 Small female head.
70 Head of Tiberius in jaspar, on gold mount of the sixteenth century.
71 Bust of 'Annius Verus'.
72 Bust of an unknown boy, the 'Young Nero'.
73 Bronze figure of Hercules.
74 Small Egyptian figure.
75 Bronze *Arion* by Bertoldo di Giovanni.
No. 75 is in the Bargello, Florence; Nos. 69, 70, 74 are in the Museo degli Argenti, Florence; No. 73 is in the Museo Archeologico, Florence; and Nos. 68, 71, 72 are in the Uffizi, Florence.
76 Octagonal table made by Ligozzi and Poccetti, now in the Opificio delle Pietre Dure, Florence.

Portraits
1 George, 3rd Earl Cowper (1738–89), Prince of the Holy Roman Empire. A distinguished collector and devoted lover of Florence.
2 Sir John Dick (1720–1804), Baronet of Braid. British Consul at Leghorn, 1754–76. He is wearing his badge as a Baronet of Nova Scotia and the ribbon and star of the Russian order of St Anne of Schleswig-Holstein; he was nominated 'Chevalier' of the order on 25 March 1774 and received the ensigns early in 1775.
3 Other Windsor, 6th Earl of Plymouth (1751–99). He was in Florence in January, February and June 1772.
4 Johann Zoffany.
5 Charles Loraine-Smith (1751–1835), second son of Sir Charles Loraine, 3rd Bt. He left Florence with Mr Doughty (16) on 14 February 1773.
6 Richard Edgcumbe, later 2nd Earl of Mount Edgcumbe (1764–1839).
7 Mr Stevenson, companion to Lord Lewisham (8) on his travels.
8 George Legge, Lord Lewisham, later 3rd Earl of Dartmouth (1755–1810). Lord of the Bedchamber to the Prince of Wales, 1782–3; Lord Chamberlain, 1804–10. He embarked on a tour of the Continent with Mr Stevenson in July 1775. They were in Florence on 2 December 1777.
9 Called Joseph Leeson, Viscount Russborough, 2nd Earl of Milltown (1730–1801). His presence in Florence is only reported in the *Gazzetta Toscana* of 8 August 1778, after Zoffany's departure; and the figure does not

agree in age or appearance with the portrait by Batoni (1751) in the National Gallery of Ireland.
10 Valentine Knightley (1744–96), of Fawsley. He is probably the Knightley who was in Florence in November 1772; and could well be the Knightley who left Florence in March or April 1773.
11 Pietro Bastianelli, a *custode* in the Gallery.
12 John Gordon. The *Gazzetta Toscana* reported on 2 July 1774 that a *sig. Gordon* was in Florence; he was probably identical with *Monsieur Godron Uffiziale Inghilese*, reported in Florence on 13 August 1774.
13 George Finch, 9th Earl of Winchilsea (1752–1826). Gentleman of the Bedchamber, 1777–1812; Groom of the Stole, 1804–12. He was in Florence from December 1772 to late March 1773.
14 Mr Wilbraham (see below, No. 21).
15 Mr Watts. He was reported in Florence on 2 January 1773.
16 Mr Doughty. He was in Florence in February 1773 and left with Loraine-Smith (5) on 14 February.
17 Hon. Felton Hervey (1712–73), ninth son of the 1st Earl of Bristol. Equerry to Queen Caroline of Ansbach and Groom of the Bedchamber to William, Duke of Cumberland. He was in Florence early in September 1772.
18 Thomas Patch (c.1725–1782). Painter of caricatures and topographical views. Active in Florence from 1755 until his death.
19 Sir John Taylor (d.1786). Recorded in Rome in 1773; perhaps also the Taylor who was

in Florence in November 1772.
20 Sir Horace Mann (1706–86). Famous as the friend and correspondent of Horace Walpole. Early in 1738 he was assisting the British Resident at the court of the Grand Duke of Tuscany and in 1740 he succeeded to the post; he stayed at Florence for another 46 years, as Resident, 1740–65, Envoy Extraordinary, 1765–82, and Envoy Extraordinary and Plenipotentiary, 1782–6. He received the Order of the Bath in 1768.
21 T. Wilbraham. The two gentlemen of this name (see above, No. 14) were perhaps two of the sons of Roger Wilbraham of Nantwich: Thomas (b.1751), George (1741–1813) or Roger Wilbraham (1743–1829). The two Mr Wilbrahams are reported in Florence by Lord Winchilsea (13) between December 1772 and 16 February 1773.
22 James Bruce (1730–94). The famous African traveller; he was in Florence in January 1774.

Paintings
23 Annibale Carracci. *Bacchante.*
24 Guido Reni. *Charity.*
25 Raphael. *Madonna della Sedia.*
26 Correggio. *Virgin and Child.*
27 Sustermans. *Galileo.*
28 Unidentified. Conceivably the old copy (in the Uffizi) of Rembrandt's *Holy Family* in the Louvre.
29 School of Titian. *Madonna and Child with Saint Catherine.*
30 Raphael. *Saint John.*
31 Guido Reni. *The Madonna.*
32 Raphael. *Madonna del Cardellino.*
33 Rubens. *Horrors of War.*
34 Franciabigio. *Madonna del Pozzo.*

Plate 65 Key to Johann Zoffany, *The Tribuna of the Uffizi*. Photo: Christopher Lloyd, *The Queen's Pictures: Royal Collectors through the Centuries*, London, National Gallery Publications, 1991, p. 172.

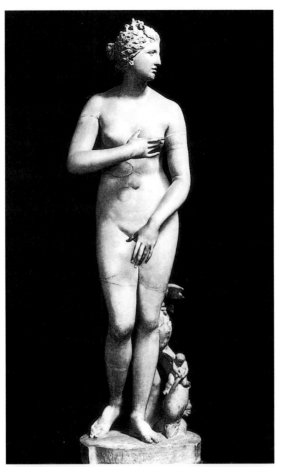

Plate 66 *Venus de Medici*, first century, Uffizi Gallery, Florence. Photo: Fratelli Alinari.

Plate 67 Titian, *Venus of Urbino*, c.1538, oil on canvas, 118 x 167 cm, Uffizi Gallery, Florence. Photo: Fratelli Alinari.

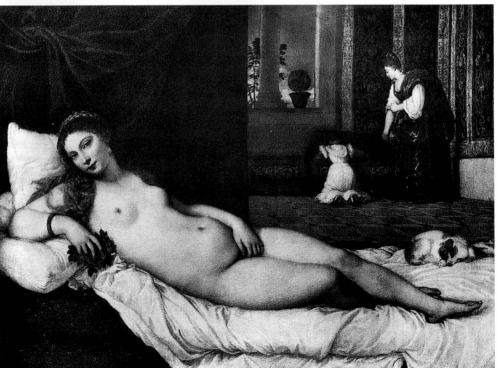

Titian's painting is one of two images of naked Venus shown in *The Tribuna*; the other is the Roman statue the *Venus de Medici* shown on the right. Both occupy important positions and are surrounded by enraptured male art lovers. As part of this rich and complicated image they tell us that the representation of the female body occupies a central role in contemporary definitions of both 'art' and 'taste'. Within art history, the figure of Venus had become a kind of symbolic code for ideal female beauty. In both her celestial and earthly forms she was famous for her carefully organized and harmonious dimensions. She was perceived as an ideal reconstruction of nature, as nature transformed into something more elevated. As such she is a central motif for the discourses of high art and academic theory.

◆◆◆

In view of our earlier discussion of the absence of studies from the female model in most European academies, you may be puzzled by this elevated status afforded to the figure of Venus. The point to note here is that the symbolic value attributed to such images was in large part derived from the idealized character of such representations of the female nude, which had clearly been reconstructed from nature. While male classical statuary had been constantly studied and classifications confirmed through the use of athletic male models in the life class, the moral and social prejudices which surrounded the profession of the female model directly affected perceptions of their value in the search for standards of taste. As Postle stated (in my earlier quotation): 'the low social status of female models was gravely at odds with the aura which surrounded their mythological counterparts'. The figure of Venus, then, provided an acceptable established motif for the representation of the female nude. As a motif which was subject to careful control and idealization, it could stand as a metaphor for high art itself. Following from this, we could argue that within Zoffany's painting this metaphorical status is suggested by the dominant central position of the *Venus of Urbino*, surrounded by the admiring (male) arbiters of taste.

There are other related levels on which we can read Zoffany's image of paintings within a painting. Of course, it contains representations of art works which feature both male and female nudes. But what is significant here (as we noted earlier) is that while there are both male spectators *and* objects of art, the females present are exclusively the objects. In fact we could argue that the painting is as much about the process of viewing art as it is about taste and 'academic' values. As spectators ourselves we are viewing a painting which shows a group of men looking at art in a public space designed for viewing. In its historical context Zoffany's *The Tribuna* evokes an eighteenth-century Enlightenment ideal of the contemplative viewing of an art object – a process which (it was believed) involves an intellectual activity and enhances the dignity of the (male) viewing subject. Thus these men are shown actively conferring, discussing and note taking. A relationship is suggested between the 'perfection' and educational possibilities of the works of art and the male art lover who actively contemplates and learns.

Both Zoffany's paintings *The Academicians* and *The Tribuna*, then, provide us with information about academic values and canons of taste, and the kinds of privileged groups who were helping to establish a contemporary culture

of high art. In both paintings women are conspicuously absent from the contemplative viewing process involved in the identification and production of such art. As we shall see, we are more likely to find evidence of the work of women artists during this period if we go beyond the public and rarefied culture of art appreciation and the Grand Tour which is represented here, to explore the actual nature and conditions of academic practice at the time.

Academic codes, 'masculine' genres and women as practitioners

The reality of life within academic circles in late eighteenth-century British art was complex. Although they were not admitted to the life class, we have seen that two women, Angelica Kauffman and Mary Moser, were among the founding members of the Royal Academy in 1768, and as 'Academicians' they regularly submitted their work to the annual exhibitions. Given the artistic environment which I have described, you may find it surprising that Kauffman and Moser were allowed this level of active participation. It seems that the predominantly 'masculine' culture of the founding institution was prepared to allow exceptions, particularly if the work of such women could be seen to have academic value, or could bring with it some international kudos or prestigious patronage.

The Swiss-born Kauffman had an established reputation as a history painter, and had been elected to the famous Academy of Saint Luke (Accademia di San Luca) in Rome in 1765. Unusually for a woman she had received an art training (in Switzerland and Italy) which enabled her to develop skills as a neo-classical painter who made extensive use of mythological themes and classical statues.[3] At the time she settled in England, the founder members of the Academy were seeking to promote historical and mythological subjects in a national climate in which the lower genre of portraiture was generally more in demand.[4] In view of our discussion so far, it is somewhat ironic that the work of a woman should serve as a model for the type of art best equipped to raise the status of British art. Mary Moser, however, was generally identified as working in the 'lesser' genre of flower painting (Plate 68), and was one of only two flower painters among the founder members. Her precocious talent and prestigious connections must have helped her to gain a place within this privileged space. Her father George Moser was first Keeper of the Royal Academy, and her work was patronized by Queen Charlotte. Moreover, in 1758 and 1759, aged only 14 and 15, she had won awards from the Society for the Encouragement of the Arts.

The terms of membership for these women were subject to restrictions, and apart from limited access to the life class, they were excluded from attendance at regular meetings. They were able, however, to take part in judging for the award of gold medals and scholarships by sending in marked lists, and they had the right to vote in elections. As Wassyng Roworth has suggested, the

[3] For details of Kauffman's early training, see Wassyng Roworth, *Angelica Kauffman*.

[4] This is discussed in '"Mere face painters"?' in Perry and Cunningham, *Academies, Museums and Canons of Art* (Book 1 in this series).

Plate 68 Mary Moser, *Vase of Flowers*, 1764, tempera on paper, 61 x 44.5 cm, Victoria & Albert Museum, London. Crown Copyright.

existence of two female Academicians may even have inspired another London exhibiting group, The Incorporated Society of Artists, to elect several women to honorary memberships in 1769 (Wassyng Roworth, 'Academies of art').

While such developments may have encouraged eighteenth-century arbiters of taste and culture to incorporate women within the institutions of art, their effects on the language of art criticism, and on the way people thought about art itself, are more difficult to assess. Although contemporary perceptions of 'masculine' and 'feminine' art were by no means fixed, many of the critical writings which commented on and helped to promote the Royal Academy reveal some gendered assumptions about genres, styles and artistic production. For example, Reynolds's annual lectures to students and Academicians, published as his *Discourses*, are addressed to a male audience: each lecture begins with the opening word 'Gentlemen' and the artist is always referred to by the male pronoun (he). Moreover, the *Discourses* are peppered with references to the 'more manly, noble and dignified manner' of the 'sublime' style associated with historical and allegorical works.[5]

[5] See my discussion of the gendered language of the discourses in Perry, 'Women in disguise', pp.19ff.

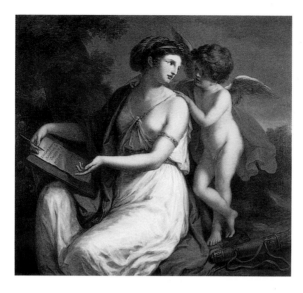

Plate 69 Angelica Kauffman, *Sappho,* 1775, oil on canvas, 132 x 145 cm, The John and Mable Ringling Museum of Art, Sarasota.

The fact that Kauffman worked in and exhibited examples of this more 'manly' style presented some problems for contemporary critics who contributed to the discourse on academic art. In the Royal Academy exhibition of 1775 she showed a portrait of Sappho and five other history paintings including *Renaldo and Armida* and *The Despair of Achilles*, which provoked the following assessment from the anonymous reviewer of *The London Chronicle*:

> Some philosophers have asserted that women have no souls. Others have maintained, and with greater probability, that they not only have souls, but that the only difference between their souls and those of men, depends on the great delicacy of the bodily organs. Miss Kauffman's genius seems to favour strongly this latter opinion; for though a woman, she is possessed of that bold and masculine spirit which aims at the grand and sublime in painting, as well as in poetry, and a History painter is as much superior to a mere Portrait or Landscape painter as an Epic or Tragic Poet is to the simple author of a Sonnet or an Epigram.
>
> (*The London Chronicle*, 4–6 May 1775)

Please look at Plates 69 and 70, which are examples of some of the works which Kauffman exhibited in the 1775 show, and re-read the passage from the review above. What gendered attitudes towards (a) women artists and (b) artistic genres are revealed in this passage?

Discussion

First, the reviewer is trying to sort out (his) views on whether or not women differ biologically and/or intellectually from men. He argues that Kauffman's work would seem to undermine the 'women have no souls' argument, but suggests that they nevertheless possess different sorts of 'souls' which are shaped by the relative 'delicacy' of their biological organs. Secondly, her mythological subjects such as *Renaldo and Armida* or *The Despair of Achilles* are recognized as 'history paintings', but by working in this genre Kauffman is seen by implication to be transgressing a traditional 'feminine' style. She is borrowing from, or 'possessed' by, a 'masculine spirit' reserved for history painting and the expression of the 'sublime'. Implicit in this notion is the idea that the kinds of intellectual activity required for the expression of the

'sublime' in history painting is not a 'natural' mode of expression for women painters; hence the view that they were better suited to working in the lesser genres of portraiture or flower painting.

◆◆

However, critical approaches evolved which could help to make the intellectual pretensions of Kauffman's works more palatable to a traditional art audience. Contemporary (and more recent) reports of her work often qualified the 'sublime' effects of her historical and mythological works by representing them as 'decorative' classicism, or as historical works which retain the 'softness natural to her sex' (*The London Chronicle*, 1777). References are frequently made to the 'tender' softness of her figures (Plate 71), although as Wassyng Roworth has pointed out:

> such sentimentality was hardly exclusive to Kauffman's paintings. This is typical of the ambivalence of those who wished to promote heroic history painting, yet had to explain why a woman was among the few that were doing it at all.

(Wassyng Roworth, *Angelica Kauffman*, p.86)

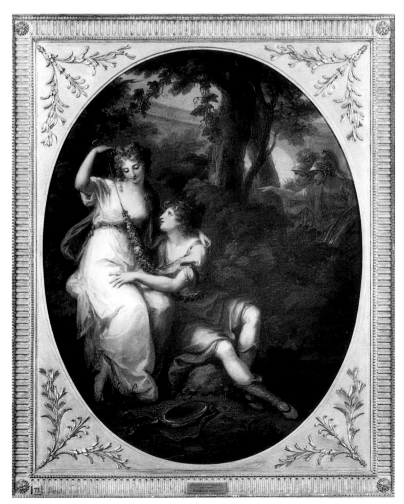

Plate 70 Angelica Kauffman, *Renaldo and Armida*, 1772, oil on canvas, oval, 128.2 x 102.3 cm, The Kenwood Trust, Iveagh Bequest, London.

Plate 71
Angelica
Kauffman, *Zeuxis
Selecting Models
for his Painting of
Helen of Troy,*
1778, oil on
canvas, John Hay
Library, Brown
University,
Providence.

The opposition of decorative versus intellectual, with its associations of
supposedly 'feminine' versus 'masculine' forms of artistic production, was
in common currency in the eighteenth century. Thus Kauffman's form of
classicism was seen to be qualified by its apparent 'feminine' qualities.

Later in her career after she had moved to Italy with her husband Antonio
Zucchi, Kauffman produced a series of more severe, restrained works on
classical themes, including *Cornelia Pointing to her Children as her Treasures,*
1785 (Plate 72). Although such works would seem better qualified for the
label 'masculine' in contemporary usage, when she exhibited a series
(including *Cornelia*) at the Royal Academy show in 1786, they were criticized
for having lost something of the 'warm' and 'delicate' nature of her earlier
history paintings (Wassyng Roworth, *Angelica Kauffman*, p.93). In other words,
the artist's gender invariably seems to intervene in perceptions of her work.
As a woman she was expected to produce an art which could be seen to
conform to contemporary perceptions of femininity and 'feminine' expression.
And as we have seen, such perceptions emerge (both explicitly and implicitly)
in both the institutional structures of, and the critical writings on, art from
the period.

It has been argued recently by feminist art historians that we need to look
beyond these restrictive academic contexts and institutions to uncover some
other enabling strategies adopted by women artists, who more often worked
on the fringes of official or professional art practices. This process of recovery
involves the study of the ways in which women have adapted and developed
certain categories of artistic production, such as flower painting, miniature
painting or embroidery, which have traditionally been seen as less important
than the higher (masculine) genres which were privileged by eighteenth-
century academic institutions. Clearly there is still much work to be done in
this area that will reveal some of the less visible practices by women which
have fallen through the net of documented art history. However, we are

concerned in this section to examine some of the public roles, activities and professional interests of those few women artists who gained access to these academic spaces, and in the process to consider the different strategies which women could adopt when working within a narrow codified system.

It is interesting to learn, then, that Kauffman was not the only history painter among the better known women artists of her day. Although Mary Moser is commonly known as a painter of flowers and decorative schemes, a trawl through the Royal Academy's exhibition catalogues from 1769 to 1792 suggests a slightly different picture. During this period she exhibited thirty-six works, of which sixteen are flower paintings, and no less than ten have historical titles, while the rest are portraits and landscapes. As most of these works with historical titles have disappeared, the idea of Moser the 'history painter' is little known. The Royal Academy catalogues also tell us that although not Academicians themselves, several other women artists successfully submitted history paintings to the annual shows during the late eighteenth century, among them Maria Cosway (who was married to the Academician Richard Cosway) (Plate 73). After she had shown four historical works in the Academy show of 1782, a reviewer in *The Painter's Mirror* wrote: 'This fair artist has unquestionably a claim to "poetic" fancy.' As we have seen, while a woman artist could have a claim to such poetic expression, she was unlikely to be represented as the creative originator of a 'sublime' historical style.

Plate 72 Angelica Kauffman, *Cornelia Pointing to her Children as her Treasures*, 1785, oil on canvas, 101.6 x 127 cm, © 1992 Virginia Museum of Fine Arts.

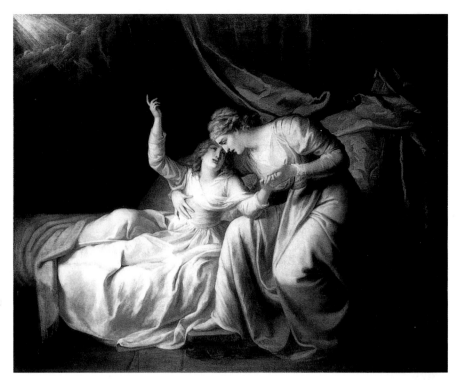

Plate 73 Maria
Cosway, *The Death
of Miss Gardiner*,
1789, oil on
canvas, Musée de
la Révolution
Française, Vizille.

Gender, portraiture and allegory

While history painting was the genre most often exhalted in Reynolds's
theoretical attempts to raise the status of art, the reality of the eighteenth-
century British art market meant that portraiture was most in demand for
commissions. The allegorical portrait, for which both Reynolds and Kauffman
(among others) won renown, was a pragmatic attempt to bridge the gap
between portraiture and history painting, to develop a marketable hybrid
genre which could claim some intellectual status (Plate 74).[6]

The conventions associated with allegorical portraiture could, on occasion,
provide women artists with some interesting possibilities of meaning. Women
were often (but not exclusively) the subjects of eighteenth-century allegorical
portraiture. Allegory was often used to elevate or aggrandize female sitters.
As women rarely occupied the same professional or political roles as
contemporary male sitters, the conventions for representing male clients in
relation to their political, military or ecclesiastical rank (Plate 75) were
unavailable to female clients.[7] It has also been argued that allegory can be
used to suggest meanings beyond the simple elevation of a sitter. For example,
associations evoked by abstruse pagan or classical references could also
destabilize the aggrandizing function of allegorical conventions.[8]

[6] This 'hybrid genre' is discussed in '"Mere face painters"?', op. cit.

[7] These conventions are discussed in '"Mere face painters"?', op. cit., and in Perry 'Women
in disguise', pp.18–40.

[8] Marcia Pointon has argued that in some of his portraits of women Reynolds uses allegory
to suggest more transgressive forms of female sexuality. She claims, for example, that his *Mrs
Hale as Euphrosyne* contains bacchic classical references which suggest an unconventional
feminine sexuality. See Pointon, *Strategies for Showing*.

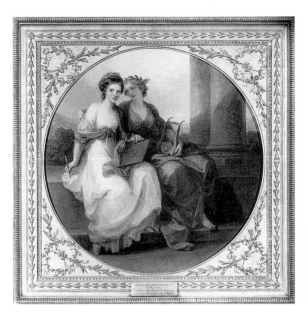

Plate 74 Angelica Kauffman, *Self-Portrait in the Character of Design*, 1782, oil on canvas, circular, 61 cm diameter, The Kenwood Trust, Iveagh Bequest, London.

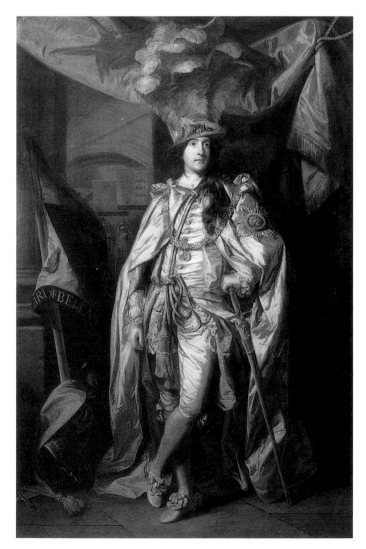

Plate 75 Sir Joshua Reynolds, *Charles Coote, 1st Earl of Bellamont*, 1778, oil on canvas, 245 x 162 cm, National Gallery of Ireland, Dublin.

I want to suggest that when allegory is used in self-portraiture by women artists it can contribute to a complex – and even contradictory – image of desirable femininity. Both Kauffman and Moser represented themselves as artists (Plates 76 and 77). In her earlier study Catherine King argued that the convention of self-representation with a brush and canvas or easel was established in free-standing portraits by women artists in the sixteenth century. This convention helped to control the public reception of such works, avoiding the possibility that the sitter might be reclaimed as a wife, mother, or simply a female subject (of representation) rather than as an *artist*. And there were other historical precedents for this sort of pose available to eighteenth-century artists. King discusses the famous Artemisia Gentileschi *Self-Portrait* of 1630 in the Royal Collection (Plate 38), which is a self-portrait of a woman artist in the act of painting. It is possible that both Moser and Kauffman would have known of Gentileschi's work. Moreover this self-portrait is an allegory of painting, playing on the allegorical conventions in which painting is usually personified as a woman, although the artist was usually represented as male. In this context the woman artist could be seen to be appropriating allegorical conventions to secure a more positive image of herself as both symbolic woman *and* as woman as creator.

Although we can't be sure that either Moser or Kauffman had intended a reference to woman's allegorical functions in the two self-portraits that I am discussing, such works allow for many ambiguous levels of meaning. Kauffman in fact produced some other paintings in which such double meanings are more clearly conveyed. In, for example, her *Self-Portrait in the Character of Design* (Plate 74) Kauffman plays more openly with the symbolic codes for representing women. She publicly places herself in the character of Design being embraced by another symbolic woman – Poetry. On one level, then, this image conforms to academic conventions. It suggests that Design (a part of the process of painting) like Poetry is creatively and intellectually inspired; it is distinct from a purely mechanical trade. At the same time Kauffman represents herself – the woman artist – being embraced by the allegorical figure of poetry, by woman as symbolic 'other'. Woman, then, plays out her allegorical functions but also lays claim to the inspiration which was traditionally seen as a male prerogative.

Conclusion

In this case study I've tried to introduce you to some of the different ways in which gender issues informed and helped to establish the culture of eighteenth-century academic art. As I hope is now clear, an interest in gender does not merely concern us with the issue of women as practitioners of art, but also involves the study of socially constructed categories of femininity and masculinity. These are involved in the processes of looking at and consuming art, in the establishment of academic conventions and institutions, and in the language of art criticism and theory.

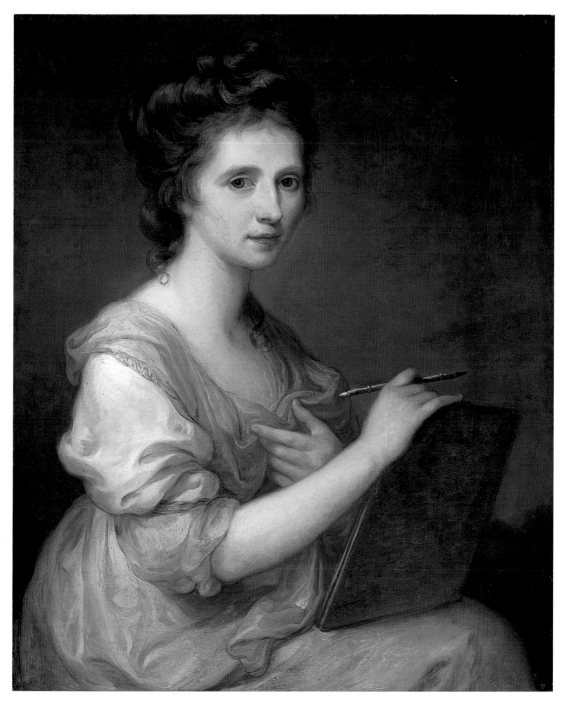

Plate 76 Angelica Kauffman, *Self-Portrait*, 1775, oil on canvas, 73.7 x 61 cm, National Portrait Gallery, London. By courtesy of The National Portrait Gallery, London.

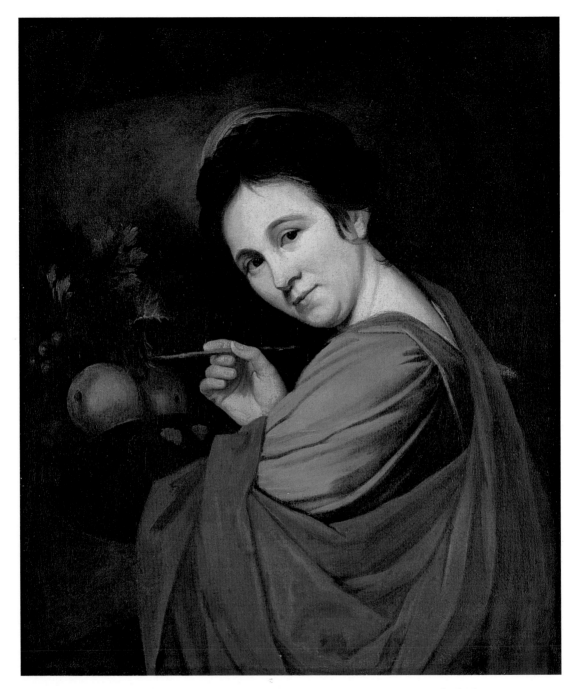

Plate 77 Mary Moser, *Self-Portrait*, 1780, oil on canvas, 73 x 61 cm, Muzeum zu Allerheiligen, Schaffhausen.

References

Perry, G. (1994) 'Women in disguise: likeness, the Grand style and the conventions of "feminine" portraiture in the work of Sir Joshua Reynolds' in G. Perry and M. Rossington (eds) *Femininity and Masculinity in 18th Century Art and Culture*, Manchester University Press, pp.18–40.

Perry, G. and Cunningham, C. (eds) (1999) *Academies, Museums and Canons of Art*, New Haven and London, Yale University Press.

Pointon, M. (1997) *Strategies for Showing: Women, Possession and Representation in English Visual Culture 1665–1800*, Oxford University Press.

Wassyng Roworth, W. (ed.) (1992) *Angelica Kauffman: A Continental Artist in Georgian England*, London, Reaktion.

Wassyng Roworth, W. (1997) 'Academies of art (Britain)' in Delia Gaze (ed.) *Dictionary of Women Artists*, London and Chicago, Fitzroy Dearborn.

Women artists and the French Academy: Vigée-Lebrun in the 1780s

EMMA BARKER

Reporting in 1783 on the biennial art exhibition held in Paris known as the Salon, one critic noted a curious anomaly:

> despite the abundance of history paintings that are to be found in this place, better than have yet been seen, despite the excellence of the numerous masters battling in this arena, who would believe it ... it is a woman who carries off the palm. I will explain myself: this is not to say that there is more genius in a painting of two or three three-quarter length figures than in a vast composition of ten or twelve life-size figures ... it means only that the works of the modern Minerva are the first to attract the spectators' attention ... and draw from them those exclamations of pleasure and admiration after which artists yearn ... The paintings in question are also the most highly praised, the most talked about ... Whenever anyone says that he has just come from the Salon, they are immediately asked, have you seen Madame le Brun? What do you think of Madame le Brun?
>
> (*Mémoires Secrets*, vol.24, 1784, p.4)

The French art world that provides the context for this quotation differed considerably from that of Britain. As we have just seen, the demands of the market meant that the theoretical supremacy of history painting received little more than lip-service from members of the recently founded Royal Academy in London. Within the long-established French Royal Academy, by contrast, history painters had always enjoyed better opportunities and the situation further improved in the late eighteenth century under a new director, the comte d'Angiviller. A new scheme of state-funded commissions offered ambitious (male) artists the chance to make their mark at the Salon (at which only members of the Academy had the right to exhibit) with large-scale compositions on historical themes. Paintings such as Jacques-Louis David's *Oath of the Horatii* (Plate 78), exhibited in 1785, were commended for their truthfulness, energy and severity, qualities which were more or less explicitly perceived as masculine.[1] On closer inspection the *Horatii* does lend itself to discussion in such gendered terms. It presents a striking contrast between the warlike males occupying most of the picture space and the women in distress on the right; masculinity is conveyed through erect poses, straight lines and strong colours, femininity through supine bodies, curving contours and soft tones. David's work is often cited today with reference to a growing polarization of gender roles in late eighteenth-century French culture and, in particular, a new emphasis on women's weakness and incapacity to engage in the same activities as men.

[1] The subject derives from an episode in ancient Roman history, telling of three brothers who defended Rome as its chosen champions against the champions of the rival city who happened to be related to them by marriage: hence the distress of their womenfolk who fear (rightly as it turns out) that they will lose both brothers and husband/lover. It should also be noted, however, that David's painting was a highly controversial one, exciting at least as much criticism as praise; for its reception in 1785, see Crow, *Painters and Public Life*, pp.211–41.

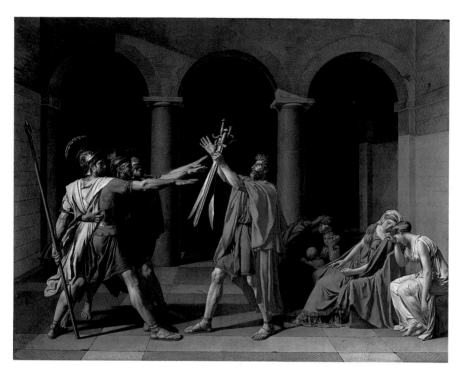

Plate 78 Jacques-Louis David, *Oath of the Horatii*, 1784, oil on canvas, 330 x 425 cm, Musée du Louvre, Paris. Photo: © Réunion des Musées Nationaux, Paris.

Nevertheless, as we saw from the above quotation, a woman could become a professional artist and even achieve considerable renown in France at this period. Moreover, despite her exceptional success, Elisabeth-Louise Vigée-Lebrun (1755–1842) was not alone in being a female member of the Academy. On the day that she was received into the Academy, 31 May 1783, the same honour was also accorded to Adélaïde Labille-Guiard (1749–1804). This case study will focus on Vigée-Lebrun with the less spectacular career of Labille-Guiard serving as a point of comparison. As in the previous case study, we will examine how institutional and cultural forces combined to produce a particular notion of the woman artist and women's art. As we will see, while the Academy worked to marginalize its female members, so the critics persistently denigrated Vigée-Lebrun's work, even as they praised it, for its lack of 'masculine' qualities. We will also consider conflicting interpretations of her work that have been put forward by feminist art historians: did she simply conform to prevailing expectations of women or, as has recently been suggested, did she assert her own, more positive self-image as a woman artist?

Women and the Academy

Since its foundation in 1648, the Academy had seldom admitted women and then only with reservations. In 1706, the Academicians went so far as to declare that no woman could be a member, though, in practice, they continued to accept the occasional woman artist into their midst. In 1770, after the female membership had risen quite suddenly to four after a long period during which the Academy remained a male enclave, it was agreed that no more than four women should be allowed to be members at any one time. Had it not been for the subsequent deaths of two of these female members, Vigée-Lebrun

and Labille-Guiard could not (in theory at least) have been accepted by the Academy in 1783. Moreover, the admission of women was always held to be, as the record of the decision to limit female membership stated, 'foreign in some fashion to its constitution' (quoted in Sutherland Harris and Nochlin, *Women Artists*, p.37, n.124). Thus, while the French Academy admitted two more women to its ranks than did its British counterpart, it nevertheless went further than the latter in adopting discrimination against them as official policy.

No doubt the rules could have been bent for Vigée-Lebrun since, unlike Labille-Guiard, she was not elected by the members of the Academy in the normal way but admitted by order of the king. She owed the exceptional circumstances of her admission to her position as a favourite painter of the queen, Marie-Antoinette. Vigée-Lebrun's candidacy had been opposed on the grounds that the Academy's statute forbidding members to engage in commerce made the artist ineligible by reason of her marriage to an art dealer, Jean-Baptiste-Pierre Lebrun (1748–1813).[2] In order to uphold the status of painting and sculpture as liberal arts cultivated without thought of material gain, the Academy strove to maintain a firm (if rather illogical) distinction between selling one's own work and dealing in someone else's. For the same reason, it did everything possible to distance itself from the Paris artist's guild, known as the Académie de Saint-Luc, which was essentially a trade organization. Significantly, the ranks of the guild also contained many more female members, including both Labille-Guiard and Vigée-Lebrun prior to their entering the Royal Academy. From the Academy's point of view, the admission of women had the undesirable effect of making it more like its less prestigious rival.

In other words, the admission of almost any woman artist carried with it the taint of trade and Vigée-Lebrun's simply more so than others. Both she and Labille-Guiard specialized in portraiture, which (as in Britain) represented the most reliable source of income for an artist and, as such, was supposed to be unworthy of the high-minded Academician. The Academy's prestige depended on the pursuit of the most intellectually and morally demanding of the genres, history painting. The training that the Academy provided for students aimed to ground them in the skills necessary for a history painter, above all the ability to depict the human form. It centred on the life class, in which male students drew only from the male model (Plate 79). To show the wider implications of women's exclusion from the life class, we can quote the comte d'Angiviller, who justified limiting female membership of the Academy on the grounds that 'women cannot be useful to the progress of the arts because the modesty of their sex forbids them from being able to study after nature' and to attend the Academy's school (quoted in Sheriff, *The Exceptional Woman*, pp.105–6). In other words, he considered that women artists didn't count because they couldn't be history painters.

Women's exclusion from the Academy's training programme meant that their careers did not progress though the same stages as those of their male colleagues. Instead of joining the Academy as an associate and only later

2 On Jean-Baptiste-Pierre Lebrun see 'The making of a canonical artist: Vermeer' in Barker *et al., The Changing Status of the Artist* (Book 2 in this series).

Plate 79 Charles Joseph Natoire, *The Life Class at the Académie Royale, Paris,* 1746, watercolour over black chalk, 45.4 x 32.3 cm, Courtauld Institute. Photo: Courtauld Institute Galleries, London.

being admitted as a full member, women gained full membership at once. Like a male artist, however, they would submit a reception piece which determined their category in the Academy. Labille-Guiard, for example, was received as a portrait painter on submission of a painting in this genre. She and other women were ineligible for promotion since only artists who had been accepted as history painters could ascend beyond the rank of simple Academician (to become a professor, for example).[3] Vigée-Lebrun bypassed conventional procedure entirely on account of the exceptional circumstances of her admission; the Academy's records give no ranking and no reception piece for her. However, *Peace Bringing Back Abundance* (Plate 80), one of her exhibits at the Salon of 1783, did enter the possession of the Academy and was widely described at the time as her reception piece. It is an allegory, depicting a personification of peace (holding an olive branch) and one of abundance (holding a cornucopia).

What does this painting suggest about Vigée-Lebrun's ambitions for her admission to the Academy and how well does it succeed in embodying them? As well as considering its genre and composition, you will need to refer back to the quotation opening this case study and to the paragraph following it.

[3] Women artists invariably entered the Academy as portraitists or as painters in still life, which was placed even lower in the hierarchy of the genres since it did not depict the human figure at all. Anne Vallayer-Coster (1744–1818), for example, entered the Academy in 1770 in this category.

Plate 80
Elisabeth-Louise
Vigée-Lebrun,
*Peace Bringing
Back Abundance,*
1780, oil on
canvas, 102 x 132
cm, Musée du
Louvre, Paris.
Photo: © Réunion
des Musées
Nationaux, Paris.

Discussion

As an allegory illustrating abstract concepts, *Peace Bringing Back Abundance*
can be seen to share the intellectual ambitions of history painting. It indicates
that Vigée-Lebrun hoped to be accepted by the Academy as a history painter.
As we know, she failed in this ambition but to have produced a history
painting at all can be seen as an achievement of a kind. Since the allegory
involves only female figures, it allows Vigée-Lebrun to circumvent the
prohibition on studying the male nude and thus to defy d'Angiviller's
assumption that women artists were debarred from the practice of history
painting. However, the dismissive comment in the *Mémoires Secrets* about a
painting with two or three three-quarter length figures indicates that this
writer at least felt that, as a history painting, *Peace Bringing Back Abundance*
did not compete with compositions on a grand scale. Taking the *Oath of the
Horatii* as a model for what history painting should be, Vigée-Lebrun's
painting might also seem insufficiently serious and high-minded. Far from
offering a severe example of heroic virtue, it appears simply to depict a
beautiful woman, with one breast bared, being embraced by another.

◆◆◆

We might conclude by saying that *Peace Bringing Back Abundance* is not simply
the work of a woman artist but could also be judged a 'feminine' history
painting. As well as depicting only female figures, Vigée-Lebrun also employs
a style that reappears (in a diluted form) in the 'female' side of the *Oath of the
Horatii*: gently inclined bodies, flowing outlines and warm hues (we will
return to the idea of a 'feminine' style below). These features might well
have made *Peace Bringing Back Abundance* appear problematic to advocates
of a more 'masculine' history painting. We can focus the issue by noting that

this painting and, more particularly, two depictions of classical goddesses that Vigée-Lebrun also exhibited in 1783 reveal a general debt to the work of François Boucher (1703–70). This connection would hardly have recommended them to d'Angiviller and his associates in the Academy, who strove to rescue French history painting from what had come to be seen as the 'debasement' represented by Boucher's frivolous and erotic compositions (Plate 81). On this basis, we can form a clearer idea of what d'Angiviller meant in saying that women could not contribute to 'the progress of the arts'. In any case, having failed to gain the rank of history painter, Vigée-Lebrun produced a few works in this genre after 1783 and instead continued to specialize in portraiture.

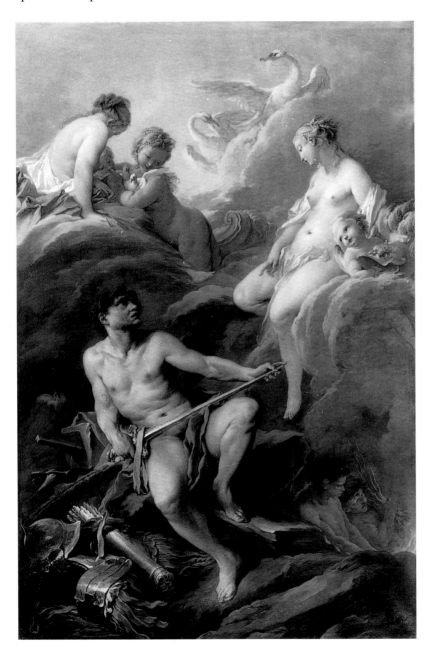

Plate 81 François Boucher, *Venus Asking Vulcan for Arms for Aeneas*, 1732, oil on canvas, 252 x 175 cm, Musée du Louvre, Paris. Photo: © Réunion des Musées Nationaux, Paris.

The woman artist

As the quotation with which I began revealed, Vigée-Lebrun made a sensational debut at the Salon shortly after the Academy had reluctantly accepted her. While the writer of the *Mémoires Secrets* praised her work, he also explained away at least some of her success by observing that she owed a good deal of her reputation to being a young and pretty woman, whose home was frequented by members of high society, including the most favoured courtiers. Vigée-Lebrun's public image as a fashionable beauty would have been reinforced by her *Self-Portrait in a Straw Hat* (Plate 82), which she also exhibited at the Salon of 1783. Rozsika Parker and Griselda Pollock interpret this painting in the following terms:

> She offers herself as a beautiful object to be looked at, enjoyed and admired, but conveys nothing of the activity, the work, the mindfulness of the art she purports to pursue. As an image of an eighteenth-century artist, it is wholly unconvincing.
>
> (*Old Mistresses*, p.96)

More recently, however, Mary Sheriff has pointed out that at least some critics at the time did not view it just as a depiction of a lovely woman but, on the contrary, judged it a brilliant piece of painting and, as such, a triumph for the artist even though (as one or two observed) it did not actually look much like her.

In order to develop our analysis, we need to consider Vigée-Lebrun's *Self-Portrait in a Straw Hat* in relation to the painting that provided the inspiration for it. As she records in her memoirs, she had recently seen a celebrated portrait by Peter Paul Rubens (1577–1640), known as *Le Chapeau de Paille* (Plate 83) or 'The Straw Hat', though the hat is actually made of felt – a detail that Vigée-Lebrun 'corrected' in her own work! 'Its great power', she explains,

> lies in the subtle representation of two different light sources, simple daylight and the bright light of the sun. Thus the highlighted parts are those lit by the sun and what I must refer to as shadow, is, in fact, daylight. Perhaps one must be a painter to appreciate the brilliance of Rubens' technique here. I was so delighted and inspired by this painting that I completed a self-portrait in Brussels in an effort to achieve the same effect … When this picture was exhibited at the Salon, I must say it did much to enhance my reputation.
>
> (*Memoirs*, p.38)

Parker and Pollock consider that the 'coquetry and sensual feeling' of the Rubens make it an inappropriate model for a self-portrait since it offers up 'Woman' as an erotic spectacle for the male viewer.

Bearing her own account in mind, compare Vigée-Lebrun's portrait to the Rubens. Consider how (if at all) she draws attention to her own identity and achievements as an artist.

Discussion

Most obviously, Vigée-Lebrun's painting differs from Rubens's because she shows herself with palette and brushes. Parker and Pollock don't think this counts for much (she only 'purports' to be a painter, in their view) but you could say that they serve to show not just that she paints but that she is

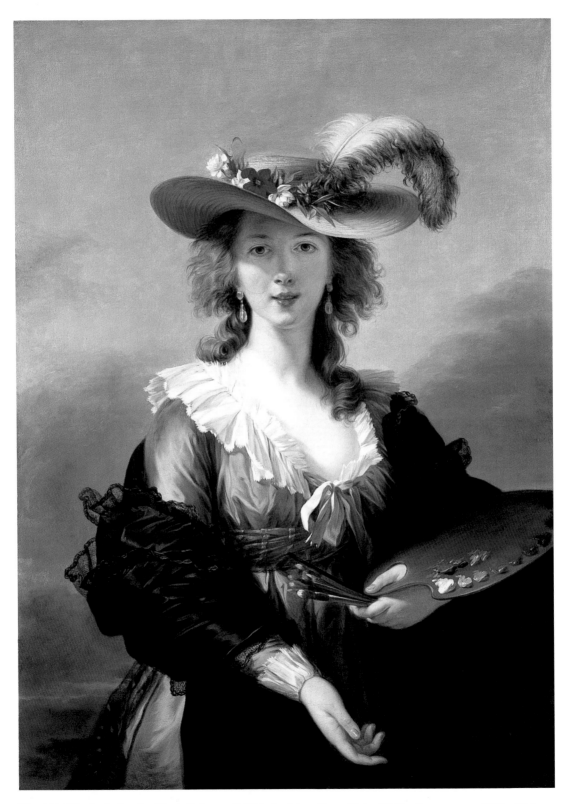

Plate 82 Elisabeth-Louise Vigée-Lebrun, *Self-Portrait in a Straw Hat*, *c.*1782, oil on canvas, 97.8 x 70.5 cm, National Gallery, London. Reproduced by permission of the Trustees of the National Gallery.

responsible for this very work. This is emphasized by the way that the colours on the brushes in her hand echo the colours elsewhere in the painting with the blue brush, in particular, picking up the bright colour of the sky behind her. Given what Vigée-Lebrun says about trying to emulate Rubens's exceptionally difficult effects of daylight, it seems that the whole point of the painting was precisely to show off her own skills as an artist rather than depicting herself in a flattering way. As in the Rubens but even more noticeably, the effects of light and shade are signalled by the dividing line between them running down her face and neck. Turning to the pose, an important difference is that Vigée-Lebrun looks directly out at us while Rubens' sitter lowers her head and looks up coyly. Also, the former holds out her hand as if to address the viewer while the latter folds hers, thereby drawing attention to her wedding ring (this sign of wifely dependence points up the contrast with the self-possessed artist). This woman's tight corset pushes up her breasts whereas Vigée-Lebrun wears a loose dress, which is both demure and flattering though hardly, you may feel, appropriate working attire for an artist.

◆◆

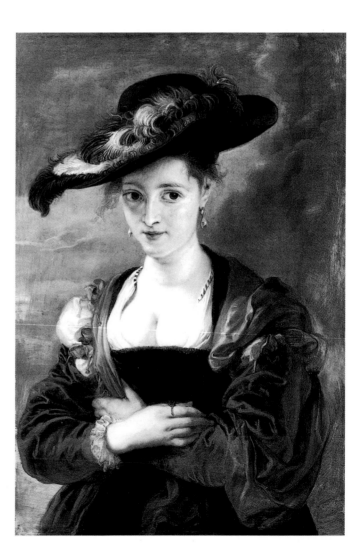

Plate 83 Peter Paul Rubens, *Le Chapeau de Paille*, *c*.1622–5, oil on oak, 79 x 54.6 cm, National Gallery, London. Reproduced by permission of the Trustees of the National Gallery.

However, it can be argued that Vigée-Lebrun's self-portrait conforms to a general convention for artists to depict themselves as affluent, successful and well-dressed. In a self-portrait shown at the Salon of 1785, for example, Labille-Guiard shows herself seated at her easel in an elaborate satin gown, which she would surely not actually have worn while working (Plate 84). Vigée-Lebrun's less formal 'chemise' dress conforms to a new fashion for simplicity that was adopted by some of the greatest ladies in France. She painted both Marie-Antoinette and favourites of the queen, such as the duchesse de Polignac (Plate 85), dressed in this way. Whether or not Vigée-Lebrun really helped to set the trend, as she claims in her memoirs, she undoubtedly did have an extremely fashionable (and largely female) clientele. Later generations of art historians tended to identify the artist with the court beauties and famous actresses whom she painted, thereby downplaying her industry and professionalism. One biographer described the paintings of 'this pretty *Parisienne*' as

> elegant, fragile, futile, utterly graceful and relaxed … She attracts because she is a woman … with her charms and her defects, which are themselves charming. Her talent involves no effort, no ambition.
>
> (Nolhac, *Madame Vigée-Lebrun*, p.2)

Although Parker and Pollock challenge this vision of an instinctively feminine artist, they still see Vigée-Lebrun as being limited by her culture's construction of femininity. Sheriff, by contrast, contends that she self-consciously constructed her own image as a woman artist.

While the *Self-Portrait in a Straw Hat* may seem to support this interpretation, contemporary art criticism testifies to Vigée-Lebrun's inability to escape from the prevailing tendency to focus on the woman instead of the artist. In words very similar to those later used by Nolhac, one critic declared of her self-portrait: 'Notice there are a thousand defects more, but nothing can destroy the charm of this delicious work … only a woman, and a pretty woman, could have conceived of this charming idea' (quoted in Sheriff, *The Exceptional Woman*, p.202). By attributing the painting's merits to an attractive woman's desire to make herself alluring to the male viewer, this writer dismisses female authorship and transforms the artist into an erotic object. We can also see something similar going on when critics refer to Vigée-Lebrun as Venus, the classical goddess of love and beauty (these would-be flattering allusions can be partly explained by the fact that the works she exhibited in 1783 included a picture of *Venus Binding Cupid's Wings*). Some writers described Vigée-Lebrun 'disputing the apple' with her female 'rivals' in the Salon, thereby likening them to the three goddesses, Venus, Diana and Juno, who demanded that the shepherd Paris award the prize of an apple to the most beautiful of them. This mythological subject had been painted many times, offering as it did an opportunity to depict three nude female figures (Plate 86). Thus, it could be argued that art criticism metaphorically strips the woman artist of her clothes and subjects her to a beauty contest in place of serious evaluation of her work.[4]

[4] The 'stripping' of Vigée-Lebrun by contemporary critics can be most clearly discerned in a number of critical comments which suggest that the artist used herself as the model for the naked female figures in *Peace Bringing Back Abundance* and *Venus Binding Cupid's Wings*, thereby insinuating that she is an immodest woman willing to display her body in public; see Sheriff, *The Exceptional Woman*, p.123.

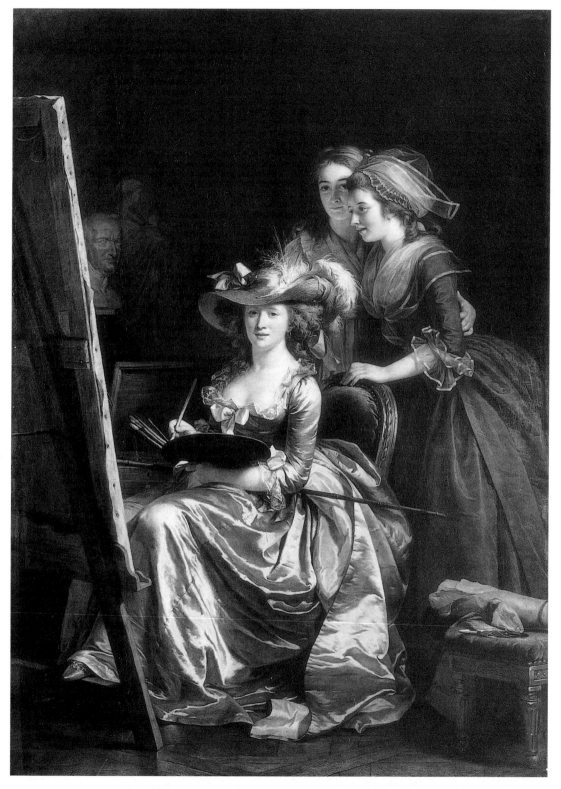

Plate 84 Adélaïde Labille-Guiard, *Self-Portrait with Two Pupils*, 1785, oil on canvas, 210.8 x 151.1 cm, The Metropolitan Museum of Art, New York. Gift of Julia A. Berwind, 1953 (53.225.5).

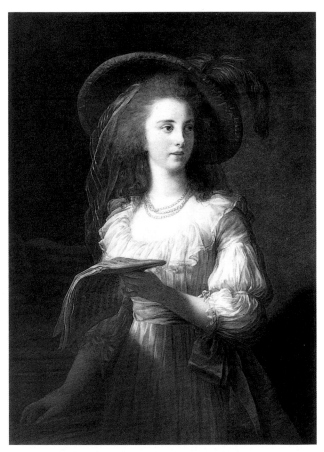

Plate 85
Elisabeth-Louise Vigée-Lebrun, *Duchesse de Polignac*, 1783, oil on canvas, 98.4 x 71.2 cm, Waddesdon Manor. Photo: The National Trust, Waddesdon Manor.

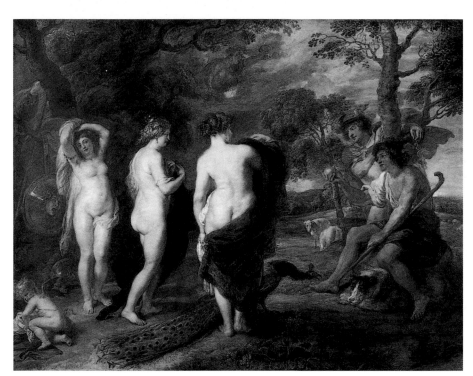

Plate 86
Peter Paul Rubens, *The Judgement of Paris*, c.1632–5, oil on panel, 144.8 x 193.7 cm, National Gallery, London. Reproduced by permission of the Trustees of the National Gallery.

What we have yet to address is the idea, implicit in the comment on the *Self-Portrait in a Straw Hat* (and the words of Nolhac), that a truly 'feminine' art may be charming but is also inherently defective. To do so, we need to look more closely at the way that Vigée-Lebrun's paintings were discussed at the time. From the first, they were praised for their 'grace', a term which carried strong erotic and gendered connotations (the graces are the three nude young women who attend Venus, as depicted by Boucher in Plate 81). At the same time, Vigée-Lebrun's handling of paint was said to be too soft, leaving the forms indistinct, and her colours too bright, producing an artificial effect. While agreeing that her work was irresistibly charming and seductive, the critics would frequently contrast Vigée-Lebrun with Labille-Guiard to the advantage of the latter. This artist's work was commended for its firm, vigorous touch and for its overall truthfulness, qualities which (as we have seen) were gendered masculine. Indeed, Labille-Guiard was sometimes said to have raised herself above her sex, to have made herself into a man. Conversely, the comments about Vigée-Lebrun's 'seductive defects' only make sense in the context of traditional notions of female nature. They cast her in the role of the biblical Eve, as an alluring woman who leads men astray. In 1787, one writer affirmed that 'this talent carries the character of her sex, and conceals under this seductive charm the greatest dangers for those who want to adopt this manner'.

The logic of such comments emerges when we relate these stylistic terms to the question of genre. Although not all the critics agreed on this point, the more outspoken among them declared that Vigée-Lebrun's talent was suited only to the minor genres and that, by trying her hand at history painting, all she did was expose her limitations: her lack of anatomical knowledge (such as could be gained in the life class), on the one hand, and of 'masculine' vigour and firmness, on the other. This may suggest to you that they would have rated Labille-Guiard's potential as a female history painter more highly since she, though a woman, was considered to have a 'masculine' talent. Any such expectations would be disappointed, however. As a full-length group portrait on a monumental scale, the self-portrait with two students that Labille-Guiard exhibited in 1785 could be seen to require similar skills as a history painting. But while the artist received much praise for her correct drawing and harmonious composition, no critic went so far as to suggest that she might aspire to be a history painter. We might even deduce that they were prepared to commend Labille-Guiard in the way that they did precisely because she, unlike Vigée-Lebrun, had not presumed to practice the highest branch of painting. Furthermore, the critics' insistence on comparing the two women artists with each other meant that neither was consistently compared with their male colleagues, thereby preventing their achievements being judged superior to those of a man.

Artist and mother

I want to conclude by considering how Vigée-Lebrun responded to being characterized in the fundamentally demeaning terms that we have examined above. In order to do so, we will look at another self-portrait, which was exhibited at the Salon of 1787, four years after she entered the Academy (Plate 87).

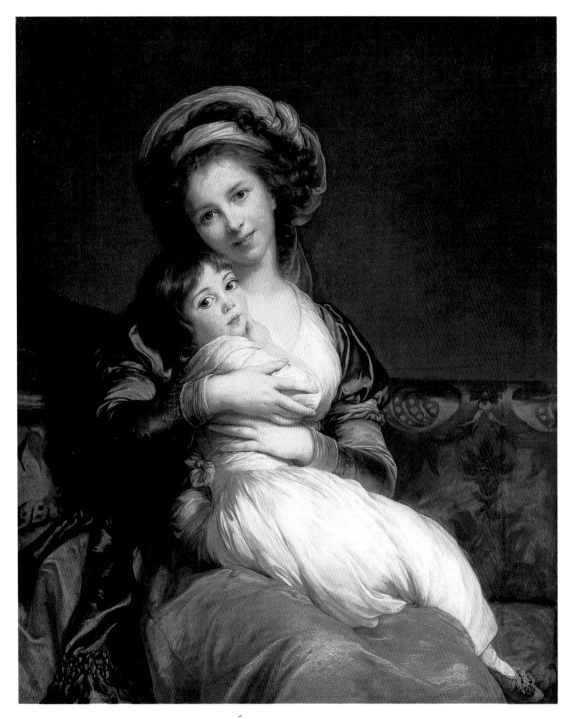

Plate 87 Elisabeth-Louise Vigée-Lebrun, *Self-Portrait with her Daughter*, 1786, oil on wood, 105 x 84 cm, Musée du Louvre, Paris. Photo: © Réunion des Musées Nationaux, Paris.

What are the main differences between this and the earlier self-portrait (Plate 82)? Does this later self-portrait put you in mind of any other kind of painting? (You will find Vigée-Lebrun's probable source among the works of art depicted in Zoffany's *Tribuna*, Plate 64).

Discussion

Obviously, this is not a portrait of the artist alone but also includes her small daughter, Julie. Additionally, Vigée-Lebrun here omits her palette and brushes, so that if you didn't know that it was a self-portrait, you would assume that it was simply a painting of a mother and child by a third party. Further differences to be noted are the indoor setting as opposed to the bright sky in the earlier work, the fact that she is seated on a sofa instead of standing, and the different costume. Whereas the pert straw hat and feather, the 'chemise' dress and black shawl create an impression of fashionable poise, the turban-like head-dress, modestly draped bosom and flowing skirt and sash create a much softer, more demure effect. The artist does not, as before, appeal to the viewer directly; instead, it is the child in her lap whose gaze links with ours. She also partly shields her mother's body from view. Their entwined forms may have reminded you of paintings of the Virgin and Child, particularly those of the Italian Renaissance. The specific painting usually cited as a source for Vigée-Lebrun is Raphael's *Madonna della Sedia* (Plate 88), which can be seen on the far left of Zoffany's picture.

◆◆

Plate 88
Raphael,
Madonna della Sedia, c.1514,
oil on panel,
71 cm
diameter,
Galleria Pitti,
Florence.
Photo: Fratelli
Alinari.

Whether or not you recognize the source, I think it is clear that Vigée-Lebrun depicts herself here as a loving mother. The association with paintings of the Virgin and Child further suggests that the relationship between mother and child is something very special, even sacred. This would have been reinforced by the presence of two other portraits of women and children by Vigée-Lebrun in the same Salon. *The Marquise de Pezé and the Marquise de Rouget with her Two Children* (Plate 89) similarly depicts turbaned women and wide-eyed children in a warm and intimate embrace. *Marie-Antoinette and her Children* (Plate 90) seems rather stiff and formal by comparison but the children share some of the same qualities, especially the young princess leaning against her mother's arm. Together, they vividly convey a sense of a feminine domestic realm in which women devote themselves to their children and are rewarded by their offspring's affection. At the time, this mother-centred vision of family life represented a powerful new ideal that was consciously adopted by certain women on the inspiration of its most persuasive advocate, the philosopher Jean-Jacques Rousseau.

The apparent espousal of this maternal ideal by Vigée-Lebrun presents us with something of a problem. How can we reconcile her high-profile career as a woman artist with the views of Rousseau? The philosopher had gone so far as to claim that nobody of any sense would be impressed by so-called women of talent since they always relied on the assistance of some man.

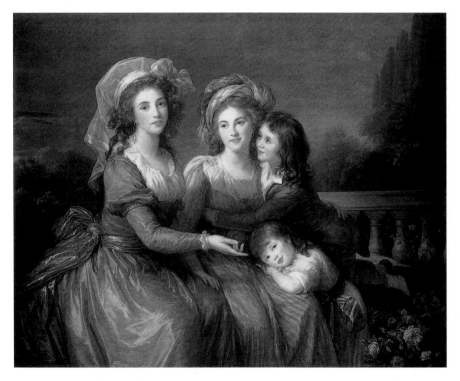

Plate 89 Elisabeth-Louise Vigée-Lebrun, *The Marquise de Pezé and the Marquise de Rouget with her Two Children*, 1787, oil on canvas, 123.4 x 155.9 cm, National Gallery of Art, Washington, DC. Photo: © 1998 Board of the Trustees, National Gallery of Art, Washington, DC. Gift of the Bay Foundation in memory of Josephine Bay Paul and Ambassador Charles Ulrick Bay.

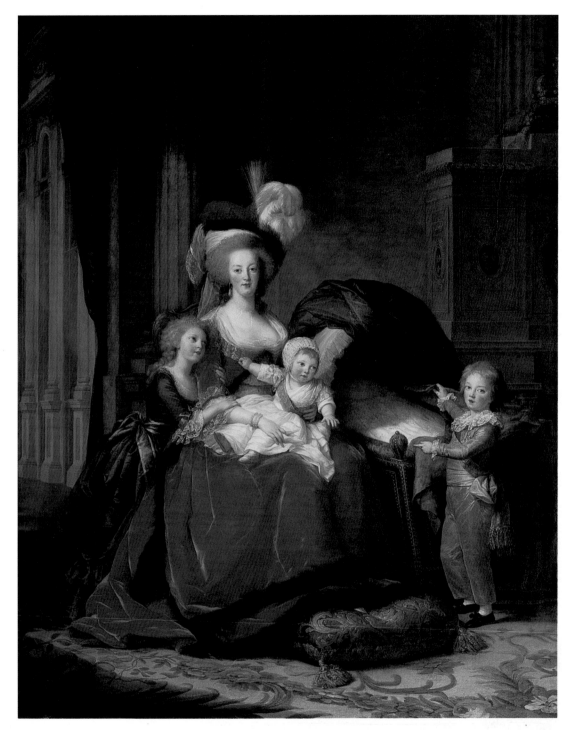

Plate 90 Elisabeth-Louise Vigée-Lebrun, *Marie-Antoinette and her Children*, 1787, oil on canvas, 271 x 195 cm, Versailles et Trianon. Photo: © Réunion des Musées Nationaux, Paris.

Writing of 'the virtuous woman', he declared: 'Her dignity is to be unknown; her glory lies in the esteem of her husband, her pleasures in the happiness of her family' (quoted in Radisich, 'Que peut définir les femmes', p.464). Any fashionable society woman could fall foul of this dictum, with the queen herself being singled out for special vilification by Rousseauian social critics. Vigée-Lebrun's portrait of Marie-Antoinette in the role of a virtuous mother had in fact been commissioned in order to counteract her reputation for immorality and extravagance. As a woman artist, a society beauty and an associate of the queen, Vigée-Lebrun herself offended on every count. She too was rumoured to have taken lovers, among them the finance minister Calonne, whose portrait by her had been exhibited at the Salon of 1785 (Plate 91), and to spend vast sums on frivolous pursuits. It seems likely that Vigée-Lebrun intended her own portrait with her daughter as a refutation of such accusations.

On one level, Vigée-Lebrun undoubtedly succeeded in presenting herself as a good mother who knows how to keep to her proper place. Commenting on the 1787 Salon, the critics hailed her self-portrait as the perfect expression of 'maternal tenderness'. In this context, the 'softness' and 'gracefulness' that elsewhere seemed to be defects could be reconceived as utterly natural and appropriately feminine. Revealingly, one critic observed that he praised the self-portrait all the more willingly since the artist seemed to have given up history painting. By sticking to portraiture, she would acquire 'a less doubtful

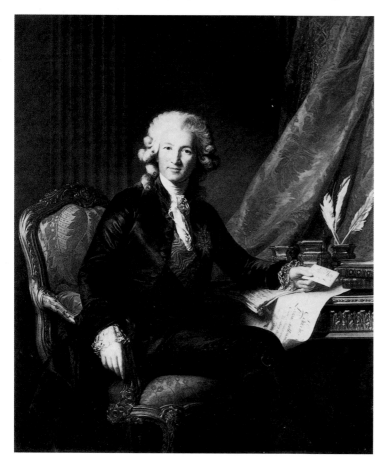

Plate 91 Elisabeth-Louise Vigée-Lebrun, *Charles-Alexandre de Calonne*, *c*.1784, oil on canvas, 149.9 x 128.3 cm. © Her Majesty the Queen.

reputation'. This phrase seems to suggest a link between Vigée-Lebrun's 'inappropriate' artistic aspirations and her notoriety as a woman in the public eye. Rather than seeing the artist as simply backing down in face of attack, however, recent commentators suggest that the self-portrait with her daughter subtly undermines Rousseau's prescriptions. Not only does this image implicitly affirm that she successfully combines motherhood with her career, but it also serves to identify her as a high-minded artist promoting virtuous motherhood and, as such, perhaps not so very different from a history painter after all. One critic declared: 'Thus art can serve morals better than the lessons of a moralist'. It was doubtless for this reason that d'Angiviller commissioned Vigée-Lebrun to produce another self-portrait with Julie, which was exhibited in 1789 (Plate 92).

This interpretation of Vigée-Lebrun's maternal self-representations allows us to characterize her as an adroit strategist who successfully manipulated prevailing constructions of femininity to her own advantage. It makes it possible to reclaim the artist for feminism to a greater extent than did Parker and Pollock, who simply saw the 1789 self-portrait as prefiguring a narrow nineteenth-century conception of woman's domestic destiny.[5] Nevertheless, a cautionary note may be in order here. Vigée-Lebrun's memoirs suggest that she relished her status as an exception and did not have much time for other women artists. Of a meeting with Kauffman, for example, she relates that she found her conversation interesting but concludes rather dismissively: 'she did little to inspire me' (*Memoirs*, p.85). Committed to her own art, Vigée-Lebrun disliked taking pupils and did so for only a brief period. Labille-Guiard, by contrast, was devoted to

Plate 92
Elisabeth-Louise Vigée-Lebrun, *Self-Portrait with her Daughter*, 1788, oil on canvas, 130 x 94 cm, Musée du Louvre, Paris. Photo: © Réunion des Musées Nationaux, Paris.

5 For a discussion of nineteenth-century representations of femininity, see Case Study 6 by Lynda Nead.

her numerous female students, two of whom are depicted in her self-portrait. Whereas Vigée-Lebrun's self-portraits make claims only on her own behalf, this painting can be seen as a kind of manifesto for the artistic aspirations of women generally, signalling that its author has not only gained admission to the Academy herself but is preparing others to follow in her footsteps. During the French Revolution, when reform of the Academy was being debated, Labille-Guiard argued forcefully for an end to the limit on female membership.

Conclusion

On the outbreak of the Revolution in 1789, Vigée-Lebrun was forced to flee the country on account of her connections with the royal family and other unpopular aristocratic figures. Women's independent activity, whether in the political or the artistic sphere, excited extreme opposition, especially from the early 1790s onwards. After the Revolution, women were completely excluded from the Academy and remained so until almost the end of the nineteenth century. However, as Gen Doy has recently emphasized, they gained as well as lost ground during the period ('Women and the bourgeois revolution'). In 1791, the Academicians' exclusive right to exhibit in the Salon had been abolished, thus opening its doors to a host of other artists, many of them female. The numbers of professional women artists in Paris continued to grow. In the long run, you might say, it was Labille-Guiard's collective approach, rather than Vigée-Lebrun's individualist one, that prevailed.

References

Barker, E., Webb, N. and Woods, K. (eds) (1999) *The Changing Status of the Artist*, New Haven and London, Yale University Press.

Crow, Thomas E. (1985) *Painters and Public Life in Eighteenth-Century Paris*, New Haven and London, Yale University Press.

Doy, Gen (1994) 'Women and the bourgeois revolution of 1789: artists, mothers and makers of (art) history' in G. Perry and M. Rossington (eds) *Femininity and Masculinity in Eighteenth-Century Art and Culture*, University of Manchester Press.

Mémoires secrets pour servir à l'histoire de la république des lettres en France depuis MDCCLXII jusqu'à nos jours, ou Journal d'un observateur, 36 vols, London, J. Adamson, 1780–89.

Nolhac, Pierre de (1908) *Madame Vigée-Lebrun, peintre de la reine Marie-Antoinette, 1755–1842*, Paris, Goupil.

Parker, Rozsika and Pollock, Griselda (1981) *Old Mistresses: Women, Art and Ideology*, London, Routledge.

Radisch, Paula Rea (1992) 'Que peut définir les femmes?': Vigée-Lebrun's portraits of an artist', *Eighteenth-Century Studies*, vol.25, Summer, pp.441–67.

Sheriff, Mary D. (1996) *The Exceptional Woman: Elisabeth Vigée-Lebrun and the Cultural Politics of Art*, University of Chicago Press.

Sutherland Harris, Ann and Nochlin, Linda (1976) *Women Artists 1550–1950*, exhibition catalogue, Los Angeles County Museum of Art.

Vigée-Lebrun, Elisabeth (1989) *The Memoirs of Elisabeth Vigée-Lebrun*, trans. Siân Evans, London, Camden Press.

All unaccredited quotations are from the Deloynes collection of Salon criticism, Bibliothèque Nationale, Paris.

PART 3
GENDER, CLASS AND POWER IN BRITISH ART, ARCHITECTURE AND DESIGN

Introduction

GILL PERRY

> ... the Women, as they make here the Language and Fashions, and meddle with Politicks and Philosophy, so they sway also in Architecture ...
>
> (Christopher Wren, 1670)

This comment by the British architect Christopher Wren, from a letter describing the new building of Versailles, attacks the feminization of French architecture. He claimed to prefer a simpler, more 'masculine' style which he adopted for some of his own designs for British buildings. Focusing on material from seventeenth- and nineteenth-century British culture, Part 3 of this book is concerned with the different ways in which art, architecture and design can reveal gendered associations. Drawing on the language of seventeenth-century architectural theory, Christy Anderson begins Part 3 by exploring some of the ways in which such gendered perceptions of architecture can be tied to issues of national and class identity and claims for cultural authority.

In response to the question: 'does architecture have a gender?' Anderson considers the ways in which seventeenth-century architectural theory often assumed associations between certain architectural forms and an authoritative, masculine, aristocratic culture. She explores these issues in relation to the work and theory of Inigo Jones, Christopher Wren and John Vanbrugh, showing how each uses (often differing) gendered languages. Lynda Nead's case study, however, has a different focus as she explores constructions of femininity and sexuality within the imagery of specific nineteenth-century paintings. But, like Anderson, she is concerned with the relationship between representations of gender and prevailing concepts of class identity. In the final case study Colin Cunningham shifts our attention towards issues of 'taste' and the relationship between so-called fine and applied arts. Through his study of the Great Exhibition of 1851, he shows how gender issues played an important part in Victorian perceptions of the roles and status of 'women's art' and the 'decorative arts'.

Plate 93 (Facing page) E.M. Osborne, detail of *Nameless and Friendless* (Plate 113).

Masculinity and English architectural classicism

CHRISTY ANDERSON

Introduction: the languages of masculinity

Does architecture have a gender? Should we think of buildings as being either masculine or feminine? While we may normally think of architecture as an 'it' rather than he or she, architectural writers have often described buildings as having a body or, more specifically, being modelled on an ideal body that was exclusively male. These connections may not seem obvious, or even necessary, to us now. In this case study, however, I will suggest that there are important implications when architects and writers use the language of gender, and specifically masculinity, in talking about buildings. Gender is one of the most important categories we have in talking about people and culture. It is a category which often seems 'elemental' and essential, though as you have seen in earlier studies the definitions and associations of gender distinctions are strongly determined by the historical moment.

In the following case study I shall explore both the architecture and the architectural debates of the seventeenth and eighteenth centuries, showing how gender was used to distinguish both architectural forms and national identities.

The classical tradition

Explanations of the origins of architectural form have often drawn parallels with the human form. This tradition extends back to the ancient Roman architectural treatise, *De Architectura* by Marcus Vitruvius Pollio (*c*.27 BCE). For Vitruvius architecture should mirror the arrangement of the body: 'In the human body there is a kind of symmetrical harmony between forearm, foot, palm, finger, and other small parts; and so it is with perfect buildings' (Vitruvius, *The Ten Books*, p.14). Based on fixed proportional ideals, symmetry in ancient architecture had a particular use in the planning and design of temples. Vitruvius wrote:

> Proportion is a correspondence among the measures of the members of an entire work, and of the whole to a certain part selected as standard. From this result the principles of symmetry. Without symmetry and proportion there can be no principles in the design of any temple; that is, if there is no precise relation between its members, as in the case of those of a well shaped man.

> For the human body is so designed by nature that the face, from the chin to the top of the forehead and the lowest roots of the hair, is a tenth part of the whole height; the open hand from the wrist to the tip of the middle finger is just the same; the head from the chin to the crown is an eighth, and with the neck and shoulder from the top of the breast to the lowest roots of the hair is a sixth.

(Vitruvius, *The Ten Books*, pp.72–3)

There are several interesting points to notice in Vitruvius's discussion of the relationship of the human body to architectural form. First, he sees the rules of symmetry and proportion as essential to architectural design because architecture must have a regular plan. He is not describing an architecture which would develop over time, with the addition of more rooms and spaces as the needs of the occupants change. This is an architecture which requires careful planning before building begins; that is, architecture must have the guiding hand of the architect from the start. Second, this proportion must be based on Nature's planning of the human body. Yet, this seems a rather curious analogy, for as we all know, human bodies are in general far from ideal. If architecture were to be planned after even the most athletic of Romans, there would be individual discrepancies and varieties of proportion. But Vitruvius was not talking about the ordinary human; he is invoking an ideal which is written about rather than found in everyday experience.

These ideals extend to Vitruvius's explanation of the origins of architectural form, in which there are three types of architecture, distinguished by gender and form. Doric temples have the squarest proportions of height to the thickness of the columns, and therefore give an appearance of strength. The Ionic and Corinthian each have more elaborate decoration on their capitals and elongated proportions. The development of the orders was, according to Vitruvius, a natural result of 'genetic development' and architectural progress.

> It is true that posterity, having made progress in refinement and delicacy of feeling, and finding pleasure in more slender proportions, has established seven diameters of the thickness as the height of the Doric column, and nine as that of the Ionic ...
>
> The third order, called Corinthian, is an imitation of the slenderness of a maiden; for the outlines and limbs of maidens, being more slender on account of their tender years, admit of prettier effects in the way of adornment.
>
> (ibid., p.104)

Each of the orders, with their masculine and feminine attributes, could be used for particular categories of the gods.

> The temples of Minerva, Mars, and Hercules, will be Doric, since the virile strength of these gods makes daintiness entirely inappropriate to their houses. In temples to Venus, Flora, Proserpine, Spring-Water, and the Nymphs, the Corinthian order will be found to have peculiar significance, because these are delicate divinities and so its rather slender outlines, its flowers, leaves, and ornamental volutes will lend propriety where it is due. The construction of temples of the Ionic order to Juno, Diana, Father Bacchus, and the other gods of that kind, will be in keeping with the middle position which they hold; for the building of such will be an appropriate combination of the severity of the Doric and the delicacy of the Corinthian.
>
> (ibid., p.15)

Vitruvius does not limit the use of the orders to one gender. Doric is appropriate for war-like gods and goddesses, Mars as well as Minerva. The middling sort of gods, Father Bacchus and Diana, have a similarly middle sort of order in the Ionic, simple and strong yet ornamented. In ancient Roman architectural theory gender and architecture are closely linked, in fact virtually inescapable, even in the most basic description of architectural form. However, Vitruvius allows for a far more suggestive connection of architecture to gender

than a simple one-to-one relationship. The orders are ranked according to male or female body types, but what those forms mean in theory (that is, in Vitruvius's description of their origins) may have a different connotation when actually used in a building. There they are to evoke more general responses in the viewer, images of war or delicate femininity.

The relationship of architecture to the gendered body was understood in the Renaissance to be more metaphorical than literal. The discrepancies between Nature and the ideal were taken up by Leon Battista Alberti (1404–1519) in his treatise, *De Re Aedificatoria* (finished 1452, published Florence 1485). Alberti acknowledged that

> Reflecting therefore upon the Practice of Nature as well [the Ancients] found from the very first Principles of Things, that Bodies were not always composed of equal parts or Members; whence it happens, that of the Bodies produced by Nature, some are smaller, some are larger, and some middling.

(Alberti, *De Re Aedificatoria,* p.195)

In fifteenth- and sixteenth-century Italy architects took up the ideas of Vitruvius in formulating a language and vocabulary of architectural form based on ancient precedent and current needs. Leonardo da Vinci (1452–1519) based his conception of the male form inscribed in a circle inside a square on Vitruvius's description of the ideal proportions (Plate 94). The male form is here equated and related to mathematical and geometrical forms. Although

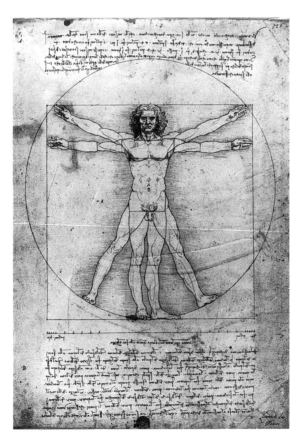

Plate 94 Leonardo da Vinci, *Ideal Man/Vitruvian Man, c.*1492, pen and ink, 34.4 x 24.5 cm, Accademia, Venice. Photo: Fratelli Alinari.

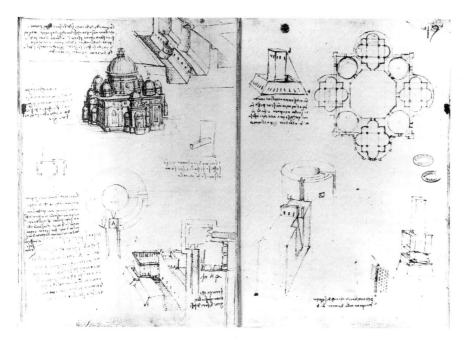

Plate 95
Leonardo da
Vinci,
Architeckturstudien,
1487–90, drawing
of centralized
church plans, 23
x 16 cm each leaf,
Bibliothèque de
France, Paris. MS
B*f* 18 v. Photo:
Bulloz, Paris.

not a part of any architectural treatise or book by Leonardo, some modern historians have seen the relationship between this famous drawing and the interest in centralized church planning of about the same period. Leonardo himself also drew a number of variations on the theme of the centralized church, all with varying compositions of outside chapels and domes (Plate 95).

The choice of styles: Inigo Jones

I am suggesting that during different periods, and for various reasons, architects have connected their architecture and designs with specific gender identities. Architecture and gender were not universally linked, so that one form did not always mean one thing. The connections were more variable and fluid. In some periods, as in seventeenth-century England, the connections between architecture and gender were used and manipulated in very clever ways for specific political and personal ends.

Perhaps no architect better exemplifies this than the English architect Inigo Jones (1573–1652), Surveyor of Works for the early Stuart kings, James I (1566–1625) and his son Charles (1600–49). Jones holds a unique position as the first English architect to use his study of classical architecture from books and first-hand observation of buildings in France and Italy as professional training.

Whereas Elizabeth I built very little, preferring her courtiers to erect great country houses in anticipation of her visits, the early Stuarts saw architecture as a potent form of court culture which could express their political power, based in Westminster. In both permanent architecture and the ephemeral court masque (or masked ball), Jones's classical architecture was highly popular at court yet it was a style that was not universally accepted throughout England, where the vitality of an architectural style which mixed classical and vernacular forms was still widely accepted.

Jones introduced a distinctive architectural court style that would compare to the grandest court architecture throughout Europe. The Banqueting House is the best known of his surviving buildings, built in 1619 to replace an earlier building that burned (Plate 96). It was to have been the first part of an extensive new palace for James that was never completed. When it was built, the new Banqueting House was a vast building that stood out from the smaller wooden buildings beside it. Jones also emphasized the façade by placing a highly thought-out composition of the orders along the building's long side. While this system of articulation made sense given the plans for a large palace complex, as built it could only serve to mark off the 'new' architecture from what had come before. A political point was made by association, marking off the reign of James from the Tudor rulers who preceded him.

Classical architecture was known and studied in England before Jones. However, it never had the status that Jones or his patrons gave it. For example, the orders and other classical details had already been incorporated within the pattern of English building, as at Robert Smythson's Wollaton Hall, Nottinghamshire (1580–88) (Plate 97). Attached columns flank the central bay and pilasters mark out each of the three stories in a sequence of the orders, Doric on the ground floor then Ionic and Corinthian, each more delicate than the one below. This is a sensitive use of the orders, and indicates that the architect (and most likely the patron, Sir Francis Willoughby) was knowledgeable in classical architectural theory from the latest treatises. However, classical details are only a small part of the design and are secondary to the overall sense of the marvellous and the fantastic that the house expresses. Wollaton rises to a tremendous height, with turrets and great viewing chambers for looking out on the landscape. Thirty years later, Jones would advocate a restrained classical architecture, but in its purest form that

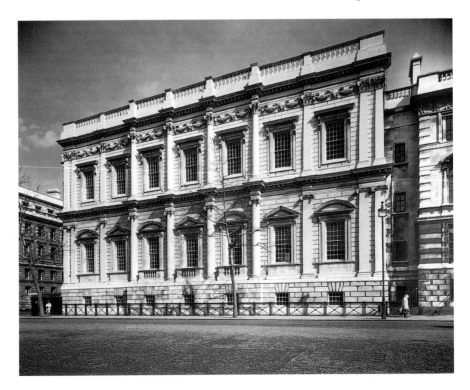

Plate 96 Inigo Jones, The Banqueting House, Whitehall, London. Photo: A.F. Kersting.

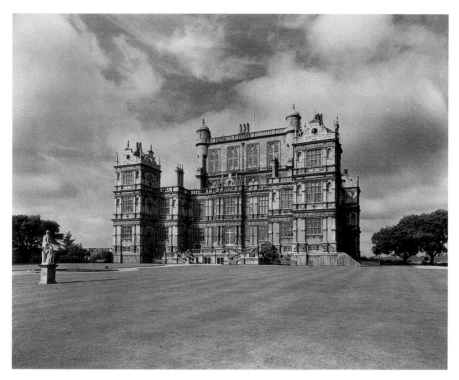

Plate 97 Robert Smythson, Wollaton Hall, Nottinghamshire, the south front. Photo: A.F. Kersting.

style would only be taken up by a very few at the court. The striking combination of classical and more 'fantastic' forms at Wollaton would continue to be the preferred architectural style well into the seventeenth century.

This disparity between the taste of the court, which often looked to other European courts, and the wider stylistic preferences is not unusual. In many countries of Northern Europe, and even in the regions of Italy itself, the ideal classical style as proposed in the treatises of Alberti and the translations of Vitruvius were always tempered based on the local building styles and traditions. This was also the case in the history of English architecture, where throughout the sixteenth century there was a rise and fall in the interest in classical styles and art; Henry VIII, for example, recruited several continental artists to work at his court, yet his daughter Elizabeth chose to promote more insular and native artistic forms. Jones's wish to transform English architecture at the court was encouraged by the royalty themselves, with their interest in the developments in artistic styles elsewhere in Europe.

However, architectural styles and building practices are notoriously slow to change. Any change in building practice also required a change in thinking about architecture and its meanings. As an aspiring court architect, Jones understood that for architecture to be taken seriously as an art and a form of court expression, it would also have to be associated with the dominant philosophical and educational ideals of the day. And many of these ideals formed part of the educational culture of young men being trained for service to the state.

Architecture and masculinity

Jones's preference for a classical vocabulary of architecture was directly associated with contemporary ideals of noble and masculine behaviour. Restrained classical architecture and the design process itself were for Jones specifically connected with contemporary ideas of masculine self-presentation. Jones made an explicit connection between architecture and masculinity in a note written soon after he returned from Italy and continental Europe in 1614. Engaged in a period of study and reflection on the nature of architectural ornament he wrote:

> As in dessigne first on Sttudies the partes of the boddy of man as Eyees noses mouthes Eares and so of the rest to bee practicke in the partes sepperat ear on comm to put them toggethear to maak a hoole figgure and cloath yt and consequently a hoole Storry wth all ye ornamentes

> So in Architecture on must Studdy the Partes as loges Entranses Haales Chambers Staires doures windoues, and then adorrne them with colloms. Cornishes. sfondati. Stattues. Paintings. Compartimentes. quadraturs.[1]

His notebooks contain pages of drawings of the parts of the human body done as drawing and anatomy exercises (Plate 98). For Jones the body, and specifically the male body, is the model for architectural design. Jones would have read about the human analogy for architectural design in his copy of Leon Battista Alberti's treatises on architecture and painting, a book on his library shelf.[2]

In January Jones also wrote on the theme of architectural decorum and the proper use of ornament, arguing that the building should be built from the inside out, the bones (or structure) organized first, with the appropriate dress (or ornament) added later according to the status of the building and based on the status of its occupant.[3]

Jones then comments on the appropriate ornament for the interiors and exteriors of buildings. Composed ornament, such as that created by Michelangelo – and we can also add to this that type of ornament popular in Northern Europe at the end of the sixteenth century – was to be limited to decorative elements on buildings such as chimney pieces. In the final section of this passage Jones equates this division in architectural decorum to the differences between masculine and feminine psychological makeup. He suggests that a building should be the embodiment of *both* the masculine and the feminine, the exterior bearing the public face of *gravitas*, the interior affected by the passions of 'nature hirself'. The interior is aligned with the emotions and the emotive, the feminine domain. The exterior gives nothing away, for this is, as Jones says, 'where there is nothing else looked for'. The exterior ornaments are to be designed 'according to the rules, masculine and unaffected'.[4]

1 Inigo Jones, *Roman Sketchbook*, fol. 76v. Now in the Devonshire Collection, Chatsworth. This passage is cited and discussed by John Peacock in 'Figurative drawings' in Harris and Higgott, *Inigo Jones*, p.285 and is reproduced here in the original spelling.

2 Ibid.

3 Ibid., fol. 76r.

4 Ibid.

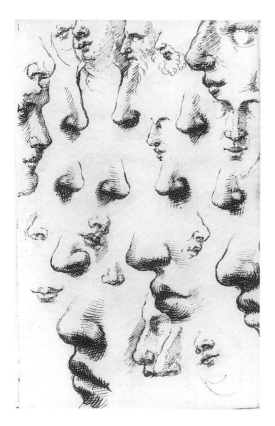

Plate 98 Inigo Jones, *Roman Sketchbook*, 1614, page of sketches of noses, ink on paper, Devonshire Collection, Chatsworth. Reproduced by permission of the Duke of Devonshire and the Chatsworth Settlement Trustees. Photo: Courtauld Institute of Art, London.

The division between a dignified exterior and a more frivolous interior had already been discussed by Alberti (*On the Art of Building*, Book 9, pt 4, p.300). Jones, however, specifically praises those qualities he associates with masculine architecture, equating a building's presentation with that of a man in the public domain. As men should present themselves with dignity and gravity, that is *gravitas*, so too should buildings.

Jones invokes an opposition between masculinity and femininity to demarcate a difference in architectural style: classicism as appropriate for the exterior of buildings (its public face); mixed and invented ornament for interiors (its private aspect). He followed this pattern even on buildings intended for female patrons such as the Queen's House in Greenwich, built over a period of some twenty years from 1617 to the mid-1630s for Queen Anne of Denmark, wife of James I, and then completed for Henrietta Maria, queen to Charles I. There the exterior included simplified Doric loggias and classical balustrades, while highly ornamented fireplaces modeled after French designs appear on the interior (Plates 99 and 100).[5] During its construction, Jones considerably changed the design, enlarging the entire scheme and changing the articulation of the elevation. Until about 1630 it was only built up to the ground storey, and that may well have been demolished when the decision came to complete the building (Harris and Higgott, *Inigo Jones*).

[5] The present-day appearance of the exterior may be misleading in its simplicity. There is some evidence from a drawing *c*.1640 that the plain surface of the upper storey, above the rusticated ground floor, was intended to be painted with a mural of trophies and triumphs. See Harris and Higgott, *Inigo Jones*, p.226.

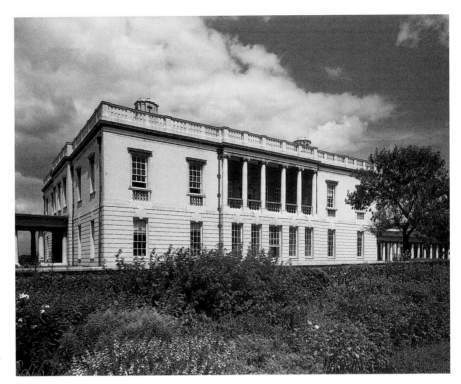

Plate 99 Inigo Jones, the Queen's House, Greenwich, 1616, view from the south. Photo: A.F. Kersting.

Plate 100 Inigo Jones, the Queen's House, Greenwich, sketch design for a chimney piece, 1616. Photo: A.C. Cooper; by courtesy of the British Architectural Library, RIBA, London.

For the exterior of the building Jones looked at models of Italian villas that he would have seen on his trips abroad and read about in his collection of architectural treatises. Various elements can be found in the villas of the Italian architect Andrea Palladio; for example, the portico is similar to that of the Villa Pisani at Bagnolo (Plate 101). The careful selection of elements from Italian villas on the exterior is matched on the interior by the completion of the building from French sources. The patron herself was French, and there may well have been some thought given to creating an interior that would accord with her tastes. However, it is also striking how Jones follows his own dictum about a plainer exterior and more ornamented interior.

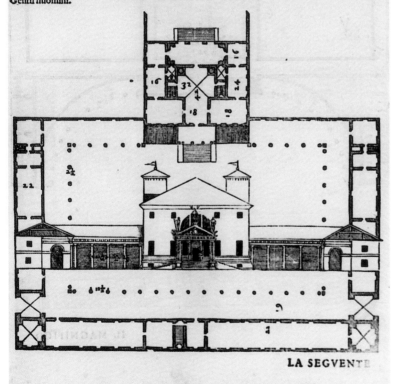

Plate 101 Andrea Palladio, Villa Pisani Bagnolo, exterior, in Andrea Palladio (1570) *I quattro libri dell'architectura*, p.47. Photo: A.C. Cooper; by courtesy of the British Architectural Library, RIBA, London.

The masculine façade

The connection between architecture and ideals of masculine nobility was widely accepted by the early seventeenth century. The façade of a man – represented through costume and comportment – was seen to define his nobility in the public arena. In a book by Henry Peacham on gentlemen's etiquette the author wrote:

> There is no one thing, that setteth a fairer stamp upon nobility than evenness of carriage and care of our reputation, without which our most graceful gifts are dead and dull, as the diamond without his foil. For hereupon as on the frontispiece of a magnificent palace are fixed the eyes of all passengers … by gait, laughter, and apparel, a man is known what he is.
>
> (Peacham, *The Complete Gentleman*, p.144)

Peacham's book was on the training of young men, and it found an eager audience as social and intellectual skills came to define the aristocracy and to provide the skills necessary for a life at court. In the early decades of the seventeenth century the definition of masculinity changed, and increasingly the arts, now including architecture, were used to help to define what it meant to be cultured and educated.

Of course, architecture had been used before as a sign of status and power. Fortified castles showed the military and economic strength of a medieval lord. However, classicism, and specifically Jones's use of classicism, operates in a slightly different way. For Jones and his patrons, architecture could also represent qualities or attributes through their associated values. In his *Roman Sketchbook* he argues for the exterior of a building which is 'proporsionabl' and 'sollid', thus connecting architecture with the language of science ('proporsionabl') and geometry ('sollid') as well as with gender. These qualities may seem to have little to do with one another, yet in the context of the early seventeenth century all of these attributes would have been understood as the marker of education and the nobility.

Jones's promotion of architectural classicism was predicated on the belief that it was the architectural expression of humanist educational ideals: rhetorical clarity, historical knowledge, and the grammar of the Latin language itself (Hexter, 'The education of the aristocracy'). These educational ideals formed the basis for the training of the male aristocracy for public service (ibid., pp.64–70), and Jones believed that architecture could similarly express these notions in built form.

Jones first learned about classical architecture in the architectural treatises he owned and carefully annotated. His copy of Palladio is the most famous of his 50 books that survive from his library (Plate 102). Travel abroad was often dangerous and difficult, but as more architectural books were published architects, masons and their patrons could study the principles of architectural design and the latest buildings at home. Jones did have the opportunity to travel and see first-hand the buildings he had studied on the page, yet books could be a ready reference to what he had seen abroad many years before.

This combined experience of architecture as both an idealized object on the page and a real three-dimensional object established a connection for Jones between books and buildings that would continue throughout his career.

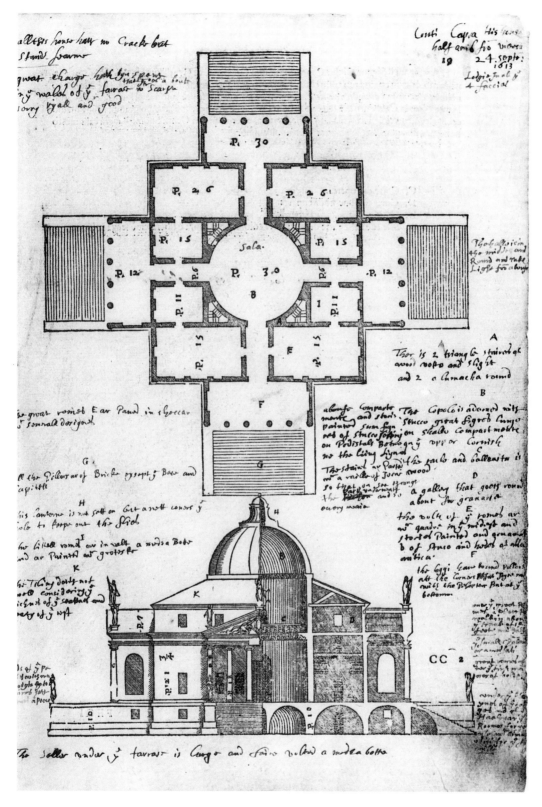

Plate 102 Inigo Jones, annotated page from his copy of Palladio's *I quattro libri dell'architectura*.
Photo: John Gibbons; courtesy of The Provost and Fellows of Worcester College, Oxford.

Like history or geometry, architecture was a scientific discipline based on careful study and the highest educational principles. Therefore, as an architect, Jones was also entitled to a share of the status associated with the use of classical architectural elements.

Jones was very clear in his annotations to his readings about the kind of architecture that he preferred, and that he thought should be built by his royal patrons and members of court. As we have seen, he equated classicism with the masculine ideals promoted at the court and for the training of young men. Yet, for all of his verbal assertions, would this architecture have been readily identified by a viewer, or even a patron, as being more masculine or espousing masculine ideals? Is there anything in the actual building that could be seen as masculine?

One way that Jones's built architecture could be seen as gendered is in his choice of architectural orders. Jones often used the Tuscan or Doric, the simplest of the orders, at times even simplifying his models from Palladio or elsewhere. Since the time of Vitruvius the Tuscan and Doric were the orders most associated with masculine form and the attributes of simplicity and strength (Plate 103). These may be seen in the many designs for garden gateways, where the Doric or Tuscan would be a logical choice as the most rustic order (Plate 104). Similarly Henry Wotton wrote in his *The Elements of Architecture* (1624) that 'the Tuscan is a plain, massie, rurall Pillar, resembling some stury well-limmed Labourer, homely clad' (p.26).

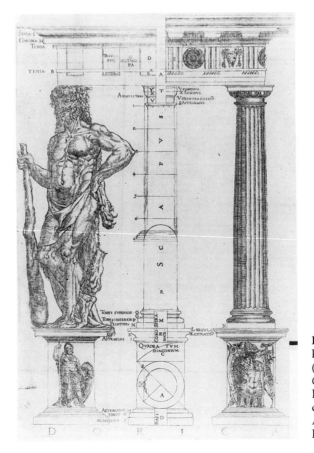

Plate 103 Plate of the Doric order in John Shute (1563) *The First and Chiefe Groundes of Architecture.* Photo: A. C. Cooper, by courtesy of the British Architectural Library, RIBA, London.

Plate 104 Inigo Jones, drawing of Doric gateway at Beaufort House, Chelsea. Photo: A.C. Cooper, by courtesy of the British Architectural Library, RIBA, London.

What is more surprising is Jones's choice of the Tuscan for one of his major urban projects, the design of St Paul's in the newly built housing scheme in Covent Garden, London (Plate 105). It is not clear from the surviving documents how much of the entire scheme can be given to the hand of Jones, though it is relatively certain that he was responsible for the design of the church, the centrepiece of this remarkable urban project. Jones reputedly said that he would build his patron the 4th Earl of Bedford 'the handsomest barn in England'. The Tuscan order would certainly have been appropriate if that was Jones's intention. We've seen that the Tuscan was a 'masculine' order, and even more, one which evoked rural images of labour. The architectural historian John Summerson has suggested that the use of the Tuscan may also have been an appropriate order for the first newly built Protestant church. The simplicity of the order would have matched the Puritan religious sensibilities, and even more generally, a reform interest in rediscovering the ancient sources of religion. As the most primitive of the orders the Tuscan might well have suggested the search for the foundations of the Christian religion, and avoided any 'popish' associations of the more elaborate and Roman of the orders.

Plate 105 Samuel Scott, *Covent Garden Piazza*, 1749–58, oil on canvas, 110 x 166.7 cm, Museum of London. Photo: Museum of London Picture Library.

It may also be that the Tuscan, as a rural and rustic order, was suitable for the intended residents of this new square of housing in Covent Garden, built so conveniently between Westminster and the City of London, that is between the court and the financial centres. With the increased centralization of the court in Westminster, it became more important for anyone who wished to have a voice at court, or to take advantage of the financial dealings in the City, to have a residence in London. A London 'season' developed when even the middling country gentry came to the city to promote their financial and political interests, as well as their social aspirations. For these few months of the winter, this growing class needed a *pied à terre* close to both the court and City. The Earl of Bedford and others of the nobility used their land holdings to create new development that would meet the needs of the country gentry. For these seasonal London residents, the Tuscan order would have spoken the language of the newly fashionable classical style with a *masculine* and rural meaning.

How do you think someone within the court would have regarded the influx of gentry to London and their preference for 'simplified' classical architecture?

Discussion

It is important to keep in mind the audience for architecture and the interests of that audience. Meaning, like praise or condemnation, was never fixed in a particular architectural form, but changed depending on the use and the attitude of the viewer. While the gentry may have desired to live in houses that were both classical and fashionable yet also masculine and rural, that same architecture could be condemned by those who resented the influx of the landed gentry as uncouth and lacking in sophistication, a lack which could even cause them to be perceived as closer to the 'feminine'. In contrast, members of the court could identify themselves with a supposedly 'purer' and more masculine classicism. Classical architecture is in this way particularly suited to being identified with gender, for as Vitruvius suggested and later writers went on to discuss, architecture is always gendered by its context and the ideas of viewers.

◆◆◆

For a seventeenth-century observer, the distinctions Jones made about the exterior of a building being male, and the interior as female, would have had a strong resonance with what some believed to be the biological and psychological differences between the sexes. Women were considered more changeable by nature, perhaps because they were thought to be at the whim of nature, as Jones wrote in his note. Women were thought to be affected by the fluctuations of the moon and the imagination. They were thought to be more prone to illness than men and psychologically weaker. These biological differences had other gendered implications. Perceptions of woman's frailer body became linked with her social and ethical status. Women were thought best suited for the care of the young, and unsuitable for exposure to the outside world and public life in general (Maclean, *The Renaissance,* p.44).

These biological ideas about women were also present in the beliefs about education for women. In the Italian Baldassare Castiglione's treatise on courtly behaviour, *The Courtier*, translated into English in 1561 and widely read, there was an emphasis on the social rather than the scholarly skills for women (Burke, *The Fortunes*). These skills were related to the interior of the house rather than the outside and included sewing, dancing, singing and entertainment.

For Jones and many other contemporary writers the distinctions between the genders are presented as either/or distinctions: men are part of the external, public world, while women belong to the domestic and interior world. In reality, of course, men and women operated in both worlds; and even in earlier architectural theory from ancient Rome through to the Renaissance, the gender of architecture could change depending on use and circumstance. However, throughout the seventeenth century a growing voice argued that women's place was in the home and that the world of public affairs belonged to men. For some modern day writers, this moment in early Stuart England would seem to confirm what they see as two anthropological universals: the secondary status of women in society and the privileging of a male public 'culture' over women's 'innate nature' (Ortner, 'Is female to male'). For the history of English architecture this equation of classicism with masculinity, and a more vernacular mixed architectural style with a feminine (and by implication, lesser) mode, became the dominant argument in favour of the classical by its advocates for the next 200 years.

I want now to consider the advantages of making an argument for a certain style of architecture based on ideas about gender. In his treatise *The Elements of Architecture*, Henry Wotton wrote about the classical orders in the following terms:

> The Dorique Order is the gravest that hath beene received into civill use, preserving, in comparison of those that follow, a more Masculine Aspect, and little trimmer than the Tuscan that went before, save a sober garnishment now and then of Lions heads in the Cornice, and of Triglyphs and Metopes always in the Frize … To discerne him, will bee a peece rather of good Heraldry, then of Architecture: For he is best knowne by his place, when he is in company, and by the peculiar ornament of his Frize (before mentioned) when he is alone.

(Wotton, *The Elements of Architecture*, pp.27–8)

In England, and specifically in Jones's formulation, architecture could incorporate distinctions between different types of people, especially when those distinctions are based on gender. This can also be seen as an anthropological idea of what architecture represents, that different sorts of people should live in different sorts of architecture with its corresponding architectural ornament. When Henry Wotton described the meaning and nature of the orders, he related them to different types and classes of people. In his earlier discussion of the Tuscan he saw it as 'resembling some sturdy well-limmed Labourer, homely clad'. Wotton sees each of the orders as being related to a specific member of society, either male or female, common worker or, as he described the Corinthian column, 'lasciviously decked like a Curtezane' (ibid., p.29).

What is particularly interesting to note here is how Wotton refers to heraldry, another kind of architectural ornament which would have been well known to his readers and the more usual way of distinguishing one group from another. In themselves, the orders would have had little of the importance normally given to heraldry as a sign of a person's status and family lineage. If Wotton, and Jones, wished to argue for a classical language of architecture, they could make their case all the stronger by using the familiar vocabulary and imagery of heraldry.

There is another, more personal, reason for Jones's use of gender in discussing the orders. Jones's description of certain kinds of architecture as masculine, and others as feminine, served a useful function for him personally and professionally as an architect. It associated his ability to design classical architecture based on continental and ancient models with other, more broadly cultural ideals held in high esteem at the court. Jones conflated the languages of masculine and courtly education with that of architecture, giving to architectural style a meaning that it would not have naturally held. For Jones himself, this provided a strong professional advantage: as the only architect or mason in England able to design in this style, he possessed a superior skill which could not easily be challenged by others.

Nationalism and masculine ideals: Christopher Wren

When the architect and scientist Christopher Wren (1632–1723) wrote about the gender of architecture he did so, as did Jones, to make the clearest possible distinctions between 'good' and 'bad' architecture. Wren elaborated on the architectural ideas of Jones, and sought to make what was earlier thought radical, that is the classical architectural language, into a universal norm. The basis for this universal architecture would be the orders, and Wren wrote in an unpublished architectural treatise that 'architecture aims at Eternity; and therefore the only thing incapable of Modes and fashions is its principles, the Orders' (Wren, 'Of architecture', p.351). To make architecture universal Wren thought it was necessary to take it out of the realm of fashion, an association made when Henry Wotton described the Corinthian order as 'lasciviously decked like a Curtezane'. Instead of fashion, Wren appeals to a language he knew well, the vocabulary of scientific language as used by the newly formed Royal Society. It is important to remember that Wren came to

architecture not as Jones did, as a landscape painter or scenery designer, but as a scientist, and through Wren's writings there is a desire to align architecture with the methods and practices of scientific analysis.

Wren wanted to keep architecture above fashion or, to be more specific, independent of the forces which govern women's fashion. He was particularly scathing in his view of French architecture precisely because it followed current taste. In a letter describing the new buildings at Versailles (Plate 106), Wren wrote that

> Not an Inch within but is crowded with little curiosities of Ornaments: the Women, as they make here the Language and Fashions, and meddle with Politicks and Philosophy, so they sway also in Architecture; works of Filigrand, and little Knacks are in great Vogue; but Building certainly ought to have the Attribute of the eternal, and therefore the only Thing incapable of new Fashions. The masculine Furniture of Palais Mazarine pleas'd me much better …

(Wren, 'Undated letter', p.41)

Plate 106 View of the interior of Versailles, drawing, 1680, in Le Clerc, Sébastien (1680) *Medeleine de Scudéry: conversations nouvelles aux divers sujets dédiées au Roy*, Paris. Photo: Giraudon, Paris.

How does Wren use gender to criticize the architecture of Versailles?

Discussion

Wren criticizes the lavish interiors at Versailles as being filled with the small details, the 'Filigrand, and little Knacks', that are the purview of women, and by implication belong to an 'inferior feminine' category of architectural decoration. He prefers the simpler 'masculine Furniture' of the Palais Mazarin. Masculine architecture is seen as that which is closer to notions of the eternal, and therefore elemental. And no architecture could more fit these ideals, according to Wren, than an architecture of classicism.

◆◆

Christopher Wren's theories about masculine architecture make an interesting comparison with those of Jones. Wren argues for a national character in architecture, one which would not be swayed by fashion on either the interior or exterior. Jones was much more interested in using classical architecture to make a distinction between social classes and the sexes. The aristocracy in Jones's view harkened back to an ancient notion of Briton, simple, noble and masculine like the Doric and Tuscan orders that he preferred. Architecture to Wren was part of his greater scientific cosmology that aligned buildings and their design with the study of the natural world, which was of course, a decidedly male pursuit. Unlike Jones, Wren makes little distinction between façade and interior, but rather between England's native greatness and the countries beyond the sea.

'A noble and masculine shew'

When Christopher Wren praised a masculine architecture, he was singling out the classical architectural vocabulary as being eternal and beyond fashion and change. Other architects of the late seventeenth and early eighteenth centuries also aimed for a masculine architecture, but allowed that it could come in a variety of forms and could be used in architecture with different functions, whether secular or religious. In the seventeenth century the country house or seat took on ever more the job of representing the owner's wealth and status through a carefully composed architectural language and references.

Early in his architectural career, Sir John Vanbrugh (1664–1726) wrote to his patron the Earl of Manchester defending his designs for the renovations to Kimbolton Castle.

> … if any Italians you may Shew it to, shou'd find fault that 'tis not Roman, for to have built a Front with Pillasters, and what the Orders require cou'd never have been born with the Rest of the Castle: I'm sure this will make a very Noble and Masculine Shew; and is of as Warrantable a kind of building as Any …
>
> (Webb, *The Complete Works*, pp.13–14)

Kimbolton was a medieval house originally built around a central court.[6] Vanbrugh redesigned the exterior façades (Plate 107). He explained his intention, in the letter, to give it 'something of the Castle Air', and we can see

[6] The interior court had previously been renovated.

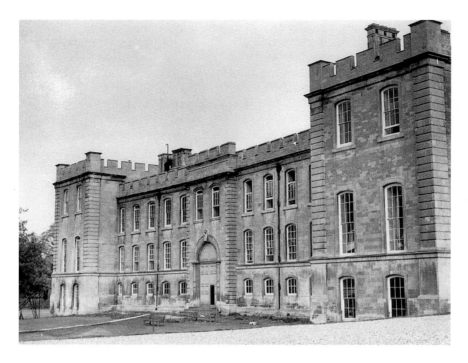

Plate 107 John Vanbrugh, Kimbolton Castle, exterior façade, west front. Photo: Royal Commission on the Historical Monuments of England © Crown copyright.

this in the use of battlements along the roof line, as well as the general fortified appearance of the massive walls and suggestions of corner towers in the projecting end blocks. The building harkens back to fortified houses, an earlier tradition of English architecture, though the house is also what Vanbrugh calls 'regular', by which we can take to mean its symmetry and classical organization. It is a clever mixture of both traditions in English architecture. This combination had a great number of advantages, not the least of which was its economy in allowing the original old stone to be reused. He wrote in another part of the letter that this would provide a 'Manly Beauty [which will be] produced out of such rough Materialls' (quoted in Downes, *English Baroque*, p.82).

While remembering that this was an older house that was renovated, it is useful to look at the choices the architect made in terms of architectural ornament and ask questions about how a contemporary might have understood them.

Please look at Plate 107. What other aspects of this façade could be considered 'masculine'?

Discussion

To begin with the façade is symmetrical around the central doorway, thus suggesting that it was built 'of a piece' and not added to over time. To build in this way would require suitable funds beforehand, and the participation of an architect or designer; all indications of the owner's status and wealth and 'manly' ambitions. Notice how at each of the corners of the building, where one mass extends outward, there are rusticated quoins. These are partly decorative, but they give the house – and the owner – an impression of strength which would have been considered 'masculine'. A medieval fortified

house would have been constructed with rusticated stonework to protect the house from artillery attack. And finally, the house is raised on a half-storey platform, especially noticeable on the east front. The main living rooms would have been raised above the ground. By this time that protection was less necessary for safety than again to suggest castles built on raised platforms. All of these architectural choices contribute to the symbolic meaning of the house as a metaphorical castle that represents the nobility and masculinity of the owner.

◆◆◆

As in this example, the architect's advocacy for a masculine architecture must certainly have had professional motivations as well, which recalls Jones's own declaration of architectural values. Vanbrugh claims that his solution would be superior to the use of pilasters that would not agree with the rest of the 'castle air'. He must have known that his patron was considering other solutions, or at least other architects, and most likely ones from Italy, to warrant his defence of his design against criticism by 'any Italians'. In the end, the Earl did employ the Italian architect Alessandro Galilei to complete the last façade, the east front (*c*.1719), with a massive Doric porch flanked by Doric pilasters and niches (Toesca, 'Alessandro', pp.189–220; Downes, *English Baroque*, p.82). Vanbrugh's complaint may have been motivated, again, by a nationalistic desire to equate the English mode of building based on English historical precedent as inherently more 'masculine'.

There are many examples where the same 'masculine' argument was made for the use of a classical architectural vocabulary. Both the classical and the castle could be seen as 'masculine' depending on the associations brought to it. The most impressive of these examples is Vanbrugh's design for Blenheim Palace, begun in 1705 as the nation's gift to John Churchill, 1st Duke of Marlborough, in honour of his military prowess and victories (Plates 108 and 109). Like the later Kimbolton, Blenheim has that general sense of the 'castle air', partly through the massive pavillion blocks which are less distinct on the plan but are carefully articulated and distinguished from the rest of the colonnade. It is impossible to avoid an appreciation of the massive scale of Blenheim, which at every point is emphasized by Vanbrugh's choice of ornamentation and orders.

Much of the decoration at Blenheim includes explicit references to the owner's military career. Arms, cannons and pikes are arranged in the north pediment. Heaped armour is present at ground level. There are also specific reminders of the English victory over the French in ornament of overturned fleur-de-lis topped by English crowns, and the 'captured' bust of Louis XIV as a trophy of war on the south front.

The choice of orders also reinforces the triumphal theme. The whole of the entrance court is in the Doric order, a suitable masculine and unadorned choice. The main block was also originally built in the Doric order, and then changed to the Corinthian, an order more associated with ancient Roman triumphal arches and triumphs generally.

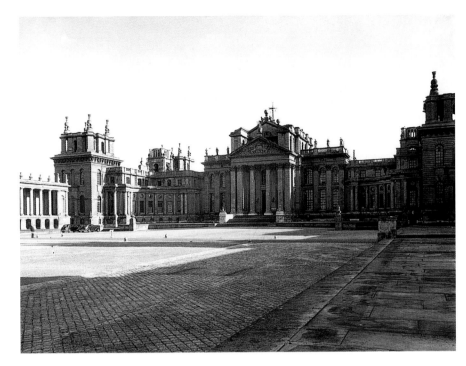

Plate 108 John Vanbrugh, Blenheim Palace, north front. Photo: Royal Commission on the Historical Monuments of England, © Crown copyright.

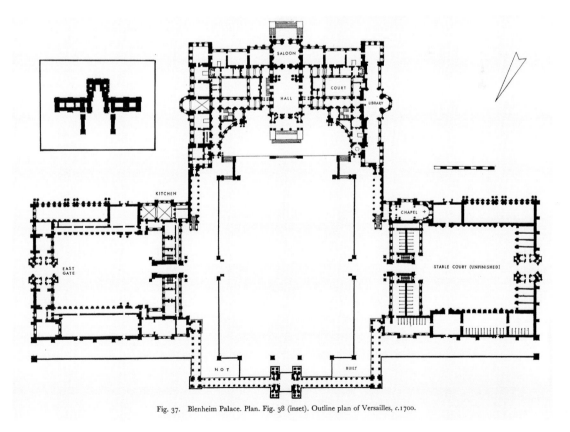

Fig. 37. Blenheim Palace. Plan. Fig. 38 (inset). Outline plan of Versailles, c.1700.

Plate 109 Blenheim Palace, plan. Photo: Kerry Downes (1966) *English Baroque Architecture,* London, Zwemmer, fig. 37.

Conclusion

Inigo Jones, Christopher Wren and John Vanbrugh all use the languages of gender in their writings and in their architectural designs. Jones emphasized the differences between masculine and feminine identity in order to promote his own architectural practice over accepted ways of building. By referring to classicism as masculine, he was able to tie into generally held cultural beliefs about male identity and nobility at a time in the early seventeenth century when those values were being questioned. For Wren, the condemnation of French architecture as feminine allowed him to highlight English architecture and national character as masculine and scientific. And Vanbrugh, working in the wake of Jones and Wren, emphasized England's own national past as masculine and heroic through the use of architectural details reminiscent of fortified buildings from the Middle Ages. Masculine building was no longer solely in the classical style.

In each of these cases we have seen that to talk about gender in architecture means attending to other factors as well: the cultural context in which the building was created, the expectations of the viewers and patrons, the current anxieties within the culture about gender identity and definition, and the status of the architect and artist in seeking to control the design process. Gender issues can often alert us to other concerns; and as gender is so central to how people define their own identity, it is a useful signal to what a work means at any time and place. We've also seen that our concern with issues of masculinity in architecture inevitably raises questions about how femininity was perceived and defined. One gender identity is inextricably tied to the other, and ultimately to the types of buildings which are being described.

References

Alberti, Leon Battista (1485) *De Re Aedificatoria*, Florence.

Alberti, Leon Battista (1988) *On the Art of Building in Ten Books*, trans. J. Rykwert, N. Leach and R. Tavernor, Cambridge, Mass., MIT Press.

Burke, Peter (1995) *The Fortunes of the Courtier: The European Reception of Castiglione's Cortegiano*, University Park, Pennsylvania University Press.

Downes, Kerry (1966) *English Baroque Architecture*, London, A. Zwemmer.

Harris, John and Higgott, Gordon (1989) *Inigo Jones: Complete Architectural Drawings*, New York, The Drawing Center.

Hexter, J.H. (1970) 'The education of the aristocracy in the Renaissance', in *Reappraisals in History: New Views on History and Society in Early Modern Euorpe*, University of Chicago Press, pp.45–70.

Maclean, Ian (1980) *The Renaissance Notion of Woman: A Study in the Fortunes of Scholasticism and Medical Science in European Intellectual Life*, Cambridge University Press.

Ortner, Sherry B. (1974) 'Is female to male as nature is to culture?', in M.Z. Rosaldo and L. Lamphere (eds) *Women, Culture, and Society*, Stanford University Press, pp.67–87.

Peacham, Henry (1962) *The Complete Gentleman*, ed. Virgil B. Heltzel, Ithaca, Cornell University Press, for the Folger Shakespeare Library, first published 1634.

Toesca, I. (1952) 'Alessandro Galilea in Inghilterra', *English Miscellany*, III.

Vitruvius (1960) *The Ten Books on Architecture*, trans. Morris Hicky Morgan, New York, Dover Books.

Webb, Geoffrey (ed.) (1928) *The Complete Works of Sir John Vanbrugh*, vol. IV (letters), London, Nonesuch Press.

Wotton, Henry (1903) *The Elements of Architecture*, London, Chiswick Press, first published 1624 .

Wren, Christopher (1965) 'Of architecture; and observations on antique temples, etc.', in Stephen Wren, *Parentalia, or Memoirs of the Family of Wrens*, London, facsimile reprint by Gregg Press, Ltd, first published 1670.

Wren, Christopher (1936) 'Undated letter from Paris', in *Wren Society*, Volume XIII, Oxford University Press.

Class and sexuality
in Victorian art

LYNDA NEAD

Introduction

The years of Queen Victoria's reign (1837–1901) were a period of intensive industrialization and urbanization. Social change was a visible feature of Victorian society. Within the span of two generations, families might move from the country to the cities and to the suburbs. New class identities were forged and new relationships between classes were demanded. Inevitably, the pace of these changes was uneven. Life did not suddenly become 'Victorian' when Victoria came to the throne. There remained traces of eighteenth-century culture alongside a keen awareness of modernity and of innovation. Within this kind of social context, the commitment to a set of absolute moral and social values could offer a sense of continuity and reassurance. For the new generations of industrial middle classes, identity was constructed around such sets of values which helped to establish the middle classes as separate and different from the aristocracy above them and the working classes below them. Broadly speaking, middle-class identity was built on a platform of moral respectability and domesticity.

Women played a central role within these ideologies. The ideal of femininity was encapsulated in the idea of 'woman's mission' as mother, wife and daughter. Women were seen as moral and spiritual guardians; as Samuel Smiles declared: 'The nation comes from the nursery' (*Self-Help*, p.294), the moral health of the nation depended on the moral health of its women. Within this interlocking set of ideas, the classification of what were identified as deviant forms of female behaviour was as critical as the definition and promotion of female respectability. These ideas concerning femininity were circulated at all levels of Victorian public life: through medical texts and religious sermons; in legislation and education; through novels and poems, paintings and prints.

The following sections will examine a number of paintings, produced in the middle decades of the nineteenth century, in terms of their role within this broader public definition of respectable and non-respectable femininities. They will also consider the relationship between these representations of gender and prevailing conceptions of class identity.

Many of these pictures were exhibited at the annual summer exhibition of the Royal Academy in London, which, until the last decades of the nineteenth century, remained the most significant space for artists to show and sell their work. The private opening of the summer exhibition was part of the London 'season' and audiences throughout this period belonged exclusively to the upper and middle classes. Some indication of the social constituency of the

Plate 110 G.B. O'Neill, *Public Opinion*, 1863, oil on canvas, 53.4 x 78.7 cm, Leeds City Art Gallery. ©
Leeds Museums and Galleries.

Royal Academy audience is given in G.B. O'Neill's *Public Opinion* of 1863
(Plate 110). Here, the artist turns the middle-class audience's aesthetic
deliberation into a light subject for a small genre painting. Inevitably, within
the broad social band of the middle classes there could be a range of social,
political, moral and cultural opinions, but paintings could work to draw the
middle classes together through the construction of forceful emotional and
aesthetic responses and the promotion of clear-cut social and moral values.
The following sections examine the kinds of images of women which were
produced in these paintings and how they were received by critics and the
public.

Before we look at individual works, there is one important caveat. The images
of women which we find in art and literature of the period are not necessarily
a reflection of how women *actually* lived and *experienced* their lives in the
period. What we discover in these representations are prevailing public views
for public consumption, and we shall see at the end of this study that there is
visual material which suggests a different reading of female respectability
and a different and more diverse experience of modern life and morality for
women in the period.

Images of women artists

By the middle of the nineteenth century, there are two main types of artistic identity evident in representations: the professional gentleman and the bohemian outsider. Both types were difficult to square with prevailing definitions of respectable femininity as domesticated, decorative and nurturing. In Plates 111 and 112 we can see two visual images of the woman artist from the middle years of the nineteenth century.

What kinds of image of the artist are presented in these paintings?

Discussion

Baldwin depicts a young middle-class woman in an outdoor setting. She is well dressed, standing with her sketch pad and pencil in hand and drawing, we can presume from the title of the picture, from the nature which surrounds her.

Titles are very significant in analysing Victorian narrative paintings. They anchor the meaning of the image and give the viewer important clues to the main elements of the narrative. The term 'sketching' here is significant. The activity was part of a gentlewoman's appropriate education. It was not regarded as a professional activity, but as an amateur accomplishment, easily reconcilable with domestic respectability.

Plate 111 S. Baldwin, *Sketching Nature*, 1857, oil on canvas, private collection.

Plate 112 O. Oakley, *A Student of Beauty*, 1861, private collection.

In Oakley's image, the student of beauty is herself an object of beauty. Although she sits by her easel with her brushes, she is not actually engaged in painting, but is deep in contemplation and, in turn, is there to be contemplated by the viewer of the picture.

◆◆◆

An image of a woman artist by a woman is Emily Mary Osborne's *Nameless and Friendless* (Plate 113), which was exhibited at the Royal Academy in 1857. It depicts a woman dressed in mourning and a boy in the interior of an art dealer's shop. They show the contents of a portfolio to the owner of the shop whilst customers look on. There are certain ambiguities in the image which puzzled the critics. Is the woman the artist of the portfolio, or is it the boy? Critics seemed reluctant to accept the young woman as the artist selling her work. The looks exchanged within the painting are also significant. The proprietor assesses the work with some disdain; the male customers/connoisseurs on the left look from the print of a ballet dancer to the figure of the young woman in a move which seems to turn the woman herself into an object for their visual consumption and pleasure. The woman herself stares at the floor, engaging no one's gaze. The viewer alone witnesses the complex set of relationships and identities constructed within the image.

The dress and physical appearance of the woman artist in *Nameless and Friendless* clearly define her social and moral identity. Her neat, black mourning dress, her delicate hands and sad, downcast expression categorize her as a 'distressed gentlewoman': that is, a middle-class woman who has fallen on hard times and who has to acquire economic independence without losing her social respectability.

Plate 113 E.M. Osborne, *Nameless and Friendless*, 1857, oil on canvas, 88 x 103 cm, private collection.

In her study of Victorian women artists, *Painting Women*, Deborah Cherry explores the significance of the pressure on professional women artists to conform to the middle-class ideal of femininity. Unable easily to adopt the artistic persona either of the bohemian or of the astute professional businessman, women artists had to draw on and develop existing images of respectable femininity. Comparing the roles of men and women artists associated with the Pre-Raphaelite group she writes:

> In the early 1850s middle-class men in the Pre-Raphaelite group were promoting an image of the artist as irregular in his hours, appearance, conduct, business transactions and sexual arrangements, the very antithesis of the masculine professional identified by his thrift and punctuality, the regularity of his habits and habitat. However, their unconventionality could not be adopted by women artists for whom, unlike men, disorderly conduct or a dishevelled appearance endangered respectability and professional activity.
>
> (Cherry, *Painting Women*, p.84)

Professional activity was itself a limited sphere for women. Throughout the nineteenth century they were excluded from membership of professional organizations such as the Royal Academy and the privileges which such membership brought. Women artists challenged the discrimination and the exclusivity of the art institutions and formed their own exhibiting spaces through organizations such as the Society of Female Artists.[1]

[1] For full discussion of women artists and Victorian art institutions, see Cherry, *Painting Women*, chapter 4 and the collection of essays in Campbell Orr, *Women in the Victorian Art World*.

You will have seen from the examples already discussed that Victorian paintings are often structured through visual signs which suggest to the viewer a story and a set of associations. Elements such as titles and pictorial details all combine to construct what are often quite complex narratives. It is important to consider how these pictures are made, their style and technique. They are often very smoothly painted and evenly finished. It is frequently difficult to detect any paint marks on the surface of the canvas because they are so highly finished. This approach to painting was itself invested with moral significance in the period. In his celebration of English character and achievement the writer Samuel Smiles particularly commended English artists for their diligence and labour:

> It was not by luck nor accident that they rose, but by sheer industry and hard work … Art is indeed a long labour, no matter how amply nature has bestowed the gift of artistic faculty.
>
> (Smiles, *Self-Help*, pp.102–3)

The smooth, highly worked canvases of Victorian narrative painters were seen as signs of noble labour. They testified to the moral value of the artist and the work.

As well as the characteristics of the painted surface, details such as costume and interiors are accurately portrayed in Victorian realist painting. The main characters are easily identified in social and moral terms; they are psychologically consistent and their behaviour conforms to our expectations of their character type. These characteristics of nineteenth-century realism can be seen in nearly all of the images discussed below.[2]

Domestic genre painting and ideals of femininity

> England, happy in her homes and joyous in her hearty cheer … is equally fortunate in a school of art dedicated to the hallowed relations of domestic life.
>
> (*Art Journal*, 1863, pp.110–11)

During the nineteenth century, new categories of art were added to the academic hierarchy of subject-matter. Although history painting was still regarded by many as the most elevated and elevating art form, others were beginning to argue that the culture and morality of the nation were most appropriately and distinctively expressed through a new category called domestic genre – small-scale, narrative paintings depicting incidents drawn from contemporary daily life. These paintings, derived from seventeenth-century Dutch art, became a major vehicle for articulating acceptable and non-acceptable gender identities in the period.

At the Royal Academy exhibition of 1863, reviewed in the *Art Journal* extract quoted above, George Elgar Hicks exhibited a triptych called *Woman's Mission* (Plates 114–116). The picture – which was divided into three compartments – depicts the three aspects of woman's mission as 'Guide to Childhood',

[2] For a full and clear discussion of the conventions and expectations of realism in relation to the moving image, see Ellis, *Visible Fictions*, from which the above paragraph is drawn.

'Companion to Manhood', and 'Comfort of Old Age'. Only the central image
is still known in the form of the final oil painting; the two side compartments
remain only as preparatory oil sketches and thus appear less 'finished'.

Plate 114 G.E. Hicks, study for *Woman's Mission:*
Guide to Childhood, 1863, oil on wood, 25.4 x 20 cm,
Dunedin Public Art Gallery, New Zealand.

Plate 115 G.E. Hicks, *Woman's Mission: Companion*
to Manhood, 1863, oil on canvas, 76 x 64 cm, Tate
Gallery, London. Copyright the Trustees of the
Tate Gallery, London.

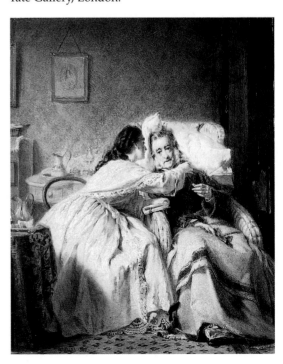

Plate 116 G.E. Hicks, study for
Woman's Mission: Comfort of Old Age,
1863, oil on wood, 25.4 x 20 cm,
Dunedin Public Art Gallery, New
Zealand.

How do the composition, technique and subject-matter of these images convey the idea of 'woman's mission'?

Discussion

The pictures represent the same woman at an optimum moment in her life, when she can carry out all three roles as young mother, devoted wife and dutiful daughter.

It is interesting to see the different ways in which the artist arranges the woman and her three male relatives. In the first picture, the young mother is positioned behind but above her young son as she guides him through a thickly wooded path (with its connotations of the path of life). Her arms encircle her child protectively, but his movement is towards independence.

In the second image, the pictorial sign of the black-edged letter tells us that the husband has received news of a bereavement, and the narrative is thus organized around the moment of the news of the husband's loss and his wife's support. He leans on the mantlepiece and shields his face with his hand. She holds on to his arm and shoulder and looks up at him with concern. The physical disposition of the couple is encapsulated in the Victorian metaphor of the oak and the ivy. He is the oak and she is the ivy. Just as the ivy needs the oak in order to be able to grow, so the wife needs the support and strength of her husband. But when the oak is afflicted, the ivy can lend it support; so the wife can assist her husband if he is cast down. Notice again the importance of painterly finish and detail in constituting the moral connotations of the narrative. The ornaments on the mantlepiece and the breakfast table are painted with care and, in turn, convey the household skills of this devoted young wife. In the third picture, the woman is shown seated with her invalid father. The book in her hand suggests that she has been reading to him and she now leans across to give him a glass of water.

In Hicks's triptych, woman's life is frozen at the moment when she can fulfil all aspects of 'woman's mission'. It is man's life span, through childhood, maturity and old age, which structures the narrative of the series and female respectability itself.

◆◆◆

It is helpful to compare Hicks's image of the ideal bourgeois woman with his image of the working-class feminine ideal. Although the values of domestic respectability emanated within the middle classes, it was also projected onto the respectable working classes. The working-class 'angel in the house' was also defined in terms of the roles of woman's mission, but on an economically reduced scale. In 1857 Hicks had produced a watercolour called *The Sinews of Old England* (Plate 117), depicting a navvy and his family standing in the doorway of a cottage.

Hicks clearly favoured the arrangement of the husband and wife, for he uses a very similar arrangement in the earlier *Sinews of Old England* to that employed in the central compartment of *Woman's Mission*. In the earlier work the man, dressed in his working clothes, stands solidly in the doorway of the cottage. He places his left arm around the waist of his wife and stares straight ahead, his attention focused on the public sphere where his labour is based.

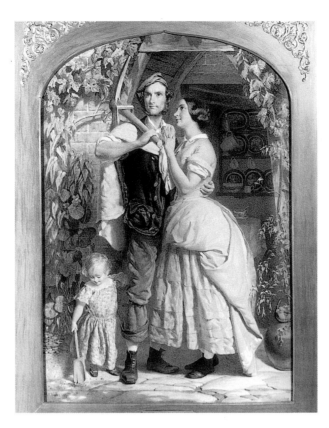

Plate 117 G.E. Hicks, *The Sinews of Old England*, 1857, watercolour, 76 x 53.5 cm, private collection.

The wife stands next to her husband; the front of her skirt is tucked up and her sleeves are rolled to the elbow, indicating that she too will be working. But her work is located in the domestic sphere which is suggested by the focus of her gaze on her husband, the interior of the neat cottage and the child at their feet. She is pretty and strong with muscular arms and a ruddy complexion. These signs are essential; they represent the differences between this woman and the middle-class ideal depicted in *Woman's Mission*. They reassure the viewer that this woman is respectable, but that she is securely placed within her own, separate working-class identity.

For a less than perfect view of 'woman's mission', we can look at Jane Maria Bowkett's *An Afternoon in the Nursery* (Plate 118). I should emphasize that it is not the case that women artists *necessarily* presented a critical view of female domesticity in their art, but it has been argued by feminist art historian Deborah Cherry that Bowkett offers a very different perspective on femininity and domesticity. It is not clear from the signs in the painting whether the woman in Bowkett's painting is actually the mother or perhaps a female relative, but elements in her representation are taken by Cherry to be a transgression of the ideal of respectable femininity advocated in contemporary manuals, journals, sermons and so on.

How is motherhood represented in *An Afternoon in the Nursery*? The setting for this picture is part of a nursery. A woman sits reading a book, whilst behind her two children play with (or, more accurately, dismantle!) a sewing box. The space of the interior is relieved by the open French windows which reveal a seascape and cliffs.

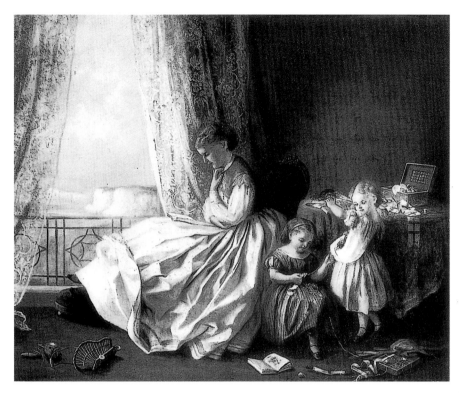

Plate 118 J.M. Bowkett, *An Afternoon in the Nursery*, n.d. (1860s), oil on canvas, present location unknown. Photo: courtesy of Christopher Wood.

Rather than the ideal attentive mother depicted in Hicks's picture, this woman pays no attention at all to the children who are causing havoc behind her. She is engrossed in her reading, and the scene outside the open windows seems to represent the escape from domesticity offered by the woman's interior, or fantasy, world. Perhaps this woman cannot be seen as deviant, but she transgresses the ideal of bourgeois femininity and represents a woman indulging her own needs and pleasures, rather than those of others.

Picturing the fallen woman

Modern urban life presented the Victorian middle classes with many complex social and moral problems. Prostitution was perhaps the most pervasive and symbolic of these concerns. Prostitution represented economic, social and moral deviancy. The prostitute was the symbol of all the dangers of the city streets. She transgressed all expectations of respectable femininity and was seen as the source of disease and moral pollution. One writer in the evangelical journal, *The Magdalen's Friend*, conjectured:

> Who can tell the pestiferous influence exercised on society by the single, fallen woman? Who can calculate the evils of such a system? Woman, waylaid, tempted, deceived, becomes in turn the terrible avenger of her sex. Armed with a power which is all but irresistible, and stript [*sic*] of all which can alone restrain and purify her influence, she steps upon the arena of life qualified to act her part in the reorganisation of society. The lex talionis – the law of retaliation is hers. View it in the dissolution of domestic ties, in the sacrifice of family peace, in the cold desolation of promising homes; but, above-all, in the growth of practical Atheism, and in the downward trend of all that is pure and holy in life.

('Popular objections', p.134)

But although she was a figure of social chaos, the prostitute was also one of the characteristic 'types' of modern life, and an artist seeking to make an impression at the Royal Academy by exhibiting a modern life painting with moral significance could attempt to picture the fallen woman.

The painter who took on this subject, however, had to reconcile different and occasionally conflicting sets of artistic conventions and expectations. On the one hand, in the tradition of academic theory, high art was expected to be beautiful and ennobling; but on the other hand, within the conventions of nineteenth-century realism, it was believed that modern life should be portrayed with adequate and convincing detail. How, then, to produce a beautiful work of art whilst also depicting the squalor associated with contemporary prostitution?

Abraham Solomon's *Drowned! Drowned!* was exhibited at the Royal Academy in 1860. It shows the body of a young prostitute who has drowned herself in the Thames and has been pulled from the river. On the left of the composition, a group of masqueraders pass along the bridge, and in the centre a man in masquerade stares in astonishment at the dead woman.

This painting is now known only in the form of an engraving published in the *Art Journal* (Plate 119). Victorian viewers found this pictorial narrative easy to read. They were familiar with conventional accounts of the life and death of the prostitute which they came across in religious texts and journalism, in novels and plays. Critics identified the male masquerader as a seducer who recognizes the dead prostitute as one of his victims. The body of the dead woman, which is reminiscent of a *pietà* (dead Christ), is surrounded

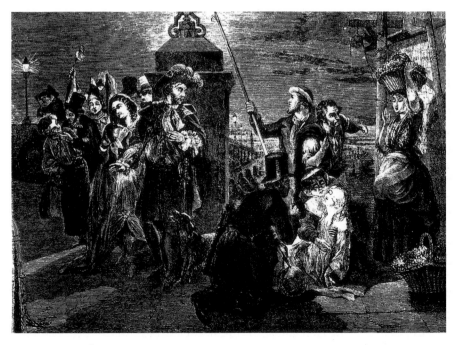

Plate 119 Abraham Solomon, *Drowned! Drowned!*, 1860, wood engraving by J. and G.P. Nicholls after the oil painting, *Art Journal* (March 1862), p.73.

by respectable working women: coster women who are presumably on their way to work. They stand upright and statuesque, in contrast to the weaving, bending bodies of the female masqueraders on the left. The contrast between the respectability of the working women on the right and the deviancy of the masqueraders on the left represents the transition from virtue to vice. The body of the prostitute can then be read as the final stage on this downward moral trajectory: a tragic death but with possible redemption and salvation. Abraham Solomon has thus encapsulated an entire narrative of female seduction, prostitution and suicide within the single image on the canvas.

Perhaps not surprisingly, the painting received mixed reviews at the Royal Academy and at other public exhibitions. At one extreme it was awarded the £100 prize from the Liverpool Academy and was described as 'a work of great power' (*Literary Gazette*). But at the other extreme, the picture was savagely ridiculed, dismissed as a cliché and the figure of the prostitute censured for its ugliness (*Athenaeum*). It was not easy for an artist taking on such a subject to satisfy all critical and audience demands.

But an even more problematic subject than the prostitute was the adulteress. In 1858 A.L. Egg sent an extraordinary exhibit to the Royal Academy. Known as *Past and Present* (Plates 120–122) it depicts the discovery and consequences of a woman's adultery. The picture is divided into three compartments. The central image (Plate 120) shows the scene of discovery which acts as a catalyst for the subsequent events represented in the two side scenes. The work was exhibited with a long caption which helps the viewer to decipher this complex and unusual narrative. The caption takes the form of an extract from a letter or diary:

> August the 4th. Have just heard that B. – has been dead more than a fortnight, so his poor children have now lost both parents. I hear *she* was seen on Friday last near the Strand, evidently without a place to lay her head. What a fall hers has been!

Look at the central image of the discovery. What symbolic details can you find relating to the theme of the Fall from Paradise?

Discussion

The picture is packed with symbolic details. The woman is shown lying on the floor, her hands clasped in a last appeal for forgiveness. Her husband sits above her, a piece of paper in his clenched hand, perhaps the 'evidence' of his wife's adultery. The theme of Eve's fall and expulsion from Paradise is woven through the image (though the details are not easy to see in this reproduction). Around her wrist, the wife wears a gold bracelet in the form of a coiled serpent. On the table, there is an apple which has been cut to reveal that it is rotten at the core. To the left of the fireplace there is a print of the 'Expulsion from Paradise' above a portrait miniature of the wife. To the right, there is print of a well-known shipwreck called *The Abandoned* above a miniature of the husband.

The room is opulently furnished and the wife and her two daughters are well dressed. The children are building a house of cards, the base of which is a novel with the first three letters of the name of the French novelist Balzac 'BAL[?ZAC]' on the spine. As they are distracted by their parents, the children

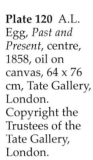

Plate 120 A.L. Egg, *Past and Present*, centre, 1858, oil on canvas, 64 x 76 cm, Tate Gallery, London. Copyright the Trustees of the Tate Gallery, London.

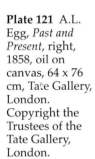

Plate 121 A.L. Egg, *Past and Present*, right, 1858, oil on canvas, 64 x 76 cm, Tate Gallery, London. Copyright the Trustees of the Tate Gallery, London.

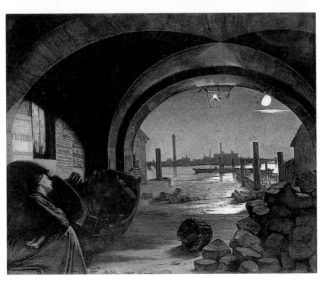

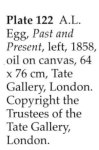

Plate 122 A.L. Egg, *Past and Present*, left, 1858, oil on canvas, 64 x 76 cm, Tate Gallery, London. Copyright the Trustees of the Tate Gallery, London.

look up and the house of cards collapses. The woman's body faces out of the picture space, in the direction of the open door which is reflected in the mirror above the fireplace. This imagery would have been read as signifying the woman's expulsion from the comfort of the domestic sphere into the dangers of the city.

◆◆◆

The two lateral scenes represent the same moment some years later (this temporality is indicated by the identical moon and wisp of cloud in the two images). To the right, the consequences are shown for the two girls. They are clearly in straitened circumstances. They sit together by a window and stare out at the moon.

In the third picture the woman herself is shown. She is an outcast and is shown huddling under a bridge by the Thames. The legs of what we presume to be her illegitimate child protrude from under her shawl, and she stares out at the river with its tempting track of reflected moonlight. In falling from virtue, the woman has fallen into the coding of prostitution, and this transition is marked in her physical transformation from the plump, well-dressed figure in the discovery scene to the sunken-cheeked, crouched body in the image of the river.

The picture caused a controversy when it was shown at the Royal Academy. Many critics felt that Egg had gone way beyond the boundaries of good taste and that images and subjects such as this should not have been at a high art exhibition where respectable young people were amongst the audience. One other question worried the critics: why had this woman fallen? If domestic life was such a joy to women, why would she be tempted away? The pernicious effects of French fiction were not adequate to explain this flaw in Victorian ideology!

The Pre-Raphaelites and gendered moralities

One of the aims of the first generation of Pre-Raphaelite painters was to return art to its original moral purpose: to produce serious art which could educate and elevate its viewers. They believed that modern issues should be confronted directly and not through historical disguise and that modern moral paintings could fulfil all the functions of history painting. In March 1850, John Tupper wrote in the Pre-Raphaelite magazine *Art and Poetry* (previously titled *The Germ*):

> If, as every poet, every painter, every sculptor will acknowledge, his best and most original ideas are derived from his own times: if his great lessonings to piety, truth, charity, love, honour, gallantry, generosity, courage, are derived from the same source; why transfer them to distant periods, and make them '*not things of today*' … Why to draw a sword we do not wear to aid an oppressed damsel, and not a purse which we do wear to rescue an erring one?
>
> (Tupper, 'The subject in art', p.121)

In pursuit of this 'truth' Pre-Raphaelite painters adopted a so-called 'realist' technique which involved minute attention to detail and a rejection of the shadowy chiaroscuro favoured by some 'academic' painters. William Holman Hunt, a key member of the group, exhibited *The Awakening Conscience* (Plate 123) at the Royal Academy in 1854. By this time, some of the Pre-Raphaelite painters had been showing their work at Royal Academy exhibitions for five years; critics and audiences were familiar with their group and individual identities and they had caused a stir at previous exhibitions.

The Awakening Conscience depicts a kept woman with her lover, sitting at a piano in an interior. As the man plays a song, the woman starts up from his lap and stares in the direction of the garden, reflected in the mirror behind her. The picture is painted with meticulous detail and an incredibly even, smooth finish. Every aspect of every object in the room is legible and plays a part in constructing the symbolic meaning of the picture. For example, the sheet music on the piano bears the title *Oft in the Stilly Night* and another piece of music lies on the floor below the table – *Tears Idle Tears*; a cat torments a bird and a discarded glove (perhaps a reference to the lover's casual use of the woman) lies on the floor.

Nevertheless, some critics confessed to being confused by the painting and uncertain of the nature of the relationship between the man and the woman. In one of a number of published defences of Pre-Raphaelite art, the eminent art critic John Ruskin wrote a letter to *The Times* explaining the meaning of the work and its aesthetic significance. Referring to the proliferation of detail in the painting, he commented:

> There is not a single object in all that room, common, modern, vulgar … but it becomes tragical, if rightly read. That furniture, so carefully painted, even to the last vein of the rosewood – is there nothing to be learnt from that terrible lustre of it, from its fatal newness; nothing there that has the old thoughts of home upon it, or that is ever to become a part of home? … the very hem of the girl's dress, which the painter has laboured so closely, thread by thread, has a story in it, if we think how soon its pure whiteness may be soiled with dust and rain, her outcast feet failing in the street …
>
> (Ruskin, letter to *The Times*, 25 May 1854)

This extract clearly demonstrates the importance of apparently insignificant details in Victorian narrative painting and the way in which narrative and morality are read from these details.

Some years later, another original member of the Pre-Raphaelite Brotherhood began a painting depicting a prostitute. Dante Gabriel Rossetti's *Found* was never finished or exhibited. It shows the meeting between a country drover and his former sweetheart who has become a city prostitute. The traditional rural connotations of the figure of the drover are starkly contrasted with the urban figure of the prostitute, with her over-trimmed and decorated bonnet, shawl and dress. The image of the netted calf in the cart and the solitary figure standing on the distant bridge suggest a bleak future for this fallen woman. Rossetti articulates the conflict of virtue and vice through the polarity of country and city. In so doing, he draws upon a prevailing debate within the period. If the countryside is the site of traditional, unchanging moral values, then the city streets are the place for the fallen and the immoral.

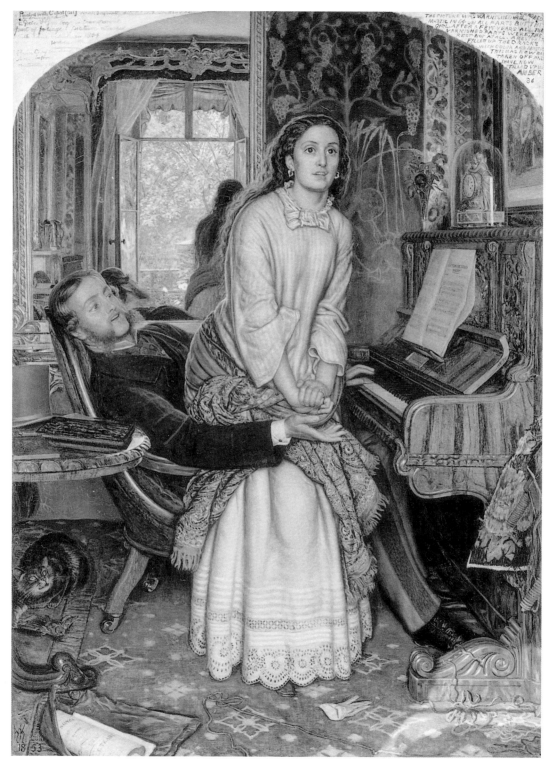

Plate 123 W.H. Hunt, *The Awakening Conscience*, 1854, oil on canvas, 77 x 56 cm, Tate Gallery, London. Copyright the Trustees of the Tate Gallery, London.

We have seen that mid-Victorian paintings of the prostitute are highly conventionalized, but that in spite of this they often received a hostile critical reception. Artists who chose to represent female deviancy in a modern-life subject were reasonably assured of critical attention, but in deviating from the traditions of high art, they risked the critics' wrath as much as their approval.

The female nude

So was it any easier for the artist who rejected modern life and chose a historical subject? In spite of claims for the primacy of domestic genre painting, history painting retained its place (if somewhat shakily) at the top of the academic hierarchy of subjects.

One of the traditional aims of history painting was to show man at his most dignified and noble, to depict physical and moral perfection. In her earlier discussion, Gill Perry considered the status and significance of the nude within eighteenth-century art academies and academic theory. Whereas in the eighteenth century it was more usual to see paintings of the unclothed male body, in the nineteenth century this gradually changed and major exhibitions were filled with canvases of female nudes in diverse historical guises.

The twentieth century has a very pronounced view of Victorian morality. The stereotype is of a prudish, repressed society in which sexuality was never mentioned and piano legs were covered up in fear of embarrassment. But as we have seen, sexual and moral behaviour was articulated in many ways in Victorian society, including in the images we have been looking at in this study. The 'repressive' view of Victorian morality has been extended to their depiction of and attitudes to the female nude. In his classic survey called *The Nude*, the art historian Kenneth Clark states:

> The unwritten code of physical respectability which was then produced seems at first to be full of inconsistencies, but analysis proves it to have one overriding aim, the calculated avoidance of reality: thus it was possible to fill a conservatory with nude figures in Carrara marble, although the mention of an ankle was held to be a gross indecency … Easier to get with child a mandrake root than consider the marble Venuses of the Victorians as objects of desire.
>
> (Clark, *The Nude*, pp.149–50)

In fact, this is a very distorted account of Victorian attitudes towards the female nude. William Etty, a Royal Academician who 'specialized' in the female nude, was avidly collected by Queen Victoria, and his disciple William Frost also achieved official success and royal patronage with his paintings of the female nude.

Nevertheless, aesthetic and moral conventions had to be continually negotiated and if an artist failed to resolve these expectations, they could bring down on themselves a storm of critical protest. I will look at one such painting which brings together many of the issues we have been considering thus far.

John Everett Millais's *The Knight-errant* (Plate 124) was exhibited at the Royal Academy in 1870. It is a large picture in which the figures are almost life-size. The composition is divided in the centre by a thick tree trunk. On the left-hand side of the frame, bound to this trunk, is a young maiden totally naked. She has thigh-length, thick, blonde, curly hair which falls over her right shoulder and around her left hip. On the right side of the canvas is a man dressed in an elaborate suit of silver armour. He stands behind the woman, holding a blood-stained sword in his right hand, cutting the ropes which tie her to the tree. The figures are located in a rocky wood. In the top right corner of the canvas, barely discernible and easily mistaken for trees, are two figures, brown strokes on the canvas, their arms in the air fleeing from the scene. These figures, together with the remnants of the woman's

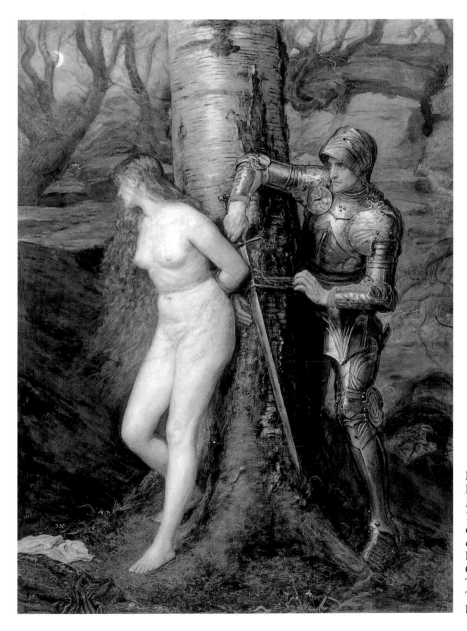

Plate 124 J.E. Millais, *The Knight-errant*, 1870, oil on canvas, 184 x 135 cm, Tate Gallery, London. Copyright the Trustees of the Tate Gallery, London.

clothes lying at her feet, construct a narrative past for the picture. Clearly, the woman has been the victim of the men in the background, who have been defeated by the knight who has come to her rescue. What is perhaps exceptional about this picture is the allusion to the sexual violence which has taken place before the arrival of the knight.

How are masculinity and femininity contrasted in this painting?

Discussion

Distinct categories of masculinity and femininity are established. The most striking visual feature of the image is the contrast between the nakedness of the woman and the shining metal of the armour-clad knight. The sharpness and hardness of the metal are emphasized by the highlights of white paint and the reflections on the surface of the armour, in contrast to the pale, soft mass of the woman's flesh. This difference is further established by the woman's flowing mass of unkempt hair. This sign of female sexuality, soft and just out of control, is made more significant through its juxtaposition with the knight's head, which is totally covered by the shining hard helmet. Because of her nakedness, the woman appears utterly vulnerable, whilst the man is structured, protected and encased in his suit of armour.

◆◆◆

What is interesting about Millais's picture is the discomfort which it caused the critics. Some tried to displace the sexual connotations of the picture by emphasizing the chasteness of the knight. The naked figure of the woman, however, proved more problematic. With the allusion to rape and the stark contrast between her flesh and the knight's armour, critics found it difficult to contain all the meanings signified by her figure within the category of high art. The critic for the *Art Journal* complained:

> [The figure of the woman] is taken from life, the blood is warm in the veins, the pulse vibrates along the tissues. Indeed, the manner is almost too real for the treatment of the nude … the lady here bound to the tree is scarcely chaste as unsunned snow. We seem to wish that she would put on her clothes, and that because she evidently has been in the habit of wearing clothes. Whereas the figures in the best antiques, and likewise in the drawings of Raphael, are clothed in a beauty all sufficing, and live and move as beings endowed by nature with attributes removed from common earth. In this female figure, Mr Millais has just escaped failure, and nothing more. How much finer is the knight, armour clad, who comes to the lady's rescue.
>
> (*Art Journal*, 1 June 1870, p.164)

According to the critics, the woman in Millais's painting does not conform to the classical ideal of the nude. The woman seems too life-like, too real, and her morality is called into question. In this way the sexual connotations of Millais's painting are displaced on to the figure of the woman and the artist's failure to conform to convention. The purity of the chivalrous knight, however, remains assured.

Conclusion

Victorian paintings contributed to the broader social definitions of masculinity and femininity in the period. Their definitions of respectable and non-respectable identities, of normal and deviant behaviour, were part of a continuous examination of gender relations within bourgeois class formation. The definition of ideal forms of masculinity and femininity was an essential element in the construction of a distinctive and powerful middle-class identity. Gender roles and moral behaviour allowed the industrial middle classes to distinguish themselves from the unregulated behaviour of the aristocracy and the nonrespectable working classes.

The paintings were seen by their viewers in very particular contexts: as exhibits at the Royal Academy or reproduced as prints or as illustrations in journals and newspapers. As we have seen in the earlier discussions of *Woman's Mission* and *The Awakening Conscience*, with their meticulous detail, high finish and smooth surfaces, the paintings offered their viewers specific aesthetic pleasures, as well as the pleasures of deciphering the narrative and the possible confirmation of their views and beliefs. But like most art, these pictures constantly negotiated aesthetic and moral expectations, and when either set of demands was not met, the critics strode into the attack.

On the whole, Royal Academy paintings tended to confirm the beliefs of their bourgeois audiences, but this does not give us the complete picture. If we look elsewhere in Victorian visual culture, we find signs of a more diverse society and a more varied understanding of female identity and experience. In a coloured lithograph, *c.*1865 (Plate 125), an evangelical clergyman offers a Bible to a well-dressed woman in Regent Street. The caption reads: '"May I beg you to accept this good little book. Take it home and read it attentively. I am sure it will benefit you." Lady: "Bless me, Sir, you're mistaken. I am not a social evil, I am only waiting for a bus."' The joke rests on the everyday presence of women on the streets of Victorian cities. Once there, she may have risked being mistaken for a prostitute, but she was not simply the 'angel in the house'.

References

Campbell Orr, Clarina (ed.) (1995) *Women in the Victorian Art World*, Manchester University Press.

Cherry, Deborah (1993) *Painting Women: Victorian Women Artists*, London, Routledge.

Clark, Kenneth (1956) *The Nude: A Study of Ideal Art*, London, John Murray.

Ellis, John (1982) *Visible Fictions: Cinema, Television, Video*, London, Routledge and Kegan Paul.

'Popular objections considered' (1861) *The Magdalen's Friend and Female Homes' Intelligencer*, vol.2.

Smiles, Samuel (1859) *Self-Help; with Illustration of Character and Conduct*, London.

Tupper, John (1850) 'The subject in art no. 2', *Art and Poetry*, no. 3, March.

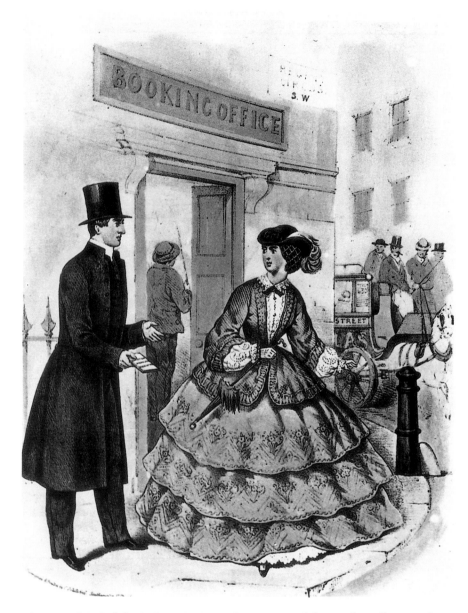

Plate 125 C.J. Culliford, *Scene in Regent Street, c.*1865, lithograph, collection of Peter Jackson. Caption reads: *Philanthropic Divine: 'May I beg you to accept this good little book. Take it home and read it attentively. I am sure it will benefit you.' Lady: 'Bless me. Sir. you're mistaken. I am not a social evil. I am only waiting for a bus.'*

Gender and design in the Victorian period

COLIN CUNNINGHAM

Introduction: 'fine' and 'decorative' arts in the Great Exhibition

This case study explores some of the ways in which design was perceived as a gendered practice in the nineteenth century. We also consider the questioning of the status of design or 'decorative' or 'applied' art and the relationship between status and gender.

London was a central focus for the decorative arts in 1851 when the city acted as host to the world's designers with the 'Great Exhibition of The Industry of All Nations'. This show attracted over six million visitors during its 141 days of opening, and is generally regarded as an important landmark in the development of design and design education. From Plate 126 we can see that the exhibition included many sculptures which would traditionally have been seen as 'fine' art, but there were also a great many other kinds of exhibits traditionally associated with 'applied' art, such as pottery and furniture. There were also tapestries, stained glass, and whole sections devoted to engineering and minerals. This range of exhibits made it difficult for some observers clearly to identify the boundaries between the 'fine' and 'applied' arts (see, for example, Honour and Fleming, *A World History*, pp. 357–9). Yet it is significant that in 1851 the National Gallery did not include any stained glass or tapestries, and the vast majority of sculpture in national collections was in other institutions such as the British Museum. The general public of 1851 therefore would most probably have felt that what was on show in the exhibition was not quite the same as what was considered to be 'art' in the National Gallery. None the less, the inclusion of sculpture meant that the exhibits were definitely linked to 'art', and the Victorians used the term 'art-manufactures' to describe goods of the sort that formed the bulk of the exhibits. The implication was that they should be judged by some of the same criteria as applied to art. The difference was in the function and the market for the objects exhibited. The exhibition, which was supported by Prince Albert, Prince Consort of Queen Victoria, has a rather anomalous position within art history as the limits of what was perceived as 'applied' and 'fine' art are not easy to establish (Plates 126 and 127). However, Prince Albert's determined support for a project which was intended to give applied art an important public status also helped to give the content of the Great Exhibition an air of cultural authority. The project was conceived as an artistic and cultural display with important political and international implications. The official 'History of the Great Exhibition' published in the catalogue records:

The maturely considered views of His Royal Highness, and the patriotic objects he proposed in making his great peace offering to mankind, are admirably set forth in the speech by him in support of the project. 'The Exhibition of 1851 would, he said, afford a true test of the point of development at which the whole of mankind has arrived in this great task, and a new starting point from which all nations would be able to direct their further exertions.

(*The Illustrated Exhibitor*, p.xiii)

The function of the objects of the Great Exhibition is of particular interest in the context of a study of gender. The majority of the objects displayed were in the form of household goods. They filled eighteen of the thirty classes into which the exhibits were divided (with sculpture models and plastic art – i.e. with moulded ornament – forming a nineteenth). Stoves, clocks, furniture, fabrics and ceramics made up a clear majority of the exhibits and provided inspiration for the competitive consumption that was so much a part of middle-class life of the time. Of course, another feature of this mid-nineteenth-century middle-class culture was the extent to which the making of a home was regarded as a woman's task.

We find, for instance, Frances Power Cobbe, in a book advising 'young ladies' on their domestic duties, summing up the prevailing view in 1881:

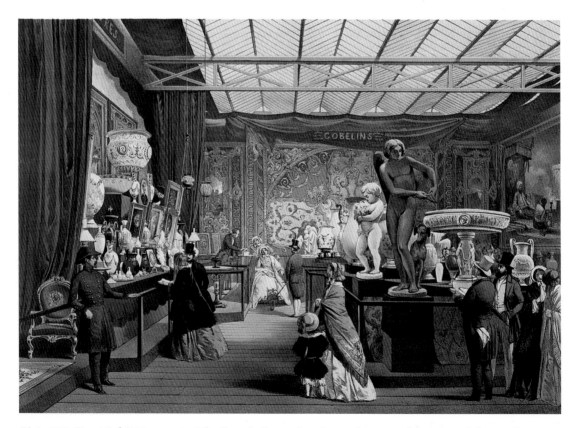

Plate 126 Great Exhibition, part of the French Court showing sculpture and ceramics, lithograph, Dickinson's *Comprehensive Pictures of the Great Exhibition of 1851*, London, 1854. Photo: courtesy of the Trustees of the Victoria and Albert Museum, London.

Plate 127 Great Exhibition, easel by F. W. Harvey of Oxford, 1851, steel engraving, *The Illustrated Exhibitor* (exhibition catalogue).

> The making of a true home is really our peculiar and inalienable right, – a right which no man can take from us; for a man can no more make a home than a drone can make a hive … [It is] a woman, and only a woman – and a woman all by herself, if she likes, and without any man to help her – who can turn a house into a home.
>
> (*The Duties of Women*, quoted in Calder, *The Victorian Home*, p.102)

Equally interesting are the assumptions of the often male, professional critics and leaders of taste. Twenty years after the Great Exhibition, Robert Kerr wrote: 'the more graceful sex are generally better qualified, both as respects taste and leisure, to appreciate the decorative element in whatever form of development' (*The Gentleman's House*, quoted in Kinchin, *Interiors*, p.20). It is worthwhile, therefore, to examine what was being offered, by whom it was designed, and how the pattern of taste and designing developed.

First, we need to consider some of the exhibits for the light they throw on contemporary attitudes to women. One of the sculptures, *The Greek Slave* by the American sculptor Hiram Powers (Plate 128), was enormously popular, attracting almost as much attention as the Koh-i-noor diamond from India that was also on show at the exhibition. It stood in the middle of the American section, with a special canopy and a background of red plush. However, the attitudes of many the critics reveal gendered interests.

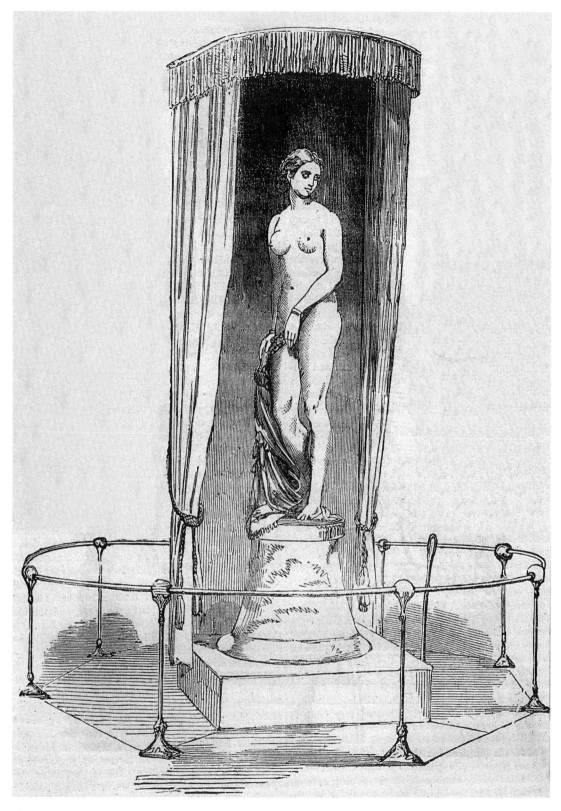

Plate 128 Hiram Powers, engraved image of *The Greek Slave* as displayed, 1851, marble statue, life-size, *The Illustrated Exhibitor* (exhibition catalogue).

Read the brief criticisms below and consider what criteria seem to be adopted in response to this work of art, and what attitudes they reveal.

> The Greek Slave is one of the 'lions' of the Exhibition, and most deservedly so.
>
> In this work a youthful creature of very delicate form is studied from life and exhibits an extraordinary refinement of form. The treatment of the back, especially, is one of the happiest efforts in modern sculpture.
>
> During the Greek revolutions the captives were exposed for sale in the Turkish bazaar, under the name of 'slaves'. The artist has delineated a young girl, deprived of her clothing, standing before the licentious gaze of a wealthy Eastern barbarian. Her face expresses shame and disgust at her ignominious position, while about her lip hovers that contemptuous scorn which a woman can so well show for her unmanly oppressor.

Discussion

You may find that both the sculptural image and the critical reactions to it reveal the sexualized relations of power which were explored in Gill Perry's discussion of looking and the 'gaze' in the introduction to this book. The story that it is supposed to depict will to some extent enhance that view. The Greek War of Independence (1821–7) was relatively recent, and so an element of historical justification is involved that is difficult for us to recapture. However, both criticisms emphasize the life-like representation. The value of the work is claimed to lie in its precise imitation of nature, in much the same way that the Parthenon marbles had been valued for their life-like depiction of the human form a generation earlier. The difference here lies in the subject. In the second quotation the viewer is inevitably put in the same position as the imaginary 'wealthy Eastern barbarian', encouraging a voyeuristic fascination with the naked captive girl. Both the subject chosen and the critical responses to it could be seen, then, to reveal a basic attitude that sees the female body as the legitimate possession of the viewing public.

◆◆

Although we now tend to mock the hypocrisy of the Victorians who could claim this work as 'fine art', the fact remains that *The Greek Slave* was one of the popular successes of the show. It is not one of those art works that has stood the test of time and remained within the canon, yet it represents artistic concerns that may be paralleled in other objects from the exhibition. Plates 129–131 show a selection of objects decorated with the female form. The Sèvres manufactory won a Council medal (the highest award) for their productions, which included the lamp (Plate 129). The use of the figure of Night on the shade lies within the traditions of classical allegorical figures, and as such is no more remarkable than most such mid-century appropriations. On the other hand, the bed (Plate 130) with half-size nude figures at each end is an extraordinary conception, and one wonders what the average mid-Victorian housewife felt when she saw it. The cheval screen (Plate 131) is perhaps, like the lamp, more typical, decorated with an image of Peace and Plenty. Once again this falls within the standard usage of the female allegorical form. Such figures have to be set alongside the ubiquitous cherubs and a significant population of knights in armour which were all added to clocks, sideboards, vases and so on. These examples, however (and it would not be difficult to find others), indicate an acceptance of the availability of the female figure as an 'artistic' adjunct to a range of manufactured objects.

Plate 130 Great
Exhibition,
bedstead by
Roulé of
Antwerp, 1851,
steel engraving,
*The Illustrated
Exhibitor*
(exhibition
catalogue).

Plate 129 Great Exhibition, Sèvres
porcelain lamp, 1851, steel
engraving, *The Illustrated Exhibitor*
(exhibition catalogue).

Plate 131 Great
Exhibition,
cheval screen by
B.T. Nicoll of
London, 1851,
steel engraving,
*The Illustrated
Exhibitor*
(exhibition
catalogue).

The design work at the Great Exhibition, then, represents a particular attitude
to the female form, and we have to accept from the popularity of the exhibition
among both sexes that that attitude was largely unquestioned at the time.
What was open to debate was the 'quality' of the designs. A cursory glance
at the catalogue descriptions suggests that what was appreciated was the
richness of ornament which adorned all forms of complex gadgetry and
applied designs. Ornament as 'art' applied to manufactured goods was the
popular taste of the mid-century. In this context ornamentation could raise
the perceived status of manufactured goods.

Design education: the South Kensington Museum

Despite Prince Albert's attempts to raise the status of British design, one of the widely accepted assessments of the wares exhibited in 1851 was that British design did not compare well with that of her overseas competitors. Many critics argued the need for Britain to do something to improve design. Owen Jones, for instance, who had been responsible for the decoration of the Great Exhibition building itself, argued as much in *The Grammar of Ornament* which he published in 1856 (Plates 132 and 133). He set out 37 propositions, the last of which read:

> No improvement can take place in the Art of the present generation until all classes, Artists, Manufacturers, and the Public, are better educated in Art, and the existence of general principles is more generally recognised.

(Jones, *The Grammar*, p.6)

Plate 132 Owen Jones, title page, *The Grammar of Ornament*, 1856, London, Day & Son.

Plate 133 Owen Jones, ornaments from embroidered and woven fabrics and paintings on vases exhibited in the Indian Collection in 1851 (now at Marlborough House), *The Grammar of Ornament*, 1856, London, Day & Son, Plate 52 .

The development of design education was directly linked to the Great Exhibition, when the Department of Science and Art began to enlarge the government collection of design objects.[1] Under the direction of Henry Cole, a civil servant with a keen interest in design, a committee was set up to purchase select items from the Great Exhibition, and to arrange for their use in the training of designers (Plate 134). This collection was initially housed in Marlborough House, but soon developed into the South Kensington Museum. This was steadily enlarged through the rest of the nineteenth century, with a major redevelopment at the turn of the century, after which it was renamed the Victoria and Albert Museum.

Many of the works in this collection were similar to those exhibited in the Great Exhibition; indeed several of them were purchased from there. Generally the collection revealed the same Victorian taste for heavy ornamentation. Several objects (Plate 135) share the pointed arches and cusped ornament that are hallmarks of the Gothic style (Plate 136). The Minton vase (Plate 137), on the other hand, is a copy of a Renaissance classical piece (Plate 138). The divide between these two styles, one based ultimately on classical Greece and Rome but viewed through the Renaissance, and the other on the Middle Ages, was central to much design thinking in the mid-nineteenth century.

Plate 134 A.W.N. Pugin, ceramic dish from the Great Exhibition, Victoria and Albert Museum, London. Photo: courtesy of the Trustees of the Victoria and Albert Museum.

[1] This development was building on earlier government policy on the need for broader 'design education' when the Parliamentary Commissions on Art and Design of 1835–6 recommended the foundation of The Central School of Design in 1836, followed by the founding of a women's school. Such schools were committed to combine art education with industrial culture, and by 1849 twenty-one schools had been founded throughout the industrial towns of Britain. See the discussion 'A note on the terms "designer", "design" and "decorative arts" in the conclusion to this part (p.193).

Plate 135 A.W.N. Pugin, cupboard, 1851, carved and painted oak, made by J.G. Crace, Victoria and Albert Museum, London. Photo: courtesy of the Trustees of the Victoria and Albert Museum.

Plate 136 Medieval monstrance, Italian, *c.*1350, copper-gilt with champleve enamel, height *c.* 12 inches, purchased 1861, Victoria and Albert Museum, London. Photo: courtesy of the Trustees of the Victoria and Albert Museum.

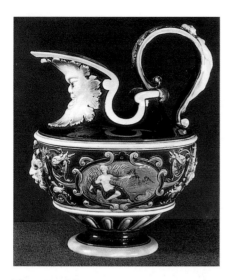

Plate 137 Minton vase in imitation of sixteenth century, nineteenth century, pottery, height *c.* 10 inches, Victoria and Albert Museum, London. Photo: courtesy of the Trustees of the Victoria and Albert Museum.

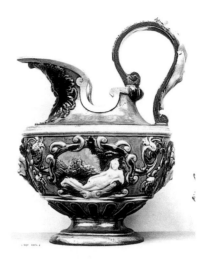

Plate 138 Bernard Pallisey, 1500-1600 ewer, pottery, height *c.* 10 inches, purchased 1860 (from Soulages Collection), Victoria and Albert Museum, London. Photo: courtesy of the Trustees of the Victoria and Albert Museum.

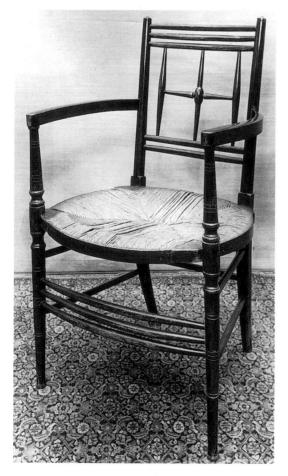

One designer who was largely responsible for the development of the Victorian Gothic Revival style was the architect Augustus Welby Northmore Pugin (1812–52). His main teaching was that decoration should never be added, but should ornament and form part of construction. I think this is demonstrated in the way the cupboard (Plate 135) is decorated, and the principle was a considerable advance on the mere addition of 'art' that we have seen in some of the products in the Great Exhibition. Pugin also argued passionately for honesty of construction, a principle that was to have a major influence on the designers of the succeeding generation who worked in what is known as the Arts and Crafts movement. One of the leading designers of this movement was William Morris; two examples of his work can be seen in Plates 139 and 140.

Plate 139 William Morris, Sussex chair, *c.*1870, Victoria and Albert Museum, London. Photo: courtesy of the Trustees of the Victoria and Albert Museum.

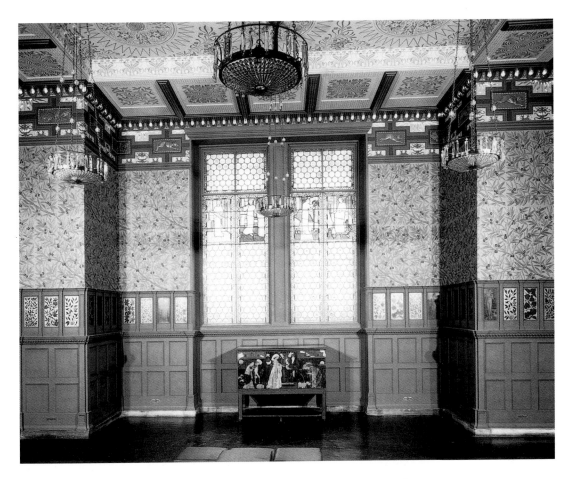

Plate 140
Refreshment Rooms, Morris Room, 1865–9, Victoria and Albert Museum, London. Photo: courtesy of the Trustees of the Victoria and Albert Museum.

However, the South Kensington Museum did not confine itself to exhibiting examples of Gothic Revival style, or preach that only one style was acceptable. The museum had its own staff of designers who were responsible for the decoration of the building, which was itself intended to be an example of good design and a mecca for designers. Although many of the exhibits and 'household objects' on display within the museum were seen to be the province of women, the professional designers who produced them were largely male. It is through the works of men such as Pugin, Owen Jones, William Morris and James Gamble that the conventional stylistic history of design is traced. The range of work produced by such leading designers can be seen in the series of three refreshment rooms commissioned by the South Kensington Museum in the 1860s (Plates 140, 141 and 142). In the Gamble room, named after its principal designer, the Renaissance classical style is used with columns, friezes and ranks of *putti*, together with foliage scrolls in the windows. This is sometimes known as the South Kensington style. The Morris room, on the other hand, although there is a mixture of motifs, is inspired by traditional old English panelling, with painted figures in the panels that have their roots in the medieval period Pugin had preferred. At the time when this room was designed, the firm of Morris, Marshall, Faulkner & Co. had not long been in business and it was seen to represent the very latest in design.

Plate 141 Refreshment Rooms, Gamble Room, 1866–78, Victoria and Albert Museum, London. Photo: courtesy of the Trustees of the Victoria and Albert Museum.

To us both rooms seem thoroughly Victorian, particularly in their eclectic use of decoration and ornament. What is important, however, is that they were designed as entities, and this reflects the approach to design education fostered by the museum as a reaction to the disorganized variety of the Great Exhibition. These rooms were a display of how rooms might be furnished in different but harmonious styles. Such displays were intended to educate the homemaker or 'the lady of the house'. Yet the 1870s, when these rooms were just opened, witnessed both shifts in taste and the opening up of new roles for women.

Design, designers and gender

It was usually assumed that women's role in the design process was as consumers, and one of their duties was the assembly of a range of designed objects to furnish a home. But, since the 1830s, schools of design were increasingly being provided for, or opening their classes to, women and it is relatively easy to find examples of women being actively involved in the process of design and manufacture in this period. What is important, however, is to understand the limits that society placed on that involvement. In London the establishment of the Central School of Design in 1836 had been followed in 1842 by the founding of 'The Female School of Design'. Unlike male students, the female pupils were expected to pay a small fee for their instruction. As F. Graeme Chalmers has written:

> It was assumed that the women who could attend daytime classes would be of a more leisured and 'respectable' class, and that their parent could afford to pay for their instruction ... The Female School of Design was founded by men from both the aristocracy and the emerging middle class. As politicians, manufactuers, and businessmen, the founders may have wished to improve British design, but they were also attending to their daughters' futures at a time when their own fortunes were volatile.

(*Women in the Nineteenth Century Art World,* p.16)

The Poynter room at South Kensington (Plate 142), with its predominant blue and white colouring, provides an interesting example of a design project which involved women designers. The colouring of the room echoes the tints of the oriental porcelain that was beginning to flood into Britain from the late 1860s. And there are other oriental elements in the decoration of the grill itself. This taste for *japonaiserie* (the depiction of Japanese subjects or objects in a western style) became part of an aesthetic movement, which was also characterized by the abandonment of the crinoline in favour of long flowing robes, the use of delicate lightweight furniture, and the white woodwork

Plate 142 Refreshment Rooms, Poynter Room showing stained glass windows and grill, 1866–74, Victoria and Albert Museum, London. Photo: courtesy of the Trustees of the Victoria and Albert Museum.

and tile hanging of the Queen Anne style that is often described as a more 'feminine' taste. Although the design of the room was directed by the Royal Academician Sir Edward Poynter (1836–1919) women students from the South Kensington art schools participated in the creation of the room (Plate 143). The involvement of women in this prestigious project, however, was merely to paint tiles that had been designed and signed by Poynter. In other words, the role of women here was simply that of copying the designs of a male professional designer.

The professional business of designing in the mid-nineteenthth century was, in fact, almost entirely in the hands of men – it was part of the world of business, as opposed to the retreat of home – and women designers were expected to work as amateurs. On the other hand, it was a regular part of a middle-class young woman's upbringing to learn to sketch and paint, and painting tiles was seen as merely an extension of this. It was the decorative painting that was regarded as women's work, and in this venture the women students of the South Kensington Art School were really no different from their working-class sisters painting pottery in the factories of Staffordshire.

The assumption that any form of decorative painting (as opposed to the intellectual effort of creating a picture) was the proper role of women was widespread, and even applied to the making of the mosaic flooring for the museum. This was designed by the museum staff under Gamble and manufactured in Woking prison as both a cost-saving and a reformatory project. But, because the floors were 'artistically designed', the work was sent to the women's prison in Woking. The actual work involved taking squares of mosaic set in a cement base and manually polishing the surface smooth – hard manual labour rather than anything 'ladylike'!

One of the first professional women designers was Elsie de Wolfe, an American who was working in the 1870s, but in Britain it was not until the

Plate 143 South Kensington School of Art students on the ceramic design course. Photo: courtesy of the Trustees of the Victoria and Albert Museum, London.

last decade of the nineteenth century that women were able to achieve prominent status as designers. The most famous examples are the MacDonald sisters in Glasgow, one of whom married the architect Charles Rennie MacIntosh (see Plate 144). There were others whose work bridged the divide between amateur and professional. Mrs Waterhouse's Yattendon Guild (see Plate 145) was one of a series of craft guilds set up in the later decades of the nineteenth century to train men and women in design. It was named after the estate of the architect Alfred Waterhouse in Berkshire, but organized by his wife Bessie as a part of her involvement in village life. It was thus an amateur effort, though the productions were highly praised by *The Studio* (Review, p.99). The designing there was done not by the architect (though he would have been well able to do it), but by his wife and the younger members of his family.

Although women increasingly entered schools of design, it is clear that, at least until the end of the nineteenth century, the role of women in design was principally that of 'amateurs' involved in directed labour or as consumers. This latter role, however, is not unimportant, since it is ultimately the customer who directs what designers may successfully produce. Yet even here the problems of assessing 'quality' of design that had been so apparent at the Great Exhibition needed to be addressed. Just as Owen Jones had set out to produce a *Grammar of Ornament* for designers, so there were authors who set out to provide manuals of taste to educate the general, and generally female, public. In the next section we shall consider two of the best known.

Plate 144 Margaret MacDonald, detail of Willow Tearooms, 199 Sauchiehall Street, Glasgow, 1903–4, plaster panel. Photo: National Monuments Record of Scotland.

Plate 145 Yattendon Guild work, brass dish, ewer and mug, private collection.

Education in taste: Eastlake and Haweis

The 1870s were particularly interesting years for interior design. The exuberance of the Great Exhibition was absorbed and replaced by the more orderly display of its products and the other goods that made up the South Kensington Museum. There were also many more opportunities for the home-maker to see and choose from a range of different designs in the shops and emporiums. Arthur Lazenby Liberty had opened his store in 1865. Tottenham Court Road boasted Maple's and Heal's. And, among the more progressive designers Morris Marshall Faulkner & Co. had been going since 1861. Manufacturers of art furniture and fittings were numerous: Minton's and Maw's for tiles, Arrowsmith's and Cottier's for furniture, Trumble's for wallpaper and Hart Son & Peard for metalwork. These were almost household names, yet they were only the leaders amongst a whole host of suppliers competing for the still expanding market of middle-class consumption. It was in response to the difficulties brought about by this perplexing variety that the various primers of taste – or critical writings on design – were produced. Two of the best-known of these primers were *Hints on Household Taste* (1869) by Charles Eastlake and *The Art of Decoration* (1881) by Mrs R.H. (Mary) Haweis.

Charles Locke Eastlake (1839–1906) was an architect and Secretary of the Royal Institute of British Architects from 1866 to 77. Thereafter he was Keeper of the National Gallery from 1878 to 98. He was thus very much a professional and at the centre of the world of fine art. His *Hints on Household Taste* was widely read and ran through a number of editions, the sixth appearing in the same year as Mrs Haweis's *The Art of Decoration*. Mrs Haweis was a professional writer whose articles appeared in a series of magazines such as *The Queen*. She was married to a clergyman, but appears to have needed, like many middle-class Victorian women, to write to supplement the family income. She was a self-proclaimed arbiter of taste, writing on *The Art of Beauty* (1878), *Beautiful Houses* (1882), as well as a novel, *A Flame of Fire* (1897), to vindicate the helplessness of womankind.

Eastlake's *Hints on Household Taste* and Haweis's *The Art of Decoration* both make a good deal of the need to educate the designer and manufacturer. What is more difficult to find out is the extent to which Haweis, as a woman critic, was able to rework or even challenge a dominant culture of design which saw men as professional designers and women as amateurs or passive consumers of the products of the design industry. Having suggested that there are 'fixed principles of taste' which can be taught, Eastlake argues (somewhat confusingly) that for 'young ladies' 'taste' in design is somehow intrinsic to female sensitivity:

> How it has been acquired, few would be able to explain. The general impression seems to be that it is the peculiar inheritance of gentle blood, and independent of all training, that, while a young lady is devoting at school or under a governess, so many hours a day to music, so many to languages, and so many to general sciences, she is all this time unconsciously forming that the sense of the beautiful, which we call taste – that this sense, once developed, will enable her unassisted by special study or experience, not only to appreciate the charms of nature of every aspect, but to form a correct estimate of art manufacture.
>
> (Eastlake, *Hints*, p.7)

Mrs Haweis's notion of 'taste' appears to be less gender specific, and she is careful to use neutral terms such as 'people' where Eastlake regularly writes of 'she'. Haweis stresses the primacy of individual taste, without clearly defining that as a woman's prerogative:

> ... the rules of taste are wide, and will admit all tastes ...

> There is no *ought* in beauty, save your own feeling of delight, and it is only the pleasure of the majority which determines art rules; and the more capable you are of comparing one sensation with another, in fact, the more you cultivate your eyes and minds, and the more fastidious you become in arranging pleasant accessories, the higher is the form of beauty resultant from you efforts. A very little, any bright scrap, pleases the uneducated, and to him it is beauty.

> (Haweis, *The Art of Decoration*, pp.20–1, 361–2)

Eastlake's book reveals a well-established notion of gendered spaces within a 'modern house'. In the case study on seventeenth-century British architecture Christy Anderson showed how gendered distinctions were often made between a 'masculine' public exterior and a more private 'feminine' interior of a building. We saw that these distinctions were often further extended to distinguish the more public (i.e. masculine) aspects of the interior from its more intimate (or feminine) parts.

Please read the following extracts from Eastlake's book. What aspects of Eastlake's account suggest that he saw the spaces of a 'modern house' in gendered terms?

> Of all the rooms in a modern house, that which is used as a library is the one least like to offend a fastidious taste by its appointments. Here at least the furniture – usually of oak – is strong and solid. The silly knick-knacks which too frequently crowd a drawing room table, chiffonier or mantelpiece, are banished from this retreat.

> In obedience to this injunction [that a dining table needs to be more solid] we sit down to dine upon an oaken chair before an oaken table, with a Turkey carpet under our feet, and a red flock paper staring us in the face. After dinner the ladies ascend into a green and gold papered drawing room, to perform on a walnut-wood piano, having first seated themselves on walnut-wood music stools, while their friends are reclining on a walnut-wood screen.

> As a lady's taste is generally allowed to reign supreme in regard to the furniture of bed-rooms, I must protest humbly but emphatically against the practice which exists of encircling toilet-tables with a sort of muslin petticoat, generally stiffened by a crinoline of pink or blue calico.

> (Eastlake, *Hints,* pp.113, 65, 191)

Discussion

The language employed by Eastlake to describe the library and the dining room suggests that these were seen as the more 'masculine' spaces. He emphasizes 'the strong solid' furniture and the lack of 'silly knickknacks' in the library, continuing the theme of solidity in the oak furniture of the dining room. In contrast with the bold red flock paper of the dining room, the drawing room to which the ladies retire after dinner has a more decorative green and gold wallpaper, and walnut-wood furniture contrasts with the strong, solid oak. Eastlake's gendered notion of design is at its clearest. and its most emphatic in his dismissive description of the bedroom in which 'a lady's taste is generally allowed to reign supreme'.

◆◆

Interestingly, Haweis's recommendation for the decoration of 'a study or library' suggests a different emphasis:

> I prefer the furniture of a study or library a little gay in colour, because a mass of books, even gilt backed, unrelieved, always tells dark and heavy; … I once knew a bookworm who, feeling the want of colour, painted his wall blood-red, his doors arsenic-green; … A soft light-red and a kindly moss-green such as a wood grows in midsummer, would have a different effect; but most colours are painful in too large a mass, and should be relieved by variations in the mouldings, or by pictures in parcel-gilt frames – filigree are the best – and a little china, or *cloisonné*, or German glass, sturdy and quaint. The books in one place and the china in another, each in its own glazed case, appears to me a joyless arrangement. Marry the gay colours of the one to the sober coats and bright thoughts of the other; mix pots and books in such a manner as that neither shall interfere with the other; and you get an artistically good effect.
>
> (Haweis, *The Art of Decoration*, p.306)

Haweis seems to be advocating a more 'gay' colourful design than the sturdy solidity of Eastlake's library. Some of these differences can be accounted for in terms of changing styles and tastes. While Eastlake was proselytizing for design in the Gothic Revival style, Haweis is more influenced by the Queen Anne and aesthetic style that was fashionable a decade later. But it could also be argued that Haweis's preference for a lighter, more colourful style fitted contemporary assumptions about more decorative 'feminine' tastes.

Eastlake clearly shares the mid-Victorian assumption that home-making was a woman's duty and his audience will therefore be mostly female. But Haweis, despite her use of neutral pronouns, makes a number of similar assumptions about the role of women. In other words, it seems as though the gendered distinctions at the heart of the design world of the nineteenth century remained surprisingly consistent throughout the period.

References

Calder, Jenni (1977) *The Victorian Home*, London, Batsford.

Chalmers, F. Graeme (1998) *Women in the Nineteenth Century Art World: Schools of Design for Women in London and Philadelphia*, London, Greenwood Press.

Eastlake, C.L. (1869) *Hints on Household Taste*, 2nd edn, London, Longmans Green.

Haweis, M.E.J. (1881) *The Art of Decoration*, London, Chatto and Windus.

Honour, H. and Fleming, J. (1993) *A World History of Art*, London, Laurence King.

The Illustrated Exhibitor: A tribute to the world's industrial jubilee comprising sketches by pen and pencil of the principal objects in the Great Exhibition of the Industry of all Nations 1851 (1851) London, John Cassell.

Jones, Owen (1856) *The Grammar of Ornament*, London, Day & Son.

Kinchin, Juliet (1996) 'Interiors: nineteenth-century essays on the "masculine" and the "feminine" room', in Pat Kirkham (ed.) *The Gendered Object*, Manchester University Press.

Review of the Home Art and Industries Exhibition (1899), *The Studio*, vol.17, p.99.

Conclusion to Part 3

GILL PERRY

A note on the terms 'designer', 'design' and 'decorative arts'

We saw in Anderson's case study that there was little clear separation between concepts of 'design' and architectural design in the seventeenth century. We have also seen that the concept carried some different associations in nineteenth-century culture. Cunningham argues that despite the fact that consumers of domestic or interior design were presumed to be women, most successful designers in the mid- to late nineteenth century were male. Although attempts were being made in nineteenth-century Britain to improve access (for men and women) to the study of design and to give it a higher status, it seems to have held constantly shifting associations, determined at least partly by the activity with which it was linked (such as 'industry' or 'art').[1] You may have noticed that many of those professional 'designers' mentioned had also established careers in professions which already commanded some status and were often defined as predominantly 'masculine' activities, such as architecture (for example, Pugin and MacIntosh) and painting (Poynter).

When applied to the development of manufacturing industries, the term 'design' could take on some other associations. Many of the works displayed in the Great Exhibition were seen by contemporaries to weld together British 'industrial design' and invention with the culture of 'fine art'. Such perceptions also carried with them political and imperialist ambitions. Supported and encouraged by Prince Albert, the exhibition was represented in the official catalogue as a great modern display which could direct the future 'exertions' of 'all nations'. Within a culture which was actively seeking to promote design education within a new industrial society, the elaborate ornament which characterized many of the exhibits could be seen as the expression of British cultural modernity.

However, the gendering of modernity was not without contradictions. While 'industrial design' could signify a forward-looking, even 'masculine' harnessing of mechanical advances, the label 'decorative art', another term often used to describe applied design, particularly that associated with domestic interiors, often carries associations of designing for a specifically 'feminine' and gendered sphere. And the concept of 'decorative art' is itself often represented as requiring less intellectual skill, and therefore is more 'amateur' and 'feminine' than a more elevated 'high' or 'fine' art. This separation, and its gendered associations, can be traced back to some of the academic and canonical hierarchies which we discussed in the Introduction and Part 2 of this book. The point to note here is that the concept of 'design' could be annexed to a range of discourses in mid-nineteenth-century culture, discourses which could be gendered in different ways.

[1] These shifting associations are discussed in A. Rifkin, 'Success disavowed: the schools of design in mid-nineteenth-century Britain (an allegory)', *Journal of Design History*, vol.1, no.2, 1988, pp.89ff.

GENDER, MODERNISM AND PSYCHOANALYSIS

Introduction: gender, modernism and feminist art history

GILL PERRY

Over the last thirty years 'modernism' has become one of the most over-used and hotly-debated terms to be found in studies of the art of the late nineteenth and twentieth centuries. Employed across a range of academic disciplines, including art history, literature and sociology, it has been seen as the central concern or characteristic of modern culture, and has become the focus of some complex debates about the relationship between art and culture, between aesthetic concerns and their social and ideological contexts. Although the term has been used differently and has different chronological boundaries within different disciplines, it has traditionally described a critical approach preoccupied with formal innovation, with the need to rework and critique the language of art. In the visual arts modernism is closely associated with the rise of so-called 'avant-garde' artistic groups. In its loosest form the term avant-garde is generally used to describe art practices and activities which were deemed to be self-consciously radical or critical of preceding artistic conventions. It usually implies some notion of 'originality' and may provoke controversy.[1] Modernist art history tends to follow a linear 'progression' through the various avant-garde movements of Impressionism and Post-Impressionism in the late nineteenth century through to Fauvism, Cubism, Expressionism and Constructivism in the early twentieth century. According to some narratives, modernism is seen to reach its apotheosis in American art of the 1950s and 1960s with the work of the Abstract Expressionists.

The problem for accounts written from feminist points of view is that such histories are almost exclusively concerned with the work and activities of male artists, and they are documented and consolidated through a discourse, or set of historical narratives, which has been seen to be 'masculinist'. In some of the preceding sections of this book authors have looked at various ways in which canonical art (of different periods) has been associated with a largely 'masculine' culture of art, identifying educational and social structures, professional and institutional cultures, and the languages of aesthetics and art criticism as crucial factors in the gendering of the interpretation and production of art works. In this part we aim to explore the ways in which such gendered associations have been sustained, reworked or critiqued within the artistic practices and theories of the modern period. We will also examine the ways in which psychoanalytic theory has informed feminist art history of the period.

Plate 146 (Facing page) Suzanne Valadon, detail of *Reclining Nude* (Plate 164).

[1] The concepts of modernism and avant-gardism and their shifting meanings are explored in more detail in Wood, *The Challenge of the Avant-Garde* (Book 4 of this series).

While much of the art now associated with modernism has been seen as radical or 'progressive' in its rejection of academic conventions and the established canons of nineteenth-century art, feminist theorists have argued that despite their technical radicalism, many forms of avant-garde practice in fact perpetuate and privilege a predominantly masculine or patriarchal value system.[2] Such systems (it is claimed) have ultimately helped to reinforce the dominance of another canonical history – a 'modernist canon' of art. These claims beg questions about how we understand the relationship between art, culture and gender, and the studies that follow will address this relationship in different ways. In the first case study I examine the role of gender within the avant-garde culture of early twentieth-century France with close reference to critical perceptions of the work of women artists on the margins of the Fauve and Cubist movements. In the second study Claire Pajaczkowska considers the ways in which psychoanalytic theory can provide useful tools for both the study of art and feminist analysis. In Case Study 10 Briony Fer develops analytical approaches derived from psychoanalytic theory in her study of the work of the post-war American artist Eva Hesse and the contemporary Lebanese artist Mona Hatoum. And in the final study I provide an overview of some of the different approaches to fetishism which have emerged in this part of the book. These later studies which are concerned with the application of psychoanalytic methods in the study of more recent art practices are more closely associated with an approach labelled 'post-modern' in that they have been seen to reject or rework some of the theoretical tenets of modernism. We will consider some of the ways in which interests in gender issues have reworked or challenged modernist ideas, contributing to an artistic culture which is now loosely labelled 'postmodern'.

In Case Study 8 on the Parisian avant-garde and the idea of 'feminine' art, I consider why and how gender issues might be seen to be relevant or useful in any study of early twentieth-century modernism. Within the visual arts, several important critics have been identified with the establishment and consolidation of theories of modernism, among them the influential American writer Clement Greenberg, whose much-quoted essay of 1960, 'Modernist painting', is often seen to have provided a clear rationale for a formalist modernist project.[3] Put very simply, Greenberg was concerned in this article to emphasize the need for 'self-criticism' and 'purity' within the discipline of art. He argued that an important characteristic of modernist art was the tendency to entrench itself more firmly within 'its area of competence', by which he meant those qualities which are unique to the medium of art, in particular the formal qualities of the painted surface. Like many theorists of modern art, Greenberg was concerned not only to sort out criteria for and a definition of 'modernism', but also to establish these criteria as a mark of the inherent 'quality' of works of art. Such theories of modernism then could be seen to establish an alternative canon – or value system – to those previously canonical forms of art which they are seeking to undermine.

[2] In 1973 Carol Duncan first published an influential essay, 'Virility and domination in early twentieth-century vanguard painting', in which she argued that many of the so-called avant-garde innovative works of the Fauves, Cubists and German Expressionists are in fact concerned with the assertion of the virility and domination of the male artist, a process which ultimately subjugates women. Reproduced in Broude and Garrard, *Feminism*, pp.292–313.

[3] This essay is discussed in the introduction to Wood, *The Challenge of the Avant-Garde* (Book 4 of this series).

Please look at Plate 147, *The Grounds of the Château Noir* **by Paul Cézanne (1839–1906). Cézanne's work is often identified as central to the development of late nineteenth- and early twentieth-century modernism. If we follow a definition of modernism which prioritizes formal innovation and the need to rework the language of art, what aspects of this painting would you single out for discussion?**

Plate 147
Paul Cézanne, *The Grounds of the Château Noir*, *c.*1900, oil on canvas, 90.7 x 71.4 cm, National Gallery, London. Reproduced by permission of the Trustees of the National Gallery, London

Discussion

The painting represents a view through the trees, broken by an outcrop of rocks. However, this is not a naturalistic image; there is no conventional use of modelling or aerial perspective to suggest three-dimensional space. Rather, the scene seems to have been built up with juxtaposed brushstrokes of different colours and tones, suggesting a series of planes and lines. Although some image of nature and some sense of depth are suggested, we are made aware of the specific *techniques* of painting, the visible application of paint on the canvas surface. We are therefore made aware of what Greenberg called the 'orientation to flatness' of modernist painting. Cézanne's technique *both*

reveals that 'flatness' (in the visible brushwork on a flat canvas) *and* evokes or suggests a sense of space and recession. Within a Greenbergian modernist account of early twentieth-century painting then, these are the factors which help to distinguish Cézanné as 'modern' or 'innovative', which show him to be seeking painterly equivalents, rather than naturalistic representations, of the natural world around him.

◆◆◆

Many art historians working during the last twenty to thirty years (some of them feminists) have suggested that if we are to examine critically the narratives of modernism, and the art works which they describe and interpret, we will have to unpick the value systems upon which they are based. For example, we will need to look critically not just at the ideas of technical innovation involved (such as those discussed above), but also at the concepts of aesthetic quality, genius, avant-gardism, etc. which have become so central to most histories of modern art. In the process we may uncover ideologies and cultures which marginalize women, or which devalue notions of 'feminine' art. But the cultural history which we seek to explore in this study of the relationship of gender and modernism is, of course, complex and shifting. My own view is that for the purposes of our study it is useful to broaden out our concept of 'modernism' to embrace some of these complexities. In other words I am suggesting that there is no one single intrinsic theory of modernism we can uncover or 'reveal'. While critics such as Greenberg have mapped out their own influential theoretical positions, they also participated in a history made up of many forms of artistic practice and cultural activity, which has increasingly involved the participation of (limited numbers of) women as the twentieth century has progressed. If modernism is understood more broadly as a complex network of ideas, debates, artistic practices and struggles around the idea of the 'modern', then there is, I believe, an important role for feminist art history in the study of this cultural network or discourse. A broader concept of modernism allows us to look at some of the different artistic groups and ideas which contributed to contemporary debates about what constituted a desirable modern art. We can then ask other questions such as: how did most women artists position themselves in relation to so-called avant-garde styles and modernist groups? (Did they see themselves as working outside such groups, or did some women seek to be identified on the margins of avant-garde movements?) What aesthetic or gender issues were seen to be at stake when women rejected or participated in the practices adopted by these groups? Given that modernist ideas are often associated with some notion of aesthetic and social freedom, did modernism actually offer women some form of freedom? Are any gendered assumptions about art revealed in the language of modernist art criticism? These are precisely the sorts of questions which I will address in the case study which follows.

References

Broude, Norma and Garrard, Mary D. (eds) (1982) *Feminism and Art History: Questioning the Litany*, New York, Harper and Row.

Wood, P. (ed.) (1999) *The Challenge of the Avant-Garde*, New Haven and London, Yale University Press.

The Parisian avant-garde and 'feminine' art in the early twentieth century

GILL PERRY

Most histories of modern art tell us that those artists' groups which have become the focus of French and European modernism before the war, notably the Post-Impressionists, the Fauves and the Cubists, consisted almost exclusively of male artists who exhibited together in the 'independent' salons[1] or in smaller private galleries. The origins of many of these groups can be traced to art academies and exhibiting societies, institutions within which (mostly) male students and artists got together to practice and develop their radical interests. In France the most prestigious government sponsored academy, the Ecole des Beaux Arts, excluded women until 1897. Before this time the only state-funded art school for women in Paris was the Ecole Nationale pour les Jeunes Filles, in which the curriculum emphasized the study of the decorative arts rather than what was seen to be the more 'masculine' pursuit of high art. At the end of the nineteenth century, then, most women who sought an art education which would equip them for a career as a professional artist studied at one of the many private academies, known as the *académies libres* or *académies payantes*, which offered classes – sometimes segregated – for women. The Académie Julian, founded in 1868, was one of the most famous schools to provide studios for women. It was one of the few places where women could study from the nude in late nineteenth-century Paris, but fees for female students were as much as twice those for male colleagues. By the early 1900s increasing numbers of private academies had opened to women, many of them offering mixed studios, including the Académie Colarossi, which attracted large numbers of foreign students.

The point to note here is that although rarely associated with the much publicized avant-garde groups, many women artists were seeking careers as professional artists in turn of the century Paris. Tamar Garb has shown that even before opportunities for art training began to open up for women in the late 1890s, many women were negotiating roles as professional artists, although these often involved membership of separate and gender-specific groups, such as the Union des Femmes Peintres et Sculpteurs, founded in 1881 (Garb, *Sisters of the Brush*). Although this association lacked permanent premises, it enjoyed official (i.e. government) approval and worked to promote women's art and exhibiting opportunities, holding annual

[1] Since its foundation in 1884 the Salon des Indépendants was regarded as a relatively liberal exhibiting salon, open to anyone. Unlike most other contemporary exhibiting societies, it did not have a jury system, an aspect which encouraged submissions from women artists who might otherwise have encountered some professional prejudice. The other independent salon patronized by 'progressive' artists was the Salon d'Automne, founded in 1903, which, as its name suggests, held shows in the autumn.

exhibitions from 1882. As Garb has shown, members of the Union campaigned energetically for women's admittance to the Ecole des Beaux Arts and helped to increase public awareness of 'women's issues' (ibid.). By 1900 debates had already been aired about the need for professional opportunities for women artists, the nature of 'feminine' art and the gendering of notions of creativity. And with the enormous expansion in private facilities for art training, the conditions and circumstances of artistic production for women were changing. Many contemporary writers noted the dramatic increase in the numbers of women artists going to Paris to study during the first decade of the twentieth century. A reviewer in the London art magazine, *The Studio,* of 1903 reported, 'Lady art students are going to Paris in increasing numbers', acknowledging that although they have less freedom than their male colleagues, Paris is sufficiently bohemian 'for the most enterprizing feminine searcher after novelty' (Holland, *The Studio*). Thus the reviewer identifies the appeal of Paris for such women as residing in the 'novelty' or newness (presumably associated largely with the art world) which the environment provides. It is significant that women should be identified here as seeking after such qualities more often associated with the male avant-garde. As the city increasingly came to be seen as the cradle of European avant-garde art, it attracted many foreign students (both male and female) from Europe and America. It was seen by many artists to provide working spaces in which progressive attitudes towards both artistic and social conventions could flourish. The idea of an artistic 'bohemia' with its associations of *déclassement* (classlessness) and sexual freedom was thriving in pre-war Paris, and often focused around the art studios and café culture of Montmartre and Montparnasse. But these associations beg the question of whether or not such bohemian attitudes actually offered greater freedoms to women artists to practise or become involved with avant-garde styles. A related question which I want to address is: did these changing circumstances (educational, professional, social) affect the ways in which women chose to paint? In other words, did the historical shifts that I have been describing affect the artistic conventions that women painters adopted?

Needless to say, there are no easy answers to these questions, but I want to set up a framework for discussing them by looking at some works from this period by male and female artists who adopt a theme commonly associated with early twentieth-century modernism: the female nude.

Modernism, gender and the female nude

As was suggested in the introduction to this book, there is sometimes more opportunity for talking about gender issues when (unlike the Cézanne landscape we have been looking at) we are concerned with works that include images of men and women. Whereas landscapes without figures may allow us to identify gendered associations within the critical writing which surrounded the art work (for example, a certain type of idealized landscape, or an ideal of nature seen to be 'feminine', or the way in which the paint is applied might be seen to have a 'feminine' quality) or gendered notions of technique or genre, the depiction of men or women within an image also allows us to analyse *both* how gender is represented and what aesthetic or cultural associations such a representation might suggest.

In my earlier case study on women artists and the idea of a 'masculine' art practice within the Royal Academy of Art in eighteenth-century Britain, I discussed some of the historical conditions affecting the study of male and female nudes, and the exclusions which these involved for women artists. We saw that such exclusions encouraged a view of women artists as best qualified to work in the genres of still life and portraiture. It's worth noting here that although female models were used quite frequently in England during the eighteenth and nineteenth centuries, in France in the state patronized Académie Royale de Peinture et de Sculpture, naked female models had been forbidden during the seventeenth and eighteenth centuries. However, in nineteenth-century France the female nude increasingly became a subject for 'academic' study. As Lynda Nead has written:

> In very general terms, it can be said that the unclothed male model dominated the life class in European academies and studios up until the late eighteenth century, but that around this time there was a perceivable shift in emphasis to the study of the unclothed female model and that by the middle of the nineteenth century the female nude had become the dominant form in European figurative art.

(*The Female Nude*, p.47)

While the theme was increasingly visible in various mythological or historical disguises on the walls of the annual state sponsored exhibition, the Salon des Artistes Français (Plate 153), women's access to the life class (i.e. studying from male and female models) was still restricted in France during the second half of the nineteenth century. Studying in private academies or through private tutors provided women's main access to the study of this genre. However, with the educational shifts which I have described around the turn of the nineteenth century the life class was increasingly opened up to women in both public and private academies (Plate 148). Moreover, an interest in the subject of the female nude relieved of her conventional mythological trappings, increasingly came to be seen as an indication of the modernity of the (male) artists concerned. Thus several works which have now come to be seen as icons of early modernist painting, such as, for example, Matisse's *Luxe, calme et volupté*, 1904–5 (Plate 149), or Picasso's *Les Demoiselles d'Avignon* (1907, Museum of Modern Art, New York), are representations of this theme.

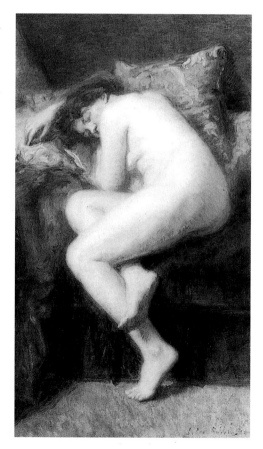

Plate 148 Lucy Lee-Robbins, *Le Repos*, 1909, 45 x 33.5 cm (shown in Paris Salon of 1909). Photo: Roger-Viollet, Paris.

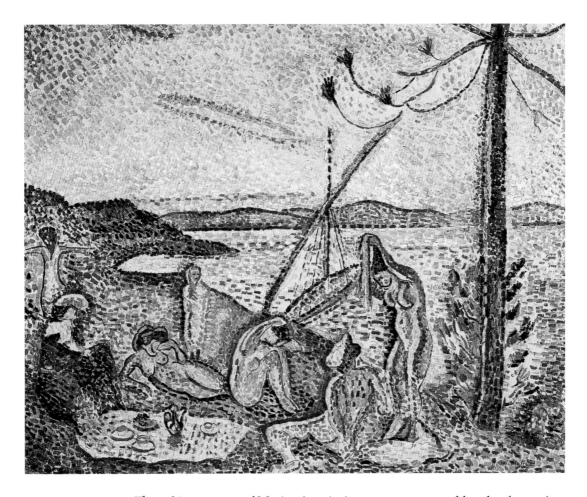

Plate 149 Henri Matisse, *Luxe, calme et volupté,* 1904–5, oil on canvas, 99 x 118 cm, Musée d'Orsay, Paris. Photo: copyright Réunion des Musées Nationaux, Paris, © Succession H. Matisse/DACS, London 1999.

The subject-matter of Matisse's painting suggests several levels of meaning. First, it could be seen as a modern leisure scene: a group of naked women appear to be relaxing and picnicking on the beach, which we know to be St Tropez. But the subject-matter is also related to the conventional pastoral theme of 'bathers' in a landscape, which can be traced back to the work of Poussin,[2] and which was reworked by many French Symbolist painters around the turn of the century (Plate 150). In fact the title of the work suggests an allegorical meaning. 'Luxe, calme et volupté' (luxuriance, calm and voluptuousness) is taken from the chorus of a poem by Charles Baudelaire, *L'Invitation au Voyage*, which describes an escape to an Arcadian land of sensuality and calm. At the time such allegorical and poetic meanings were associated with nineteenth-century academic traditions in painting. For a contemporary audience, however, these conventional associations jarred with what was seen as the less orthodox handling of the work. Although some of the female figures are painted to suggest rhythmic sensual forms reminiscent of some earlier Symbolist works on this theme (Plate 150), others appear crudely drawn or simplified. In his use of visible brushmarks of bright colour Matisse has adapted a Neo-Impressionist (sometimes called 'pointilliste') style more commonly found in the work of Seurat or Signac from this period (Plate 151).

[2] Poussin's use of pastoral themes is discussed in Perry and Cunningham, *Academies, Museums and Canons of Art* (Book 1 of this series).

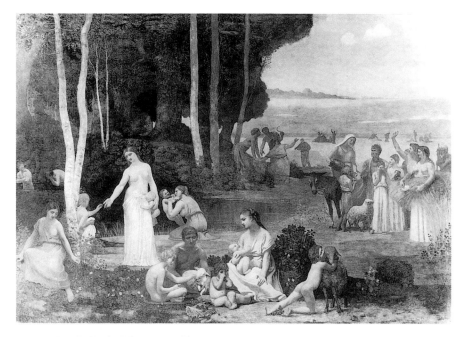

Plate 150 Puvis de Chavannes, *L'Été*, 1873, oil on canvas, 30.5 x 50.7 cm, Musée d'Orsay, Paris. Photo: copyright Réunion des Musées Nationaux, Paris.

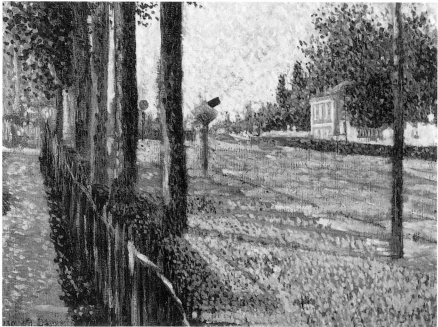

Plate 151 Paul Signac, *The Railway Junction at Bois-Colombes*, 1886, oil on canvas, 34 x 47 cm, Leeds City Art Gallery.

Please look at Matisse's *Luxe, calme et volupté* (Plate 149).

What kind of image of the female nude (in terms of Matisse's technique and his interpretation of subject-matter) is suggested in this painting?

Discussion

Matisse's reworking of this technique appears deliberately crude and even unfinished, precisely the qualities which contributed to contemporary perceptions of the work as innovative or 'modern'. In terms of the modernist narrative which I mapped out earlier, Matisse's work could be seen to be

concerned with the specific characteristics of the medium of painting itself. He reveals the painted surface through his seemingly crude application of paint, creating an image which appears decorative – even distorted – rather than illusionistic. This work is often recognized as an early example of Fauve painting, a highly-coloured and controversial style which broke with the conventions of naturalistic representation and achieved notoriety as a modern movement around 1905–6. For example, controversial reviews accompanied a show of paintings by Matisse and his friends in the 1905 Salon d'Automne, including Matisse's *Woman with a Hat* (Plate 152), which appeared to some critics as unfinished or 'childlike' in its crude technique.[3]

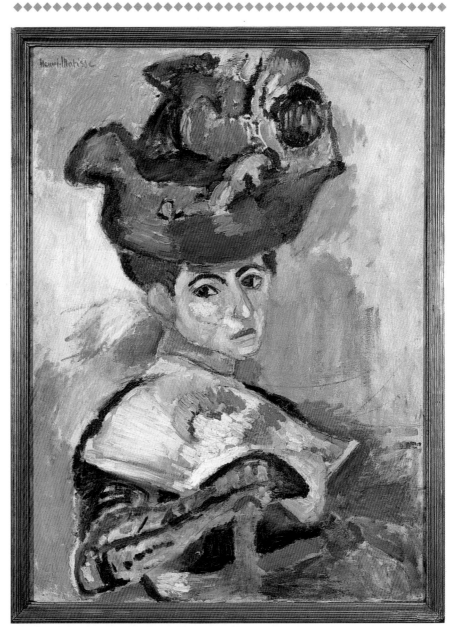

Plate 152 Henri Matisse, *Woman with a Hat,* 1905, oil on canvas, 80.6 x 59.7 cm, San Francisco Museum of Modern Art. Bequest of Elise S. Haas, © Succession H. Matisse/DACS, London 1999.

[3] See fuller discussion of the reception of this exhibition on pp.214, 219.

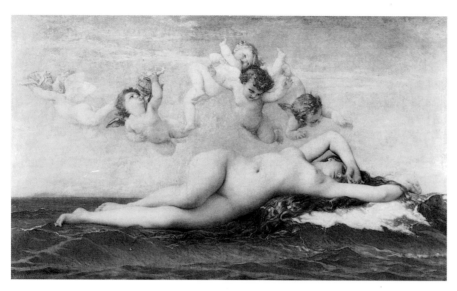

Plate 153
Alexandre
Cabanel, *Birth of
Venus*, 1863, oil
on canvas,
103 x 225 cm,
Musée d'Orsay,
Paris. Photo:
copyright
Réunion des
Musées
Nationaux,
Paris.

The difficult question to answer here is: how does the artfulness – the visible use of simplified lines and bright colour areas – affect our reading of the female nudes depicted in the painting? On one level it belongs to a well established tradition of male artists representing female nudes in passive and erotic poses, as the objects of male sexual desire. The annual Salon des Artistes Français was full of such images during the second half of the nineteenth century (Plate 153) including Jamin's *Brenn and his Share of the Plunder*, which we discussed earlier (Plate 16). We saw that the voyeuristic narrative and the realistic technique with which it was painted made Jamin's work especially easy to interpret in terms of an objectifying 'male gaze'. Although some of the figures in Matisse's painting assume poses which seem to accentuate their sexual availability, it could also be argued that the distortions, simplifications and strange colouring effects give some of these figures a physical oddness, a disturbing or unreal quality which may undermine any easy perception of these women merely as objects of male sexual desire. Put another way, can artistic processes interfere with or 'mediate' the social and sexual politics which may have informed the work? Or can the bodily distortions themselves symbolize a misogyny behind modernist practice, a tendency to represent women as defaced or deformed bodies? I'm not suggesting there are any obviously right or wrong answers here, but rather seeking to open up some of the conflicting arguments and issues which have preoccupied art historians concerned with gender issues.

Although their works tend to be less well known in most histories of modernism, many women artists were working on the theme of the female nude around the same time that Matisse produced *Luxe, calme et volupté*. In fact two years before Matisse showed this painting, Jacqueline Marval (1866–1932) had shown her *Odalisques* of 1903 (Plate 154) in the Salon des Indépendants. The 'odalisque' theme, with its associations of an oriental harem, had a well established pedigree in the work of both traditional and more innovative artists in the mid to late nineteenth century, and the canvases of Ingres (Plate 155) and Delacroix on this theme are often cited as an influence on the work of modernist artists such as Matisse or Picasso (Perry *et al.*, *Primitivism*, Chapters 1 and 2).

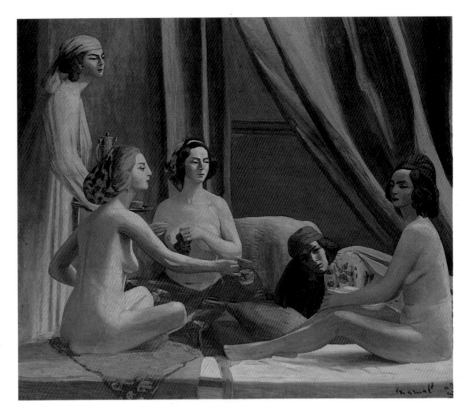

Plate 154
Jacqueline
Marval, *Les
Odalisques*, 1903,
oil on canvas,
194 x 230 cm,
Musée de
Grenoble.

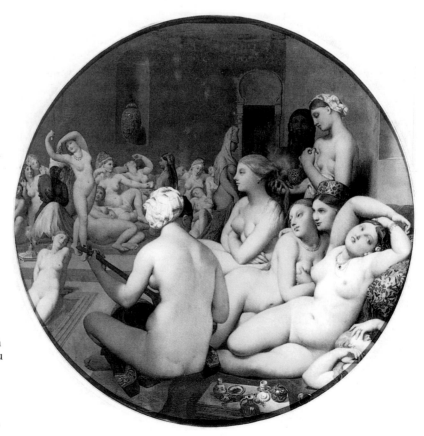

Plate 155 Jean-
Auguste-
Dominique
Ingres, *La Bain
Turque (Turkish
Bath)*, 1816, oil on
canvas, Musée du
Louvre, Paris.
Photo: copyright
Réunion des
Musées
Nationaux, Paris.

Appropriating the 'gaze'

Developments in feminist art history have encouraged us to associate the odalisque theme, particularly in its nineteenth-century variations, with a voyeuristic objectification of the female body for (largely) masculine consumption. The theme of the eastern harem was, of course, replete with associations of available feminine sexuality, and it often played on the colonial myth (constructed by a western audience) of the uninhibited sexuality of oriental women.

Although largely the prerogative of male artists who had access to the training, the models and the travel required for the production of these sorts of subjects in the late nineteenth century, Marval's work reveals a woman artist appropriating this popular contemporary theme. The use of such subject-matter could be seen as evidence of the changing conditions of artistic production for women around the turn of the century which I have been describing. Yet hers is a curious reworking of the genre. This group of women, with their lifeless white bodies and cold expressions, appear disturbingly still and stiff, without the more relaxed – and one might argue voyeuristic – sensuality often associated with the odalisque theme (Plate 155). Moreover, the models appear to be modern western women participating in an oriental ritual. When the painting was first exhibited in 1903 at the relatively progressive exhibiting society, the Salon des Indépendents, it aroused much critical interest, and it was subsequently hailed by some critics as an important 'modern' work. Moreover it was selected as one of the French exhibits in the famous New York Armory show of 1913, a major exhibition claiming to represent the state of modern art in Europe and America. Although the work did not achieve the notoriety of some later Fauve works, it does seem to have been seen as unconventional. My view is that Marval's painting caught the attention of the critics because it was both rooted in a conventional and popular genre, and yet also suggested some strange or jarring associations of western and non-western, and of the traditional and the modern. What is especially significant in the context of my arguments is that a work by a woman artist could be claimed as 'modern' in this way.

Another painting by a woman artist on a similar theme, Emilie Charmy's *La Loge* (Plate 156), may help further to open up these sorts of issues. Although little known today, Charmy (1878–1974) developed a reputation as a successful Fauve painter in the late 1900s and 1910s, and exhibited widely in the 1920s and 30s (Perry, *Women Artists*). Despite the title – loosely translated as *Artists' Dressing Room* – the subject-matter of this painting suggests the interior of a brothel. Naked women are shown sitting around in groups, as if waiting for clients. Some are naked apart from knee-high black stockings, recognizable signifiers of prostitution, which are often to be found in the works of male artists who regularly painted the theme in the late nineteenth century, among them Toulouse Lautrec and Degas (Plate 157). But the brothel was an unusual theme for a woman artist to adopt at this time, and raises some difficult questions about how (if at all) women artists could participate in contemporary modernist practice around the turn of the nineteenth century. Like most women able to work as artists during this period, Charmy came from a respectable middle-class background, and it is extremely unlikely that she would have visited a brothel herself. This raises the questions: why and how did she choose to paint this theme?

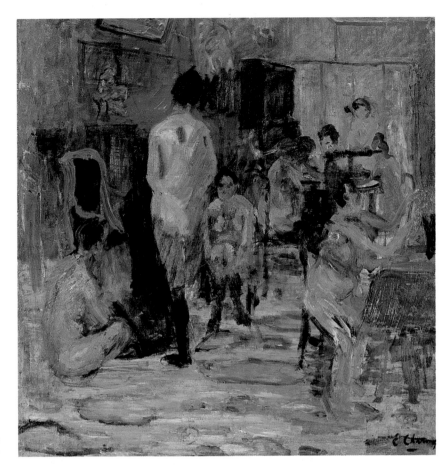

Plate 156 Emilie
Charmy, *La Loge*,
*c.*1902, oil on
board, 72 x 71 cm,
private collection.

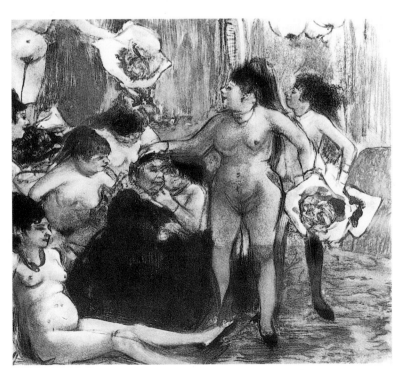

Plate 157 Edgar
Degas, *The
Madame's Birthday*
(one of a series),
*c.*1870, monotype,
location unknown.
Photo: Roger-
Viollet, Paris.

Within feminist art history much work has now been done on the art of late nineteenth-century women Impressionists such as Berthe Morisot and Mary Cassatt (Plates 158 and 159), showing how their chosen subjects (such as middle-class domestic and leisure scenes) and methods of depiction can reveal gendered and class-bound cultures. In an important essay 'Modernity and the spaces of femininity' published in 1988, Griselda Pollock argues for the need to deconstruct some of the 'masculinist myths of modernism' in the work of these two women artists. She suggests that, given the restrictions of class and gender, women's experiences of modernity and contemporary urban life would not have been the same as those of contemporary male artists. Those urban spaces, such as the café concerts, bars and brothels, which have come to be seen as part of the iconography of late nineteenth-century modernity, were largely inaccessible to middle-class women. Within Impressionist painting, then, the representation of such spaces invokes – or suggests – a masculine spectator. Pollock argues that the 'contrived orders of sexual difference' help to structure what and how middle-class women artists such as Cassatt and Morisot actually painted.[4] In contrast to her male colleagues, their subjects are largely those of bourgeois leisure and recreation, and private and domestic activities familiar in middle-class households; they represent the social and pictorial 'spaces of femininity'.

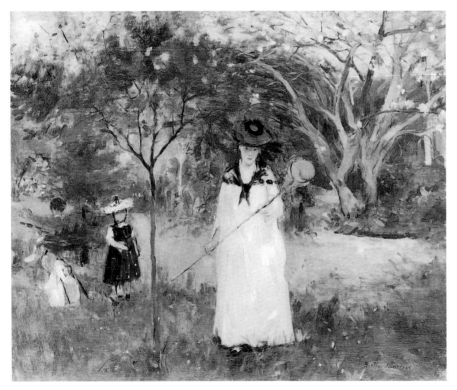

Plate 158 Berthe Morisot, *Butterfly Hunt*, 1874, oil on canvas, 47 x 66 cm, Musée d'Orsay, Paris. Photo: copyright Réunion des Musées Nationaux, Paris.

[4] Pollock also develops her argument further in some works to identify a parallel between the social space of the represented and the pictorial space of the represented (see especially *Vision and Difference*, p.63).

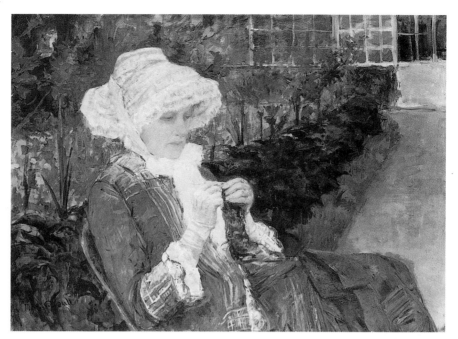

Plate 159 Mary Cassatt, *Lydia Crocheting in the Garden at Marly*, 1880, oil on canvas, 66 x 94 cm, Metropolitan Museum of Art, New York. Photo: The Metropolitan Museum of Art, New York, Gift of Mrs Gardner Cassatt, 1965. (65.184)

Many of Charmy's earliest canvases, painted in Lyon in the 1890s, would seem to fit this model. A large number depict aspects of bourgeois domestic life, and are inhabited largely by women who are shown reading, sewing, playing music or chatting (Plate 160). However, shortly before moving to Paris in 1903, she began working on *La Loge*, a painting which does not seem to fit the 'spaces of femininity' model. This choice of subject-matter suggests that by the early twentieth century some of the models or paradigms which have dominated feminist art history of the nineteenth century may need adjusting. Although she is unlikely to have visited a brothel, she would have had access to nude female models through working in the studio of her private tutor, Jacques Martin. And her reworking of the theme suggests a positive interest in participating in the production of a 'modern' iconography. Apart from access to art journals and exhibitions of contemporary art which would have helped to familiarize her with the genre, when she moved to Paris her participation in the Salon des Indépendants and the Salon d'Automne gave her direct access to the work of 'progressive' male artists involved with these salons, and to the bohemian culture with which such groups were associated.

Does *La Loge* reveal Charmy as participating in a voyeuristic fascination with the commodity of female sexuality which can be found in the work of some contemporary male artists on this theme, including Degas's famous brothel monotypes (Plate 157)? I want to argue that although she occupies a space traditionally reserved for the 'masculine' spectator, Charmy has adjusted her focus to suit her own interests as a woman involved in 'modern' practices. Influenced by Impressionist and Post-Impressionist techniques, her paint is loosely applied and her figures ill-defined. Unlike a Degas brothel monotype in which women are often shown in awkward positions or lined up across the picture space with their breasts and pubic areas emphasized, Charmy's figures are not overtly sexualized or eroticized. Some of them are barely recognizable as nudes. Thus the technique seems to help to establish a distance between the spectator and the groups of figures, removing any sense of

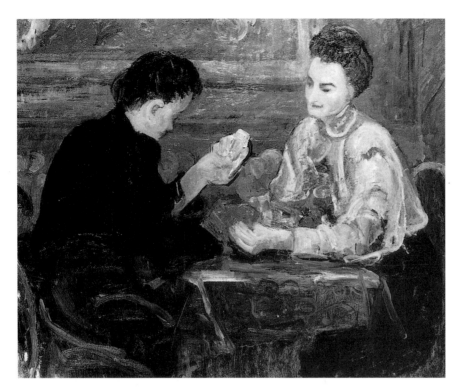

Plate 160 Emilie Charmy, *Women Playing Cards*, *c*.1898, oil on canvas, 76 x 95.5 cm, private collection.

available female sexuality usually associated with this subject. We could argue that in adopting a contradictory viewing position (i.e. that of a woman viewing female sexuality) and a modern technique, she has produced an ambiguous version of a popular contemporary theme. In terms of the theories of looking which we have been discussing in this book, we could argue that Charmy has appropriated and reworked a 'male gaze', removing some of the erotic pleasure involved in the part of the viewing subject.

It is likely that Charmy saw *La Loge* as evidence of her modern artistic interests which she intended for public view. It is one of several works proudly displayed in a studio photograph taken in Paris in 1906 (Plate 161), and was later sold. This studio photograph (showing the artist posed with her works) belongs to an established genre often used by male artists and represents a claim for professional status. If we look closely at the work displayed around her, which includes still lives, nudes and domestic themes, all painted in a seemingly bold, loose technique, we can see that this photographic record is also a claim for recognition as a modern artist.

I have suggested that Charmy's adaption of a theme which has come to be seen as an iconographic signifier of late nineteenth-century modernity was part of a broader historical shift in the art of the early twentieth century. Women artists increasingly engaged with themes and techniques traditionally associated with the male avant-garde. But we should note that the historical patterns are complex, and that different women artists working at this time developed the theme of the nude in many different ways. Despite the oddness of *Les Odalisques*, Marval, for example, produced many nude studies which now seem eroticized and stylized, and provide little evidence of a woman artist deliberately transforming a 'masculine' language of looking at the female body (Plate 162).

Plate 161 Studio photograph of Emilie Charmy, 1906, private collection.

Plate 162 Jacqueline Marval, *La Bohemienne*, 1921, oil on canvas, 130 x 200 cm, private collection.

Feminist art history has tended to rehabilitate, or invest with value, works by women artists who worked outside the key modernist movements but who seem to have produced more transgressive or unconventional images of femininity and female sexuality than those of contemporary male painters. Thus the boldly painted, heavily dimensioned and sometimes strangely asexual nudes of Suzanne Valadon from the 1910s and 20s (Plates 163 and 164) have attracted the interest of many feminist art historians. It has been argued that these powerful yet unidealized nudes could actually be seen to refuse an eroticized 'male gaze' (Mathews, 'Returning the gaze', pp.415–30). Given

this complexity and the different arguments which are raised, perhaps the point to note here is that although it has traditionally been associated with the innovations of male modernists, the female nude, in its various iconographical variations, became an important focus for many women artists engaging with problems of representation both outside and on the fringes of modern movements.

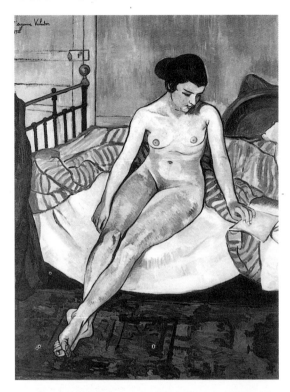

Plate 163 Suzanne Valadon, *Nude with Striped Coverlet*, 1922, oil on canvas, Musée d'Art Moderne de la Ville de Paris. © Phototheque des Musées de la Ville de Paris.

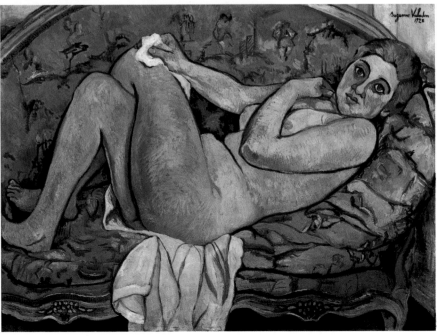

Plate 164 Suzanne Valadon, *Reclining Nude*, 1928, oil on canvas, 60 x 80.5 cm, The Metropolitan Museum of Art, New York. Robert Lehman Collection, 1975 (1975.1.214). Photo: © 1986, The Metropolitan Museum of Art.

Avant-gardism and 'feminine' art: women and 'wild beasts'

Histories of early twentieth-century modernism, in particular the Fauve and Cubist movements, have tended to focus on the role of the controversial and much-publicized exhibitions which launched or established the radicalism of the groups in question. For example, histories of Fauvism tend to see the exhibits by Matisse and his friends in the Salon des Indépendants and the Salon d'Automne of 1905 and 1906 as the key events of the movement. I cited earlier the critical outrage which greeted the daring and violently coloured works by this group in one of the central rooms (the *cage centrale*) of the 1905 Salon d'Automne (Plates 152 and 165). Such critical responses have helped to consolidate an avant-garde or modernist status for the Fauve work of Matisse and his friends. The term *les fauves* or 'wild beasts' was first used by the art critic Louis Vauxcelles to describe the exhibits in the *cage centrale* and to emphasize their contrast with some of the more conventional sculptures in the show (*Gil Blas*, 23 March 1905). More recently it has been argued that we must be cautious of overplaying the myth of an outrageous group of 'wild beasts' suddenly appearing on the art scene and shocking the public. Many of the characteristics of painting which we now identify as Fauve, which include bright, non-natural colour, distortions and loose application of paint, were in evidence before the shows of 1905 and 1906, and the critical responses to the show were more mixed than some of the histories suggest (Oppler, *Fauvism Reexamined*). It has also been argued that many of the subjects favoured by the Fauve painters, such as landscapes, bourgeois leisure scenes and portraits, were hardly innovatory for they echoed the favoured themes of the late nineteenth-century Impressionist painters.

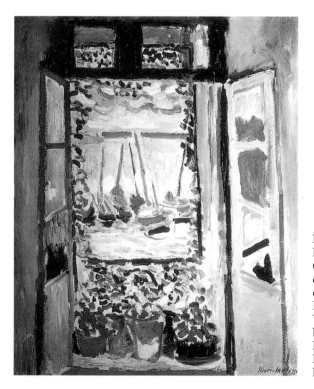

Plate 165 Henri Matisse, *Open Window at Collioure*, 1905, oil on canvas, 54 x 46 cm, collection of Mrs John Hay Whitney, New York. Photo: The Bridgeman Art Library, London, © Succession H. Matisse / DACS, London 1999.

As I suggested earlier, the controversial exhibitors in these much publicized shows were exclusively male. Matisse, Derain, Vlaminck, Marquet, Manguin and Camoin (Plates 165–168) are among the Fauve artists who showed paintings in these shows, and whose work is now best known. Moreover, the representation of these artists as 'wild beasts' carried with it connotations of savage or violent behaviour which was more easily associated with the idea of a 'radical' male artist. According to this idea, the creative process which produced the seemingly loose brushwork and violent colours of Fauve canvases involved some kind of wild, instinctive expression.

Plate 166 André Derain, *The Old Tree*, 1904–5, oil on canvas, 41 x 33 cm, Musée National d'Art Moderne, Paris. Photo: Musée National d'Art Moderne, Centre Georges Pompidou, Paris, © ADAGP, Paris and DACS, London 1999.

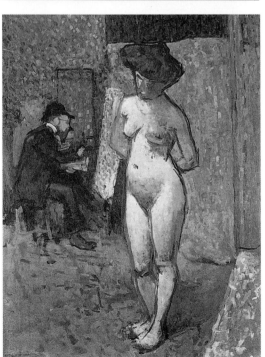

Plate 167 André Derain, *View of Collioure*, 1905, oil on canvas, 66 x 83 cm, Museum Folkwang, Essen. © ADAGP, Paris and DACS, London 1999.

Plate 168 Albert Marquet, *Matisse Painting in Manguin's Studio*, 1905, oil on canvas, 97.9 x 70.3 cm, Musée National d'Art Moderne, Paris. Photo: Musée National d'Art Moderne, Centre Georges Pompidou, Paris, © ADAGP, Paris and DACS, London 1999.

However, around the time of these now notorious exhibitions, there were in fact many women artists who were painting similar subjects and working in comparable styles which we might loosely label 'Fauve'. These include Emilie Charmy, Jacqueline Marval, Marie Laurencin, Jeanne Hébuterne and Sonia Delaunay (Plates 169–175), all of whom showed in the independent salons. Both Charmy and Marval were friendly with Matisse and his colleagues, and both showed canvases in the notorious Salon d'Automne of 1905, but their submissions were hung separately from those of Matisse's group in the *cage centrale*. Exhibits in both independent salons were usually hung as many as five or six deep, and the works of lesser-known artists were often given less favourable positions. Access to better hanging space could be helped by having influential friends, or by being involved oneself on the relevant salon committee. It is significant to note that in 1905 Matisse was on the committee of the Salon d'Automne and was chairman of the hanging committee of the Salon des Indépendants.

Plate 169 Sonia Delaunay, *Young Finnish Girl*, 1907, oil on canvas, 80 x 64 cm, Musée National d'Art Moderne, Paris. Photo: Musée National d'Art Moderne, Centre Georges Pompidou, Paris.

Plate 170 Jeanne Hébuterne, *Self-Portrait*, 1916, oil on board, 50 x 33.5 cm, Musée du Petit Palais, Geneva.

Plate 171 Marie Laurencin, *Portrait of the Artist's Mother*, 1905, oil on canvas, 41 x 33 cm, Ashmolean Museum, Oxford. © ADAGP, Paris and DACS, London 1999.

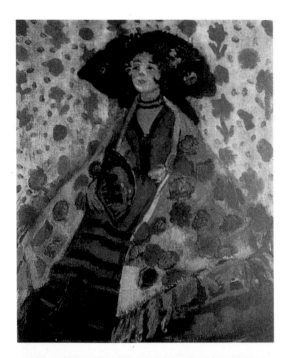

Plate 172 Jacqueline Marval, *L'Espagnole (The Spanish Woman), c.*1904, oil on canvas, 55 x 46 cm, private collection.

Plate 173 Emilie Charmy, *Seated Pregnant Woman,* 1906–7, oil on board, 106.5 x 74.5 cm, private collection.

Plate 174 Emilie Charmy, *The Bay of Piana, Corsica*, 1906, oil on canvas, 17 x 26 cm, private collection.

Plate 175 Emilie Charmy, *Woman in a Japanese Dressing Gown*, 1907, oil on canvas, 81 x 68 cm, private collection.

We have seen that the group label 'Fauve' was not actively adopted by Matisse and his friends; rather it was a critical concept initially imposed on their work by Louis Vauxcelles, and we should therefore be cautious about constructing a clearly defined picture of the Fauve group and its chronological limits. However, evidence from exhibition catalogues, reviews and contemporary accounts does suggest that Matisse helped to group around him artists working in similar styles, and encouraged the organization of a recognizable exhibiting circle. Women painters who adopted similar styles were rarely included in the group hanging space and collective studio activity and were not mentioned in critical representations of so-called Fauve artists. The self-image of these 'wild beasts' seems, then, to have involved some sense of largely masculine professional and creative roles. This is not to argue that conscious decisions were made to keep women out of professional spaces. Access to such exhibiting space and studio groups was rarely sought by artists such as Charmy or Marval, for whom a more marginal relationship with professional male colleagues was regarded as the cultural norm. In what sense, then, could the actual artistic practices of these women be described as Fauve?

Please look at the following reproductions:

Henri Matisse, *Open Window at Collioure*, 1905 (Plate 165)

Henri Matisse, *Luxe, calme et volupté*, 1905 (Plate 149)

André Derain, *View of Collioure*, 1905 (Plate 167)

André Derain, *The Old Tree*, 1905 (Plate 166)

Emilie Charmy, *The Bay of Piana, Corsica*, 1906 (Plate 174)

Emilie Charmy, *Seated Pregnant Woman*, 1906 (Plate 173)

Jacqueline Marval, *L'Espagnole*, c.1904 (Plate 172)

Marie Laurencin, *Portrait of the Artist's Mother*, 1905 (Plate 171)

(I have included in this list works by Matisse and Derain which were shown at the Indépendants and the Salon d'Automne in 1905.) Looking at these reproductions as a group, are there any formal characteristics which they all seem to share? Are there any grounds for arguing that the techniques employed in these works reveal gendered characteristics (i.e. could they be seen as 'masculine' or 'feminine')?

Discussion

In several of these works, including Matisse's *Luxe, calme et volupté* and *Open Window at Collioure*, Derain's *View of Collioure* and Laurencin's *Portrait*, the artists have used dots of bright separated colour influenced by Neo-Impressionist techniques. As we saw in our earlier discussion of the Matisse, this somewhat crude reworking of Neo-Impressionist techniques, sometimes combined with flatter areas of rich colour, is to be found in many early Fauve paintings. However, this Neo-Impressionist separation of dots of colour is absent in Derain's *The Old Tree*, Charmy's *The Bay of Piana* and *Seated Pregnant Woman*, and Marval's *L'Espagnole*, which are characterized by flatter areas of bright colour, sometimes applied with loose, bold brushwork. In several of the paintings, such as Matisse's *Open Window at Collioure*, both techniques are employed, and are often referred to as 'mixed technique'.

In terms of the methods of painting employed, there is no visible or consistent distinction between the sorts of techniques employed by male or female artists. If you did not know the gender of the artists involved, I suggest that it would be impossible to construct an argument which identified different sorts of methods being used by the women artists. Some of the historical associations discussed earlier in this book, according to which women were thought better suited to more 'delicate', 'sensitive' or 'decorative' styles, would not seem to be borne out by the evidence of these works.

◆◆

Yet there were many contemporary critics for whom a sense of 'masculine' and 'feminine' modes of expression were part of a conceptual apparatus for understanding modern art. When writing about Charmy's work (rather later) in 1921, the critic Roland Dorgelès wrote that she 'sees like a woman and paints like a man' (Dorgelès, *Emilie Charmy*). He was writing about works which included some of her Fauve canvases, and was full of praise for her bold handling of paint. But implicit in his division of her work into 'masculine' and 'feminine' aspects was the view that her bold use of thick impasto heavily applied (as is clearly illustrated in, for example, her *Seated Pregnant Woman*, Plate 173) was more appropriate for a male artist. In contrast, he saw her choice of subjects, which were largely portraits, nudes and still lives as somehow 'feminine'. For Dorgelès the processes and techniques of painting were gendered, and Charmy was seen to be imitating the more vigorous skills of a male artist or – in the context of her Fauve works – of a 'wild beast'. Although significant numbers of women artists became involved with Fauve practices, many critics found it difficult to apply the term 'Fauve' to a woman painter. Thus in describing Laurencin's relationship with the movement, the critic Guillaume Apollinaire wrote that among 'les fauves' she was the 'fauvette' (*Le Petit Bleu*, 5 April 1912).

As with many contemporary attempts to conceptualize art practice in gendered terms, we find that the criticism which surrounded the Fauve movement was often contradictory. The preoccupation with the role of colour as a pictorial element which could define and distort space and objects was, in fact, sometimes associated with another, more academic form of artistic discourse. The theory which accompanied the activities of the French Academy in the nineteenth century often involved perceptions of drawing as a more intellectual 'masculine' preoccupation, as against a concern with colour as a more superficial 'feminine' interest. Despite the early twentieth-century resistance to academic convention, colour continued to be identified in some critical writings with the more 'decorative', 'feminine' spheres of art. But with the emergence of an avant-garde group for whom experiments with colour were of central importance, the language of art criticism and theory could shift such preoccupations into the sphere of masculine creativity. Thus the metaphor of 'wild beasts', with all its connotations of violent, instinctive expression, could be clearly separated from a more 'delicate', 'feminine' preoccupation with colour.

Gender and cubism: a 'masculine' art?

Modernist art history has tended to represent the Fauve movement as a short-lived prelude to the more historically significant – and ultimately more radical – Cubist movement. The former has tended to be seen as concerned with completely different aesthetic concerns to the more conceptual, intellectual interests of Cubism, epitomized in the work of Picasso, Braque and Gris. In contrast with the Fauve concern with colour, the Cubists are widely represented as more influenced by the 'structural' aspects of Cézanne's works. More recently it has been suggested that this notion of diametrically opposed movements misrepresents some of the shared aesthetic and cultural influences on, and interests of, both groups of artists (Antliff, *Inventing Bergson*, esp. Chapter 3). It could also be argued that the dominant perception of Cubist artists as primarily preoccupied (at least during the early stages of the movement) with conceptual and intellectual problems, particularly those concerned with the representation of space and reality, has tended to encourage gendered readings of the interests of these artists. As we shall see, such preoccupations were easily described as 'austere' and 'masculine'.

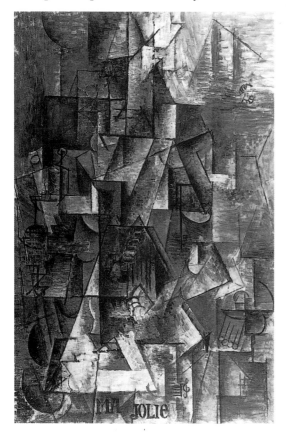

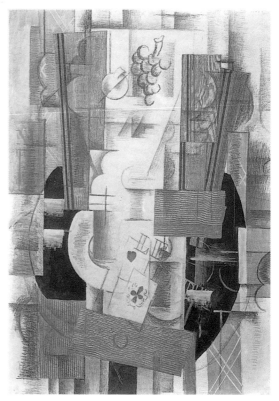

Plate 176 Pablo Picasso, *'Ma Jolie', Femme à la Guitare ou Cithare (Woman with a guitar or zither)*, 1911–12, oil on canvas, 100 x 65 cm, Museum of Modern Art, New York. Acquired through the Lillie P. Bliss Bequest. Photo: © 1998 The Museum of Modern Art, New York/DACS, London 1999.

Plate 177 Georges Braque, *Composition with Ace of Clubs*, 1912–13, oil, gouache and charcoal on canvas, 80 x 59 cm, Musée National d'Art Moderne, Paris. Photo: Musée National d'Art Moderne, Centre Georges Pompidou, Paris, © ADAGP, Paris and DACS, London 1999.

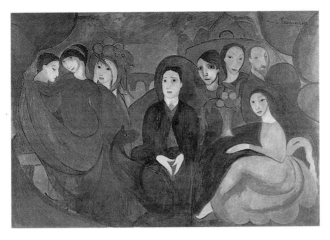

The conspicuous absence of women from most modernist histories of Cubism is usually taken as a 'given', which is confirmed by the lack of available evidence of women artists engaged in the forms of technical radicalism 'pioneered' in the work of Picasso and Braque in the early 1910s (Plates 176 and 177). The only woman artist usually attributed a (marginal) role in histories of Cubist art is Marie Laurencin, although her work has only tenuous links with the formal projects of Cubism (Plate 178). I have suggested that Laurencin's relation-

Plate 178 Marie Laurencin, *Apollinaire and his Friends*, 1908, oil on canvas, 82 x 124 cm, Musée National d'Art Moderne, Paris. Photo: Musée National d'Art Moderne, Centre Georges Pompidou, Paris, © ADAGP, Paris and DACS, London 1999.

ship with the circles that gathered around Picasso's Montmartre studio, the *Bateau Lavoir*, was promoted through the critical writings of her then partner, Apollinaire, thus encouraging a public perception of her as a woman Cubist (Perry, *Women Artists*). However, unlike the early Fauve exhibitions, women's names became visible in the catalogue lists of some of the Cubist group shows. And recent research has shown that around 1912–18 several women artists were producing work which reveals a greater involvement with the aesthetic and technical concerns of the movement than was the case with Laurencin. Among them was the Spanish artist Maria Blanchard, the Russian artist Marevna (born Marie Vorobëv) and the Polish artist Alice Halicka (Plates 179–184). All three had moved to Paris around 1912 to study art, and in the language of the reviewer from *The Studio* quoted earlier, could be represented as 'enterprizing feminine searchers after novelty'.

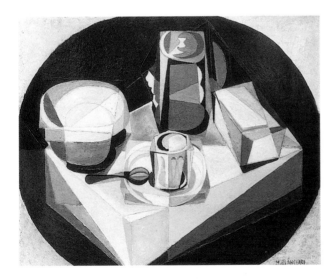

Plate 179 Maria Blanchard, *Still Life*, 1915, oil on panel, 60 x 70 cm, Musée Petit Palais, Geneva. © VEGAP, Madrid and DACS, London 1999.

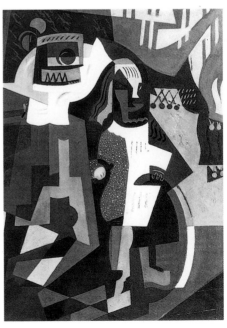

Plate 180 Maria Blanchard, *Child with a Hoop*, *c.*1915, oil on panel, 128 x 95 cm, Musée Petit Palais, Geneva. © VEGAP, Madrid and DACS, London 1999.

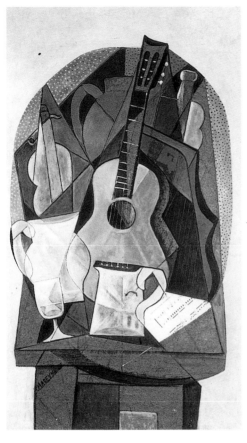

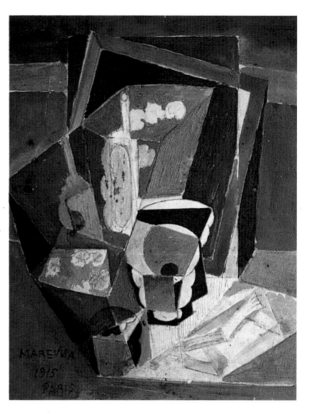

Plate 182 Marevna, *Still Life (L'Atelier rue Asseline)*, 1915, gouache on paper, family collection. Photo: Gill Perry, © ADAGP, Paris and DACS, London 1999.

Plate 181 Marevna, *The Guitar*, 1914–15, oil on board, 110 x 61 cm, private collection. © ADAGP, Paris and DACS, London 1999.

Plate 183 Alice Halicka, *Cubist Still Life with Guitar*, 1916, oil on canvas, 59.5 x 72.5, Musée Petit Palais, Geneva. © ADAGP, Paris and DACS, London 1999.

Plate 184 Alice Halicka, *Cubist Composition with Violin and Musical Score*, 1919, oil on canvas, 61 x 81 cm, private collection, Paris.

All three women artists produced works during the period *c.*1912–15 which suggest a serious engagement with Cubist practices. Examples illustrated in Plates 179–184 reveal not only that each of these artists adopted still-life themes popular with Cubist artists, but that they were concerned with the distortion and flattening out of three-dimensional space, tilting objects from different angles, suggesting overlapping and broken planes. Similar techniques were adopted in the so-called 'analytical Cubist' works of Braque and Picasso from around 1911–12 (Plate 176). And some paintings by both Marevna and Blanchard·from the mid-1910s have a collage-like appearance. Painted surfaces are sometimes textured to suggest wood grain, fabric or paper (Plates 180–182), echoing some of the visual ambiguities which were exploited by Picasso, Braque and Gris in their Cubist collages from around 1914.

Most histories of modern art tend to place special emphasis on radical or innovatory developments, on the work of those artists who were seen to 'initiate' or first produce 'progressive' ideas and art practices. Thus Picasso and Braque in their earliest Cubist works are seen to have 'initiated' radical new ways of looking at the objects around them, of perceiving reality. Within modernist histories special emphasis is placed on 'newness' and 'originality', and those artists who are seen to have initiated different or unconventional forms of art have tended to dominate these histories.

I am *not* suggesting that, contrary to these accounts, the women artists that I have been discussing were in fact 'initiators' of these avant-garde art practices. We have seen that even at the beginning of the twentieth century historical and cultural conditions largely excluded women from the key sites (professional, educational, etc.) of modernist practice and limited the visibility of their work. What I have suggested, however, is that conditions were shifting

and that the conventional view that women played little part in such modernist histories, and were more likely to work in separate and independent styles, may now need revising. As we have seen, several women did become involved in Cubist practices, albeit on the margins of the movement, although the history books have tended only to represent the various male figures who played more marginal roles, including names such as Roger de la Fresnaye, Louis Marcoussis, André Lhôte and many others (Plate 185).

The problem for feminist art history is that many works produced by women working on the margins of modernist groups have fallen through the historical net which documents and records for posterity. Although several women's names appear in the early Cubist shows, in general they are less likely to be found in the accounts and critical reviews of controversial shows which have come to be seen as key moments in modern art history. Such women usually worked separately from male-dominated avant-garde groups, often sold through private collectors, or, being in the shadow of better-known male partners, had problems selling their works at all. Marevna's autobiography, *Life in Two Worlds*, published in the 1960s, highlights some of the contradictions which women had to confront if they sought to participate in avant-garde circles. She describes the artistic circles centred around the bars

Plate 185 André Lhôte, *Port of Call*, 1913, oil on canvas, 210 x 185 cm, Musée d'Art Moderne de la Ville de Paris. Photo: © Phototheque des Musées de la Ville de Paris/ADAGP, Paris and DACS, London 1999.

and studios of Montparnasse and the mythical figure of Picasso, showing how they were self-consciously associated with a culture of bohemianism which traded in myths of permissive sexuality and anti-bourgeois attitudes. Yet she also suggests that admittance as a woman to such avant-garde space had to be negotiated on certain terms. Throughout her autobiography she describes the problems for women artists who are without independent means, and the double standards they confront when competing with their male colleagues:

> If I am asked why I held aloof from the circle of contemporary artists who have all achieved universal recognition, my answer is that my exhibitions were always followed by long blanks, because I had to fight fearfully to bring up my child, devote much time to commercial art and to decorative art, and give up exhibiting for lack of money …

> … All my life unfortunately, money has come between me and my work. In order to paint a woman must enjoy a certain security, even if she has only a quite small family to support. For the man the problem is easier to solve: he nearly always has a woman, wife or mistress, who earns money: she works for 'her man'.

(Marevna, *Life in Two Worlds*, p.183)

Plate 186 Marevna, *Homage to Friends from Montparnasse,* retrospective painting of 1961 (showing from left to right: Rivera, Marevna and her daughter Marika, Ehrenburg, Soutine, Modigliani, Hébuterne, Max Jacob, Kisling, Zborowski), oil on canvas, 160 x 305 cm, private collection. © ADAGP, Paris and DACS, London 1999.

Marevna's sense of the double standards of her male colleagues was fuelled by her difficult personal experiences as one of the lovers of the Mexican painter Diego Rivera. Shortly after arriving in Paris in 1912 she became friendly with Rivera, who first gave her access to the Cubist circles around Picasso. She bore his child (Marika) in 1919 while he also continued a relationship with another partner. Apart from intermittent support from Rivera, she was forced to bring up the child on her own, particularly after he returned to South America in the 1920s. A retrospective painting, *Homage to Friends from Montparnasse,* painted at about the same time that she produced her autobiography represents – in a frieze-like form – some of the main characters from that period of her life around 1920 (Plate 186).

Please look at this painting and the key provided in the caption. Are there any aspects of the style and organization which tell us anything about Marevna's self-image as a woman artist within the Cubist group?

Discussion

Although this is a retrospective work, the somewhat angular Cubist technique suggests that Marvena wished to assert or illustrate her earlier participation within that movement. But she places herself very much on the margins of a group dominated by the centrally positioned male artist Modigliani. The blond-haired Marevna, with her daughter Marika, are placed in front of Rivera, but to the left of the group of artists, dealers and critics which surrounds the heroically posed Modigliani, shown naked to the waist as the good-looking, sexual, creative artist. His raised glass is probably a reference to the alcoholism which helped to kill him when he died of tubercular

meningitis in 1920. Marevna's image could thus be seen to reinforce the myth of the short-lived creative genius whose bohemianism became notorious in the cafés of Montparnasse. The only other woman depicted in the group is the Fauve painter Jeanne Hébuterne, who was Modigliani's partner. She is positioned behind him, very much in the background of the group. Pregnant with their second child, she committed suicide shortly after hearing of his death.

◆◆

I have argued that the critical theory which helped to establish the Cubist movement was especially vulnerable to gendered readings of creative expression and production. Thus a critical terminology was developed to distinguish the work of those women who developed Cubist interests from that of their male colleagues. Alice Halicka's Cubist work from the mid to late 1910s reveals an increasing interest in the role of colour (Plates 183 and 184), although this is rarely combined with the more mischievous collage techniques to be found in the work of Picasso and Braque from the same period. Not surprisingly, perhaps, this aspect of her work has encouraged representations of hers as a 'feminine' version of Cubism. Many contemporary critics saw the creative impulses behind the movement as deriving from a 'masculine' impetus. Thus in 1927 the influential critic Maurice Raynal denied Halicka the full status of 'Cubist'. He may also have been influenced by her return to more figurative styles after 1920, writing of her work: 'From Cubism she took not the aesthetics, but the discipline and the practical methods. In effect her female sensibility prevented her from taking the conception of an art of pure creation' (Raynal, *Anthologie*, p.187). The concept of 'pure creation' then is firmly gendered here in the masculine. A similar critical language of difference has been employed to represent the work of Blanchard. Even a relatively recent appraisal of her work presents a view of Cubism as 'too austere for her femininity' (*Maria Blanchard 1881–1932*).

Conclusion

There are no simple answers to the question posed earlier: did modernism offer women a fiction of freedom? As we have seen, the participation of women artists within the social and professional spaces associated with the production of modern art was fraught with contradictions. There were many social, cultural, and aesthetic conditions to be negotiated in the pursuit of a career as a 'modern' woman artist. However, what should have emerged from the preceding discussion is that despite their absence from the history books, increasing numbers of women artists were participating on the margins of groups which we now label modernist. And that participation often involved some engagement with techniques and subject-matter which have been seen as 'innovative' or 'modernist'. The terms of their engagement were often complex and much of the history still remains to be investigated. As I have suggested, a narrative which represents modern art simply as a masculinist modernist discourse (of the avant-garde) on the one hand, with a separate and marginalized group of independent 'women's art' on the other, leaves us with an inadequate and partial history of the modern art of the early twentieth century.

References

Antliff, M. (1993) *Inventing Bergson*, Princeton University Press.

Dorgelès, Roland (1921) *Emilie Charmy*, introduction to catalogue, Galeries d'Oeuvres d'Art.

Garb, Tamar (1994) *Sisters of the Brush*, New Haven and London, Yale University Press.

Holland, Clive (1903) 'Lady art students' life in Paris', *The Studio*, December, pp.225–30.

Marevna (1961) *Life in Two Worlds*, London, Abelard-Schuman.

Maria Blanchard 1881–1932 (1988) museum pamplet (no author), Geneva, Petit Palais.

Mathews, Patricia (1991) 'Returning the gaze: diverse representations of Valadon', *Art Bulletin*, vol.73, no.3, pp.415–30.

Nead, Lynda (1992) *The Female Nude*, London, Routledge.

Oppler, Ellen C. (1976) *Fauvism Reexamined*, New York and London, Garland Publishing and James Herbert.

Perry, G. (1995) *Women Artists and the Parisian Avant-Garde*, Manchester University Press.

Perry, G. and Cunningham, C. (eds) (1999) *Academies, Museums and Canons of Art*, New Haven and London, Yale University Press.

Perry, G., Frascina, F. and Harrison, C. (1993) *Primitivism, Cubism and Abstraction*, New Haven and London, Yale University Press.

Pollock, Griselda (1988) 'Modernity and the spaces of femininity' in *Vision and Difference: Femininity, Feminism and the Histories of Art*, London, Routledge.

Raynal, Maurice (1927) *Anthologie de la peinture en France – de 1906 à nos jours*, Paris, Editions Montaigne.

Psychoanalysis, gender and art

CLAIRE PAJACZKOWSKA

What is psychoanalysis?

You have probably already heard about psychoanalysis, at least heard jokes about psychiatrists or 'shrinks', perhaps even know the difference between psychoanalysis, psychotherapy, psychology, psychiatry and other ways of understanding the life and structure of the mind. Throughout this section certain technical terms will be used, many of which you may find difficult. To help you understand these ideas I will begin with a general introduction to some of the concepts used in psychoanalytic art history.

Psychiatry and psychology have been established as sciences since the mid-nineteenth century. Psychology is the scientific study of the mind, often using tests to measure mental abilities and processes. Psychiatry is the specialism within general medical practice that enables some doctors to treat mental illness, possibly including the use of drugs or technological cures. Psychoanalysis, a type of psychology formulated by Sigmund Freud in the late nineteenth century, uses different forms of knowledge and treatment to those of clinical psychology and psychiatry.

Sigmund Freud (1856–1939), the founder of psychoanalysis, conceived of his work as a '*metapsychology*', that is a general theory that could be applied both to the treatment and cure of mental distress, and also to understanding culture and society. He believed that a general theory of the mind could be applied to understanding individuals and larger human groups. About one-half of Freud's writings are on specific mental illnesses and case studies of their treatment, whilst half are discussions of the origin of such cultural forms as religion, literature, art and mythology. According to Freudian theory, then, psychoanalysis can be used within the study of such disciplines as anthropology, history, sociology and literary criticism as well as art history.

The unconscious

'If Freud's discovery had to be summed up in a single word, that word would without a doubt have to be "unconscious"'(Laplanche and Pontalis, *The Language of Psycho-Analysis*).[1] The unconscious had been in use as a concept in psychology before Freud published his pioneering *Studies in Hysteria* (1895) and *The Interpretation of Dreams* (1900). However, it was only through psychoanalysis that the unconscious was conceived as a dynamic and active force comprising energies and processes not present to conscious thought. Freud described the unconscious by using an archaeological metaphor of different strata of the mind overlaying and concealing more fundamental psychic structures.

[1] This is a useful annotated dictionary of psychoanalytic terms and concepts.

By 1923 Freud had refined his picture of how the mind or psyche might be 'mapped'. This map comprised the interaction of three different parts of the mind: the ego, the id and the superego. He asserted that the id, composed of psychic and bodily impulses and drives, is completely unconscious, while aspects of the ego and most of the superego are also unconscious. The ego is the part of the psyche that works with the biological organs of response, the eyes, ears, nose, mouth and other tactile or sensory zones. Part of the ego receives stimuli from inside the body such as physical signals of hunger or pain. Moreover, the ego is capable of translating the inner or psychic reality into representational forms such as visual imagery or spoken language. The superego, derived from social values and moral conventions as well as from parental influence, exerts an influence over the ego in such as way as to contribute to the subject's socialization. The superego is the source of those feelings which are common to all of us such as guilt, responsibility or concern for oneself and for others. Illnesses and 'imbalances' of the superego may result in destructive or self-destructive actions, such as masochism. The superego is thought to govern the languages we adopt in creative activity. It can affect the way we structure language and the form and content of visual images. In other words, our conscious and unconscious anxieties and fantasies play a part in the way we organize images and the subjects we choose to represent in art.

The divided subject

One of the most important consequences of this description of the unconscious was that the human individual came to be understood as a *divided subject*, capable of being split between conscious beliefs or thoughts that can be spoken and rationally communicated, and other non-rational motivations that might contradict or underlie the former. Extreme psychic contradictions between the conscious and unconscious mind might cause symptoms such as anxiety or fetishism. Fetishism is used here to describe a process whereby obsessive sexual desire is displaced on to a safe or familiar object associated with the original object (or body) of desire. We will return to the concept of fetishism below, but we are concerned here with the symptoms of this split between unconscious desires and anxieties and conscious beliefs.

This idea of the 'divided subject' may be quite familiar to you. Indeed, in family life we are used to people communicating in quite contradictory ways, for example, feeling disapproval whilst consciously praising (the superego divided from ego), feeling anger whilst publicly grieving (in depression). According to Freud these split-off or repressed parts of the self may be unconscious and may be expressed symbolically in communicable forms such as physical symptoms, anxieties, illnesses or through the language of art.

It was this psychoanalytic concept of a dynamic unconscious that made the idea of the divided subject more generally understood. On a theoretical level it replaced the more widespread concept of a unified subject, of a complete individual in control of his or her acts or desires, that had been created by religion, maintained by philosophy and unchallenged by science in European thought since the Enlightenment.

To summarize, psychoanalysis has a history which began in the late nineteenth century, when Freud made significant advances in the psychological

understanding of physical symptoms such as hysteria (where the body uses such symptoms to express trauma and sexual desire). Psychoanalysts were able to conceive of a mind that was strongly influenced by fantasy (an imaginary scene representing the fulfillment of a wish) and unconscious desire as well as by biological instincts. This clinical practice of psychoanalysis also gave rise to a metapsychology, a general theory that was applied simultaneously to individuals in the consulting room and to general problems of culture and society. In psychoanalytic explanations of culture the human subject is never thought of as unified in a single consciousness, but is seen as a complex interaction of a number of psychic agencies in conscious and unconscious ways. This is why we use the term 'subject' rather than 'individual' or 'person' to indicate a constructed and developing identity rather than a clearly defined, fixed character.

Oedipal reality

Freud considered that the most difficult of the truths discovered by psychoanalysis were those of 'infantile sexuality' and the 'oedipal complex'. Within psychoanalysis the adult mind is conceived as a product of a complicated developmental process. Adulthood is partly the result of evolutionary development of the species, and of individual growth from infancy to maturity. As we shall see, one consequence of this developmental perspective of psychoanalysis is that the enigma of human sexuality is rendered explicable.

In Freudian theory, infantile development is thought to progress through a number of libidinal (sexual) stages from the earliest oral phase, through the anal, phallic, and oedipal phases to the completion and resolution of infantile sexuality in what is called the castration complex (or anxiety about the possiblity of losing the phallus). Freud believed that every little boy becomes terrified that his mother's lack of penis is the result of castration. This complex involves the fantasy that the female gender is castrated male, that the difference between masculine and feminine sexuality is to do with the *presence* or *absence* of the phallus. Freudian theory sees mental development as the psychological equivalent of bodily experiences rather than their physical reality.[2]

The later phallic phase, which involves curiosity about the penis, is closely associated with exhibitionism and voyeurism, both components of the gaze. Voyeurism is considered briefly by Gill Perry in the introduction to this book and explored further in Case Study 11. The perverse pleasures of being seen and 'showing off' (or exhibitionism) are identified by Freud as the passive form of the phallic phase, while the drive to see, look or watch (voyeurism) is its active form. In the phallic phase children are compelled to demonstrate their physical control and mastery; 'watch' and 'look at me' are its ubiquitous commands.

[2] For example, the oral phase is at once the age at which the embryonic cells in the uterus develop into a prototype of the mouth, and the age at which babies use their mouths as the main organ of exploration and empirical knowledge of the world. This phase is also seen to contribute to psychic structures which remain repressed in adult mental life. Such repressed structures can be revealed symbolically through the use of language or through artistic expression.

Freud suggested that children of both sexes behave, in the phallic phase, like little boys, believing that 'everyone' has a penis. This belief, which was further developed by the theorist and analyst Jacques Lacan and called 'phallic monism', is especially directed at the mother, or at least at the fantasy that there is no real difference between the sexes and no real difference between the generations. It is because the child is becoming aware of the limitations of his own physical mastery and self-control that he seeks to control the presence and actions of his mother, and seeks to deny knowledge of the difference between them. This desire for control and mastery coincides, according to Freud, with a fantasy about sexual difference in which difference is both acknowledged and denied, resulting in a divided self that may later re-emerge in adulthood as a perversion such as fetishism.

The phallic phase develops into the oedipal phase, in which all the perverse fantasies and beliefs of the oral, anal and phallic phases of infantile sexuality are unified into a 'collage' of fragments. These are directed towards the parent of the opposite sex, and cause an intense identification and rivalry with the parent of the same sex. Freud derived this model from the classical myth of Oedipus in which the narrative drama centres around a boy fated to kill his father and to marry his mother. Having been rejected by his parents, the boy survives through adoption to live out the fate foretold, bringing tragedy to himself, his family and his kingdom. In the Greek myth this tragedy results in blindness and then wisdom, or 'insight'. In psychoanalysis this model is known as the Oedipus complex and is a matter of intense emotions and sexual desires of a kind more usually associated with dramas of tragedy and great romance. Oedipal desire is irresolvable. Children cannot consummate their libidinal longing for their object; they can be neither adults nor parents, nor can they understand what is happening to them.

The Oedipal phase, then, founders on its own impossibility. This stage entails the repression of infantile sexuality. Psychoanalysis proposes that unconscious structures underlie all cultural practices and that the fundamental purpose of the Oedipal structure is to introduce the subject to two axes of external reality: that of generational difference (age and time) and that of sexual difference (male and female).

How do these ideas of unconscious structures and the divided subject translate into visual representation? As I suggested above, the unconscious can be seen to exist in visual representation if we understand the visual language of a work as somehow containing the tension of psychic contradiction. I want to see how this interpretation might work with reference to a work by the British Pop artist Allen Jones.

Look at Allen Jones's *Leopard Lady* (Plate 187) and read the following extract from an article by Laura Mulvey on an exhibition of works by Allen Jones held in London in 1970. List what you perceive to be the most striking visual features of this image. Drawing on our discussion so far, which of these do you think might suggest unconscious themes or fetishistic imagery? (Note: this work is a portrait of a fashion model, Evelyn Kuhn, commissioned by a collector in Kenya.)

Plate 187 Allen Jones, *Leopard Lady,* 1976, oil on canvas, 180 x 120 cm, private collection. Photo: Marco Livingstone (1979) *Allen Jones: Sheer Magic,* London, Thames & Hudson. Reproduced by courtesy of Allen Jones.

Fetishism, Freud first pointed out, involves displacing the sight of woman's imaginary castration on to a variety of reassuring but often surprising objects – shoes, corsets, rubber gloves, belts, knickers and so on – which serve as signs for the lost penis but have no direct connection with it. For the fetishist, the sign itself becomes the source of fantasy (whether actual fetish objects or else pictures or descriptions of them) and in every case the sign is the sign of the phallus. It is man's narcissistic fear of losing his own phallus, his most precious possession, which causes shock at the sight of the female genitalia and the subsequent fetishistic attempts to disguise or divert attention from them.

(Mulvey, 'Fears, fantasies', pp.10–11)

Discussion

You may have listed the leopard skin, the woman's shiny skin-tight body sheath, the silhouette of the stiletto shoes, the erect nipples, the open jaws of both the leopard and the woman baring their teeth, the whip tail and horse's tail.

As Mulvey's article tells us, many of these objects are commonly associated with sexual fetishism. According to Freud, fetishism has a conscious aim of stimulating sexual desire, and (as we have seen) an unconscious aim of providing an object of desire that is safe and familiar (such as a shoe or a leopard skin) rather than threatening. Mulvey is especially concerned in this extract with the way in which male castration anxiety helps to shape or select the fetish. While Jones may have deliberately selected erotic imagery inspired by the model Evelyn Kuhn, and the leopard skin to make the association with a collector living in Africa, some of the fetishistic associations are (according to Freud) derived from the artist's unconscious. For example, we could argue that the artist (unconsciously) displays the oral components of fetishism in his representation of the open mouths and sharp teeth of both leopard and woman. Thus the subject-matter of this image could be seen to be divided between contradictory conscious and unconscious aims.

◆◆

Apart from Mulvey's interest in Jones's imagery, several feminist art historians in the 1970s discussed Allen Jones's work in similar terms, exploring precisely these sorts of fetishistic representations of women and their bodies (Tickner, 'Allen Jones'). It has been argued that Jones depicts women as two-dimensional effigies resembling cartoon characters or rendered flatly unreal by the visual language of popular graphics reminiscent of the soft pornography of the previous generation. Jones's images have the fascination of 'old fashioned' erotica and hold the attraction of a previous generation's illicit sexual fantasy. Pop art used images from advertising, cinema, television and other forms of popular culture, and we can see from Plates 188(a) and (b) that Allen Jones directly references such sources in *Leopard Lady*.

(a)

Plates 188 (a) and (b) Collection of imagery of women from contemporary magazines, comics and newspapers, put together by Allen Jones, *Allen Jones Figures*, 1969, Galerie Mikro, Edizioni O, Milan, pp.23, 31. Courtesy of Allen Jones.

(b)

Thus gender difference and sexual difference are central to the formation of identity and subjectivity, to our sense of ourselves as male or female. Since, according to Freud, these structures underlie all forms of culture and symbolic activity, both gender difference and sexual difference are central to our understanding of visual art. We have seen that art has a particular relationship to gender difference because it is a predominantly visual form of culture. The purely physiological processes of perception are inextricably intertwined with the unconscious processes that are involved in visual perception. We have seen that these may involve fantasies about the gaze, knowledge, power, castration, and desire.

Why is psychoanalysis useful in the study of art and gender?

The application of psychoanalytic models to the study of art and visual culture has produced some illuminating accounts of the ways in which gender and sexuality are implicated in culture in general. It has also provided accounts of the ways in which conscious and unconscious processes can be identified in the meanings of works of art. For Freud creativity involved 'sublimation', a process which transforms bodily energy into mental or psychic drives, and directs it towards objects and goals that are recognized and expressed by consciousness. In cultural practices such as art, Freud claims that these perverse, childlike and sensual pleasures can be expressed as fantasies which we can detect beneath the sophistication of the conscious artistic language employed by the artist in a painting, a sculpture or a novel. By 'perverse' pleasures I mean the self-centred sensuality that is normal in children and seen to be perverse in adults. According to this model, then, art can express fantasies and perversions which originate in the unconscious mind.

The psychoanalytic perception of the closeness of art and perversion often makes psychoanalysis unwelcome as an explanatory method for those whose lives depend on the production of art. As the understanding and enjoyment of art depends largely on visual pleasures, the process of looking at art provides rich material for psychoanalytic study. For example, psychoanalytic theory has pointed out that the pleasure of the gaze is closely connected to unconscious fantasies of control and power. We have also seen that the perversions of voyeurism and exhibitionism involved in the gaze are often culturally polarized into the active form of masculinity which looks at and controls a more passive femininity.

Issues of authorship

Until psychoanalysis concerned itself with modernism and postmodernism within art, most psychoanalytic art criticism involved an investigation into issues of *authorship*. This approach to art assumes that the meaning in art originates predominantly from the subjectivity of the artist, and is communicated either consciously or unconsciously to the spectator through his or her art. Authorial approaches to art often entail psychoanalytic accounts based on biography which frequently focus on hypotheses about the influence of an artist's early childhood on their adult subjectivity and creativity. One example is Freud's own biographical study of Leonardo da Vinci published in 1910 (*Leonardo*). According to this approach, elements selected and employed by the artist, such as style, colour, scale, composition, materials and subject-matter, are often interpreted as clues to that artist's individual imagination and subjectivity. In authorial approaches to art very scant attention was paid to the reception of art, and it was often assumed that the viewer finds meaning through the imaginative act of identifying with the artist. Spectators are offered emotional excitement by supposedly coming close to the soul of the artist through looking closely at the work of art. A popular example of biography which is influenced by this approach is the well-known book and film *Lust for Life* about Vincent Van Gogh (starring Kirk Douglas as Van Gogh). Both the book and the film invite an audience to identify with the artist as a romantic individual whose paintings reveal his

tortured inner psyche. This enables the spectator to 'psychoanalyze' the creativity of the artist.

Repression and the canon

Psychoanalysis has proved useful to feminist art history through its explorations of how unconscious patterns of meaning can be found beneath the seemingly arbitrary patterns of inclusion and exclusion such as, for example, those that underpin the western canon of art. Issues of judgement, value, taste, standards of beauty and pleasure (aesthetics) are all involved in these patterns. Feminist writers have explored the construction of 'difference' in art history as a product of an unconscious need to maintain and protect the fragile stability of certain (male) narcissistic identities. As psychoanalysis suggests that sexual difference is central to the formation of identity, such a theory provides a pertinent account of how representations of gender difference within art history can be distorted by the power of unconscious fantasy and its effect on more rational thinking. If the Oedipus complex forms the core of infantile repression, as Freud suggests, then all attempts to think of historical difference will be distorted by the inability of the unconscious to understand the significance of generational and sexual difference. This in turn will affect the way in which art history is written. So with the help of psychoanalysis, art historians can explore why, for example, there is such an unquestioned need for the identity of the 'artist' to be a romantically masculine one, why the significance of the name and the authorship of an art work is so important, or why 'originality' has become so significant within a modernist culture of art. Art historians can use the theory of the unconscious to explore why certain conventions and types of subject-matter underpin dominant canonical values.

Looking and the gaze

A more recent development in feminist art history is, as we have seen, the discussion of voyeurism, the unconscious determinants of sight and the concept of the gaze. The cultural concept of the gaze was first applied to popular cinema by Laura Mulvey in her essay 'Visual pleasure and narrative cinema'. We've already looked at the general implications of this theory for the role of sexual difference in the process of looking, but I want now to look at Mulvey's arguments in more detail. She identified three levels of sight. These are in operation when the spectator observes and identifies with the cinema screen or, if we apply the model to painting, when the spectator looks at a visual image. The three gazes are, first, the artist's look at the reality that inspires him/her to produce the work; secondly, the spectator's look at the text (or film) itself; and thirdly, the 'sight lines' in operation within the art work itself, such as the characters' looks within a film sequence or within the pictorial space of a figurative image. It has been argued that this theory of the three gazes depends largely on works that employ realist conventions such as film, photography or figurative painting. In such media the figures or characters depicted are both the objects of our gaze and can be seen to look (at each other) within the pictorial space of the film or the picture. This theory, then, suggests a hierarchy of gazes in which the image or film being gazed upon provides a kind of 'window on the world'. This hierarchy serves to underpin a psychic structure in which certain forms of looking remain

largely unconscious whilst others, like the third gaze, are allowed to be 'seen' by the spectator and are therefore involved in a more conscious process of looking. In psychoanalytic terms, the forms of unconscious looking that are involved in this process of 'gazing' are related to the perverse pleasure of the infantile phallic phase described earlier. These drives are particularly aimed at mastery of the enigma of sexual difference and, unconsciously, at gaining knowledge of the parents' sexuality and the mother's body. The anxiety associated with this enigma is mastered, according to Freudian theory, through fetishism. The subject remains divided between spectator and visual object, between 'knowing' and 'not knowing', between conscious and unconscious thoughts, and between contradictory desires.

Psychoanalysis and feminism

In introducing you to some basic concepts from psychoanalytic theory we have concentrated on some of the most influential models developed by Freud and (in some cases) reworked by Jacques Lacan. Although we have suggested ways in which psychoanalytic models can be used to understand the construction of gender and sexual difference, feminists have been divided on the usefulness of specifically Freudian models.

You've probably found some of these models difficult and baffling enough, but it is important to note that recent feminist art history has also been significantly influenced by the psychoanalytic writings of several French women writers who have been sympathetic to the feminist movement, although they have not wished to call themselves feminists in the conventional sense. They include the philosopher Julia Kristeva (b.1941) the psychoanalyst Luce Irigaray (b.1937) and the writer and playwright Hélène Cixous (b.1937). In broad terms, these writers contested the Freudian and Lacanian emphasis on the masculine equation of femininity with castration, claiming that this marginalizes research demonstrating that femininity, even pre-oedipal femininity, has an autonomous development which is not centrally based on the phallic phase. They claimed that the meaning of phallic loss that was so central to masculinity could be further deconstructed to understand its origins in the anxieties of early masculine dependency on feminine care. They sought to reconstruct our understanding of the world and the language in which it is expressed at the very deepest level. Although they have developed differing positions and emphases, these female writers claimed to recognize basic forms of representation which (they argue) are specific to feminine sexuality and identity such as containment, tactile and textural qualities, and a tender recognition of the ubiquity of emotional life and loss. The term *écricture feminine* or 'feminine writing' was devised to describe an alternative form of writing which their work proposed, a form of writing which was outside the phallocentric realm and which expressed these essential feminine qualities.

In mapping out interests derived from the work of these and earlier writers, we have tried to give you an overview, a broad sense of the different ways in which psychoanalytic theory has informed the study of gender and sexual difference. In the next case study we will see how some of these ideas can directly inform and enrich our understanding of some recent works of modern art.

References

Freud, Sigmund (1910) *Leonardo da Vinci and a Memory of his Childhood*, reproduced in *The Standard Edition of the Complete Psychological Works of Sigmund Freud*, 1957, London, Hogarth.

Laplanche, J. and Pontalis, J. B. (1973) *The Language of Psycho-Analysis*, London, Hogarth Press.

Mulvey, Laura (1989) 'Visual pleasure and narrative cinema', in *Visual and Other Pleasures*, London, Macmillan, first published 1975.

Mulvey, Laura (1989) 'Fears, fantasies and the male unconscious *or* "You Don't Know What is Happening, Do You Mr Jones?"', in *Visual and Other Pleasures*, London, Macmillan, first published 1973.

Tickner, Lisa (1979) 'Allen Jones – A Serpentine Review', *Block*, issue 1.

The work of art, the work of psychoanalysis

BRIONY FER

Since its inception in the writing of Freud, psychoanalytic theory has sought to understand the creative impulse. Traditionally, this meant trying to understand the unconscious motivations of the artist from the point of view of what is sometimes called, usually perjoratively nowadays, 'psychobiography'. Freud's famous essay on Leonardo da Vinci, written in 1910, traced the workings of the adult artist's mind back to unresolved conflicts in his earliest infancy. However, elsewhere in his writings, Freud's emphasis was rather different. He frequently stressed that artists and poets had 'discovered' the unconscious long before psychoanalysis, and he often drew on literature in particular in order to exemplify his claims. Nowhere in Freud is there an 'aesthetics' laid out, only the premise throughout that artistic creativity is not only subject to, but also a vehicle for, the workings of the unconscious. Freud's tastes were those of a cultured, bourgeois gentleman of his time, but he considered both art and literature valid subjects for investigation from a psychoanalytic perspective, referring to the work of writers 'as a class of dreams that have never been dreamt at all' (Freud, 'Gravida', p.33).

It was never Freud's nor Lacan's intention to provide a theory of art, yet we've seen that the visual processes of *sight* have always been central to psychoanalytic thought and that psychoanalytic models have been applied to the understanding of art. Whilst we do not look to psychoanalysis for a clear understanding of how images are made, psychoanalysis may help us to understand how images mobilize certain drives, not only within individuals but within a culture in general. As well as social and cultural factors that are doubtless involved in the production of art, there are also *psychic* factors which we need to take account of, and which psychoanalysis can help us identify and describe. By 'psychic' I mean those factors derived from our unconscious rather than our conscious mental life. Whilst the work of art and the work of psychoanalysis might not be synonymous, there may be some gain from recognizing where they intersect. Psychoanalysis, then, does not simply usurp or take the place of an art-historical investigation into the art object so much as provide us with tools to question how and why works of art might operate as objects of fantasy. 'Fantasy', in this context, does not mean anything like the whimsical, but refers to a scene on to which wishes, fears, or desires might be projected. In such a scene, there is always a 'protagonist', an active viewing figure around which the scene revolves, and I am taking for granted here that the spectator (that is, you or me viewing the work) might be one such. An imagined historical spectator (who may have been an original viewer of a work produced long ago) may be another. Rather than the response of an individual, whose subjectivity is quite unique, the point stressed in psychoanalytic theory is how the individual is subject to a collective pool of fantasies which are shared, and so are all the more powerful.

This case study focuses on a small group of works made in the 1960s by the American artist Eva Hesse (1936–70) (Plates 189 and 190), as well as a recent installation from the late 1990s by Mona Hatoum, a Lebanese artist who has lived in London since 1975. None of these works of art pictures a world of things or people that we can readily identify (as in 'this is a picture *of x* or *y*'), but they are all palpably material objects which exist in the world. A box on the floor may not be easily recognizable as art without some prior knowledge of what modern art has become. Like all art objects, it exists in a context of other art objects and ideas about art which help to make sense of it. Like all art objects, it elicits a range of different responses and interpretations. But, however much we know, arguably an object such as Hesse's *Accession II* (Plate 189) still holds a certain strangeness. It invites us, as spectators, to figure it out, and in that process there may be pleasure or anxiety or both. We may be made to work quite hard to figure out what the object is. Thus emphasis on figuring out a range of possible effects triggered by a work of art is quite different from wanting to pin down what were the artist's innermost emotions when he or she was actually making it (which we can never truly know).

Plate 189 Eva Hesse, *Accession II*, 1967, galvanized steel and rubber tubing, 78.1 x 78.1 x 78.1 cm, Detroit Institute of Arts, Founders Society Purchase, Friends of Modern Art Fund and Miscellaneous Gifts Fund.

Plate 190 Eva Hesse, *Accession III*, 1968, fibreglass. Photo: Rheinisches Bildarchiv, Köln.

Initially it may appear that an object like Hesse's *Accession* could have very little to do with the question of sexual difference – but there are several possible ways in which we could claim that it does. One of these is that it is a work of art made by a woman and that Hesse's experience as a woman artist in a world where most successful artists were men is necessarily different and distinct. Another, which is my focus here, is to explore how the abstract spaces and textures of an art work might relate to the body, which, in my account, is understood as the place on to which we most readily project fantasies of sexual difference.

Thinking psychoanalytically about art is not a question of applying a ready-made theory, of making the art 'fit' a theoretical model derived from Freud. Rather, it is a matter of how we might draw upon psychoanalytic theory in order to formulate certain questions about works of art. 'Psychoanalysis' is not a static model, let alone an orthodoxy, but a system of thought which is open to development and change (as you saw in the last case study). Whatever its shortcomings, psychoanalysis is in my view the best theory of sexuality on offer. As we are concerned here with questions of sexual difference, it offers a framework within which to think about such problems. (I am using 'sexual difference' rather than 'gender' here because this signals a psychoanalytic rather than a sociological understanding of the processes of sexual differentiation.) But let me make a brief comment on what sexual identity might mean in a psychoanalytic context. Nobody, I think, has put this better than Jacqueline Rose in her discussion of Freud's 'Leonardo' essay when she wrote: 'It is often forgotten that psychoanalysis describes the psychic law to which we are subject, but only in terms of its *failing*' (Rose, *Sexuality*, p.232). She has explained that whilst sociological accounts assume that the internalizing of gender norms roughly work, psychoanalysis does not. There is no position, she claims, for either women or men which 'is ever simply achieved' (ibid., p.91). Sexual identity is neither simply given, then, nor absolutely stable or fixed. Furthermore, our sense of ourselves as male or female subjects (our subjectivities) is achieved only at some cost, which entails a whole series of losses and separations; these losses necessarily leave the subject incomplete and fractured.

The encounter with the art object: the work of Eva Hesse

Eva Hesse made *Accession II* in 1967 out of galvanized steel and rubber tubing. It was one of five versions to which she gave the title *Accession* – all boxes – which she made between 1967 and 1968 . This is one of the largest, others are smaller. Hesse frequently made groups of works like this, in a way which forces our attention on to their material differences. Whether the tubing is thick and made of latex or fine and made of fibreglass makes for very different effects. Hesse called the fibreglass version 'jewel-like' because of its translucency and its capacity to absorb as well as reflect light. But even amongst the metal versions, the metal used may be different, the holes cut into one finer, the tubing softer or harder. What I want to do here is to consider how one might question the work's effects in terms of the psychic structures of fantasy which they set in train, structures which it has been the business of psychoanalytic theory to elucidate. Hesse's work does not 'depict' the body but none the less evokes the 'bodily' in often indirect ways.

Can you suggest any ways in which this work evokes or makes associations with the body?

Discussion

Lucy Lippard, a critic who wrote a key monograph on Hesse, offered an answer to this question, in terms of what seemed important when the work was first produced in the 1960s. Lippard curated an exhibition called 'Eccentric

Abstraction' in 1966 in which she included some work by Hesse. In the text to accompany the show, she insisted that the bodily associations remained implicit rather than explicit – symbolic in the broadest sense rather than 'symbols' in the narrow and conventional sense of one form or shape standing for a part of the body – a breast or a phallus or whatever. In other words, we could argue that the forms and shapes of this work suggest bodily associations rather than depict specific body parts. Lippard insisted that Hesse's work avoided a Freudian lexicon of symbols by their 'formal understatement' (Lippard, *Eva Hesse*, p.83). That is, Lippard wanted to maintain a sense of the necessary ambiguity of Hesse's shapes and forms, the ways in which formal interests in materials and processes of making the object always took precedence over some – she implies – inappropriate identifiable 'subject-matter'. That is, she stressed how Hesse made it impossible to say simply this is an image of any particular *thing*.

If you were to look up 'box' in Freud's *Interpretation of Dreams* you would find that, like a bag or any other hollow object, it tends to figure as a symbol of a uterus. But as Lippard rightly stresses, Hesse simply does not use 'symbols' in this way, as if one thing stood for another, and you could discover what it meant by looking up a key, like a dictionary definition. Indeed to try to interpret the art object and fix its meaning in this way is the antithesis of what I understand thinking psychoanalytically to mean in relation to art. More than once, Eva Hesse explained that whilst she often used bodily forms, forms which protruded, forms which acted like receptacles, the point was not that these stood for either male or female genitalia. That the objects have a genuinely ambiguous bodily and sexual resonance is undeniable – but in more complex ways than this, and in ways in which the role of the spectator is much more active in the encounter with the art work.

◆◆◆

Hesse's *Accession* series are all boxes placed directly on the floor, and this removal of the *base* of a sculpture, to make sculpture floor-bound, was seen by the writer Jack Burnham in 1968 as the inevitable consequence of the gradual undermining of the plinth in modern sculpture. The placing of a sculpted figure, singly or in a group, on a base or plinth – as you would find in the kind of nineteenth-century public sculpture we see in any town or city – had been whittled away by sculptors like Rodin and, in the early twentieth century, the great modern sculptor Brancusi. Conventionally, Burnham said, the base 'creates a twilight zone both physically and psychically' (Burnham, *Beyond Modern Sculpture*, p.19) – rooting the sculpture to its surroundings and setting it apart, that is, setting apart an imaginary space for sculpture. Without the base there was no interim space that allowed the spectator to make the imaginative leap to a fictive world of figurative sculpture. The sculpture on a plinth allows us to be drawn into the world the sculpted figures inhabit, rather than the real world we are actually standing in. Burnham stresses, then, the actual material presence of the object placed directly on the floor, its presence not in a world of fantasy but in the 'here and now'. In retrospect, however, this distinction seems rather less clear-cut. Looking back now, Hesse's work, or even that of American artists Robert Morris (b.1931) or Donald Judd (1928–94), also seem to inhabit phantasmatic as well as literal spaces (that is, spaces of fantasy and projection as well as spaces we occupy as we literally encounter and move around an object) (Plates 191 and 192).

Plate 191 Robert Morris, *Untitled*, 1965–71, mirror, plate glass and wood, 91.4 x 91.4 x 91.4 cm, Tate Gallery, London. Photo: courtesy of the Trustees of the Tate Gallery, London, © DACS.

Plate 192 Donald Judd, *Untitled*, 1972, copper, enamel and aluminium, 916 x 155.5 x 178.2 cm, Tate Gallery, London. Photo: courtesy of the Trustees of the Tate Gallery, London, © DACS.

The box placed directly on the floor was, as these examples by Judd and Morris show, a familiar element in the language of minimal art. But the particular materials used, whether they are mirrored or transparent, or inlaid with texture as in Hesse's, lend themselves to very different effects. In part Hesse's box derives its identity from the contrast with the smooth coloured surfaces of a Judd. Like Judd, Hesse used pre-fabricated materials; like Judd, she was interested in the relationship between inside and outside. But otherwise it is those characteristics that are '*unlike*', that are strange and alien within such a context. Hesse was not alone in making such strangeness central to her work. In the 1960s Lucas Samuras, an artist Hesse admired, also followed a path that has been called 'grotesque', producing a series of empty 'boxes' using pins to articulate the edges. We can hardly fail to notice the

actual or literal presence of such objects in the gallery, even if it is only to say that they get in the way. As art objects, they also seem to demand attention or to be attended to in a special way, or at least differently from how we might attend to things which get in our way outside the art gallery. That is, they are not just material objects in the 'here and now', but they also enter the life of the imagination.

For *Accession II*, Hesse first had the box made to order from galvanized steel with perforated sides. This series was the first she had had made for her by Arco Metals in Manhattan. Hesse herself cut to length the rubber tubing and threaded it through the sides – each length looped through to create two tufts on the interior. When the box was damaged at its first exhibition, by people apparently climbing into it, she had to have it remade and an assistant then helped cut the tubing. Hesse reported that what she liked about her boxes was the way the outside and the inside could look completely different, though made of the same material. It is as if the object were Janus-faced, two objects in one, almost like a visual metaphor where two different terms collide and spark. The thing is quite luscious on the inside with shiny shanks of latex (the latex is surprisingly sensuous) that fall against one another, suggesting crevices and invisible depths. They also suggest the obsessive work that was involved – cutting many thousands of tubes in five-inch lengths (over 30,000 estimated) and then threading each through by hand. The threading through pierces the object with a precision that tends to contrast with the random way the tubes fall on the other side.

Thinking about the object from the point of view of sexual difference, one might say that the threading through recalls women's work and a 'feminine' realm of sewing or weaving compared with the industrial and 'masculine' realm of the prefabricated steel box. But then, those very distinctions are undercut by the fact that the thread is made of latex, itself an industrial and ready-made material. The box may be perforated like a geometric grid, but it also forms the basic framework for the weaving of the latex through it, thus seeming rather less like a factory product and rather more like a loom. Such resonances, whilst I think they are in play here, tend to obscure the powerful double action of the object that is at once box *and* orifice, at once open and what Lippard called 'secretive' (Lippard, *Eva Hesse*, p.104). The normal distinctions that we might like to keep in place between inside and outside are breached and rendered contradictory. This is reminiscent of Meret Oppenheim's famous *Déjeuner en fourrure (Fur Breakfast)* of 1936 (Plate 193), a surreal object where Oppenheim covered a mass-produced teacup with the fur of a Chinese gazelle. This was thought of as a kind of modern fetish object. Through this combination of textured fur and manufactured object, of fetish (a displaced object of desire) and orality (the pleasure of the mouth), Oppenheim stirs a powerful, witty cocktail which will be discussed further in the final case study of this book. The Surrealist artists who were especially interested in Freudian psychoanalysis thought such incongruous juxtapositions of conflicting images sparked a sudden recognition of repressed desires. Such desires were normally hidden within the unconscious, and could be revealed by strange juxtapositions, as in a dream image. Hesse said that she pursued the most extreme contrasts because the most extreme contrasts were also the most absurd. These contrasts may be 'abstract' in the sense that they involve textures and materials rather than dream images *per se*, but they are no less effective for that.

Plate 193 Meret Oppenheim, *Le Déjeuner en fourrure (Fur Breakfast)*, 1936, fur-covered cup, saucer and spoon, cup 10.9 cm diameter, saucer 23.7 cm diameter, spoon 20.2 cm long, overall height 7.3 cm, The Museum of Modern Art, New York. Photo: © 1998 The Museum of Modern Art, New York.

When Eva Hesse wrote some brief notes about one of her last works called *Contingent* (Plate 194), she said she wanted something that was 'non-anthropomorphic' which offered 'a total other reference point' (Hesse cited in Lippard, *Eva Hesse*, p.165). Rather than an object which looked like something specific or looked like a body, she wanted, this suggests, what one could perhaps call another point of view on the object. The middle sections of *Contingent* are made of latex and cheesecloth, with the latex painted in layers on to the cloth. Above and below is clear fibreglass, which is moulded. There are eight sections hung vertically at right angles to the wall. They are hung like so many pieces of fabric, a sense enhanced by the obvious loose weave of the cloth, but set hard as if petrified; the slightly collapsed or undulating character of cloth is frozen in the hardest of substances, translucent fibreglass. Hesse thought of this work as neither painting nor sculpture. She was not alone in making art which was placed somewhere between the wall and the floor. This state of being neither a picture (a 2D flat plane hung on the wall) nor a sculpture (a 3D thing on the floor) was familiar at the time – just as the box had become a typical shape to work with.

Hesse's peculiar treatment of cloth, latex and fibreglass in *Contingent* renders the elements of the object as if they were detached from defining any solid body and in a state of limbo – not body, not painting, not sculpture. The suspended veils of material have no inside and no outside and so resist the kind of anthropomorphizing of bodily spaces that was more in evidence in her earlier boxes. The sections are placed in a repetitive pattern, the same but different where the patina of each alters. Hesse was well aware of how a material like latex deteriorates over time when exposed to light, and this process of decay and inevitable discolouring was always envisaged by her as part of the life of the work. There is a sense in which these sheets of rubberized cheesecloth are both seductive in their translucency and have the possibility of destruction already built into them, in what are not only sheer but also scarred surfaces. The spectator is caught in the pattern of repetition and difference, repetition to the point of absurdity as Hesse liked to see it.

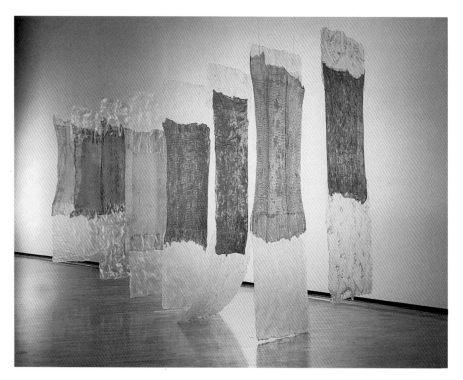

Plate 194 Eva Hesse, *Contingent*, 1969, cheesecloth, latex, fibreglass, overall installation size: 350 (h) x 630 (w) x 109 (d) cm, National Gallery of Australia, Canberra.

Such repetition is not a logical or rational order but allowed her to pursue what she called the object's 'non-logical self' (Eva Hesse, quoted by Lippard in *Eva Hesse*, p.131). Repeating the same element several times, often described at the time simply as 'one thing after another', set up in Hesse's work a to and fro movement of seduction and repulsion. The work, from this point of view, triggers quite contradictory and oscillating effects, just as we saw in the double action of box *and* orifice in Plates 189 and 190.

In a famous passage, Freud describes a game he has observed his grandchild playing in his crib (Freud, *Beyond the Pleasure Principle*, pp.283–7). The child throws a cotton reel attached to a thread out of his cot and then pulls it back. Accompanying his game he makes sounds which Freud interprets as 'fort', gone, and 'da', here. Freud connected the game to the child's mother going away, the game reiterating the abandonment by and retrieval of the mother. But why, asked Freud, would the child repeat the game over and over? Why, in addition to the pleasure, should the child repeat the 'unpleasure' that is the going away? Freud concluded that the repetition enabled the child to master the situation. Later, the psychoanalyst Lacan read this rather differently and in a way which highlights his difference from Freud. Whilst for Freud the point was ultimately to master the situation, for Lacan the loss or departure of the mother was ultimately the very cause of desire, which could not be mastered. The very repetition was, for Lacan, a repetition of the gap or absence that is at the heart of the subject. This is in some ways a more pessimistic view than Freud's, but it is also, I think, one that corresponds closely with the work I look at next.

Recollection: loss and retrieval

A more recent work by the artist Mona Hatoum called *Recollection* (Plates 195(a)–(c)) engages the spectator in another game of loss and retrieval. *Recollection* was first made in 1995 especially for a gallery space in Kortrijk in Belgium, originally an abbey inhabited by nuns. Hatoum has said that she had the idea of a closed world of women very much in mind when she made the installation (not a picture or a sculpture now, but the whole space of a huge room of a building used as the basis for the art work) (Hatoum quoted by Catherine de Zegher in Archer *et al.*, *Mona Hatoum*, p.100). Later, the installation was shown in the innovative 1996 exhibition of women's art called *Inside the Visible*, which Gill Perry discusses in her conclusion. The spectator's first impression on entering the room was to look for the art work, as it was not immediately clear where it was. The eye alighted on a small table at the end or at a side of the room, depending upon the installation (Plate 195(a)). On the table was a tiny loom (Plate 195(c)). Then perhaps you noticed scattered at your feet that the whole space was strewn with small balls of hair (Plate 195 (a) and (b)). Only then perhaps did you notice something brushing against your cheek or, worse, in your mouth: hundreds of the most delicate strands of hair, each knotted to make a length, which hung from ceiling to floor, catching the light .

(a)

(b)

(c)

Plates 195(a), (b) and (c) Mona Hatoum, *Recollection*, 1995, hair balls, strands of hair hang from the beams in the ceiling, wooden loom with woven hair, table, installation at the Beguinage St Elisabeth, Kortrijk, Belgium. Photos: Fotostudio Eshof, courtesy of Mona Hatoum.

In some respects, the random scattering of these small balls drifting across the floor recalls what were called 'scatter pieces' made by artists in the 1960s. Hesse herself had also produced works which favoured irregular and random arrangements across a floor. With the vertical hang of Hatoum's threads of hair, we might recall Hesse's *Contingent* and its movement downward towards the floor. The intrusion of the small table, however, adds an enigmatic narrative element, but one which refuses to add up to a coherent story; whose table? whose loom? are not really questions to which there are answers, except to say that there is the powerful suggestion that whoever may have been there is there no longer. The various elements create a scenario or scene of fantasy, but one which is hard to make sense of, in which the spectator is cast as some kind of protagonist but without being quite clear what part to play.

During the twentieth century works of art have been made of almost anything; the use of what are called 'ready-made' materials has a long history behind it. Hesse had used industrial materials like the latex tubing, but artists since the Cubists had introduced fragments of 'real' materials like newspaper into their works. But the use, literally, of a bodily material, especially one, like hair, which is balanced so precariously between the living and the dead, is particularly visceral in its effects. Over several years Mona Hatoum collected her own hair. It does not just *evoke* the body now; the art work is literally made out of hair – a part of the body but a part that has been separated *from* the body.

What kinds of associations with the body does hair evoke?

Discussion

Hair is seen as adornment for the body, a sign of beauty *and* bodily debris. And that debris is material for collection, for keeping. Using hair as her material in this way, Hatoum draws on many traditional conventions in which hair has been treated as a keepsake – as in a locket of a loved one's hair, or as a commemorative locket or piece of jewellery where the hair of a dead loved one is kept. Often such keepsakes were woven or plaited. The associations of hair with both love and loss, of desire for another and mourning for a lost object of desire, are set in train in the installation. Hair, of course, is traditionally seen as a sign of feminine beauty; it can function as fetish or as narcissistic display and adornment. But it also veers to other extremes, from an extreme of seductiveness to an extreme of repulsiveness – to the hair, for example, that you might find in the plug hole of a bath or sink. Catherine de Zegher has discussed the work as a 'complex reflection on bodily pollution', quoting a well-known phrase from the anthropologist Mary Douglas, who said that 'dirt is matter out of place' (Douglas, *Purity and Danger*, pp.2–3, discussed by Catherine de Zegher in Archer, *Mona Hatoum*, p.93). Hair can be precious or it can be discarded. Depending on the context, hair can seduce or make one retch with violent disgust. One could see this idea of the out of place recalling precisely that 'other reference point' which Hesse had struggled for.

◆◆◆

There are certainly social and cultural taboos and customs in operation here, but these are also shot through with what has been identified as the compulsive logic of the unconscious. The work of saving and collecting, the work of weaving – all this is often seen as women's work which points to a realm of femininity, but it also points to compulsive and obsessional activity. This is not, therefore, a straightforward celebration of femininity. It contrasts starkly with Judy Chicago's positive celebratory attitude to female sexuality and history discussed by Gill Perry in the introduction to this book. For whilst it does suggest a feminine realm, Hatoum's work is marked by a far more ambivalent approach to the question of femininity. It is important to remember here that Hatoum's work needs to be seen in relation to a later phase in feminist thinking, and reflects the move from validating women's experience which had been rendered invisible to exploring the more contradictory and difficult aspects, the gains and the losses, of femininity.

In *Recollection* the body is nowhere depicted, yet everywhere present. And the body is not subjected to rationalization or represented as a totality. Hatoum has talked about the work in terms of 'the dispersal of the body' which has long preoccupied her (Mona Hatoum interviewed by Michael Archer, *Mona Hatoum*, p.25). The body is rendered only in terms of these fragmentary displacements of physical matter. Hatoum's title draws attention to the different dimensions in play – 'Recollection' suggests the processes of collecting and the processes of remembering that hark back to earlier experiences; it suggests material lost and found. Just as hair can function as a symbol for remembrance, here the installation functions as a work of mourning (for the lost self). In his work on mourning, Freud drew a link between mourning and melancholia, where mourning could be understood as the loss of a loved object and melancholia or depression could be understood as the loss of a part of oneself. The installation could be a room of abandoned relics, which gradually works like a web or a trap for the spectator, like a web of fantasy into which the spectator is drawn. This is not simply Hatoum's fantasy but a collective fantasy in which we, as spectators, share and participate. For Freud, 'the finding of an object is in fact a refinding of it' (Freud, *Three Essays*, p.145). An 'object' here is understood in the psychoanalytic sense of some person or thing that is the aim or target of the sexual instinct – for which the child sucking at the mother's breast is the prototype of every later relation of love. This constant refrain of something lost suggests that subjectivity is made up of so many relics from the past – very much the picture which Hatoum makes for us.

In a sense, the work of art is itself a work of recollection, of 'refinding', of repetition. It is a kind of obsessive activity – whether the art object is made of paint or latex or hair – and of making strange. The spectator is also engaged in the task of recollection, of memory and forgetting, that necessarily invokes unconscious processes. In part the art work is a matter of conscious knowledge, of knowing what art has become, that art can look like this, at the very least – but once this is known and understood, then what is also triggered is a realm of fantasy that deals with taboos, desires and anxieties not only within ourselves but within our culture in a way that exceeds rational thought. Psychoanalysis does not offer an explanation of what art means so much as opens a field of speculation on to what might be its disturbing qualities as well as its pleasures.

References

Archer, Michael, Brett, Guy, and de Zegher, Catherine (1997) *Mona Hatoum*, London, Phaidon.

Burnham, Jack (1968) *Beyond Modern Sculpture*, New York, George Braziller.

Douglas, Mary (1966) *Purity and Danger: An Anlysis of the Concepts of Pollution and Taboo*, London, Routledge.

Freud, Sigmund (1910) *Leonardo da Vinci and a Memory of his Childhood*, reproduced in *The Standard Edition of the Complete Psychological Works of Sigmund Freud*, 1957, London, Hogarth.

Freud, Sigmund (1984) *Beyond the Pleasure Principle*, Penguin Freud Library, vol.11, Harmondsworth, Penguin, first published 1919–20.

Freud, Sigmund (1985) 'Gradiva' in *Art and Literature*, Penguin Freud Library, vol.14, Harmondsworth, Penguin.

Freud, Sigmund (1977) *Three Essays on the Theory of Sexuality* in *On Sexuality: Three Essays on the Theory of Sexuality and Other Works*, Penguin Freud Library, vol.7, Harmondsworth, Penguin, first published 1905.

Lippard, Lucy (1992) *Eva Hesse*, New York, Da Capo Press.

Rose, Jacqueline (1986) *Sexuality in the Field of Vision*, London, Verso.

Gender and fetishism: an overview

GILL PERRY

A theme which has appeared throughout Part 4 of this book is that of 'fetishism'. Feminist art history has shown that fetishistic images of women have pervaded both the images of high art and the mass media within our culture. But we've also seen that fetishistic images have been produced by both male (for example, Allen Jones) and female artists (for example, Meret Oppenheim and Eva Hesse), and have been employed to different ends – or at least have been subject to some very different interpretations. We have been largely preoccupied with a concept of fetishism which involves representations of female sexuality. We have explored a Freudian notion of fetishism, which is seen to be part of male sexuality, and which invokes an unconscious process. The meaning of the term fetishism has changed and evolved, and it is sometimes used in ambiguous or even contradictory ways.

Today the word is sometimes used broadly to indicate the projection of some kind of meaning on to a material object which is beyond the apparently 'true' value of that object. The term is often used in discourses on power or cultural authority in which that power is projected on to a subordinate or alien group, such as women, so-called 'primitives' or the 'insane'.

The concept of the fetish was probably first used by European traders in Africa in the sixteenth and seventeenth centuries to describe the seemingly alien and inexplicable native practices and objects which they observed. In the eighteenth century it was employed to signify the antithesis of so-called rationalist ideas which were so prized by many eighteenth-century writers and thinkers. To 'fetishize' became associated with irrational and arbitrary values of some religious and mystical beliefs. Such early uses involved the projection of an irrational and inexplicable 'otherness' – or strangeness – on to the fetishized object or person.[1] In the nineteenth century Karl Marx shifted the concept from the domain of 'otherness' and identified its role as central to the workings of the capitalist system. For Marx, then, 'commodity fetishism' signified the capitalist obsession with the value of material possessions as they appear on the market, an obsession which sustained capitalist economics.[2]

When Freud adopted the concept of fetishism it became directly involved with male sexuality, in particular with the male castration complex. In her essay, Claire Pajaczkowska showed how some of Allen Jones's images could be read as fetishistic imagery of women, citing Mulvey's article on Allen Jones which provided a definition of fetishism rooted in psychoanalytic theory. We

[1] The concept of 'otherness' when used in the context of ethnicity and perceptions of non-western art is explored in King, *Views of Difference* (Book 5 of this series).

[2] For a fuller discussion of the associations of the term fetishism, see Nelson and Shiff, *Critical Terms* and Ades, 'Surrealism-fetishism's job', pp.67–85. According to Marx, the productive activity of any capitalist enterprise is affected by 'goods' as they appear on the market. In the process these goods – or commodities – not only mask the productive relations between people, but they also appear to create them, since things (or commodities) appear to establish human relations rather than human relations producing things. On the definition of 'commodity' see Wood, 'Commodity'.

saw how the concept has been directly associated with male castration anxiety.

In the 1920s and 30s the Surrealist artists were preoccupied with the nature of the *object* of fetishism, with the displacement of desire on to familiar objects such as shoes, corsets, etc. We saw in the preceding study by Briony Fer that the Surrealists' interest in Freudian ideas on the unconscious led them to explore incongruous juxtapositions of images, as in, for example, Meret Oppenheim's *Fur Breakfast* of 1936 (Plate 193). Oppenheim employed these juxtapositions in several other works from the 1930s, including her *My Governess* of 1936 (Plate 196) in which two high-heeled shoes are trussed up on a serving dish. What's especially interesting about these two works in the context of this book is that a woman artist is herself exploring a form of fetishism which, according to Freudian theory, is a part of *masculine* sexuality. Pajaczkowska interpreted a work by Allen Jones as revealing masculine fetishistic preoccupations with parts of the female body, preoccupations which may reveal (repressed) unconscious desires. In contrast, Oppenheim has consciously chosen to foreground the possible fetishistic meanings of objects and to display them as art works.

Plate 196 Meret Oppenheim, *My Governess*, 1936, high-heeled shoes with paper ruffles on an oval platter, 14 x 21 x 33 cm, Moderna Museet, SKM, Stockholm, © DACS, 1999.

Please look at *Fur Breakfast* and *My Governess* (Plates 193 and 196). What aspects of these works suggest the artist's interest in Freudian notions of fetishism? Does your knowledge of the gender of the artist contribute in any way to your understanding of the works?

Discussion

Some of the ways in which *Fur Breakfast* plays on the idea of the fetish were suggested in Fer's essay. By covering a cup, saucer and spoon in the fur of a gazelle, Oppenheim combines a sensual, natural material (with its own sexual

connotations) with a commonplace manufactured object. The cup and the spoon are also associated with oral pleasure, another form of stimulus which, as we saw in Pajaczkowska's essay, is central to Freudian theories of sexuality. The Surrealists were particularly concerned not simply with the sexual associations of these individual objects, but with the effect which these strange juxtapositions could have on the viewer, with their capacity to trigger recognition of previously repressed desires, fears or pleasures – to reveal the unconscious.

My Governess employs similar strategies of association and juxtaposition. The stiletto heels (all too familiar fetish objects) are tied up and adorned with paper crowns which are usually used to decorate a rack of lamb. Once again, oral pleasure is suggested through the association with food. And the title itself provides an unexpected association, a puzzling level of meaning to do with being taught by a female teacher. We are prompted to ask, does this work include a reference to a sexual education? In both of these examples, the final work is a kind of composite object consisting of several juxtaposed elements. They are constructed as complex fetish objects with multi-layers of meaning and ambiguity. I would argue that each could be seen to be – so to speak – reflecting on itself. Each work is irresistibly funny in its absurd combinations and mixed associations; as viewers we are drawn in to acknowledge the mischievous wit behind the construction of these complex objects. The power of the fetish could therefore be seen to be both revealed and critiqued at the same time.

Plate 197 Man Ray, *Érotique Voilée (Meret Oppenheim à la presse) (Veiled Erotic)*, 1933, photograph, Musée National d'Art Moderne, Paris. Photo: Musée National d'Art Moderne, Centre Georges Pompidou, Paris.

It is perhaps more difficult to answer my second question about the gender of the artist. Although women's bodies were (according to Freudian theory) usually the passive objects of fetishistic processes, that does not necessarily make it easier for women rather than men to critique or reflect on those processes. Indeed, many male Surrealist artists, among them Max Ernst and Picasso, also produced strange juxtapositions of objects and images with fetishistic associations. We can only speculate on Oppenheim's intentions in constructing these works. However, our knowledge that she is a woman artist may well support (rather than prove) the suggestion that these works have a witty – even self-critical – edge to them. As a woman who was often photographed by other Surrealist artists in poses which could evoke fetishistic desires (Plate 197), she could have seen these works as an opportunity both to control and make fun of the objects of male sexual desire.

◆◆◆◆◆◆◆◆◆◆◆◆◆◆◆◆◆◆◆◆◆◆◆◆◆◆◆◆◆

More recently a British woman artist, Jemima Stehli (*b*.1961), has engaged directly with the kind of fetishistic imagery which preoccupied Allen Jones and which has provoked a body of critical feminist writing. In 1997–8 Stehli produced three life-size black and white photographs of herself naked (apart from high-heeled stilleto shoes) (Plate 198), acting out Jones's earlier installations of a woman's body as a piece of furniture (Plate 199). Her photographs are troubling to the viewer familiar with feminist discourse on the 'male gaze' and the misogyny of some fetishistic imagery of women because it is difficult to establish, as one reviewer put it, 'whether we are intended to read these blatant simulations as either critique or homage' (Higgs, 'Review soundings', p.18). The artist herself has claimed, 'I never thought I was being critical of Allen Jones, rather I'm interested in the fact that he's exposed his own sexuality in his work' (interview with the author, October 1998). She argues that she has reworked the image to explore her own sexuality and her own desires and experiences as a sexual 'object'. She refuses to censor what might be seen as her own complicity, claiming that would be to deny her sexuality. She has represented herself as both subject and fetishistic object in order to explore and expose her sexuality.

Stehli's work, then, raises tricky questions about the role of the woman artist in the representation of female sexuality. It problematizes our earlier reading of the theory of the gaze in that it raises the issue of female desire. Whether or not you support the artist's analysis of the possible meanings of *Table 2*, it invites us to engage with some difficult and troubling issues around the nature and function of fetishistic imagery of women.

Plate 198 Jemima Stehli, *Table 2*, 1997–8, black and white photograph, 137 x 241 cm. Photo: courtesy of Jemima Stehli.

Plate 199 Allen Jones, *Table Sculpture*, 1969, painted fibreglass, leather and hair, life-size, Ludwig Forum für Internationale Kunst, Aachen. Photo: Ann Munchow.

Conclusion

The subject of fetishism is a particularly appropriate one with which to end this book, in that it involves many of the themes and issues which have been central to our study of the relationship between gender and art. We have seen that a study of the concept of fetishism involves consideration of the nature of masculine and feminine sexuality, issues of looking and spectatorship, and the role of psychoanalysis in feminist theory.

In the introduction to the book I suggested that psychoanalytic models have had a broad influence on the development of feminist theory, even if they have not been universally adopted or directly acknowledged. We have seen, for example, that theories of looking have played an important role within feminist studies, and they have informed our understanding of how masculine and feminine sexualities are constructed and represented in visual images. Moreover, the idea that identity – or subjectivity – is not fixed or given, that it is socially and psychically constructed, has influenced many of the contributors to this book. Different authors have explored some of the ways in which constructions of femininity and masculinity can be revealed in the form and content of paintings and visual images and in the theory and practice of architecture and design. We have also seen how such gendered associations may be deeply embedded in the aesthetic and cultural values within which the work was produced, whether it be, for example, a Renaissance portrait, a seventeenth-century stately home, a Victorian genre painting, a work of 'decorative' art or an example of twentieth-century modernist painting.

This book has also placed special emphasis on the cultural and social roles, practices, and aesthetic preferences of women who have worked as artists within a (largely western) culture. We have explored some of the educational and social constraints which they encountered, and some of the aesthetic and professional strategies which they adopted in the pursuit of careers as 'artists'. I began by taking the first exhibition of Judy Chicago's *Dinner Party* as a focus of our exploration of the development of feminist art history. I want to conclude this exploration by briefly comparing this show and its political agenda with a more recent exhibition of the work of women artists entitled *Inside the Visible*, which was shown in Flanders, Belgium, Boston, Massachusetts and London, England in 1994–6. The exhibition was designed not so much as a 'reclaiming' of women's art (as was Chicago's earlier show) but as an attempt to explore more elusive and complex themes around the idea of the feminine, hence its subtitle: *An elliptical traverse of 20th century art – in, of, and from the feminine*. It contained the work of thirty-seven women artists from around the world from the 1930s to the 1990s. As was explained in the press release which accompanied the London show, it was 'not a survey of "women's art". Instead it examined hidden themes in twentieth century art – themes addressed by women but often ignored by the artistic establishment'. It explored themes such as the roles of the body, ethnicity and identity within representations of women, gender and sexuality and the relationship of gender to abstraction, pattern-making, and memory. The show included Mona Hatoum's *Recollection* (Plates 195(a), (b) and (c)), which was discussed earlier by Briony Fer and which (as we have seen) uses the medium of hair to evoke an ambiguous relationship with ideas of feminine seductiveness, the body and memory. The theme of the body combined with issues of race and identity were prominent in exhibits by, for example, the

Cuban artist Ana Mendieta, as in her *Silueta Works in Mexico* (Plate 200) and by the black American artist Carrie Mae Weems in her *Burnt Orange Girl (Colored People)* (Plate 201). An impressive range of works by western and non-western artists of markedly different backgrounds, some well-known to modern and feminist art history, including names such as Louise Bourgeois, Nancy Spero, Eva Hesse and Mary Kelly, contributed to a vivid and complex display of 'an alternative view of the art of our century' (press release). The organization of the exhibition, and the variety of works on show, encouraged the visitor to think about issues of gender difference in wide-ranging ways. 'Art' was presented in many and complex forms (including painting, graphics, sculpture, photography, video and installations) which engaged variously with issues of sexual, ethnic and political difference. In her introduction to the catalogue, Catherine de Zegher, one of the organizers, argued that we should see difference not so much in terms of fixed oppositions – for example, between 'masculine' and 'feminine' characteristics – but more as fluid ongoing oscillations between such characteristics. She wrote:

> Difference is far more entangled and complex than we like to admit. Taking this into account, I have attempted to develop an exhibition concept that bypasses the artificiality of 'oppositional thinking' while acknowledging the work of deconstructionism, feminism and post-structuralism, which has been instrumental in revealing the operations that tend to marginalize certain kinds of artistic production while centralizing others. Unfolding as an open-ended process, this exhibition is prompted by observation of multiple convergences in aesthetic practices both in time (over different periods of the twentieth century) and in space (in different parts of the world).

(de Zegher, *Inside the Visible*, p.20)

Plate 200 Ana Mendieta, *Silueta Works in Mexico*, 1973–7, colour photograph documenting earth/body with flowers on body, El Yagul, Oaxaca, Mexico, 50.8 x 33.7 cm. Photo: courtesy of the artist and Galerie Lelong, New York.

Plate 201 Carrie Mae Weems, *Burnt Orange Girl (Colored People)*, 1989–90, toned silver print, 77.5 x 77.5 cm. Photo: PPOW Gallery, New York.

De Zegher represents the exhibition unfolding as 'an open-ended process' rather than a linear survey, encouraging us to see its contents as fragmentary and producing different sorts of meanings when they are 'recombined' in new configurations. This critical approach is characteristic of recent developments in feminist art history which I outlined in the introduction to this book. I suggested that such approaches have tended to emphasize the fluidity of gender difference and the instability – or shifting nature – of meanings which have been attached to visual representations of femininity and masculinity.

We could see *Inside the Visible*, then, as revealing the approaches, and mapping the broader range of interests, with which feminist art history has engaged in recent years. Whether or not we see these interests as constituting an 'alternative view', they have undoubtedly enriched the discipline of art history as a whole.

References

Ades, Dawn (1995) 'Surrealism-fetishism's job', in A. Shelton (ed.) *Fetishism: Visualising Power and Desire*, London, Lund Humphries, pp.67–85.

de Zegher, Catherine (ed.) (1996) *Inside the Visible: An Elliptical Traverse of Twentieth Century Art in, of, and from the Feminine*, Cambridge, Mass. and London, MIT Press.

Higgs, Mathew (1998) 'Review soundings', *Artist News Letter*, March.

King, Catherine (ed.) (1999) *Views of Difference: Different Views of Art*, New Haven and London, Yale University Press.

Nelson, R. and Shiff, R. (eds) (1996) *Critical Terms for Art History*, University of Chicago Press.

Wood, P. (1996) 'Commodity', in R. Nelson and R. Shiff (eds) *Critical Terms for Art History*, University of Chicago Press.

Recommended reading

Betterton, Rosemary (1966) *Intimate Distance: Women, Artists and the Body*, London, Routledge.

Broude, Norma (1997) *Impressionism: A Feminist Reading*, Colorado, Westview Press/Icon Editions.

Broude, Norma and Garrard, Mary D. (eds) (1982) *Feminism and Art History: Questioning the Litany*, New York, Harper and Row.

Cherry, D. (1993) *Painting Women: Victorian Women Artists*, London, Routledge.

Deepwell, Katy (ed.) (1995) *New Feminist Art Criticism: Critical Strategies*, Manchester University Press.

Deepwell, Katy (ed.) (1998) *Women Artists and Modernism*, Manchester University Press.

de Zegher, Catherine (ed.) (1996) *Inside the Visible: An Elliptical Traverse of Twentieth Century Art in, of, and from the Feminine*, Cambridge, Mass. and London, MIT Press.

Fer, Briony (1997) *On Abstract Art*, New Haven and London, Yale University Press.

Garb, Tamar (1994) *Sisters of the Brush: Women's Artistic Culture in Late Nineteenth-Century Paris*, New Haven and London, Yale University Press.

Garb, Tamar (1998) *Bodies of Modernity*, London, Thames and Hudson.

Garrard, Mary D. (1989) *Artemesia Gentileschi: The Image of the Female Hero in Italian Baroque Art*, Princeton University Press.

Gaze, Delia (ed.) (1977) *Dictionary of Women Artists*, London, Fitzroy Dearborn.

Gouma-Petersen, Thalia and Mathews, Patricia (1987) 'The feminist critique of art history', *Art Bulletin*, September.

King, Catherine (1998) *Renaissance Women Painters*, Manchester University Press.

Mulvey, Laura (1989) *Visual and Other Pleasures*, London, Macmillan.

Nead, Lynda (1992) *The Female Nude: Art, Obscenity and Sexuality*, London, Routledge.

Ortner, Sherry B. (1974) 'Is female to male as nature is to culture?', in M.Z. Rosaldo and L. Lamphere (eds) *Woman, Culture and Society*, Stanford University Press, pp.67–87.

Parker, Rozika and Pollock, Griselda (1981) *Old Mistresses: Women, Art and Ideology*, London, Routledge.

Perry, Gill (1995) *Women Artists and the Parisian Avant-Garde*, Manchester University Press.

Pointon, Marcia (1997) *Strategies for Showing: Women, Possession and Representation in English Visual Culture 1665–1800*, Oxford University Press.

Pollock, Griselda (1988) *Vision and Difference: Femininity, Feminism and the Histories of Art*, London, Routledge.

Pollock, Griselda (1999) *Differencing the Canon: Feminist Desire and the Writing of Art's Histories*, London, Routledge.

Salomon, Nanette (1991) 'The art-historical canon: sins of omission', in Joan E. Hartman and Ellen Messer-Davidow, *(En)gendering Knowledge: Feminists in Academe*, Knoxville, University of Tennessee Press, pp.222–36.

Sheriff, Mary (1996) *The Exceptional Woman: Elizabeth Vigée Lebrun and the Cultural Politics of Art*, University of Chicago Press.

Wagner, Anne (1996) *Three Artists (Three Women): Modernism and the Art of Hesse, Krasner and O'Keefe*, Berkeley, University of California Press.

Index

Page numbers in *italics* refer to illustrations.